How the Other Half Looks

How the Other Half Looks

The Lower East Side and the Afterlives of Images

Sara Blair

Princeton University Press

Princeton and Oxford

Copyright © 2018 by Princeton University Press

Published by Princeton University Press
41 William Street, Princeton, New Jersey 08540

In the United Kingdom: Princeton University Press
6 Oxford Street, Woodstock, Oxfordshire OX20 1TR

press.princeton.edu

Jacket art: (Top): Alexander Spatari, *Chinatown seen through fence on a foggy day, NYC*. (Bottom): Ben Shahn, detail from *Untitled* (Lower East Side, New York City), April 1936, Harvard Art Museums / Fogg Museum, gift of Bernarda Bryson Shahn, © President and Fellows of Harvard College

All Rights Reserved

ISBN 978-0-691-17222-4

Library of Congress Control Number: 2017959640

British Library Cataloging-in-Publication Data is available

This book has been composed in Adobe Text Pro and Cooper Hewitt

Printed on acid-free paper. ∞

Printed in the United States of America

10 9 8 7 6 5 4 3 2 1

for Jonathan: always
for Ben and Miriam: a world repaired

Contents

List of Illustrations ix

How the Other Half Looks: A Preview 1

Object Lesson
Halftone and the Other Half 16

1 On Whose Watch?
Animation, Arrest, and the Subject of the Ghetto 29

2 On Location
D. W. Griffith, Early Film, and the Lower East Side 59

3 What Becomes an Icon?
Photography and the Poverty of Modernism 93

4 Looking Back
Henry Roth, Ben Shahn, and the Interwar Ghetto 119

5 Writers' Blocks
Allen Ginsberg, LeRoi Jones, and the Territory of the Image 152

6 Remediating the Lower East Side
Dystopia and the Ends of Representation 184

Coda
How We Look Now 219

Acknowledgments 223

Notes 229

Bibliography 255

Index 273

List of Illustrations

Color Plates (following page 128)

PLATE 1. Unknown Artist [formerly attributed to George Catlin],
The Five Points, c. 1827

PLATE 2. Paul Strand, *Wall Street, New York*, 1915

PLATE 3A. Raphael Soyer, *East Side Street*, c. 1929

PLATE 3B. Henry Roderick Newman, *Fringed Gentian*, 1861–1897

PLATE 4. Ben Shahn, *Untitled* (Lower East Side, New York City), April 1936

PLATE 5. Cover, *Collier's*, August 5, 1950

PLATE 6. *Collier's*, August 5, 1950, pages 12–13

PLATE 7. Chesley Bonestell, *Saturn as Seen from Its Moon Triton*, 1944

PLATE 8. Screenshot, Jeff Orlowski, *Chasing Ice*, 2012

Figures

FIGURE P.1. *A Plan of the City of New York* (Corlear's Hook as Crown
Point during British Occupation), c. 1776 4

FIGURE P.2. Unknown Artist [formerly attributed to George Catlin],
The Five Points, c. 1827 8

FIGURE P.3. *Five Points*, 1827, McSpedon & Baker lithograph after a
painting by George Catlin, c. 1850 10

FIGURE P.4. W. A. Rogers, "Cheap Clothing: The Slaves of the
'Sweaters,'" *Harper's Weekly*, April 26, 1890 12

FIGURE OL.1. Stephen Henry Horgan, *Shantytown*, 1880 16

FIGURE OL.2. Cover, *The Daily Graphic*, March 4, 1880 21

FIGURE OL.3. William A. Rogers, "Tenement Life in New York—
Sketches in 'Bottle Alley,'" *Harper's Weekly*, March 22, 1879 22

FIGURE OL.4. Jacob Riis, *Lodgers in a Crowded Bayard Street
Tenement—"Five Cents a Spot,"* 1889 25

FIGURE OL.5. Drawing after Jacob Riis, *Lodgers in a Crowded Bayard Street Tenement—"Five Cents a Spot,"* from *How the Other Half Lives: Studies among the Tenements of New York*. New York: Charles Scribner's Sons, 1890 26

FIGURE 1.1. Detail of advertisement for the Eight-Hour Plug Tobacco Company, *Knights of Labor*, April 10, 1886 38

FIGURE 1.2. Joseph Keppler, *Arbitration Is the True Balance of Power*. Puck: "Don't meddle with the hands, gentlemen—this pendulum is the only thing to regulate that clock!" *Puck*, March 17, 1886 39

FIGURE 1.3. Lewis Wickes Hine, *11:30 a.m.* Jennie Rizzandi, nine-year-old girl, helping mother and father finish garments in a dilapidated tenement, 5 Extra Pl., New York, New York, 1913 41

FIGURE 1.4. "The Street-Girl's End," illustration in Charles Loring Brace, *The Dangerous Classes of New York and Twenty Years' Work among Them*. New York: Wynkoop & Hallenbeck, 1872 44

FIGURE 1.5. Abraham Cahan, *Yekl: A Tale of the New York Ghetto*, first edition. New York: D. Appleton and Company, 1896 52

FIGURE 2.1. Screenshot, Auguste and Louis Lumière, *La Sortie de l'Usine Lumière à Lyon* [*Workers Leaving the Lumière Factory*], 1895 60

FIGURE 2.2. Edison "peep-hole" Kinetoscope, New York, undated. Photo by PhotoQuest/Getty Images 61

FIGURE 2.3. A Kinetograph camera, patented in 1891. Photo by Topical Press Agency/Hulton Archive/Getty Images 62

FIGURE 2.4. Henri Brispot, Poster for Cinématographe Lumière, 1895. BIFI Bibliothèque du film, Cinémathèque Française 65

FIGURE 2.5. Bain News Service, Socialists meeting in Union Square, May 1, 1908 68

FIGURE 2.6. Social Map of the Lower East Side. *New York Times Magazine*, April 3, 1910 69

FIGURE 2.7. Screenshot, D. W. Griffith, *Musketeers of Pig Alley*, 1912 74

FIGURE 2.8. Screenshot, D. W. Griffith, *Musketeers of Pig Alley*, 1912 75

FIGURE 2.9. Screenshot, D. W. Griffith, *Musketeers of Pig Alley*, 1912 76

FIGURE 2.10. Screenshot, D. W. Griffith, *Romance of a Jewess*, 1908 79

FIGURE 2.11. Screenshot, D. W. Griffith, *Musketeers of Pig Alley*, 1912 81

FIGURE 2.12. Screenshot, D. W. Griffith, *An Unseen Enemy*, 1912 82

FIGURE 2.13. Screenshot, D. W. Griffith, *Musketeers of Pig Alley*, 1912 84

FIGURE 2.14. Screenshot, D. W. Griffith, *Musketeers of Pig Alley*, 1912 87

FIGURE 2.15. Screenshot, D. W. Griffith, *Musketeers of Pig Alley*, 1912 89

FIGURE 2.16. Screenshot, D. W. Griffith, *Musketeers of Pig Alley*, 1912 90

FIGURE 2.17. Screenshot, D. W. Griffith, *Musketeers of Pig Alley*, 1912 90

FIGURE 3.1. Paul Strand, *Wall Street, New York,* 1915 94

FIGURE 3.2. Udo J. Keppler, *Following the Piper: His Music Enchants the World.* Chromolithograph. *Puck,* September 17, 1902 96

FIGURE 3.3. Bain News Service, Wall Street bomb, September 16, 1920 97

FIGURE 3.4. Irving Underhill, J. P. Morgan & Company Building, Wall and Broad Streets, ca. 1914 98

FIGURE 3.5. "Hat" Detective Camera (camera hidden inside bowler hat), Advertisement, 1900 99

FIGURE 3.6. Bain News Service, Bowery, New York City, ca. 1910–1915 102

FIGURE 3.7. Paul Strand, *Portrait, Five Points Square,* 1916 104

FIGURE 3.8. Paul Strand, *Conversation,* 1916 106

FIGURE 3.9. Paul Strand, *Portrait, New York (Yawning Woman),* 1916 107

FIGURE 3.10. Paul Strand, *Blind Woman, New York,* 1916. Alternate title: *Blind* 109

FIGURE 3.11. Walker Evans, *Truck and Sign* [workers loading neon "Damaged" sign into truck, West Eleventh Street, New York City], 1928–1930 112

FIGURE 3.12. Walker Evans, *License Photo Studio,* New York, 1934 113

FIGURE 3.13. Jacob Riis, *Dens of Death,* 1872 115

FIGURE 3.14. Walker Evans, *Negro Church, South Carolina,* 1936 117

FIGURE 4.1. Percy Loomis Sperr, *Avenue C at 13th Street, East side to the Southeast,* 1931–1942 120

FIGURE 4.2. Raphael Soyer, *East Side Street,* c. 1929 121

FIGURE 4.3. Frank Lloyd Wright, St. Mark's-in-the-Bouwerie Towers project, New York City, aerial perspective, ca. 1927–1931 123

FIGURE 4.4. The proposed Chrystie-Forsyth Parkway, from *The Regional Plan of New York and Its Environs,* 1930 124

FIGURE 4.5. The Metropolitan Museum of Art, Wing A, 1st Floor Room 38. Group of children in the Hall of Casts in 1910 131

FIGURE 4.6. Capitoline She-wolf with Romulus and Remus, 5th Century B.C.E. or Medieval Age bronze 133

FIGURE 4.7 Henry Roderick Newman, *Fringed Gentian,* 1861–1897 136

FIGURE 4.8. Ben Shahn, *Untitled* (Seward Park, New York City), 1932–1935 143

FIGURE 4.9. Ben Shahn, *Untitled* (Sig. Klein's Fat Men's Shop, 52 Third Avenue, New York City), 1935–1936 145

FIGURE 4.10. Ben Shahn, *Untitled* (Lower East Side, New York City), November 1935–1936 148

FIGURE 4.11. Ben Shahn, *Untitled* (Lower East Side, New York City), April 1936 150

FIGURE 5.1. Weegee (Arthur Fellig), *Outside the Yiddish Art Theatre, New York*, 1945 156

FIGURE 5.2. Gordon Parks, *New York, New York, push cart fruit vendor at the Fulton fish market*, May 1943 159

FIGURE 5.3. Todd Webb, *Suffolk and Hester Street*, New York, 1946 160

FIGURE 5.4. Allen Ginsberg, *Untitled (Myself seen by William Burroughs, Lower East Side, New York)*, 1953 163

FIGURE 5.5. Fred W. McDarrah, *"Rent-a-Beatnik" Party in Brooklyn.* Guests at a "Rent-a-Beatnik" party ($40 for the first beatnik, plus extra for each additional one), Brooklyn, New York, April 9, 1960 170

FIGURE 5.6. Sonny Rollins plays his saxophone on the Williamsburg Bridge, June 19, 1966 172

FIGURE 5.7. Fred W. McDarrah, *Ted Joans in His Loft*, November 4, 1959 173

FIGURE 5.8. Herb Snitzer, jazz musician Lester Young outside the Five Spot Club, New York, 1958 176

FIGURE 5.9. Detail, Leonard Bloom, "The Adventures of Superiorman!" *The Realist* 59 (May 1965), page 17 182

FIGURE 6.1. Cover, *Collier's*, August 5, 1950 185

FIGURE 6.2. *Collier's*, August 5, 1950, pages 12–13 186

FIGURE 6.3. Jimmy Hare, *Wreckage of the USS Maine in Havana Harbor, Collier's Weekly*, March 12, 1898 192

FIGURE 6.4. Screenshot, Orson Welles, *Citizen Kane*, 1941 195

FIGURE 6.5. Chesley Bonestell, *Saturn as Seen from Its Moon Triton*, 1944 196

FIGURE 6.6. Martha Rosler, detail of *The Bowery in two inadequate descriptive systems*, 1974–1975 200

FIGURE 6.7. Martha Rosler, detail of *The Bowery in two inadequate descriptive systems*, 1974–1975 200

FIGURE 6.8. Jacob A. Riis, *A Seven-Cent Lodging House in the Bowery*, ca. 1895 201

FIGURE 6.9. Lewis W. Hine, *Midnight at the Bowery Mission Breadline*, 1906–1907 202

FIGURE 6.10. Weegee (Arthur Fellig), *Drunks, The Bowery*, 1950 203

FIGURE 6.11. Harvey Wang, *The Andrews Hotel*, 1998 204

FIGURE 6.12. Martha Rosler, detail of *The Bowery in two inadequate descriptive systems*, 1974–1975 207

FIGURE 6.13. Martha Rosler, detail of *The Bowery in two inadequate descriptive systems*, 1974–1975 207

FIGURE 6.14. Martha Rosler, *Semiotics of the Kitchen*, 1975 208

FIGURE C.1. Screenshot, Jeff Orlowski, *Chasing Ice*, 2012 221

How the Other Half Looks

How the Other Half Looks

A Preview

When police-beat journalist Jacob Riis began using that quintessentially modern technology, the camera, to make the social life of New York City's newest, most threatened (and threatening) subjects visible, he had no idea that his work belonged to a longer history of response to a key space of encounter—or that it would come to inform a remarkable array of events unfolding over the century to follow. These included the evolution of photography as an art form, the rise of the American film industry, contests over literary realism, the dynamics of Jewish American cultural production, projects for rethinking the offices of poetry in Cold War America and those of the novel in the twenty-first century, and efforts to reanimate US print and visual media in global and digital contexts. Taking the project of observing the home of the "other half"—America's ur-ghetto—as a point of departure, *How the Other Half Looks* conducts a critical experiment. It offers a site-specific account of visual experience, practice, and experimentation, and considers how these inform literary and everyday narratives of America, its citizens, and its modernity.

For such an experiment, the Lower East Side offers a remarkable opportunity. Throughout its long and evolving history, the ghetto and tenement district, variously conceived, figured, and named, remained inseparable from the urgently modern problem of managing social difference and change. Home to the first free black settlement in New York City and to successive waves of immigrants, working-class laborers, culture workers, and other "others," the Lower East Side and its many avatars and analogues (the East Side, the Old East Side, *Kleindeutschland*, Baxter Street, Loisaida, Alphabet City, the Bowery; even, as I will argue below, the Five Points) has shaped the image repertoire of modern America. The neighborhood's

long associations with labor, criminality, vice, racial heterogeneity, and the inassimilable have informed its representation in every genre and medium, and made it an enduring resource for experiments in observing and imagining America and its citizens, its histories and possible futures.

In part, the Lower East Side remained a staple subject in emerging US visual media, from illustrated journalism and the mass press to documentary photography and early cinema, because it subjected all comers—its own residents, journalists and ethnographers, tourists and slummers, the guardians of health and welfare sent to police it—to intensely heightened experience, especially in visual terms. On its crowded sidewalks, in its commercial thoroughfares and overcrowded tenements, whether seen from a safe ethnographic distance or at close range, it made the challenges and limits of American modernity (including the challenges of knowing such sites at all) strikingly visible. In the face of its unprecedented density and raw materiality, new technologies and practices for observing American social life were tested, from halftone reproduction and flash lighting to location shooting and techniques for the visualization of nuclear holocaust. These in turn generated representational and media histories, as well as habits of observation that focused literary and popular expression, projects of social reform and social control, and aspirations for the American modernity they shaped, celebrated, and resisted.

Focused on that unfolding history, *How the Other Half Looks* explores the complex life and afterlives of America's downtown ghetto and tenement landscapes, as well as their inhabitants, as a source for an emergent iconography of modern experience, and a resource for probing the currency of new (and, for that matter, fading or outmoded) representational projects, genres, and media. Commentators have noted that the explosive growth of the Lower East Side as a site of entry into America and its ever-renewing newness coincided with an explosive growth in print culture, visual technologies, and mass publics, and with the rise of New York City as epicenter for their industry.[1] The nature of their intersection has, however, been left largely unexplored. Before and after Riis's camera work, I ask, what kinds of aesthetic strategies, what techniques or apparatuses for seeing, did observers develop in response to the spectacle and specter of the "Lower East Side"? In what expressive and visual forms did writers and artists imagine its contributions and challenges to American social life? How did its distinctive energies and its mixed temporal registers—a coalescence of

old worlds and new, of lifeworlds emergent and radically transformative—shape its representation in visual and literary forms and in other media?

Two key notions require clarification from the outset: the question of mapping or location, and the matter of iconography (from the Greek εἰκών, "image," and γράφειν, "to write": image-writing).[2] Readers conversant with foundational accounts of the Lower East Side, particularly in Jewish American studies and US social history, will note that the location of the space I invoke is labile: deliberately so. The historian Ronald Sanders noted some decades ago that "Lower East Side" as a geographical term has historically been "evasive," "shifting and expanding" to refer to shifting spatial coordinates and patterns of settlement and resettlement.[3] This is true, however, not just of the version of the space that has figured so prominently and so intimately in Jewish American experience. In fact, the currency of "Lower East Side" as a way of naming Jewish American experience during the era of peak immigration has had the effect of making previous immigrations and social dynamics virtually invisible. In the words of a longtime guide to the twenty-first-century neighborhood, "understanding the area" as a social site before the heyday of immigration "can be like trying to unstir a cup of coffee."[4] Yet the "before" view—the prehistory—of the Lower East Side as a space for observation and encounter made it a favored resource for experiments with apprehending the modern city as well as for closer views of its emerging social challenges. On the matter of site work, then, I take my cue from the myriad writers, journalists, image-makers, city-dwellers, and guardians of order who, from the mid-nineteenth century on, named the urban site in question with a remarkable combination of precision (as to political wards, economic activity, labor and criminal practices, and social typology) and vagueness (as to experiential location and demographic history).[5] This combination resulted, I argue, from the power of a gathering image repertoire of New York's working-class, immigrant, and otherwise unassimilated downtown, which was itself shaped by the distinctive histories and cultures of lower Manhattan.[6]

A onetime Lenape Indian habitation, Dutch colony, and English settlement by treaty (the booty of intercolonial warfare), the area served early in Manhattan's Anglo-European life as a trading post and commercial enterprise zone, a source of farmland, and a nexus of maritime, mercantile, and military exchange. These prehistories marked the netherlands of the nineteenth-century city, lending them to a fluid imagination of poverty, progress, and ethnoracial type. The commercial logic of Dutch power,

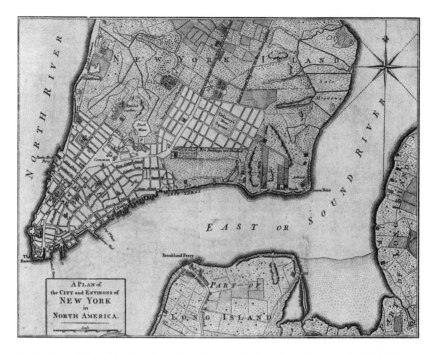

FIGURE P.1. *A Plan of the City of New York* (Corlear's Hook as Crown Point during British Occupation), c. 1776. Library of Congress, Geography and Map Division.

extended under the English (particularly that of the first English governor, Irish-born Thomas Dongan), had drawn a relatively varied Anglo-European population, including French Protestants and the soon notorious Irish.[7] Soon after the Revolution, the seizure of the property of Loyalist James Delancey (for whom the Lower East Side's major artery, running from the Bowery to the East River, is still named) put paid to the vision of a decorous city ballasted by an aristocratic urban square, modeled on those of London's West End. As one commentator puts it, the resulting development "established the resolutely democratic nature of the neighborhood forever."[8]

Even a glance at that earlier vision, as recorded in an aspirational map made by British planners during colonial occupation, suggests how radically the actual city departed from it (figure P.1). Ensuing patterns of immigration and settlement contributed to some version of this "democratic" effect. In the decades after the Revolution, the area known as Corlear's Hook—the hump of land jutting into the East River around what

are now Delancey and Cherry Streets—rapidly developed as a navy yard and shipyard, associated with transient, far-flung sailors and the immigrant shipbuilders, blacksmiths, and instrument-makers who settled their families there.[9] As early as 1816 the area was notorious for bars, brothels, and streetwalkers, a "resort for the lewd and abandoned of both sexes"; by midcentury, "hooker," after "the Hook," had become (as it remains) a widely used American synonym for "prostitute."[10] In 1832, the same site became the epicenter for an outbreak of cholera and a makeshift hospital to treat it, to which 281 patients, African American, Irish American, and other, were admitted.[11] The following year, the area had the dubious distinction of becoming home to the first purpose-built tenement in the United States, on Water Street east of Jackson between Grand Street and the East River.[12] That built form, designed to house a maximum number of families with minimal ground and living space, came to characterize the neighborhood as it grew to accommodate surges of new Americans settling there from the 1820s through the decade following the Civil War.[13]

Vice, prostitution, disease; the rapid expansion of laboring classes and immigrant populations; transiency, crowding, and sharply rising density, all feeding genteel flight and the rise of the tenement: long before the so-called golden age of immigration or the rise of the Jewish ghetto, long before the Lower East Side came into view as such, its earlier avatars embodied, for everyday citizens, city-dwellers, and Americans at large, the downside of the city's rapid capital and industrial expansion, demographic growth, and nascent globalization. In so doing, it figured the perils of modernization as a social and cultural project. Throughout its various lives, in all its shifting spaces and boundaries, the territory that would become known as the Lower East Side brought home the threats and promise of American modernity.

A point of entry both for aspiring citizens and for the writers, pundits, and regulators aiming to observe them, this space and its rapidly expanding citizenry offered themselves up as raw materials for figuring what labor and industry, the body politic and the working masses, urban life and Americans in the making might look like—how they could be made visible and apprehended. No wonder that the material locations indexed by "the Lower East Side" shifted considerably over time and from context to context. By the end of the nineteenth century and well into the twentieth, wherever immigrants, Jews, unassimilated others, poverty, sweatshops, tenements, street markets, flashy goods, pushcarts, radical politics, suffocating crowds,

child labor, street gangs, nests of prostitution or vice, disease, epidemics, or vagrancy were to be found in some synergy or combination—as historical phenomena or in real time—there was the Lower East Side.

Accordingly, a key premise of *How the Other Half Looks* is that the very term "Lower East Side" became in a critical sense self-fulfilling: it named a contested social space that defined the manner of its own invocation. In this sense, "Lower East Side" offers a powerful example of the cultural function of deictic language as described by Roland Barthes. Like the word "there" in the phrase "look there," such language "bring[s] into existence" what it selects, locating meaning spatially and temporally.[14] I invoke Barthes pointedly, since his thinking on the power of such language implicates his understanding of photography—that privileged form of inscription through which otherwise invisible experience may become visible. For Barthes, famously, the photograph is "never anything but an antiphon of 'Look,' 'See,' 'Here it is'; it points a finger at certain *vis-à-vis*, and cannot escape this pure deictic language."[15] As the readings that follow will show, the knowledge and the stance of encounter (the "*vis-à-vis*") afforded by the photograph found charged uses in relation to America's iconic ghetto. Real-time images of the Lower East Side helped bring rapidly changing forms of experience into view for social control as well as for shared knowledge and aesthetic pleasure. In an era of burgeoning mass imaging and spectatorship, the space of the other half became a critical, even unique, site of experimentation with visual apparatuses, techniques, and aesthetics. It thus also became a laboratory for testing the social uses of mass imaging, especially in evolving cultural narratives about the modern city and nation.[16]

In underscoring visual practices—in particular, practices indebted to photography—in relation to the Lower East Side, I challenge some key assumptions about its histories. In her acclaimed account of the making of Jewish American memory, the historian Hasia Diner notes that the Lower East Side "is automatically understood by all as distinctive, replete with a set of icons associated with it, and usually with it alone."[17] Further, she argues, "these icons have become firmly fixed in the American Jewish consciousness"—"thoroughly reified"—"as synonymous with *the* American Jewish experience." In Diner's reading, notably, it is the iconic status of the objects and types associated with the ghetto and tenement landscape that constitute it, for American Jews, as a generative (in her terms, sacred) space. But the iconography of the Lower East Side has a powerful life beyond that collective imagination, one that implicates evolving American

assumptions about modernity, poverty, racial and ethnic identity, the laboring classes—even art.

Durable yet mobile, this iconography appeared in a striking variety of cultural contexts from the late nineteenth century and through the twentieth. It also entered into a wide range of experiments with visual and literary forms and their legacies, and with the cultural agency of emerging new media. Only by acknowledging the effects of this long-standing, evolving iconography, I argue, can we account fully for the Lower East Side as a site of social and imaginative encounter—and hence, as Diner's work suggests, for the expansive hybridity of Jewish American culture itself.[18] Such an account may in turn help us better understand the agency of an image repertoire that moves across visual and textual fields, in an era in which explosive print and visual cultures claimed new participants, staked expanding social territories, and came increasingly to define collective experience. To trace that movement is also to rethink the life of the image as it enters into visual and textual genres, histories, and media.

How, then, to account for how the other half looks—how subjects who are not yet or not fully citizens are framed, encountered, and imagined in the dynamic, consequential space they inhabit? And how do such subjects look back at (and with) the forms and modes used to represent them? Let me offer a brief preview of the matter and manner of the pages that follow, and how they look at and with their varied subjects.

I begin with an image notable for both its origins and its afterlives: an 1827 oil painting titled *Five Points* (plate 1 and figure P.2). By any reckoning, this work is among the earliest visual representations of urban street life in the United States. It was long attributed to George Catlin, a Philadelphia lawyer turned painter who became the first artist to depict American Indians extensively in their own territories, thereby creating America's largest prephotographic image archive of Native peoples. Given Catlin's timeline and defining subject matter, however, the attribution to him of this work would always have been unlikely.[19] Nor does the image comport well with historical evidence about the evolution of visual genres from the Republican era into the antebellum. Not until 1830 did public exhibition spaces newly opening in New York, Boston, and Philadelphia make it possible for painters to venture beyond the realm of portraiture, with its logic of private commission, to experiment with new subjects for a growing American citizenry. Their efforts typically took the form of so-called genre paintings that

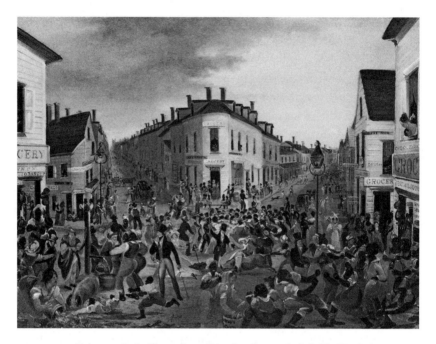

FIGURE P.2. Unknown Artist [formerly attributed to George Catlin], *The Five Points*, c. 1827. The Metropolitan Museum of Art. Oil on wood panel. Bequest of Mrs. Screven Lorillard (Alice Whitney), from the collection of Mrs. J. Insley Blair, 2016. *See also* Plate 1.

focused on everyday or community life in rural settings linked to cherished national ideals. Catlin painted his first Native portrait in 1827 and thereby inaugurated what he described as "a whole lifetime of enthusiasm" for the vanishing American in a vanishing wilderness.[20] Why might he have chosen for the subject of a new visual mode a site already infamous among city-dwellers not for nobility but for an alarming kind of savagery—as an irate reader of the *New York Evening Post* put it in 1826, "houses of ill fame, tippling shops, drunken persons and other kinds of filth"?[21]

One possible connection is the commitment to environmental authenticity. I have in mind not the logic of in situ works, designed for a patron's home or referring to their own site of exhibition, but an interest in the continuity between human subjects (Native communities, heterogeneous urban communities) and the spaces they inhabit. Notably, if *Five Points* offers a protodocumentary account of how the lower orders look—brawling, swilling, and race-mixing, amid casual prostitution and alcoholic consumption, abetted by the area's plethora of "groceries" selling beer, ale, gin, and

rum—it takes a relatively dispassionate view of that landscape.[22] (The year of its production was the same in which slavery in New York was outlawed, and newly freed African Americans made up the majority of the area's population.)[23] A dense foreground, irregular composition, and odd cropping challenge the spectator's ability to navigate the streetscape. At the same time, however, the image makes specific lines of sight clear and unimpeded. Capitalizing on the distinctive geometry of the Five Points, where Orange, Cross, and Anthony Streets intersected in the ironically named Paradise Park, the painting attributed to Catlin makes New York's most notorious public space the point of origin for imagined movement northward, in the direction of the city's growth and future.

Visually, then, *Five Points* suggests not the project of containing poverty, disorder, and licentiousness but rather the inevitable expansion of a dynamic and heterogeneous community, along with the city itself, toward an as-yet-unseen horizon. Absent the idealizing motive the would come to characterize genre painting, *Five Points* anticipates the latter's interest in observing what Metropolitan Museum of Art curators H. Barbara Weinberg and Carrie Rebora Barratt describe as its key subject: "the character" of Americans as "individuals, citizens, and members of ever-widening communities."[24] Here, precisely what is not readily assimilable to decorum and social order—or the spectator's eye—will "widen" into the city of tomorrow.

In a specific sense, the vision of the American future implied in *Five Points* became a self-fulfilling prophecy. Although the painting attributed to Catlin was privately held after its production (in fact, until 2017), it enjoyed an afterlife that embodies the iconographic power of the site it observes. Booming growth and immigration drove a nearly threefold increase in the city's population between 1825 and 1855, accompanied by similarly rapid growth in infrastructure and institutions devoted to its governance, welfare, and social discipline.[25] One strategy for keeping up with this dynamism was an annual publication, *The Manual of the Corporation of the City of New York* (known, after its original editor, as *Valentine's Manual*), which compiled city reports and directories related to governance, commerce, charitable activity, and city services. In an apparent nod to the challenge of creating a collective history of rapidly changing built and cultural environments, the *Manual* included a wide range of high-quality engravings of notable sites. Beginning with the 1855 edition, these included a rendering of the notorious Five Points. Notably, however, in spite of significant changes

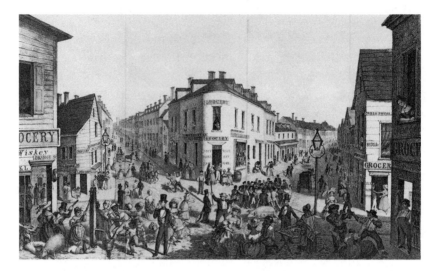

FIGURE P.3. *Five Points*, 1827, McSpedon & Baker lithograph after a painting by George Catlin, c. 1850. Published in D. T. Valentine, *Manual of the Corporation of the City of New York*, 1855. Museum of the City of New York. 97.227.3.

in downtown demographics and built landscape, the image produced for the volume was based not on present-tense observation, but on the 1827 painting attributed to Catlin (figure P.3).

The 1855 rendering has clearly been updated to speak to its mid-nineteenth-century context. The viewer's distance from the human actors on the scene has been lengthened—or rather, those figures have been made smaller in scale and less prominent, with the exception of the man and woman on the right edge of the image, whose placements and postures indicate that her sexual services are (still and again) for sale.[26] The composition has been significantly tightened; habitués of the street now cluster in more-regular geometrical groups. They have also been significantly whitened—a smaller number are now visually marked as African American, and these appear for the most part spatially segregated or engaged in activities consistent with servitude. The midcentury rendering may reflect actual shifts in demography (including the movement of most African Americans to areas of the city west and north of the Five Points)—or urgent fantasies, on the lead-up to Draft Riots and Southern secession, of social control enacted through visual representation.

In either case, however, what's most striking is not the changes that reflect contemporary concerns but the persistence of an iconography of the city's nether regions and the lower orders inhabiting them. In a moment when, as Meredith McGill has argued, illustrations and the broader graphic environment of antebellum print culture were driven by the imperative to make recirculated texts visually distinctive—to confer on them a "proprietary" singularity and value by virtue of their visual novelty—this tutelary image of the city's underworld falls back on a received view.[27] The *Manual's* midcentury view of the Five Points recycles the downtown crossroads as a visual and symbolic device, binding the energies of threatening disorder to indeterminate prospects for the city's future.

The force of this perspective becomes clearer when we consider a later and very different illustration, made by the respected *Harper's Weekly* house artist William Allen Rogers to accompany an April 26, 1890 editorial titled "Slaves of the Sweaters" (figure P.4). Like the photographs included in Riis's *How the Other Half Lives*, which was published in book form the same year, Rogers's image was designed to create what he called "a frontal attack" on its viewers, forcing them to look squarely at the subjects of poverty and the ghetto.[28] The accompanying editorial begins by noting that "the observer need not go to Hester Street, as the artist has done, to find an exemplification" of the heavy "burden of poverty."[29] Clearly, however, this is a Hester Street of collective imagination and the image repertoire. No site along that thoroughfare, running west from Division Street to (then) Centre Street, would have afforded the perspective Rogers offers. He has significantly altered the streetscape and its densities so as to stage the isolation of the tenement-dwellers, groaning under their burdens, from the modernity of the larger city. He also locates his subjects squarely at an imaginary crossroads, reminiscent of earlier views of the geographically adjacent Five Points.[30]

Here, however, the crossroads opens not away from but toward the viewer, emphasizing its openness as a site of encounter. The "army" of tenement-dwellers and sweater's slaves—what *Harper's* calls the " 'surplus humanity' of Europe"—is coming, and will in "an ever-increasing stream" continue to come. What's more, the "very gradual process" framed as their "emancipation" in the "promised land" necessarily involves the movement of these toiling aliens into social spaces the viewer occupies—a prospect about which, in the context of mass immigration and the cultures of the

FIGURE P.4. W. A. Rogers, "Cheap Clothing: The Slaves of the 'Sweaters,'" *Harper's Weekly*, April 26, 1890. Library of Congress, Prints and Photographs Division.

ghetto on the eve of the twentieth century, *Harper's* remains ambivalent.[31] In any case, opening this prospect for its readers means invoking a familiar, even mnemonic, visual device of the era, connected with an earlier urban space of alterity and threat. Visually and graphically, the future of the ghetto—which, *Harper's* makes clear, implicates America's future—comes into view as an effect of the apprehension of past and adjacent sites of challenging otherness.

My juxtaposition of these disparate images takes certain critical liberties in order to suggest the mobility of a broader iconography of social difference, poverty, and vice that shadows visual and textual accounts of the Lower East Side. It also suggests how that site gets sutured to photographic representation. Even as the need to see—to comprehend and remediate—poverty and the unassimilated grew urgent in the era of mass immigration, the space most associated with those conditions lent itself in remarkable ways to the expression of concerns about the experience of modern times. Just as its geographical juxtaposition with earlier sites of urban threat hastened their conflation with images of the ghetto, the presence of shtetl-made Jews and other figures of the Old World encouraged what I call a habit of *arrest*. Observers of all sorts—nativist, philosemitic, artistic, and disciplinary—shared a tendency to view the Lower East Side and its inhabitants as outside or behind the temporal reach of the city's modernity. "Splendid types of that old Hebrew world," drawn from the pages of the Hebrew Bible (a.k.a. the Old Testament), are "everywhere" visible on its crowded thoroughfares, William Dean Howells opined in 1896; some thirty years on, a new guide to the city encouraged visitors to take in the quaint markets in Hester Street—"the type, little altered to this day, of the earliest markets in the world."[32] Relegating its inhabitants to a static, typological past, in spite of their active shaping of dynamic institutions and cultural practices, "native" observers render the ghetto discontinuous with the dynamic life of the modern city. In so doing, they normalize as the stance of the contemporary observer an essentially photographic mode of seeing, predicated on instantaneous arrest. They borrow a transcriptional agency from the operations of the camera, reinforcing the status of their subjects as objects of knowledge or encounter.[33]

Given the real-time role of the ghetto and tenement district as a crucible for decisively modern social practices and forms, ranging from labor activism and radical politics to street culture, popular music, and experimental theater, the impulse to distance or arrest it looks like a mode of

temporizing, of playing for time to imagine less threatening possibilities for America's future.[34] But observers attuned to the challenges of representing the felt experience of modernity, the compression and intensities of lived time, saw the Lower East Side as a resource for a very different kind of engagement. Unprecedented densities of persons and experience; Old World subjects morphing into change-agents, driving new organizations of labor, capital, and sociality; close encounters with unimaginable histories in the making: given these defining conditions of ghetto and tenement life, what better place to test modes of documenting and imagining the fraught experience of historical being? Training the camera on that urgency, image-makers learned to apprehend the temporal instability associated with the ghetto as an analogue for that of the photograph itself. To be sure, camera work came to aid significantly in the later framing of the Lower East Side as the portal to a fixed past and a *lieu de mémoire*.[35] But emerging photographic practice in response to that site and its citizens prompted exploration of the affective and social problem, for all modern city-dwellers in the face of rapid change, of being in time. In this way, the project of representing the landscape of the other half entered into varied narrative and literary experiments with timely form. At the same time, it embedded histories of engagement with the Lower East Side in evolving practices for observing, documenting, and giving vital expressive form to everyday modern life.

These practices were hardly confined to the practice of photography, as the pages that follow attest. But they intimately involved concerns about visibility, exposure, transcription, timelessness and timeliness, fidelity to experience, realism in relation to modernism, the limits of social knowledge and the forms of its production, and other matters into which photography entered (and with a vengeance). The history I unfold here, the image archive I bring into view, begins with a landmark nineteenth-century development in the technology of mass imaging, and comes to rest in the problem of reanimating representationally the waning media of the twenty-first century. Along the way *How the Other Half Looks* raises questions about visual culture, literary history, and their entangled lives, and about our collective image of immigration and its life (newly urgent as I write these words) in American modernity. What do the birth of mass photojournalism, the invention of photographic modernism, and the invention of the spectator of early cinema owe to energies and habits of observation on the Lower East Side? How does the image history of that site enter

into the life of literary forms, from realism, naturalism, and the immigrant novel to postwar lyric and the novel in the digital era? With what effects do writers and image-makers on the Lower East Side look back at the "native" Americans who observe and represent them—and make aesthetic forms robustly new by challenging the model of assimilative modernity, along with conventional understandings of the relationship of immigrant to native, Old World to New? How do ways of seeing on the Lower East Side travel across social contexts and media? Finally, across all its subjects and materials and sites of engagement, this book asks how, once and anew, the Lower East Side looks, and how a thoughtful, widely informed response to that question might change the ways we look back on this project we call America and see ourselves in its image.

Object Lesson

Halftone and the Other Half

FIGURE OL.1. Stephen Henry Horgan, *Shantytown*, 1880. Getty Images/George Eastman House.

On March 4, 1880, the popular *New York Daily Graphic* made history by publishing a photograph of a New York City streetscape (figure OL.1). The first full-toned photographic image ever photomechanically reproduced in a newspaper, it appeared courtesy of a technical breakthrough, one that would come to revolutionize the nature and impact of mass illustration in the United States. Using a specially designed screen over an engraving plate based on the photograph, graphic artist Stephen Henry Horgan broke the image down into a series of reproducible dots—a proto-dot-matrix—whose placement and gradation mimicked the effect of photography's continuous

tonal range. This process of reproduction became known as halftone screening. Previously it had been necessary to redraw every photograph by hand on a wood-block engraving plate. That labor-intensive process could involve as many as forty artists working for hours or even days.[1] The *Daily Graphic*'s "Reproduction Direct from Nature"—crude as it admittedly was in this inaugural form—promised direct transcription and dramatically reduced turnaround time from event to published image.[2] In the context of New York's briskly competitive news market and its burgeoning culture of print and illustration, this was nothing less than a sensation.

It was not, however, a fully welcome one. News illustrators vehemently opposed any innovation that would interfere with their stock in trade, pen drawing—which, ironically, often relied on archival photographs to supplement on-the-spot sketching for accuracy and richness of detail. Even Horgan himself "was artist enough to see the limits of his invention," on the theory that "every illustration should have the 'touch of the artist' to make it acceptable."[3] That magic touch was supposed to redeem mechanically reproduced images from the crudity and promiscuity of America's explosive mass visual culture, whose banality *Nation* editor E. L. Godkin had famously attacked in 1874 in the mode of "chromo-civilization."[4] But the bid for redemption was a risky one. Illustrated news organs were thought to be *fast*, in every sense of the term: quick to respond, and eager to visualize the seamy side of the modern city. Their respectable rivals, gentry organs like *Harper's Weekly*, were content to be gray "lumbering stage coach[es]" on the new information highway, affording their passengers a statelier, more elevated view of urban life.[5] As cultural historian Neil Harris puts it in an influential account of the halftone revolution, from the perspective of genteel culture-makers, "the mass of . . . sometimes sensational illustrations that took up increasing space in periodicals represented degeneration."[6]

Crude, mass, degenerate: the register of description attending the birth of the halftone process, in its moment and since, makes it all the more striking that the subject matter of Horgan's experiment has gone unremarked. "A Scene in Shantytown, New York" figures routinely in histories of photography, visual communications, journalism, print culture, and even graphic design.[7] They attend—in sometimes rapt detail—to the processes, materials, and technical manipulation that brought the image into print. But the question of why a stretch of squalid shanties should have become the matter of this heralded breakthrough has never been raised.

What difference might the site of a newly powerful mode of social see-
ing have made to that act, or to its perceived value? The way we address
the question depends in part on how we locate Horgan's landmark pho-
tograph. At a historical distance, the idiom "shanty town" has reflexively
suggested those staple figures of urban lore, Irish Americans. Thanks to the
Great Hunger in their home country, Irish immigrants had dramatically
swelled the population of US cities and the infrastructure of abject pov-
erty throughout the mid-nineteenth century. By 1854, they accounted for
25 percent of the population of New York City, Boston, and other metro-
politan centers. Beyond urban cores, their makeshift dwellings had sprung
up across the country, marking their labor on the railroad as it lapped the
miles. In Salem, Massachusetts, Nathaniel Hawthorne remarked in 1843 on
the presence of "a little hamlet of board-built, turf-buttressed hovels" near
Walden Pond—"habitations the very rudest, I should imagine, that civi-
lized men ever made for themselves."[8] In New York City, the identification
of Irish immigrants with shantytown blight—particularly on vacant land
north of the developed city, above 59th Street on the West Side—was so
reflexive that it inspired its own etymology. Despite early uses derived from
French Canadian vernacular (*chantier*, hut, temporary camp), "shanty"
was unequivocally said to derive from the Irish *seantigh* (prounounced
shant-ti), "old house."[9]

Not surprisingly, then, commentators assumed Horgan's *Scene in Shan-
tytown* was photographed uptown, recalling such infamous antebellum
encampments above the city's northern boundary as Dublin Corners,
Seneca Village, and the Piggery, home to thousands of Irish immigrants.
The visible topography of the scene in Horgan's image aids this assump-
tion. But many of these settlements, collectively known as Shanty Town,
had been razed in 1857 for the construction of Central Park. By 1880, the
haunts of "the original freesoilers"—"Celt" builders and their makeshift
dwellings—had "become things of the past," thanks to the law of eminent
domain, police actions, and the liberal use of gunpowder: more than the
stores exploded by both armies at the Battle of Gettysburg.[10] Blown to
smithereens, the city's original Shanty Town was a lingering memory—
or to put it another way, an icon with an afterlife.

Still, huddles of surviving shanties could still be found in Manhattan, in-
cluding downtown.[11] One account of *A Scene in Shantytown* suggests that
the photograph was taken by *Daily Graphic* staff photographer Henry New-
ton on a routine tour of sites "near the newspaper's office."[12] The journal

was housed at 39–41 Park Place; it was one of many printing and publishing enterprises that clustered from Pearl Street, the southern extension of the Bowery between the under-construction Brooklyn Bridge and the future site of the Manhattan Bridge, to the blocks abutting City Hall—a zone encompassing the southern tip of the soon-to-be teeming Ward 10 (the Lower East Side), the infamous Ward 6 (the Five Points), and the areas west of the rough-and-tumble slips along the East River.[13] Not just the camera, then, but the journal itself may have been "in the immediate presence of the shanties which are shown in it": an agency for seeing embedded in the sites on which its gaze was trained. Its sight work, in other words, may have been inseparable from its embeddedness on site.

Whether or not this was the case, the *Daily Graphic*'s editors seem strangely silent about the potential topical appeal of their groundbreaking image. Far from highlighting dire conditions of poverty or the inassimilable, the journal invoked the shanties to demonstrate the revolutionary potential of halftone reproduction as a technique—in other words, to advertise the *Daily Graphic*'s unrivaled power to offer city readers a spectacular panorama of city life. Part of a two-page spread illustrating "Fourteen Forms of the Graphic Process," from wood engraving and collotype to photolithography, *A Scene in Shantytown* appeared alongside hand-produced images of picturesque landscapes, "dainty specimen[s]" of rural life, portraits of luminaries, and the journal's own staff "Preparing a Double Spread for Tomorrow's Graphic." Commenting on the photo-image, the *Graphic*'s editors focus on "the effects . . . obtained by the use of vertical lines" in the halftone screen process under development. For "this class of work," the editors note, "architecture appears especially suited." In their accounting, it's the tonalities of *A Scene in Shantytown*—its pictorial qualities—that lend themselves to halftone reproduction, presaging an era when "streets and houses will be rendered" with an otherwise elusive "fidelity."[14]

To be sure, the *Daily Graphic*'s halftone breakthrough occurred just before the vaunted floods of immigration to the Lower East Side, beginning roughly in 1881, that became foundational to its life and afterlives.[15] But concerns about immigrants, a labile working class, and the evils of overcrowded and unsanitary conditions in downtown tenements long preceded that date. In the context of long-standing anxiety about downtown as a zone of otherness, "architecture" seems an oddly euphemistic term to denote the makeshift structures that feature in Horgan's halftone. The cover of the March 4, 1880 *Daily Graphic* emphasizes this logic of euphemism—that is,

the suppression of any link between the halftone "class of work" and representation of the city's swelling underclasses (figure OL.2). There, in celebration of its own anniversary, the journal represents itself as an allegorical figure, standing before an easel on which appears the very double-page spread at the center of the number. If the figure's pose is conventional, her right arm and hand, delicately grasping an illustrator's tool, are strategically placed to obstruct our view of *A Scene in Shantytown* on the bottom left of the page spread. The artist's pen, it would appear, must be mightier than the poor ward or the mode of its reproduction. Even as the *Daily Graphic* trumpets the technological achievement of the halftone screen technique, it screens the subject of its own breakthrough experiment from view.

Within a decade, halftone photography would come to be closely associated with the project of exposing urban poverty, particularly in downtown New York. But as the *Daily Graphic*'s cover image suggests, that development was far from inevitable. In light of future developments, we might ask why America's ur-ghetto would be made invisible as the subject of visual innovation. To answer that question, we might look to the interpretive confusion said to be created by the halftone image. Nineteenth-century readers were encountering photomechanical images in mass print culture for the first time. In a context of rapid growth in literacy, print forms, and mass print culture, the appearance of the halftone radically undercut a long-standing contract between readers and nineteenth-century print organs. Familiar modes of mass illustration openly displayed the conventional nature of their imaging. Cartoons, portraits, streetscapes, other "views," based on a wide variety of reprographic processes: all were obviously the product of an artist's subjective vision, selecting for matter and taste, employing a chosen medium.[16] A *Sketch of Tenement Life* for *Harper's Weekly*, another work by illustrator William A. Rogers, is a case in point (figure OL.3). Organizing iconic scenes of tenement life—the den of drink, the squalid courtyard, children at risk in the teeming street (all highlights of Riis's work)—in a layout that pinpoints distinct and appropriate objects of observation, Rogers's *Sketch* literally offers the reader a big picture and a whole field of vision: variable yet totalizing, discontinuous yet holistic. Through such imaging, the result of long-standing interpretive conventions, Harper's readers could trust that the sobering facts of tenement life were being made appropriately visible for their apprehension.

With photomechanical reproduction of a photomechanical image, however, the basic "sign function" of the hand-made image—advertising

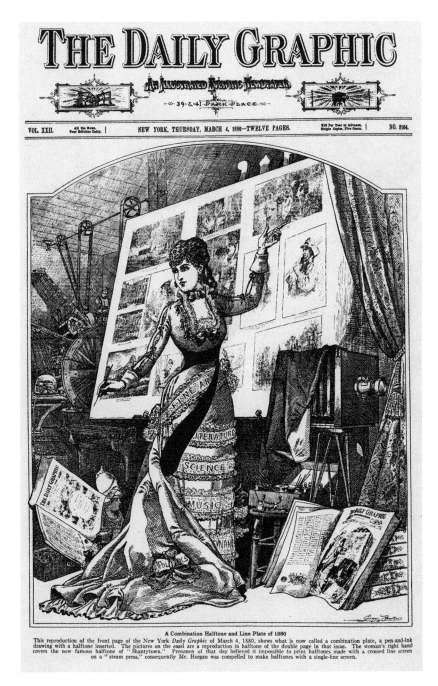

A Combination Halftone and Line Plate of 1880

This reproduction of the front page of the New York *Daily Graphic* of March 4, 1880, shows what is now called a combination plate, a pen-and-ink drawing with a halftone inserted. The pictures on the easel are a reproduction in halftone of the double page in that issue. The woman's right hand covers the now famous halftone of "Shantytown." Pressmen of that day believed it impossible to print halftones made with a crossed line screen on a "steam press," consequently Mr. Horgan was compelled to make halftones with a single-line screen.

FIGURE OL.2. Cover, *The Daily Graphic*, March 4, 1880. University of Michigan Library. Photo credit: Austin Thomason.

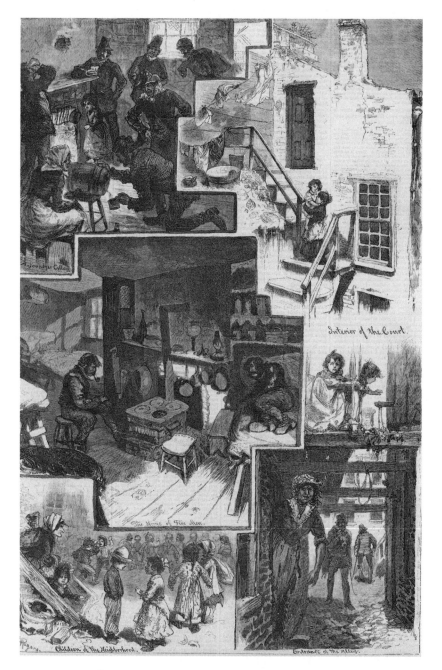

FIGURE OL.3. William A. Rogers, "Tenement Life in New York—Sketches in 'Bottle Alley,'" *Harper's Weekly*, March 22, 1879. New York Public Library, Art and Picture Collection.

its own status as a mediated representation—was voided.[17] Instead of symbolic representations based on shared graphic and cultural conventions, readers were offered the illusion of being, as the *Daily Graphic* put it, "in the immediate presence" of the matter. In this way, halftone reproduction created a radically new kind of experience: encounter, within print culture, with "what was actually supposed to have existed."[18] For the first time on a mass scale, the image could become a substitute for—rather than a guide to or a rendition of—social life. "Thus," Harris notes, "we have entered the modern world of visual reproduction" (199).

As the *Daily Graphic's* screening out of its screened image suggests, there was considerable anxiety about this state of affairs. It was the hand-wrought image that was thought, as one prominent illustrator put it, to "make the needed facts very plain and intelligible, whilst in a photograph they may be entangled with many other details that are not wanted."[19] In other words, the experience of unmediated presence introduced into print contexts by halftone reproduction was widely thought to undermine readerly engagement and conditions of intelligibility alike. What visual historian Estelle Jussim, in a landmark study, describes as the "high-density code of illusionism" new to the halftone—its transmission of minute gradients of texture, light and shadow, contour, and mass in the appearance of the visible world—was as yet illegible to readers.[20] How could they make usable sense of so much information? More to the point, how might this radically new frame for encounter, in which the act of framing itself had become invisible, alter economies of representation?

Such concerns (all too familiar in our own digital era) were especially heightened in the arena of late nineteenth-century book versus magazine or daily newspaper publication, given the mission of publishing houses to defend their territory against the encroachment of mass-market enterprises inflected by other-than-genteel taste. Illustrator and art critic Philip Gilbert Hamerton spoke broadly for the Anglo-American industry when he declaimed in 1889 that "a pure photograph from nature is out of place in any book whatever."[21] Absent the mediation of the artist-illustrator, the raw data of "nature," offered up not as a general sign of experience but as an index and substitute for it, could only sow confusion about the meaning of visual images: their status as signs, their relationship to originals, the codes they embodied and conveyed. Only in a social context that privileged the evidentiary powers of the photograph—its transcription of an irreducible state of affairs or being at a given time in a given place—could the use of

halftone reproduction make obvious sense for nineteenth-century editors, publishers, image-makers, or readers.

Ironically, it was architecture after all that provided that context—more specifically, the iconic site shadowing the birth of the halftone: downtown New York, America's ur-ghetto. The first book published in the United States to make significant use of halftone photographs was none other than Jacob Riis's now canonical 1890 jeremiad *How the Other Half Lives: Studies among the Tenements of New York.*[22] The "tenement house problem," Riis influentially argued, was the defining evil of America's burgeoning urban modernity. It subjected swelling numbers of New Yorkers at large—a full three-quarters of the city's population by the late 1880s—to "an atmosphere of actual darkness, moral and physical."[23] Progressive reformers had sought a way to promote private charity, organized and scientifically managed, against the evils of noxious living conditions; appeals to "the evidence of [the] senses" were critical to activating genteel sympathy on behalf of the worthy poor.[24] Riis quickly discovered that conventional reporting—statistics, firsthand narrative accounts of degraded conditions in the tenements—"did not make much of an impression" on sanitary officials, not "until my negatives, still dripping from the dark-room, came to re-enforce them. From them there was no appeal."[25]

The illusion of presence and a surfeit of visual information were both crucial to this inevitability. Riis shot groundbreaking images during "raiding" parties that "invaded the [Lower] East Side by night"; he was eager to test a new flash technology (originating in Germany, it had the apt name of *Blitzlichtpulver*, lightning-flash powder) that allowed unprecedented image capture in spaces without available natural light or illumination. In one memorable experiment, Riis photographed illegal basement lodgings in Bayard Street, where, with "no pretence [sic] of beds," the impoverished slept for five cents a spot, a cut below the city's mandated seven-cent rate (figure OL.4).

Commentators have noted that the subjects arrested here by Riis's camera, if not by the sanitary police who accompanied him, appear dazed in the light of the harsh magnesium flash-powder he ignited without precedent or warning.[26] But Riis and his fellow raiders were also, in a critical way, in the dark. As art historian Bonnie Yochelson has noted, "No one, including Riis, could clearly see the scene, but the resulting image reveal[ed] a devastating tableau."[27]

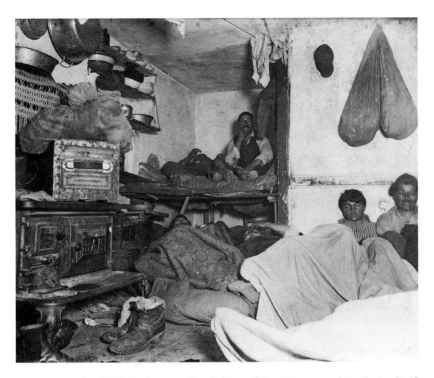

FIGURE OL.4. Jacob Riis, *Lodgers in a Crowded Bayard Street Tenement—"Five Cents a Spot,"* 1889. Jacob A. (Jacob August) Riis (1849–1914) / Museum of the City of New York. 90.13.1.158.

The point of Riis's raids, in other words, was to record with the camera's unblinking mechanical eye a kind and density of information otherwise literally invisible to guardians of the city's welfare. In the context of the tenements, both ordinary perception and iconographic conventions—the usual protocols for making orderly sense of a social landscape—failed. As Riis put it retrospectively, "a drawing would not have been evidence of the kind I wanted."[28] An abundance of raw data, in itself inassimilable and offered up in photographic form, without the mediating frame of the artist-illustrator's sensibility or hand: this was the technique Riis discovered for framing the tenements, particularly those on the Lower East Side, as a social problem that demanded city–bureaucratic response. Halftone reproduction made it effective on a mass scale.

For general readers and viewers of the time, however, the evidentiary function long associated with photography had to be supplemented with

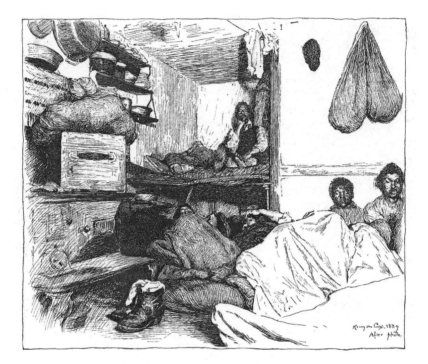

FIGURE OL.5. Drawing after Jacob Riis, *Lodgers in a Crowded Bayard Street Tenement—"Five Cents a Spot,"* from *How the Other Half Lives: Studies among the Tenements of New York* (New York: Charles Scribner's Sons, 1890). Special Collections, University of Michigan Library.

codes that allowed for a more familiar kind of appeal. Of the thirty-nine illustrations included in the first edition of *How the Other Half Lives* published by Scribner's, only twelve were halftone photographs.[29] The remainder were engravings drawn from Riis's images by a Scribner's illustrator. *Five Cents a Spot* was among them (figure OL.5). Even a casual comparison suggests how significantly the visual effect of Riis's image alters with the mediation of the artist's hand. Tonalities are more schematic. The visual density and complexity of the image decrease notably; the sleeping figures are drawn in such a way as to distinguish them more clearly from their environment—to bring them, in effect, out of the darkness and render them separable from it. These choices reflect reigning conventions for representing poverty's subjects (at least some of them) as amenable to charitable remediation.[30] Visualizing the assimilability of tenement-dwellers

to reformist aims, the illustrator made both the problem and the solution *real* for nineteenth-century readers (figure OL.5).

That crucial effect may be lost on twenty-first-century viewers. But the copresence of halftone photographs and hand-wrought images in Riis's text reminds us how difficult it was for nineteenth-century readers to become responsive—to become subject—to the halftone's very different reality effect. Even as Riis insisted on the photograph as irrefutable evidence, he was well aware of the illusory character of its realism. Before *How the Other Half Lives*, before halftone reproduction, he had begun exhibiting his photographs as magic-lantern slide images, photographs projected larger than life-size for mass audiences with the help of the intense incandescence of limelight.[31] The uncanny quality of magic-lantern projection helped grow its popularity in the nineteenth-century United States. By the 1880s, magic-lantern images were everywhere on the cultural landscape: in homes, schools, churches and fraternal lodges, mass public halls and theaters, exhibited in as many as 150,000 public shows a year.[32] Notably, their experience and appeal were informed by the earlier life of the magic-lantern show in Victorian popular entertainment, where, under the guise of phantasmagoria, it had been dedicated to the fantastic and the supernatural. As the film scholar Tom Gunning has noted, the popular appeal of the magic lantern was rooted in its unrivaled ability to give "the illusion of supernatural apparitions" and uncanny visual effects.[33]

This invisible prehistory is critical to Riis's broader enterprise. In their preprint incarnation as magic-lantern-slides, his images of the ghetto married the transcriptional character of the photograph to a rich experiential context of visual illusion. Experimenting with the project of representing downtown tenement spaces, Riis exploited the link between these agencies. Having accidentally underexposed his negatives of paupers and their graves in the city's Potter's Field, Riis noted, "the very blackness of my picture proved later on, when I came to use it with a magic lantern, the taking feature of it. It added a gloom to the show more realistic than any the utmost art or professional skill might have attained."[34] Here is the open secret of Riis's evolving enterprise of documentary representation of poverty and immigrant others. The realism of their representation by photomechanical means depended every bit as much on techniques of enhancement—on special effects—as the illusionistic visual modes with which those means remained entwined.

Confronting the problem of the tenements, *How the Other Half Lives* oscillates between legibility and a new kind of transcription, between visible mediation and the illusion of none at all. In that published volume, we can see the halftone method being sutured to the project of exposing urban poverty, particularly in downtown New York, right before our very eyes. Like the uncanny animation of material objects or the apparition of living bodies becoming skeletons and back again in popular nineteenth-century visual forms, this transformation is revealing. Riis's use of photomechanical production and reproduction suggests how naturally the effects of the halftone lent themselves to the project of representing the tenements and the ghetto. But it also suggests how downtown sites of poverty and the inassimilable catalyzed a dominant visual logic of photo-realism. If documentary imaging brought the poverty and threat of the tenements newly into view, they were an urgent rationale for index-based representation, in which the power of visual conventions, print platforms, and the illustrator to shape social seeing was made invisible. Halftone and the world of the other half, it turns out, were made for one another.

Attending to the matter of Horgan's breakthrough suggests how critical the landscape—the real and symbolic space—of poverty and otherness was to the halftone revolution and to the dynamic print culture it grew. Taken for granted, in some sense, as the object of this experiment in mass imaging, the downtown ghetto lent itself to many other efforts to envision, narrate, and respond to defining social challenges. How the landscape of the ghetto and the tenements—shanty town, Jew town, downtown—developed as a place to negotiate otherness and encounters with it; how it generated new visual technologies, aesthetic strategies, and ways of seeing an American modernity in formation; how it allowed image-makers, writers, and other observers of modern life to test the realism of illusion and promote illusions of the real: this is the story the pages that follow will unfold.

Chapter 1

On Whose Watch?

Animation, Arrest, and the Subject of the Ghetto

On July 20, 1892, Jacob Riis—by then celebrated as the author of *How the Other Half Lives*—gave a dazzling lantern-slide photo lecture, featuring over a hundred of his images of New York City's slums, in Ocean Grove, New Jersey. Having worked small-town America as a magic-lantern operator before attempting to fill urban lecture halls, Riis knew how to put on a show. During the early 1880s he had tried his hand as a self-styled "street fakir," providing patter for travelogue-style images; they were projected onto a seventeen-foot screen mounted in public squares in Long Island villages (the bulk of his earnings was from advertising).[1] When Riis committed himself to photo lectures for the social-gospel cause, he used that experience to create what historian Daniel Czitrom calls a "vaudeville of reform": a theatrical mix of extemporaneous remarks, exhortation, anecdotes drawn from his work on the downtown police beat, dialect jokes, and hymn-singing, shaped around his shocking, larger-than-life, lime-lit images of the slums.[2]

On the strength of his unprecedented use of "Photographs from Real Life," Riis patented his lectures. He also branded them as a new kind of visual experience.[3] In the persona of a tour guide leading his audience through the threatening landscape of the ghetto, Riis gave dynamic form to moral convictions that were, as he put it, "too hot for pen and ink" (278).[4] Riis's Ocean Grove audience presumably responded as spectators, encountering his work not in print but in the form of projected stereopticon slides, typically did: with gasps, moans, other displays of feeling and frequent applause, in appreciation "that the entertainment provided for them had proved most excellent."[5]

Although the Ocean Grove lecture was only one of many Riis gave, it unfolded in a setting that lent special force to the double life of his images as

entertainment and enlightenment, evidence and spectacle. Founded as a Methodist camp-meeting community, Ocean Grove had become a summer resort for genteel city-dwellers seeking to escape the oppressive heat and crowding of the ever-more dense metropolis. That summer, threats associated with downtown crowding would have been much on their minds. An outbreak of typhus and cholera epidemics within the immigrant community of the Lower East Side during the winter and early spring had become a source of panic across the city, and indeed the US public health officials and proponents of immigration restriction had cried the need for cordoning off "the impoverished, unkempt class" of Eastern European Jews presumed to be the source of the "scourge."[6] Withdrawing from stifling air and talk of contamination, gathered in the historic site of communal conviction, Ocean Grove's summer class was the ideal audience for dynamic exhortation about the Lower East Side's moral threats and ills.[7] What better place for Riis to arouse Christian sentiment about the urgent problem of the slums on the strength of spectacular visual display? And what better context to press the power of an image repertoire of the other half taking shape in the city's dynamic print and visual cultures?

At least one of Riis's spectators can be said to have seen the light—that is, the point of the spectacle as such. In his audience that day was a twenty-year-old youth, the fourteenth and youngest child of a well-known Methodist minister and a leading light of the Women's Christian Temperance Union, respectively.[8] A recent dropout of Syracuse University, he was employed as a stringer for his brother's summer news agency, which wrote up society gossip and reports of shore town events for the New York papers. Four days later, the *New York Tribune* published his brief account of Riis's lecture. Among notices of society arrivals and leisure class "shore doings," the text appears quite unremarkable. Yet within a matter of months, the same young man began writing what would become the most celebrated nineteenth-century fiction of the underclasses of downtown New York, a novel hailed then and since as a benchmark of documentary power and of literary naturalism. The text in question was the notorious *Maggie: A Girl of the Streets*; the author, Stephen Crane.

Where, we might well ask, did Crane's landmark, breakout novel come from? Self-published in 1893, *Maggie* was the work of an unknown, untested writer who had slim journalistic credits to his name. Not surprisingly, the resources for its genesis have been a matter of considerable speculation. Once hailed as the product of avid slumming in the haunts of

downtown street gangs, tenement-dwellers, and Bowery toughs, *Maggie* has more recently been read as the precondition for Crane's low pursuits, an imaginative exercise that preceded his actual experience. Some of the evidence (notoriously inconclusive) suggests that Crane completed a full draft of the novel before he took up residence in a midtown tenement, began haunting Lower East Side precincts of vice and need, or wrote the journalistic essays, like "An Experiment in Misery" and "An Experiment in Opium-Taking," that describe these exploits.[9] Given the sensational power and wide circulation of Riis's *Other Half* images, the supposition that they served as a point of departure for *Maggie*'s unflinching naturalism is, well, natural. Crane, critical readers have argued, was "undoubtedly" influenced by Riis.[10] How could the fledgling writer of the ghetto not have responded to the most famous of the era's guides to the urban frontier, the showman said to combine "the aims of the Brothers Mayhew and the realistic instinct of Zola" in one?[11]

For my purposes, the fact of Crane's engagement is less critical than the critical presumptions about what his engagement might mean. Typically, the precedent of Riis is invoked to explain both Crane's fascination with downtown New York and his documentary expression of it. But a sense of Riis's broader practice should give pause about his images as models for any kind of transcriptional realism. What Riis's lantern-slide shows might more likely have communicated was the spectacular effects to which photography could be put—especially in response to the landscape of the tenements.

By virtue of his family and upbringing, Crane was intimately familiar with Protestant and reform deployment of the so-called power of attraction wielded at contemporary Methodist revivals, temperance meetings, youth camps, and church lectures. "Chalk-talks" and other visual demonstrations, designed to promote personal piety by engaging sentiment and the senses, had become a key strategy for marketing evangelical faith and culture.[12] Crane's tireless mother, Mary Helen Peck Crane, had striking success in this line. Her signature lecture, "The Effects of Alcohol on the Organs and Tissues of the Body," expounded on the evils of inebriation with a brio worthy of the lantern-slide circuit or even P. T. Barnum. Its climax was a dramatic explosion of flaming egg whites: this is your brain; this is your brain on booze. Popular up and down the Jersey Shore, her rousing performances were written up, her temperance lectures published, in the very journals to which her son later contributed.[13] (Her disposition was also reflected, with vitriolic irony, in Crane's *Maggie* and his 1896 novel

George's Mother.) If, as one of Crane's biographers puts it, Crane "gave no sign of being moved" by Riis's Ocean Grove lecture in the published account of it, he was exceptionally well prepared to consider its double agency.[14] In Riis's magic-lantern photo lectures, unprecedented fidelity to visual detail was pressed in service of realizing—making real—a far from objective, monitory vision of the world of the other half.

What Crane might have taken away from Riis's performed images, in other words, was not a propensity for some kind of documentary or realist fidelity to hard facts or social conditions, but in effect the opposite: an awareness of the affective power of iconography, in the form of those arresting images Riis called "lightning flashes from the slums."[15] The spectacular projection of Riis's images in the form of three-dimensional stereopticon slides, accompanied by music and framed by practiced showmanship and oration "humorous, statistical, and pathetic"—a kind of precinematic *Gesamtkunstwerk*—would have had the effect of making the tenements thrillingly vivid as an experiential landscape while at the same framing their subjects as dramatic figures of distress, helplessness, and shock.[16] The effect produced by this form of visual spectacle on its genteel viewers was readily sutured to conditions of poverty and viciousness. But its production in the first place was surely intensified by the guerrilla tactics of Riis and the sanitary officials who accompanied him into the tenements, setting off volatile, dangerous chemicals to produce the flash illumination that enabled unprecedented photographic capture under low- or no-light conditions. Riis himself admits as much. "Our party carried terror wherever it went," he retrospectively noted. "The spectacle of half a dozen strange men invading a house in the midnight hour armed with big pistols which they shot off recklessly"—Riis's original mechanism for exploding magnesium powder to produce flash—"was hardly reassuring."[17] (Indeed, Riis noted, tenement-dwellers "bolted through windows and down fire-escapes where we went," and "the recollection of our visits h[ung] over a Stanton Street block like a nightmare.")[18] If Riis was leading a war on the tenements, it was in fact a shooting war. No wonder the rudely awakened sleepers of *Five Cents a Spot* look so disoriented, so inadequate to their own remediation (see figure OL.4). Thus framed, they entered the image repertoire of the photograph, and of modern times, in America.

In the context of this image and the many like it that featured in Riis's lantern-slide shows, Crane's presence at the 1892 lecture brings into view a key effect of Riis's work and his own—an effect native to the broader

project of imaging the tenements that both helped make definitive of late nineteenth-century US culture. The spectator of Riis's lantern-slide flashes from the slums is *animated* by a heightened sensory experience of the slum as contact zone, even as—in part because—its visible figures are *arrested*, caught in iconic gestures or displays of the intransigence of their condition. To be sure, photography came into being as a technology of arrest, to solve the problem of what pioneer William Henry Fox Talbot called "fixing the shadow": arresting the chemical process by which nitrates changed color after exposure to light, thereby making possible the creation of permanent visual records.[19] But as Allan Sekula has shown, not until the later nineteenth century did a regime of "instrumental social realism" mobilize such records for a fully fledged project of social control over its citizens. By the early 1890s—at the very moment when Riis was experimenting with his lantern-slide shows of the ghetto—photography, in the form of mug shots, Bertillon cards, and other imaging systems, promoted the actual arrest of alien, criminal, and otherwise threatening bodies.[20] The logic of photographic capture thus offered itself up for new kinds of engagement with the spectacle, and specter, of the social other.

With respect to Riis's images of the ghetto, their power depends on a dynamic of capture and spectacle that was both spatial and temporal in effect. Creating what photo historian Maren Stange calls "an attractively secure and collective point of view from which to survey the show" (and, we might add, the social landscape it framed), and mobilizing the effects of lantern-slide projection, which heightened the sensory experience of its subjects, Riis's lectures hail his spectators as citizens of a progressive, forward-looking America, capable of mobile response to urgent challenges and the city's rapid transformation.[21] Consider by contrast the figures who typically populate Riis's signature images: immobile, flash-blinded, huddled against the glare of charitable discipline and the law. Photographically arrested, they appear unequal to the very modernity they themselves—as new masses, tenement-dwellers, street hustlers, organized laborers, sweatshop workers, alternative culture-makers—are bringing into being. The contrast created and made iconic by Riis's work raises a powerful question: on whose watch is American futurity being shaped?[22] The temporal disjunction founded in the photograph's structural effect of arrest, and heightened by Riis's technique, aims, and ideological bent, provides a useful point of entry into Crane's textual response to the tenements. It also helps frame the problem that photographically inflected modes of seeing

posed for real-time inhabitants of the Lower East Side confronting such responses. In its movement between animation and arrest, Riis's work modeled a historically salient way of seeing immigrant and ethnic New York, of marking modern time and belonging (or unbelonging) in it. Its effects can be traced in *Maggie*'s distinctive temporality—and beyond, in writing of and from the Lower East Side attuned to the problem of making visible the modernity of the other half.

Readers' responses to *Maggie*, we might note, were always about time. Long before the revival of critical interest in naturalism and the movements of history that reshaped Americanist literary studies in the 1980s and 1990s, the text struck readers as temporally disordered in a fundamental way. A reviewer for the *New York Tribune*—Crane's own organ as a fledgling journalist and reviewer of Riis—seized on a distinctly "monotonous" quality attending the novel's "vicious themes," the dialect of its downtown toughs (whose "talk is as dreary as their lives are empty"), and its "stupid roughness" alike.[23] Even its brutality and shock, the reviewer opines, are repetitive as clockwork; to read its pages is "like hav[ing] one's face slapped twice a minute for half an hour."[24] Complaints about the brutish protagonists and deliberate vulgarity of literary naturalism were common in its context. But the effect underscored by the *Tribune* reviewer exceeds naturalism's hallmark concerns with geological or evolutionary time and the logic of reversion to type.[25] How might we understand the kind of shock *Maggie* creates in relation to its clock-like effects? In what follows, I want to suggest that the experience of animation generated by the text corresponds with, and depends upon, a certain mechanical temporality or arrest, by which the inhabitants of the slums are *watched* in Crane's distinctive narrative mode.

If, as Jennifer Fleissner has argued, naturalism's "most characteristic plot" is marked "by an ongoing, nonlinear, repetitive motion—back and forth, around and around, on and on"—the "stuckness in place" that defines the narrative world of *Maggie* and the reader's experience of that world encodes a distinctive logic.[26] The immobility traced and conditioned by Crane's fledgling text seems only remotely akin to the kind that, in Fleissner's incisive reading, figures "what happens to history" at modernity's critical juncture, "when women start to leave the sphere of nature behind," flocking to the cities, embracing new forms of work and subjectivity (3). The

immobility of *Maggie*, and the shock it elicits in readers, is less an effect of the New Woman liberated from bio-determinism than a residue of the Old World in the form of immigrant others who cannot be assimilated to genteel norms or to the progressive, technocratic modernity overtaking them. Like Riis's lantern-slide show, Crane's narrative seeks to produce an experience of animation—titillating, shocking, even violent—in and through an aesthetics of arrest, an annulling of the new temporal order that immigrants, members of the working classes, and other others were forced to confront.

More specifically at stake in *Maggie* is a textual and narrative stasis conditioned on a decisive social immobility. The spasmodic fury of the inhabitants of Rum Alley is nothing if not fixed and unvarying. Maggie's brother Jimmie is beaten for "fightin' agin" first by his father, then by his mother (131); paradoxically, the former then upbraids the latter in a fine display of imitative form: "Yer allus poundin' a kid . . . Don't be allus poundin' a kid" (132). A sympathetic neighbor who harbors Jimmie when he seeks relief from this domestic terror similarly asks, "'Eh, child, what is it dis time? Is yer fader beatin' yer mudder, or yer mudder beatin' yer fader?'" (134). The relentless quality of the family's domestic life—neither a periodic cycle nor in any meaningful sense a progression—is itself a matter of wry comment within the world of the fiction. Court officials, we read, "invariably grinned, and cried out, 'Hello, Mary, you here again?'" (143). That maternal figure, "eternally swollen and disheveled," is "a familiar sight on the island" (that is, Rikers, which had recently been established as the city's primary jail [143]). All the more terrifying for her maudlin invocations of maternal sentiment, Mary is both a fixed type and a figure of fixity, a chronic offender who "measure[s] time by means of sprees" (143).

In this disposition, she embodies the logic of Crane's narrative: its interest not in mimicking a rhythm of compulsion, but in measuring a dysfunctional experiential time. Linked with the iconic landscape of poverty, otherness, and vice, that time remains incommensurate with meaningful social experience, history, and the possibilities for transformation associated with them. Again and again arrested, Maggie's mother enacts not just a state of irremediable viciousness but a narrative condition—call it dystemporal—that attaches to every figure in the tenement world. The temporal disorder that attends Crane's tenement subjects, and to which they are subjected by his aesthetic, marks itself forcefully in some of the most perfunctory (and often cited) sentences in the novel:

> The babe, Tommie, died. He went away in an insignificant coffin, his small waxen hand clutching a flower that the girl, Maggie, had stolen from an Italian. She and Jimmie lived. (138)
> The girl, Maggie, blossomed in a mud puddle. (141)

Although distinctive, such moments exemplify Crane's narrative logic. Pre- and overdetermined, they occur within a suspended time, neither evolutionary nor regressive but static, resistant to meaningful social reckoning. This temporal mode attaches both to Maggie's experience and to the narrative that relays it. That it is symptomatic becomes clear when, after having met Jimmie's street-mate, the swaggering Bowery playboy Pete, Maggie feels compelled to take the measure of her surroundings in light of his departure from them: "Turning, Maggie contemplated the dark, dust-stained walls, and the scant and crude furniture of her home. A clock, in a splintered and battered oblong box of varnished wood, she suddenly regarded as an abomination. She noted that it ticked raspingly" (145).

Like the ill-fated lambrequin she makes to "freshen" the family's dirty, disheveled flat (it's destroyed in another of her mother's alcoholic rages), the clock suggests how "piteous" are Maggie's inchoate aspirations to mobility, order, and futurity (145). With its unpleasant rasp, the clock does indeed tell time, mark movement toward a future—but one so inexorable and alienated that the experience preceding it can hardly count as such. In this tableau of arrested development, the battered box of varnished wood already figures the coffin in which Maggie, following her infant brother, will be laid to rest, only so as to reap the effects of her mother's final threat: "Oh, yes, I'll fergive her! I'll fergive her!" (189). Like its splintered instrument, time itself in this imagined space has ceased to measure anything but the fixed, unbridgeable distance between tenement subjects and the objects of their need or desire.

Figures of the literary naturalism that had been imported from Europe—most notably the grifters, grafters, and petty shopkeepers who populated Zola's Rougon-Macquart novels, set in Second Empire Paris—had already been recognized by readers in the United States for their arrested evolutionary development, their tragic inability to break free of fixed trajectories of causality and fate. But the problem of oppressive temporalities and ways of marking time had distinctive resonances for the American and would-be American laborers, immigrants, and tenement-dwellers featured in *Maggie* and subsequent accounts of the other half. In the early 1890s

Americans at large, including the "native" and genteel, were still adjusting to a regime of standard time instituted throughout the United States in 1883—not by act of Congress, the president, or courts but by that ruthless engine of industrial expansion and wealth-creation, the railroads, for which precisely regulated alignment of times and time zones had become critical to transcontinental dominion.[27] The formal institution of clock time— abstract, cut off from bodily and social process, minutely divisible in the service of mechanization and profit—constituted a decisive triumph for industrial modernization, and it radically altered the way everyday citizens experienced their social spaces and being.

Nowhere was this more acutely so than in the urban precincts of the working and immigrant poor or for tenement-dwellers like Maggie, she of "the eternal collars and cuffs" (147). (The materiality of Maggie's labor becomes more striking when we recall the fact that Crane had the habit of writing notes for his fiction on his own shirt-cuffs.)[28] Standardization and ever more precise measurement of time strengthened the disciplinary regime of the factory and sweatshop, whose owners were determined to clock labor-power to the moment and the fraction of a cent. Tensions surged over control of the production regime—the hours mandated in a working day, the measurement of start and stoppage times. As timekeeping became an increasingly powerful resource for management and capital, it generated a thriving culture of resistance, from as early as the institution in 1831 of a "Mechanic's Bell" sounding workers' time in Cannon Street (just south of Delancey and the future entrance to the Williamsburg Bridge) to organized labor (likewise burgeoning downtown) and its highly visible "eight-hour" campaigns of the post–Civil War era.[29] By the mid-1880s, the imagery of the workers' clock, of time reapportioned and aligned to the needs of the laboring body, had become central to these campaigns (figure 1.1).

In other words, American modernity shaped itself—often violently— around the question: on whose watch? An 1886 cover of the nation's popular journal of satire *Puck* makes it clear that contestation between urban capital and labor over control of the clock had become a defining effect and condition of the nation's industrial boom (figure 1.2). But as the illustrated antics of the eponymous sprite suggest, no amount of arbitration could resolve such a volatile structural standoff. After May 1886, in the wake of the notorious Haymarket Square bombing in Chicago—which targeted a peaceful workers' demonstration in support of the eight-hour workday— bourgeois Americans and titans of industry alike were determined to crush

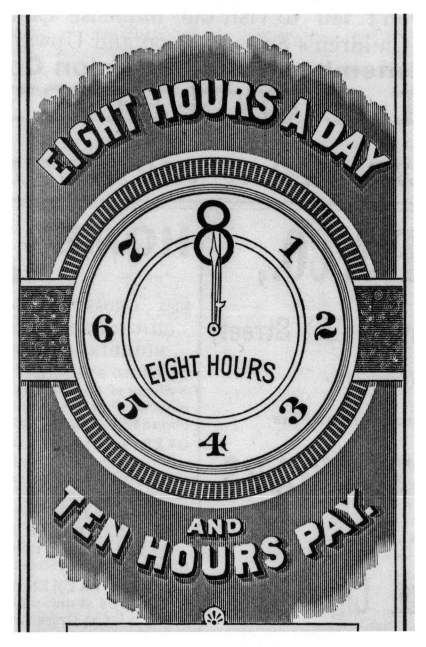

FIGURE 1.1. Detail of advertisement for the Eight-Hour Plug Tobacco Company, *Knights of Labor*, April 10, 1886. Chicago History Museum, ICHI-168903-01, www.chicago.history.org.

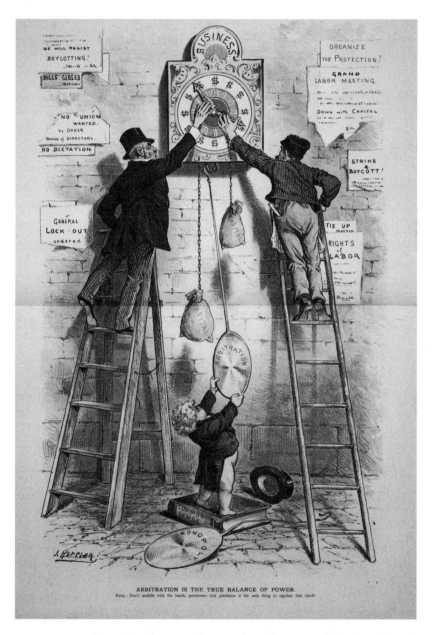

FIGURE 1.2. Joseph Keppler, *Arbitration Is the True Balance of Power*. Puck: "Don't meddle with the hands, gentlemen—this pendulum is the only thing to regulate that clock!" *Puck*, March 17, 1886. Library of Congress, Prints and Photographs Division LC-USZC4-5956.

any threat of foreign, anarchic, or otherwise threatening resistance to law and order—not least the time-discipline driving the nation's astonishing industrial growth: 433 percent in manufacturing profits and 550 percent in total wealth between 1860 and 1890 alone.[30]

From the perspective of labor activism and its histories, the increasingly divisive politics of temporality was framed as an issue for the urban working *man*. But life in immigrant, working-class enclaves arising across the nation subjected women to particularly intense, redoubled regimes of temporal discipline. At once pieceworkers and caretakers, immigrant women and girls were charged by charitable agencies and agents of social reform with keeping time for their families and their men. A representative *Primer for Foreign Speaking Women*, compiled in 1912 for the California Commission for Immigration and Housing, devotes two full pages to the evils of tardiness, particularly for the male child imagined as the future and de facto head of household: "If you [let him be late for school], when he grows up he will be late at his work. Thus he will lose his job, and always be poor and miserable."[31] Such injunctions had become time-honored among the charitable institutions that sprang up in New York City during the late 1880s and 1890s to address perceived threats to hygiene, moral order, and the American way of life posed by massive immigration and tenement crowding. Under the sign of women's care, their instruction held sway.

Given the disciplinary emphasis by the city's guardians of welfare on time-discipline, the clock itself came to serve as a visible emblem of aspiration and belonging to modernity in tenement households. Historian Elizabeth Ewen details the case of a Lower East Side family that immigrated from Galicia in 1895 whose husband felt compelled to choose between a sewing machine and "a bronze clock for the mantelpiece" as a gift for his wife, given that his tenement neighbors all "purchased one or another" to mark their domestic spaces as American (thus reinforcing the link between the machinery of sweatshop labor and that for measuring adherence to its regime).[32] Given this protocol, it is unsurprising that clocks figure with increasing prominence in documentary images of tenement life. In the early tenement studies of progressive documentarian Lewis Wickes Hine—for example, his tenement portrait of a nine-year-old girl, finishing garments alongside her parents (figure 1.3)—the clock surveys the landscape of domestic life and labor, signifying a normative aspiration to citizenship and social fitness.

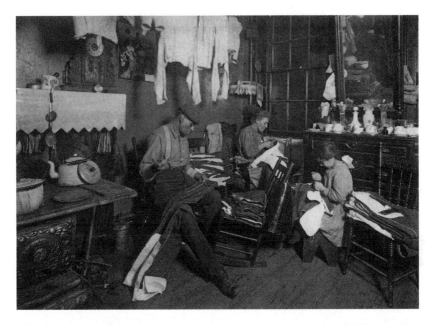

FIGURE 1.3. Lewis Wickes Hine, *11:30 a.m.* Jennie Rizzandi, nine-year-old girl, helping mother and father finish garments in a dilapidated tenement, 5 Extra Pl., New York, New York, 1913. Library of Congress, Prints and Photographs Division, National Child Labor Committee Collection LC-USZ62-42207.

In a grim irony, however, the very investment of the working poor in ownership of domestic instruments of time-discipline tended to intensify its oppressive effects. Riis himself describes a telling incident along these lines. Calling at the home of "a poor washer-woman living in an East Side tenement," he is confronted by her daughter, who inquires whether he is "the clock man"—the salesman who has come to collect yet another payment, on the installment plan, for a timepiece the family can ill afford. Hers, Riis notes, is "a life measured from the cradle by such incidents"; the flow of experience in the tenement world is marked by the invariable and straitening effect of a desperate struggle to remain on time and in time, for which the clock is both an emblem and the disciplinary mechanism.[33]

In this broader sense of struggle with temporal frameworks, Maggie is clocked from the outset of the narrative. Her identity consists in her failure to be an agent of any kind of transformation. This is both a matter of her character (so Jimmie's worldlier love interest, Nell, suggests: " 'A little pale

thing with no spirit . . . Did you note the expression of her eyes?" [179]) and of the logic of the narrative. Hence Maggie's pathetic question to Pete as he scorns her for her loss of respectability (which he himself, of course, has compromised): "But where kin I go?" (180). Maggie can only "go t'hell," as Pete directs her to do (180); she can only free-fall, in the gravity of her circumstances, into the physical and moral depths for which she is destined from the outset.

Narratively speaking, however, that outcome is not only a matter of naturalist-inflected predetermination. Maggie's fate is an effect of the fixity of her character and social being. Both remain impervious to willed or meaningful movement over time. Throughout the novel, the action most associated with Maggie is precisely that of going—but only in the past tense, and in a curiously passive mode. Confronted with her mother's vituperations about her keeping company with Pete, "Maggie went" (158); abandoned by Jimmie in her moment of ruin and need, "Maggie turned and went" (178). As reiterated over the course of the narrative, Crane's distinctive use of the intransitive past tense conveys not motion but its opposite: the act of continuing in a given state or condition, like that of a ragged child who "went barefoot," or "went without." A fixture in her environment, Maggie embodies an involuntary withdrawal from social agency as well as being in time.

Nowhere is this more striking than the chapter in which the flower of the tenement, now turned prostitute, comes (or goes) to her end. In the city's brilliant precincts of "pleasure and prosperity," she "of the painted cohorts of the city went along the street" (182). Estranged from the ranks of pleasure-seekers, upright citizens, and street habitués alike, she "went into gloomy districts near the river" (183). Failing to connect (or hook up) with any of the shadowy inhabitants of that shadow world, she "went into the blackness of the final block" (183). The static quality of Maggie's narrative condition is all the more notable in the context of Crane's insistence on the vivid color and motion of the streetscape against which it comes into view. Surging crowds, "clatter[ing] cabs," the "tossing seas" of the pavements, the "endless procession" of the throngs toward elevated stations, the whole lit with the "blurred radiance" of electric lights: at no other time throughout the narrative is the city as social context so dynamic, so modern, so animated (181, 182). (By comparison, it seems far more alive than the woman herself; even the most derelict buildings "seemed to have eyes that looked over" the streets, as the streetcar bells "jingled with a sound of merriment

[182].) Moved through a scenography of modern times, the streetwalking woman appears to be set iconographically against them, rather than in them or of them. In spite of her attempts to generate custom among the men she passes, she belongs to another temporal order than that of urban daily life, with its "metropolitan" getting and spending (182). Her movement synchs itself not to the ebb and flow of progress or the streets but to that of the "deathly black . . . river" (182), that iconic site or chronotope of the woman ruined, passed, in the image repertoire of US temperance and reform fiction, beyond lived time and social redemption (figure 1.4).

In her final chapter, in other words, the "woman"—no longer even individuated enough for a name—embodies her own status as an icon: a figure barred from temporal being and futurity.[34] More to the point, her banishment from social time intensifies our sense of the dynamism of the modern times to which she cannot belong. In this she differs critically from the reader of Crane's narrative, whose very engagement with representations of the tenement lifeworld and its "gloomy districts" is an emblem of belonging to modernity: a "metropolitan seal," a badge of contemporaneity if not of courage (182). Like the spectator of Riis's lantern-slide shows, the reader of *Maggie* is animated—shocked, titillated, disgusted, entertained—by the very prospect of the tenement-dweller's arrested being. In this sense, Crane's narrative approximates the effects of Riis's lantern-slide exhibitions. In both modes of social observation, fixity and animation become mutually mediating, with the effect of intensifying the felt sense of the tenement world as an incommensurable time zone and a temporally disordered space. If, as one of Crane's biographers puts it, his developing aesthetic coalesces around his "arresting word pictures," it owes something of its force—its animation—to the logic of arrest conditioning representations of the ghetto and the other half after Riis.[35]

With respect to this logic, we might also say that Crane's characters are imprisoned not only in or by the slums but in and by the emerging conventions, pace Riis, of its visualization. Legible as types indexed, made newly real, through the agency of photographic capture and display, Crane's figures of the other half are imprisoned within an image repertoire, disabled from speaking to—or even registering—the experience of its negotiation. Linked with Riis's magic-lantern imaging, *Maggie* draws our attention to the effects for actual subjects of the tenements of their place in realist representation, their temporal and existential arrest in the iconographic mode. In this way, if no other, Crane's tenement-dwellers—long recognized as

FIGURE 1.4. "The Street-Girl's End," illustration in Charles Loring Brace, *The Dangerous Classes of New York and Twenty Years' Work among Them*. New York: Wynkoop & Hallenbeck, 1872.

mash-ups of figures from reform literature, temperance iconography, and sensational accounts of the slums—are suggestively true to life. What indeed might actual social beings who have been made to embody poverty, inassimilability, and worse—the irremediable state of being left behind— contribute to the representation of American modernity? What kind of realism or modernism of expression could make visible their ways of experiencing intense and rapid transformation, or their struggle to negotiate the image repertoire defining their place within it? To address these questions, let me turn to a writer who has often figured in the shadow of Riis, Crane, and the realist project, and whose work responds quite differently to the challenges of making the other half real and visible to so-called native Americans.

In October of 1897, Riis—now the acknowledged boss reporter of downtown New York, famed for his activism and his ongoing exposés of life in the tenements—briefly took on a journalistic apprentice. Riis's previous partner in reform had been Police Commissioner Theodore Roosevelt, whose dramatic midnight raids on downtown dives, caves, and lodging houses had earned him a reputation for tough efficiency that launched his national political career.[36] By contrast, the newcomer was a thirty-seven-year-old immigrant Jew from Russia, a socialist who had fled the czar's police. A onetime factory hand, he was well known inside the ghetto as a union organizer, translator, and journalist in the Yiddish-language press for the socialist weeklies the *Neuetseit* and the *Arbeiter Tseitung*. To his surprise, he had just been hired as a staff reporter on the city desk of the *Commercial Advertiser*, the oldest daily newspaper in New York City. Under Lincoln Steffens, the unconventional city editor who aimed to transform the polite organ into a "bright-eyed journal of culture and sensibility," the newcomer's beat was police reporting, centered in police headquarters on Mulberry Street and in the surrounding tenement and vice districts.[37] Having landed, struggled, taught, written, and preached collective action and cultural enlightenment on the Lower East Side, the newcomer hardly needed instruction from Riis on the poverty and exploitation to be found there. Soon to become editor-in-chief of the largest, most influential Yiddish-language journal in the United States, he had recently published his first novel in English, expressly designed to represent the immigrant community for native readers and to afford him a place on the landscape

of US literary realism. That novel was *Yekl: A Tale of the New York Ghetto*; the newcomer, Abraham Cahan.

What would it have been like for Cahan to be schooled by Riis on the project of representing the landscape of the other half, to apprentice to the celebrated muckraker who had singled out the inhabitants of the ghetto's "Jewtown" for "their low intellectual status" and the "intensely bald and materialistic . . . aspect" of their culture?[38] From the redoubt of later prominence, Cahan would dismiss Riis as an exploitative outsider sensationalizing Jews and the Lower East Side for his own gain.[39] For the aspiring literary realist, however, such tutelage was instructive. Observing the downtown lifeworld for genteel English-language readers meant negotiating conventions for seeing the modern city that Riis's work had helped to codify. At the same time, Cahan's contact with Riis in the shadow of the tenements brought home the problem of his own visibility as an observer from within the space of the ghetto. To work with Riis was, in effect, for Cahan to see himself being seen as subject to an increasingly powerful image repertoire of the ghetto's Jews: figures both of the "busy industry" that makes American modernity hum, and of a distinctive time warp, "stand[ing] . . . where the new day that dawned on Calvary left them standing, stubbornly refusing to see the light."[40]

If the encounter with Riis throws light on this problem of being watched, Cahan is hardly unique in confronting it. For Yiddish-language Lower East Side writers in the late nineteenth century and well into the twentieth, lament about their perceived condition of belatedness and the invisibility of their aesthetic and cultural innovations forms a steady refrain. (As the celebrated critic Abraham Tabachnik, associated with the eddying currents of Yiddish-language modernism in New York, put it, "People come to the East Side expecting to find gefilte fish . . . Instead they find T. S. Eliot.")[41] At stake was recognition not only of the innovative culture of the tenements, but of something more profound: a suppressed history of mutual mediation through which American modernism and modernity were forged. For US writers and artists prone to experimentation or a progressive outlook, the Lower East Side offered far more than raw material for realist or sensational representations of urban life. It was a catalyst for their own transformation. Exploiting the energies and resources of Yiddish- and European-inflected practices and institutions, from labor activism and free-speech movements to radical political networks and expressionist theater, native renegades from Protestant sobriety (like Crane) remade themselves as protagonists of a

self-consciously modern American culture. Slummers and avant-gardes alike sought to frame their activities as sui generis, the creation of a distinctly new stance or gestalt. They thus obscured the indebtedness of their innovations in practice and style to the social world that immigrant tenement-dwellers, sweatshop workers, and urban masses were making. In the process, they helped reproduce the image repertoire of the Lower East Side as a vestigial, atavistic space, and of its inhabitants as untimely, insufficient to the very modernity their energies were catalyzing.[42] Like the spectators of Riis's lantern-slide photographs, America's moderns animated themselves by representing the alterity they courted as a condition of immobility or belatedness. The subjects of their observation and encounter remained imprisoned in iconography, and therefore, in lived social terms, invisible.

No figure embodies this problem more profoundly than Cahan. Written into histories of Yiddish-language production as a progenitor with outmoded politics, footnoted in accounts of American culture as an imitator of native movements, Cahan is trapped in the classic position of the alien, caught between two unfolding histories, in neither of which he wholly belongs. The literary gatekeeper who helped bring *Yekl* into being, William Dean Howells, puffed its author along just those lines: as "a Hebrew" and "a Russian" with a racial facility for the "naturalistic" that issues from some ethnically marked place "between a laugh and a heartache."[43] Yet it was Cahan who led Howells into the world of labor activism as background for Howells's 1892–1893 novel *A Traveler from Altruria*; Cahan who introduced the native muckrakers and radicals clustered around the *Commercial Advertiser*, Schwab's saloon, and the labor-affiliated lecture halls of Eldridge and Chrystie Streets to the ferment of Yiddish-language debates on European political ideologies, avant-garde movements, and global events; Cahan who shepherded Howells, Steffens, Henry James, and other literary lions to the Yiddish theater, home not just to immigrant melodrama but to serious aesthetic experimentation; Cahan who facilitated exchanges between German-, Russian-, and English-speaking activist communities via the organs of Yiddish press and print.[44] Yet when he praised Cahan's tales of ghetto life as "entirely of our time and place," Howells presumed a modernity belonging to "native" Americans—those of "our race and civilization," for whom the immigrant's historical consciousness could only remain belated and radically "foreign."[45]

Cahan's self-consciousness about such timekeeping was profound. In choosing English as his vehicle, he cast himself as an agent of progressive

change, uniquely positioned to expose American readers to the thought of such European intellectuals as Marx, Turgenyev, and Dostoyevsky. Far from imitative or belated, in other words, Cahan understood his work as mediating meaningful literary and social responses to modernity for US writers and readers alike. It was not the famously green masses of the immigrant ghetto, he opined, but America's literary gatekeepers who figured as "hopelessly 'romantic,' 'unreal,' and undeveloped in their literary tastes and standards."[46] From the vantage point of the émigré intellectual schooled in the most radical European social movements, America's native culture-makers needed serious training in modern reality, let alone the expressive possibilities of realism. On whose watch, then, would meaningful responses to modernity be made?

Anticipating Cahan's experience of shadowing Riis in the precincts of squalor and vice, *Yekl* foregrounds the problem of Cahan's own visibility as a problem of being in time. Like *Maggie*, Cahan's *Tale of the New York Ghetto* registers the condition of arrest dramatized—intensified—by Riis's photographs. But it understands that mode to govern both the incompletely American subject of the Lower East Side and the immigrant Jewish intellectual, whose mutually transformative engagements with American modernity remain invisible within the realist project and on the broader landscape of literary culture. Paradoxically, Cahan explored this condition by experimenting with modes of visibility conditioned by print. The linked problems of belatedness, timekeeping, and cultural transmission resonate in the very look of *Yekl*, in whose pages and around whose production Cahan grappled with his own dual identity as belated imitator and bearer of the avant-garde.[47]

Like Crane's *Maggie*, Cahan's protagonist is subject to a fate whose predetermination is strikingly overdetermined. Having immigrated from a raw shtetl just three years previously, the onetime blacksmith's son Yekl has become Jake, a cloak-maker in the needle trades and a fixture in the ghetto's world of sporting and entertainment. So passionately does he embrace the prospect of transformation as a "*regely* Yankee" that when his wife Gitl and their child finally join him he is appalled by the sight of her Old World garments, her speech, religiosity, and bodily hexis (15). She appears to him disturbingly alien, a "bonnetless, wigged, dowdyish little greenhorn" (75). Unable to countenance Gitl's very modesty, lured by his dancing-school partner Mamie (who is as fast, in the vernacular sense, as Gitl is slow), Jake divorces Gitl, only to feel trapped at the prospect of the

marriage Mamie has exacted as the price of her payment of his legal bills. In a key sense, Yekl's willed transformation as an acculturated American recalls not his namesake Jacob—that figure whose wrestling match with an angel yields a new identity, Israel, at a critical moment of change in Jewish history—but Esau, Jacob's older twin brother, who sells his birthright for the infamous mess of pottage.[48] Jake, it would seem, can never belong wholly to America. What price belonging, writ as contempt for a past he can experience only as fixed and untimely?

As the novel opens, Cahan's narrator leads the reader directly into the world of the sweatshop, whose inhabitants are caught in a different kind of fixity, a state of waiting; when the piece goods arrive, the frantic rush to work will begin. Cahan makes it clear that this condition of arrest or "suspense"—historically specific, organic to the rhythm of industrial sweatshop labor—is marked by a range of dynamic, transformational activity.[49] A "rabbinical-looking man," accommodating the machinery of labor to his needs, has his chair "tilted against his sewing machine" as he shuttles between an "English" newspaper and the Yiddish-English dictionary balanced on his knees beneath it (1). Another sewing machine becomes the prop for a socialist organ of the Yiddish press, over which its reader "sway[s] to and fro," lending an ages-old "Talmudic intonation" and traditions of Judaic literacy to the radical ferment of Lower East Side political culture (2). Across the shop floor, three seamstresses and a presser variously occupy their own machines, which configure a theater for the "impromptu lecture" delivered by a boisterous, self-confident Jake on the relative merits of Boston and New York as metropolitan lifeworlds and the finer points of boxing (2). This, Cahan suggests, is the relevant form of arrest: a state of becoming that impinges on the conditions generating it. Here, the very habits and gestures that mark ghetto subjects as Old World index their fitness for a New World context of coalescing social forms and rapid change: the sweatshop, the ghetto, urban modernity.

Jake is not the only one to offer a lecture of sorts on immigrant life, "treat[ing] the subject rather too scientifically" (5). Cahan's narrator is an authoritative guide who takes the reader from the sweatshop floor into the streetscape of "the New York Ghetto," tracing Jake's progress "through dense swarms of half-naked humanity; past garbage barrels rearing their overflowing contents in sickening piles," past "fire escapes, barricaded and festooned with mattresses, pillows, and featherbeds," through streets packed with "the teeming populations of the cyclopic tenement houses" (27).[50]

Mimicking the perspective and rhetoric of Riis's didactic tour of the ghetto in *How the Other Half Lives*, the narrator follows the narrative's subject to Suffolk Street only to probe its placement "in the very thick of the battle for breath," at the very center of "the Ghetto of the American metropolis" that is "the metropolis of the Ghettos of the world" (28).

But where Riis in *How the Other Half Lives* sees undifferentiated "Jewry" and other clearly legible types, Cahan's narrator observes extraordinary multiplicity. In his exposition, fixed notions of racial type are beggared by varieties of national, linguistic, socioeconomic, and experiential being. In fact, the dancing school—conspicuously not the synagogue, tenement flat, or sweatshop—offers itself as the most salient space for the reader's encounter with this new New World in the making, precisely because it produces the dynamic, unsettled, spectacular "effect of [a] kaleidoscope" (32):

> Hardly a block but shelters Jews from every nook and corner of Russia, Poland, Galicia, Hungary, Roumania; Lithuanian Jews, Vohynian Jews, south Russian Jews, Bessarabian Jews; Jews crowded out of the "pale of Jewish settlement"; Russified Jews expelled from Moscow, St. Petersburg, Kieff, or Saratoff; Jewish runaways from justice; Jewish refugees from crying political and economical injustice; people torn from a hardgained foothold in life and from deep-rooted attachments by the caprice of intolerance or the wiles of demagoguery—innocent scapegoats of a guilty Government for its outraged populace to misspend its blind fury upon; students shut out of the Russian universities, and come to these shores in quest of learning; artisans, merchants, teachers, rabbis, artists, beggars—all come in search of fortune. (28–29)

If these are "the children of Israel of the great modern exodus," they embody not a condition beyond or out of time but the turbulent global "metamorphoses" of modernity: political upheaval, urbanization, imperial nationalism, ethnic cleansing (29). The Jews of the ghetto may have come to seek fortune, but they know how elusive their relationship to futurity may be, and the location Cahan chooses to map Jake's initial mobility suggests as much. As his own protagonists would know—but his English-language readers would not—"Suffolk" is a homonym for "*soffick*," the Yiddish for "doubt."[51]

The question of what becomes intelligible, or visible, to Cahan's English-language readers shapes the very form of *Yekl* and its pursuit of the realist

project. Even a cursory glance at the text suggests how deeply Cahan embeds the problem of negotiating the contexts of Yiddish and English, immigrant and native, Jewish modern and "Yankee" modern, in its pages, which are rife with running italics, asterisks, footnotes, and variant orthographies (figure 1.5). Throughout, the fluent Yiddish of Jake and his fellow inhabitants of the tenements is recorded in English (if a notably stilted one), while their uses of American English appear in italics, suggesting the double otherness of this language: still foreign to Yiddish speakers in the text; not readily legible, in its nonstandard, accented mode, to English-language readers encountering it on the page. Hana Wirth-Nesher has persuasively argued that Cahan renders ghetto speech in this way so as to turn realist conventions to his own ends, staging a hybridity only the multilingual intellectual himself can mediate.[52] As she suggests, a key aspect of this practice is its visual impact: Cahan's mobilization in material form of what Mikhail Bakhtin called *"the artistic image of a language"* in the novelistic mode.[53] In the context of the influence of Riis's work, however, the image thereby problematized is not only, or even primarily, figurative. Against the iconography codified in Riis's images of the other half, *Yekl* activates typography, whose dyamic effects beggar the assignment of arrest to ghetto subjects, and simultaneously make the reader's experience of the text continuous— coeval—with immigrant social experience.

To put this another way, Cahan aims in *Yekl* to create a very different kind of "arresting word pictures," whose mode of arrest concerns his native readers rather than his unassimilated subjects. Confronted with his pages, those readers must struggle to respond to a typography of mutual mediation: a jumble of vernacular variants, italicized renderings of English language phrases used (and misused) by Yiddish speakers, quintessential Yiddishisms rendered in semantically odd English, and the unstable argot of "the American metropolis," all jostling and contending (3). To read *Yekl* is not to be animated by the spectacle of subjects caught in a belated temporal regime. It is to be subjected to such a regime: forced to "reenact the slowed pace of encounter with strange words and signs," parsing the text's pages for elusive meaning, struggling with their visual as well as aural irregularity.[54]

Until recently, these effects were dismissed as unsuccessful attempts on Cahan's part to assimilate to the project of native literary realism. His experiments in the look of ghetto idioms were read in light of the controversy raging in realist circles during the mid-nineties about so-called eye or sight

4 YEKL.

" *Say*, Dzake," the presser broke in, " John Sullivan is *tzampion* no longer, is he?"

" Oh, no! Not always is it holiday!" Jake responded, with what he considered a Yankee jerk of his head. " Why, don't you know? Jimmie Corbett *leaked* him, and Jimmie *leaked* Cholly Meetchel, too. *You can betch you' bootsh!* Johnnie could not leak Chollie, *becaush* he is a big *bluffer*, Chollie is," he pursued, his clean-shaven florid face beaming with enthusiasm for his subject, and with pride in the diminutive proper nouns he flaunted. " But Jimmie *pundished* him. *Oh, didn't he knock him out off shight!* He came near making a meat ball of him "—with a chuckle. " He *tzettled* him in three *roynds*. I knew a feller who had seen the fight."

FIGURE 1.5. Abraham Cahan, *Yekl: A Tale of the New York Ghetto*, first edition. New York: D. Appleton and Company, 1896.

dialect, the rendering of regional or local idiolects in phonetic form.[55] If eye dialect in the hands of local colorists representing Southern and Midwestern vernacular speech was bad enough, on many critical readings, Cahan's mimetic attempts to render the language of immigrant Jews are worse. They register his anxiety over his own fitness for English letters; reflect an "insecure taste"; manifest his "contempt" for his illiterate protagonist, serving as the overemphatic "record" of his own lofty "distance from the

vulgar, mutilated Yinglish" of that unfortunate figure.[56] In none of these accounts does the visually marked duality of Cahan's dialect—its intense self-consciousness about time scales for culture-making—register in the slightest. Indeed, the ongoing reception of Cahan's text might be said to replicate the scenes of failed transmission recorded within it.

Read with respect not only to issues of translation but to the problem of visibility of Lower East Side intellectuals on the field of turn-of-the-century culture, *Yekl*'s pages can be seen to inscribe something like what Jerome McGann has called the "visible language of modernism": a rendering of fraught scales and contexts for cultural transmission, in the marked effects of dialect.[57] Consider a key scene set in the Lower East Side dancing school to which Jake makes his way after release from the sweatshop, joining the Americanized siren who will become his pretext for abandoning the wife he has left temporally and affectively behind. Cahan's attempts to render the unevenness of Jake and Mamie's oscillating dialect (Americanized Yiddish; Yiddish-ridden English) make for laborious reading as—because—they highlight the energy of contemporary idioms in the making:

"You are a monkey from monkey-land," he said. "Vill you dansh mit dot feller?"

"Rats! Vot vill you give me?"

"Vot should I give you?" he asked impatiently.

"Vill you treat?"

"Treat? Ger-rr oyt!" he replied with a sweeping kick at space.

"Den I von't dance."

"Alla right. I'll treat you mit a coupel a waltch."

"Is dot so? You must really tink I am swooning to dance vit you," she said, dividing the remark between both jargons.

"Look at her, look! she is a *regely* getzke* [*Cahan's footnote: "A crucifix"]: one must take off one's cap to speak to her. Don't you always say you like to *dansh* with me *becush* I am a good *dansher*?"

"You must tink you are a peach of a dancer, ain' it? Bennie can dance a——sight better dan you," she recurred to her English.

"Alla right!" he said tartly. "So you don' vonted?"

"O sugar! He is gettin' mad again. Vell, who is de getzke, me or you? All right, I'll dance vid de slob. But it's only becuss you ask me, mind you!" she added fawningly.

"Dot'sh alla right!" he rejoined, with an affectation of gravity, concealing his triumph. "But you makin' too much fush. I like to shpeak plain, shee? Dot'sh a kin' a man *I* am." (39–42)

What "kin' a man" is Jake is the central question of the text—that is, whether he is the "kin' a man" who can successfully belong to America and its futurity. (His unduly confident Americanisms, readers generally argue, imply not.) But the passage also raises a less obvious question. Who here is the "getzke"? The word, a classic Yiddishism, derives from the German *gotze*, meaning "false idol." Cahan gives it the more pointed meaning of "crucifix," an icon of America's secular religion: class standing, social power, a New World identity both commanding and specious, longed for and derided. That the term goes visually unmarked yet conspicuously translated in a footnote is a leading index to Cahan's project: making visible the life of Yiddish as a dynamic vernacular, uniquely responsive to the emerging realities of the American now. Infused with that dynamism—the give-and-take of the downtown streets, the energies of the laboring classes and their "beesnesh"—the visibly fractured speech of Cahan's protagonists tells time in an unexpected way. It suggests the hesitancy of the native reader's American languages for naming social reality after the Gilded Age. At the same time, it insists on the just-in-time cultural mobility of its immigrant Jews, illiterate, socially awkward, or vulgar as they may be. Even Jake's unwelcome wife Gitl, who has literally just stepped off the boat after running the official gauntlet at Ellis Island, begins immediately to accommodate herself to the brave new world of the Lower East Side by negotiating the relations between English and Yiddish as cultural forms:

"You must be hungry?" [Jake] asked.
"Not at all! Where do you eat your *varimess* [Cahan's footnote: "Yiddish for dinner]?"
"Don't say varimess," he corrected her complaisantly; "here it is called dinner."
"*Dinner?* [Cahan's footnote: "Yiddish for thinner."] And what if one becomes fatter?" she confusedly ventured an irresistible pun. (38)

If this is indeed Gitl's "first lesson" in "English words and phrases" (81), it momentarily puts Cahan's reader—for whom translation is alike necessary—in the position presumed to be Gitl's: groping for ways to comprehend familiar objects rendered unfamiliar, illegible, in their movement

between contexts and ways of naming contemporary experience. Confronted with such exchanges, Cahan's American readers inhabit a zone of encounter not unlike that of the Lower East Side. However briefly, they too occupy a site of estrangement from secure reference where a definitively modern identity is being forged in real time.

At large, Cahan's use of dialect in *Yekl* speaks to his concerns about coeval modernities, and the mutual mediation of immigrant and "native." The visually marked character of his protagonists' exchanges can be seen as an experiment in making this mediation visible in the form of protocollage. I use the term cautiously, aware of its privileged place in histories of modernism and in theories of cultural hybridity. (Among other things, collage has been called "the single most revolutionary formal innovation in artistic representation" of the twentieth century.)[58] Still, the resonances with Cahan's text—with its look and ambitions—are striking. Collage depends on the displacement of materials from one context to another, and its elements lead "necessarily to a double reading": of the fragment "in relation to its text of origin" and "as incorporated into a new whole."[59] Crucially, as David Antin has pointed out, collage also involves deliberate confusion of hierarchies of meaning or value—which elements are subordinated, dependent, or entailed by others.[60] And in spite of claims for collage as a primarily spatial form (as against montage), it has marked temporal effects. Conjoining frictional elements, it creates a new and hybrid time frame, inassimilable to any of its source contexts.

In its use of incongruous registers and its shifting frames of reference, *Yekl* uses a protocollage sensibility to explore an alternative way of watching and telling time. Within its unfolding, the text calls into question the dominant model of cultural transmission presumed to define American modernity: from native to immigrant, modern to Old World, historically progressive to temporally belated. In this respect, *Yekl* echoes the life of very different pages on which, by 1897, Cahan also labored: those of the *Forverts*, a.k.a. the *Jewish Daily Forward*. His leadership transformed the journal from an obscure and doctrinaire socialist organ to the leading advocate for inhabitants of the ghetto and a critical voice for socialist thinking in the United States.

Cahan's ambitious claims on the status of his readers—laborers and new Americans, making America's future—were reflected in both the look and the substance of the journal. Its masthead was printed in Yiddish, Polish, and English; headlines included borrowed phrases and rank Americanisms,

rendered in both Yiddish and English. Its front page occasionally featured translations in English as well as multilingual political cartoons; inside matter included such features as "People's" songs and poems, written in English with Yiddish titles, in Yiddish with transliterations of American argot, and in other hybrid forms. Printed alongside and around this gray matter were the journal's advertisements, whose effects offer a useful frame for viewing Cahan's fiction. Freely mixing Yiddish, Hebrew, and Russian, they literally force readers to reorient themselves in midtext, as they move between right-to-left orthography (employed for Yiddish and Hebrew) and left-to-right (for English and Cyrillic alphabets), and between horizontal and vertical orientations. If, as historian David M. Henkin has argued, the pages of mid-nineteenth-century English-language newspapers in New York register the social logic and dynamics of encounter in the city's rapidly changing streets, the pages of the *Forverts*—and, more subtly, of Cahan's own fiction—reflect the exponentially greater forces of cultural dislocation acting on turn-of-the-century East Side Jews.[61] The very act of reading in Yiddish, on the Lower East Side, meant negotiating competing visual frames: the literal push and pull of languages, experiential histories, and temporal scales for understanding social reality. This kind of collage effect, it can be argued, allowed immigrant readers not only to assimilate or adjust to modernity but to make a distinctive, timely sense of its proliferating forms. And this sense—an ability to link, or hold in tension, competing cultural and experiential frames—registered in social practices, idioms, and projects that in turn shaped the emergence of definitively modern American cultural forms.

To see this effect in Cahan's early fiction in English is to insist on his self-consciousness about temporal identities. Implicit to *Yekl* and its engagements with modes for observing the ghetto is a series of questions about where modernity begins, and whose modernism—whose cultural projects, whose literary forebears and revaluative gestures—makes the most powerful sense of those beginnings: in other words, on whose watch? That question figures quite literally in the narrative of *Yekl*, which suggests what it means to be a subject on (and at the same time off) the clock. Notably, the problem of time and timekeeping asserts itself most literally at, and as, a moment of regression, as Jake receives the news of his father's death in a letter (61). In response to the news, Jake lapses into a state of morbid sentiment and guilt. Alone in his tenement, paralyzed with dread, he lies "vaguely listening to the weird ticking of the clock on the mantelpiece

above the stove," which sounds the inevitability of death not as a movement toward the future but as a frightening hegemony of the past: " 'Cho-king! Cho-king! Cho-king!' went the clock ... presently he felt the cold grip of a pair of hands about his throat" (68).

What overcomes Jake in this moment is the threat not of death so much as of a special kind of arrest: an entombment in the regime of the inexorable "old belief," the world of our fathers whose horizon remains fixed and unyielding (68). By the end of the novel Jake's mastery of Yankee modernity has taken the form of a radically altered temporal subjectivity, reflected in the transformation of his way of telling time. On board the Third Avenue El, headed to the mayor's office for the civil ceremony that will join him with Mamie in a secular American marriage, Jake marks the rapid motion toward his future—an ostensibly more perfect union—by way of "the pause" produced "each time the car came to a halt" (190). Seized with doubts about the nature of his new freedom, Jake now longs to occupy the very condition of arrest that once threatened him; "he wished the pause could be prolonged indefinitely" (190). By now, however, arrest has become irrelevant to Jake's lived experience—and equally to the realist representation of it. With each "violent lurch" of the speeding El car, Jake experiences "a corresponding sensation in his heart" (190). Animated, in synch with the time-motion of that iconic conveyance of modernity, the train, he has become a quintessential modern, riding a streetcar whose name is desire. The "dark and impenetrable future" he faces arises not only from his willed rejection of a timeless Judaic past (89). The same unreadable future, haunting as it beckons, is being shaped for all the inhabitants—Jew and Yankee, newcomer and native—of a frighteningly mobile time.

Ultimately, *Yekl* implies something radical indeed: that the exemplary subject of American modernity is none other than the inhabitant of the ghetto, whose incomplete assimilation is both a symptom and an index of contemporary social being. Far from merely imitating realist conventions, Cahan attempts to recalibrate them, to disrupt the dynamic of arrest and animation that marks the postphotographic project of seeing the other half. His fiction never succeeds in overcoming its own reception in the realist context. (Notably, the last word of the published text in the first edition of *Yekl* is given over to advertisements for work by the likes of Crane, Joel Chandler Harris, and Charles Darwin—texts that collectively shape and are shaped by notions of the temporal otherness of the other half, the primitive, the regressive, against which Cahan struggles.)[62] In this

sense, Cahan becomes, like his own protagonist, a kind of "defeated victor" (190). Still, read with a view to a hardening iconography of the ghetto, *Yekl* opens another understanding of the landscape of the tenements: as a critical site of engagement with an unfolding history of moving subjects and moving images, observant Jews and animated tenement-dwellers, on whose watch Americans will learn to see their emerging social life in unprecedented ways.

Chapter 2

On Location

D. W. Griffith, Early Film, and the Lower East Side

The closing image of *Yekl*, a kind of moving picture of a Lower East Side subject in motion, helps me raise a new question. What does it mean to make cinematic images *on location*? The concept is second nature to viewers and historians of film alike. In the context of film production and experience, "location" just means a place, found or altered, outside the studio where a movie, or a part of it, is shot. The notion is so self-evident that no major encyclopedia of film history or film theory devotes significant discussion to it; it has been written into film history as a given from film's earliest inceptions. In the rare moments when location *is* made visible as an aspect of film practice, its inherent strangeness, and even contradictions, go largely unremarked. Yet location is a fundamental agency of filmic representation: at once a guarantor of reality (or at least the reality effect) and a strategy that indexes the illusionistic character of all film images.

The capacity to transport viewers to another, materially specific place was among the first of cinema's powers to be tested. In the first-ever public screening of moving images, on December 28, 1895, in Paris, Louis and Auguste Lumière showed ten short films, led by *La Sortie de l'Usine Lumière à Lyon* ("Workers Leaving the Lumière Factory"). Lasting just forty-six seconds, *Sortie* recorded the end-of-workday outrush of workers from the family's photographic concern, as viewed from the fixed vantage point of the street (figure 2.1). Although the camera is raised above eye level, the swift, irregular flow of workers onto the pavement, the close approach of carriage horses, and the wayward movements of bicycles and dogs across the viewer's field of vision all conjoin to create a felt sense of locatedness, of being present to the rhythms and motion of the street.

Limited as it is, *Sortie* accomplished just what its makers intended: it proved that two key problems with existing film technology had been

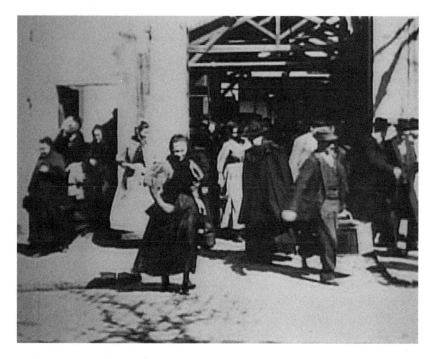

FIGURE 2.1. Screenshot, Auguste and Louis Lumière, *La Sortie de l'Usine Lumière à Lyon* [*Workers Leaving the Lumière Factory*], 1895.

overcome. Previously, the reigning format for moving images had been Thomas Edison's peephole Kinetoscope, a piece of hardware whose design restricted the film experience to one viewer at a time and whose bulk meant that film production was of necessity confined to the studio (figure 2.2). With their perfection of the relatively mobile Cinématographe—a camera, developer, and projector in one—the Lumière brothers lifted filmmaking out of the studio and into the streets, and even onto the rooftops (figure 2.3). They thereby became associated with the mode of moving images known as *actualités*, or actualities: continuous footage of everyday social actors and events, transformed into spectacles by the fact of their being recorded on film.

From the outset, the power of these early moving images was entangled with the effects of location. Of the ten films screened at the Lumières' premiere, at least half owe their communication of "actuality" to the camera's placement in a specific location: factory, public meeting place, urban public square, seaside.[1] By critical accounting, viewers of these

films were astonished by the sheer experience of filmic motion. A familiar anecdote—one so often repeated that it has been branded "the founding myth of cinema"—tells of terrified viewers running in panic from the all-too-real specter of an oncoming cinematic train.[2] Countering that myth, the indispensable film scholar Tom Gunning has argued that the unique achievement of the cinematic apparatus was not a heightened reality effect

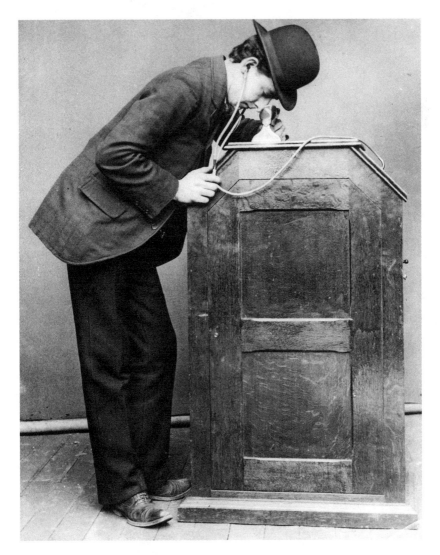

FIGURE 2.2. Edison "peep-hole" Kinetoscope, New York, undated. Photo by PhotoQuest/Getty Images.

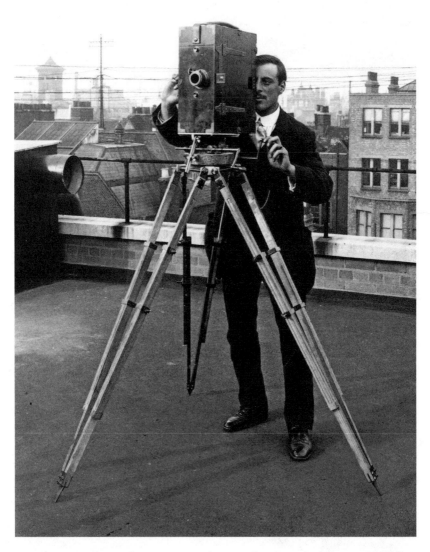

FIGURE 2.3. A Kinetograph camera, patented in 1891. Photo by Topical Press Agency/Hulton Archive/Getty Images.

but the illusion of projected motion: the production for the viewer of an experience oscillating between the familiar and the incredible—or, we might say, between lived social experience and fantasy.[3]

The Lumières' premiere suggests that location had a significant place in the disposition of that effect. In many of their earliest works, the experience of dislocation was conditioned by the camera's placement in specific sites whose very familiarity made them readily available for cinematic transformation.[4] Georges Méliès, the Paris-based filmmaker famed for special effects and the creation of visual illusion, attended an early Lumière show and recorded a response that indicates as much:

> A still photograph showing the place Bellecour in Lyon was projected. A little surprised, I just had time to say to my neighbor:
> "They got us all stirred up for projections like this? I've been doing them for over ten years."
> I had hardly finished speaking when a horse pulling a wagon began to walk towards us, followed by other vehicles and then pedestrians, in short all the animation of the street. Before this spectacle we sat with gaping mouths, struck with amazement, astonished beyond all expression. (quoted in Gunning, "Aesthetic" 118–19)

In Méliès's account, the attribute of animation belongs not to the technology of moving pictures but to the streetscape of modernity. The magic of the cinema, its power to produce "amazement," lies in its ability to transport this "animation of the street," to reproduce it as an unprecedented phenomenon in the experiential space of the cinema. In these inaugural experiences of filmgoing, we might say, the location effect was redoubled: the living, everyday street is reanimated, transformed into a new kind of spectacle, as the space of spectacular experience becomes available for new kinds of imaginative projection.

Méliès's account points to a special synergy between cinematic representation and the cinematic experience of urban spaces—particularly the urban street. Like the railroad, "all the animation of the street" lends itself to the display of film's unprecedented power to transport the viewer in space and time, and paces itself to the rhythm of shock that was fast becoming, Walter Benjamin later noted, the shared condition of film experience and everyday urban life.[5] That animation also approximates the social experience of cinema itself as it was coming into being. In the Lumières' brief sequences of men and women exiting the factory, disembarking from the

train, transforming themselves from orderly cadres of workers and travelers into subjects of wayward motion and dispersal, the first filmgoers could see reflected something of the logic of their own gathering and dispersal. So indicates an early poster advertising the Cinématographe Lumière, featuring animated spectators of all ages and many ranks of social life milling in the Place de l'Opéra—notably, under the watchful eye of a gendarme (figure 2.4). However inadvertently, in the course of experimenting with location and actuality effects, cinema was testing its power to create a new kind of social space and the subjects who would collectively inhabit it.

This synergy between social space and cinematic space—created on screen by the film's mise-en-scène (everything visible, or "put in the scene")—had a variable life in the development of early cinema. Film theorists have argued that the emergence of what has come to be called classical cinema—narrative in form, designed to suture the spectator to filmic point of view through self-conscious editing techniques—depended on a decisive rupture between social and cinematic spaces. To the extent that filmgoers are located beyond the space of the actors' performance, sealed off from the kind of direct address that marked the earliest cinema of attractions, it's argued, they "can identify with the camera's power to unmask and penetrate into the hidden feelings of the figure[s] on the screen."[6] In this way, the modern, voyeuristic spectator, and the narrative cinema designed to address same, are jointly born. The understanding of cinematic space as the object of a gaze sutured to the camera's, inherently available for visual penetration from beyond itself—as in the close-up—became foundational to classical cinema, and second nature to its viewers. The rest is Hollywood, or cinematic history.

Yet what we might call the location/actuality effect—a labile connection between cinematic space and social space—had distinctive power during a critical moment in the life of US cinema. And this power and its effects had special resonance with a distinctive location: New York City's iconic immigrant downtown. Between 1908 and 1913, a period of critical transition for cinema as a cultural institution, the Lower East Side provided a resource for film to test its developing narrative codes as it reframed its own rapidly expanding history. In these years, film historians argue, a "double vision" pervaded the US film industry, as it sought to lift itself up from the tradition of cheap amusements from which it had derived—the fairground, exhibition, variety theater and vaudeville show—into the more profitable, legitimated realm of middle-class entertainment.[7] A key

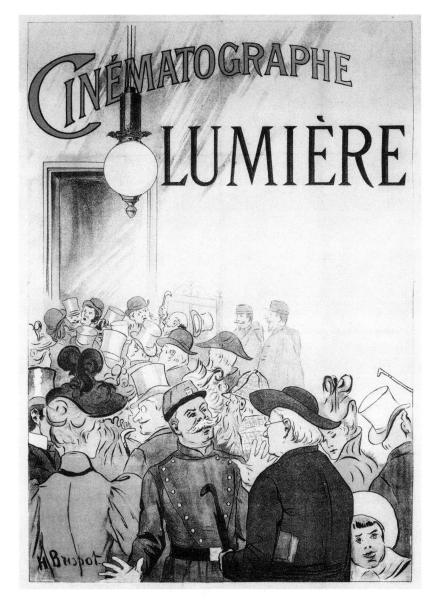

FIGURE 2.4. Henri Brispot, Poster for Cinématographe Lumière, 1895. BIFI Bibliothèque du film, Cinémathèque Française.

strategy for this project, film theorist Miriam Hansen has argued, was the attempt to link the "relatively autonomous public sphere" of the working-class nickelodeon—typically, a makeshift storefront space for film exhibition, located in immigrant and working-class neighborhoods, often on New York's Lower East Side—to the "comprehensive . . . public sphere of an emerging consumer culture."[8] At a determinative moment in film history and US social history, in other words, the ghetto-and-tenement dream of upward mobility coincided with the film industry's own program of "uplift," taking film as a cultural form "a step up in class."[9] If, as film mogul Adolph Zukor opined, the project of repurposing film as a distinctly American industry and art form required its producers "to kill the slum tradition in the movies," the actual slum—America's original, most storied ghetto—offered itself as a resource and a resonant location for that act.[10]

No figure catalyzed these transformations more effectively than the now notorious director D. W. Griffith, whose career, from his early one-reelers through his odious landmark *Birth of a Nation* (1915), has become synonymous with the evolution of classical—that is to say, modern—cinema. Subject to multiple revisionist readings, Griffith is no longer credited with originating film's founding visual language (the close-up, fade-out, full shot, medium shot, the spot-iris, the mask and parallel editing, among other indispensable techniques).[11] But he is said to have transformed filmic language so as to condition a new kind of spectator, responding to a new kind of cinematic space.[12] Within this project, coalescing in his early work at the American Biograph Company between 1908 and 1913, the Lower East Side has a particular place, allowing for special location and actuality effects. Without apologetics or quarter for Griffith's work at large, we can recognize that its earliest versions belong to the story of the Lower East Side as a site of defining visual encounters and of the evolution there of new techniques for making modernity visible.[13]

To be sure, so-called ghetto films—focused on the hardships of tenement living, sweatshop labor, the tensions of assimilation—represented only a small percentage of Griffith's prodigious early output (some 450 films), and they composed only a fraction of the film industry's. But their power to signify the changing meanings of film as a cultural institution greatly dwarfs their numbers.[14] Within the burgeoning industry apparatus (advertisements, reviews, production journals), films of, in, and about the "ghetto" quickly became a benchmark for testing the possibilities of filmic

realism. "Ghetto scenes" filmed on location in New York's downtown were applauded for their especially "realistic" representations, which paradoxically provided a context for full-throttle melodramas of immigrant life.[15] Such scenes, film historians have argued, were intended to cut both ways: to sustain the appeal of the founding genre of "local actualities" (films, like the Lumières' images of the Place Bellecour, that represent everyday life in spaces familiar to their viewers), as they addressed middle-class and upwardly mobile audiences beyond the tenements. These hybrid actuality/ narrative films were said to sell nostalgia to alrightniks—strivers who had made it, and made it out of the ghetto—as they peddled "local color" to genteel Americans: romanticized memories and ethnographic amusement in one.[16]

This reading is persuasive with respect to a wide array of tenement-centered films.[17] But Griffith's invocations of the Lower East Side suggest a different kind of doubleness, not assimilable to Hansen's "dialectic of mass-cultural representation and consumption": an overdetermination of location and actuality effects.[18] At key moments, his site work creates an unstable symmetry between cinematic and social spaces, between the actual space of the ghetto that enables filmic illusion and the space of fantasy and identification that viewers—modern Americans in the making—inhabit. In this doubling is enacted a shadow version of the birth of the twentieth-century nation: a flickering recognition of the mediation of native by alien, and of purity by engagement with alterity, in which American modernity is coming to be forged.

That account becomes visible only in light of the distinctive ways in which Griffith locates his filmmaking enterprise on the Lower East Side.[19] Both Biograph and Griffith himself, we might say, were animated by their proximity to the Lower East Side, and by histories of encounter with its iconographies.[20] In the context of interest in early cinema I use the term "animation" advisedly, with reference to recent conversations among film theorists and historians about the need to account more broadly for the "moving" aspect of moving pictures as a matter not just of diegetics or ontology—that is, as a property of cinematic objects, technologies, and procedures—but as matter of the sensory experience of cinema.

Beginning in 1903, Biograph's studio was located at 11 East Fourteenth Street, on the border of what had become an extension of the Lower East Side's immigrant, working-class cultural domain. Fourteenth Street abutted

Union Square; although the latter was originally named to mark the conflu-
ence of the city's two great thoroughfares, eventually named Broadway and
the Bowery, it had long since become an epicenter for radical protest and
labor movements, from pro-Union demonstrations after the firing on Fort
Sumter to the first Labor Day celebration in 1882, with radical, progressive,
and anarchist demonstrations of every variety (figure 2.5). The blocks just
south of the square had become a haunt for artists, inhabiting cheap tene-
ments and studios, and the area had a distinctive resonance as a microcul-
ture. Shaped by a dynamic population of native and immigrant comers and
strivers, Fourteenth Street had become one of New York City's most dynamic
contact zones, best known for its vibrant street life, its cheap amusements
and eating houses, and its shops offering mass-produced merchandise for
working people, "on the square" (Union Square).[21] Broadly speaking, the
area indexed a spread northward of the culture, social histories, and iconog-
raphy of the vice, tenement, and street cultures of downtown. So suggests
an account published in the *New York Times* magazine in 1910, titled "The
Old East Side Gives Way to the New," with an accompanying map of the
"spreading" of its social geography (figure 2.6).[22]

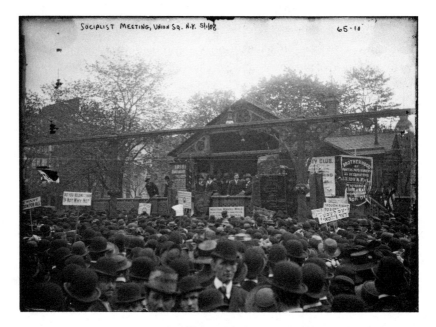

FIGURE 2.5. Bain News Service, Socialists meeting in Union Square, May 1, 1908. Library of Con-
gress, Prints and Photographs Division, George Grantham Bain Collection LC-DIG-ggbain-00332.

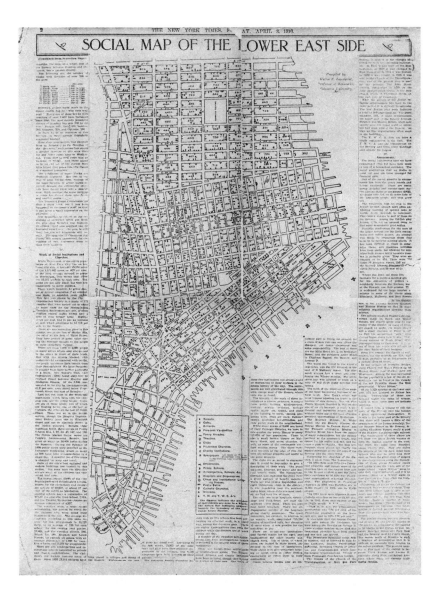

FIGURE 2.6. Social Map of the Lower East Side. *New York Times Magazine*, April 3, 1910. The New York Library Digital Collections, https://digitalcollections.nypl.org/items/8ae8bd90 -f78e-0130-dc5a-58d385a7b928.

More to the point, by 1904–1905 the Lower East Side itself had become by far the most heavily nickelodeonized neighborhood in New York City—and thus, by extension, in the United States. The steady northerly drift of its ranks of workers, hustlers, and street-dwellers helped make the area between Houston Street and Union Square a fertile field for growing the film industry, born of the nickelodeons—crude storefronts offering varied cinematic wares for a mere five cents. In the account of Griffith's cameraman, G. W. (Billy) Bitzer, the first film actors were "drifters who could handle props or pack films or sweep floors," and "came out of Union Square"; the earliest women's roles were often filled by "servant girls or waitresses from the neighborhood," those who "could easily be seduced into appearing before the camera."[23] (We will have occasion to return to the trope of seduction.) Griffith himself found the male lead for his first Biograph film just "coming down Broadway" as he trawled the neighborhood for likely characters.[24] Working out of what Griffith referred to as "the old Fourteenth Street dump" or the "joint"—a former Dutch patroon's mansion, dilapidated and parceled out to various commercial concerns, including that symbolic figure of Lower East Side needle trades, a tailor—Biograph's actors and production team under Griffith appropriated the fabled energies of New York's downtown, styling themselves "vigorous, vital, crude, lusty."[25] From the earliest days, Biograph's competitors made physical distance from downtown vice and entertainment districts structural to their enterprises. Thomas Edison's Black Maria studios relocated in 1907 from East 21st Street to the still-genteel Bronx, and Vitagraph established New York studios in faraway Flatbush.[26] For Griffith, however, the energies of downtown—including the haunts of the other half and of the Yiddish theater, to which he routinely took his favored actors—offered critical resources.[27]

Not only was the downtown street iconic of the striking "environmental detail" favored by Griffith's naturalist models (Emile Zola was a particular inspiration); not only did its visual dynamism support the development of narrative cinema, whereby disparate visual, scenographic, and dramatic elements were made to enhance the rhythms of narrative.[28] For Griffith, self-proclaimed product of a rural Southern boyhood in an "old Kentucky home," entry into theatrical life and into modernity itself was mediated by the Lower East Side—or so insists his autobiography, *The Man Who Invented Hollywood*.[29] Describing his arrival in New York City as a would-be actor, Griffith places himself not in "New York proper" but in the world

apart of the tenements and street hustlers, beating the pavements and sleeping "in the shadow of the Brooklyn Bridge."[30] His early life in the profession and the city, as he recounts it, was dominated by the experience of negotiating the space of the Lower East Side—the "rattle, roar and bang of the elevated and the raucous voices of the street"; "the dismal streets and alleys with beggars everywhere"; the "vermin-infested bed" of the cheap lodging house, with its "little red stains revolting reminders of scrunched bedbugs." The itinerant life of the actor required Griffith to get wise in the ways of freight-hopping and the free lunch counter. But it is the ghetto street, the "gaudy night scenes" of Bowery vice, that most fully animate Griffith as a protocinematic observer and a cinema-inventing subject:

> The Ghetto, Mulberry Bend, the Bowery, and Chinatown were all well known to me, but Rivington Street was the lively one, eternally jammed with pushcart peddlers hawking their wares . . . Rivington Street never appeared as a melting pot to me, but more like a boiling pot. Here were Italians, Greeks, Poles, Jews, Arabs, Egyptians, all hustling for a living. Emotional, tempestuous, harrowing Rivington Street was perpetually a steaming, bubbling pot of varied human flesh. And the Bowery by night! . . . I knew every hot spot there. (Griffith and Hart 55–56; 56)

Among them, Griffith fastens most keenly on the bagnios, bistros, and other haunts of prostitution on the Lower East Side, where the women who "chant . . . the one hymn to lust" do so "in many languages and accents," and where the streets afford opportunity to encounter temptresses and "houris" whose skin colors encompass "every known hue."[31] If Griffith responds with special gusto to the district's erotic animation, his interpreters typically respond to this by probing his work's hallmark preoccupation with threats to unprotected women, what Hansen calls its "ideological signature": American (white, Anglo-European) girls kidnapped by gypsies, threatened by ne'er-do-wells and rapists. In this context, it seems self-evident that the space of the Lower East Side allows Griffith both to experience and to cordon off energies that bespeak crises of impurity, attraction (to gesture toward cinema's earliest, low forms), and the alien. But Griffith's invocations of the downtown street are less than uniform, and the resolution of threat to beset American womanhood there does not always support this logic. In key moments in his formative work the effects of location are more wayward, and they implicate the place of the viewer in the changing landscape of American modernity, actual and fantasmatic.

These are, we might say, special effects in which the segregation of spectator from cinematic subject—of social space from cinematic space, of the cinematic gaze from figures of otherness or social alienation—is troubled and even undone.

Nowhere is the problem of location more pronounced than in Griffith's remarkable one-reeler *The Musketeers of Pig Alley,* released on October 31, 1912. *Musketeers* is often credited as the first gangster film ever made, the godfather of an indelibly American film genre. This claim rests on what was advertised as, and thought until very recently to be, the film's extraordinary location shooting in the shadows of the dingy tenements and crowded streets of the Lower East Side. Bitzer, who served as cameraman, claimed that *Musketeers* was "one of the first realistic films" and "one of our best" in respect to its uses of location. Indeed, he notes, the film was cast on the Lower East Side, at least for extras, in a "memorable tryout" in a converted Lower East Side storefront. Alongside Biograph actor Elmer Booth, playing the film's gangster-protagonist the Snapper Kid, *Musketeers* features such actual Lower East Side career hoods as Kid Broad, Spike Robinson, and Harlem Tom Evans, who obligingly play versions of themselves, lending the film "environmental" authenticity and a certain iconographic charge.[32]

Charged as they may be, casting and visible features of the film's mise-en-scène are hardly the only elements in its mobilization of actuality effects. The film's scenario is more than a little wayward: a struggling musician leaves his plucky young wife to fend for herself in the tenements while he seeks work, with the result that both become entangled in an outbreak of gang warfare. But what film historians have failed to note is that this yarn was written by Griffith and a young Anita Loos in a gesture toward "actuality": the sensational real-life murder on July 16, 1912 of gambler Herman Rosenthal by four members of a Lower East Side gang. That event was blazoned loudly in the press as an unprecedented gangland killing, one that exposed the deep infrastructure of Gotham corruption. (Even the usually staid *New York Times* ran sub-headlines like "Shots Penetrated Gambler's Forehead and Pierced His Face Below the Eyes.")[33] Along with Lefty Loewy, Whitey Lewis, Dago Frank, and Gib the Blood Horowitz, New York City police officer Charles Becker was convicted for having ordered Rosenthal's hit.[34] He became the first US police officer ever to receive the death penalty for murder; the scandal of his arrest and trial remained one of the most resonant cultural episodes of the Progressive Era. Nor

did Becker's notoriety lack a literary pedigree. A onetime bouncer in a Bowery beer hall (he had paid a fat fee to the Tammany Hall machine to insure his appointment to the city police force), Becker became a national byword in the fall of 1896 when he manhandled a young woman known to be a prostitute, on lower Broadway, who happened to be accompanied by none other than the journalist Stephen Crane. (Perhaps because of the notoriety of the ensuing trial against Becker and its disastrous effects on Crane's career, popular accounts continue to insist, erroneously, that the incident was a key source for *Maggie*.)[35] Three decades later, Becker's currency as a metonym for a threatening modern corruption rooted on the Lower East Side remained so strong that he figured in a key moment in F. Scott Fitzgerald's *The Great Gatsby* (1925). Thus the shady Jew (is there any other kind?) Meyer Wolfshiem recollects the trial and electrocution—"Five [put to death], with Becker"—as prelude to offering Nick Carraway the opportunity for "a business gonnegtion."[36]

Like *Maggie* and *Gatsby*, *Musketeers* registers the fact that location with respect to the Lower East Side is always already a reality effect. To situate representations of everyday modern life there is inevitably to trade in a history of fantasies, imaginings, and image repertoires through which a modernizing America and its unassimilated others are being brought into collective view. In the case of *Musketeers*, this entanglement of actuality with iconography has special power, special effects, for the expression of Griffith's signature interest in purity and danger. At the heart of the film lies the familiar yet urgent question: what will happen to the vulnerable American, in the iconic form of the American Girl, who encounters all the animation of the ghetto street, and of urban modernity; who enters the contact zone between old worlds and new ones in the making? This is the point of locating the narrative on "New York's Other Side," as Griffith's first intertitle has it: not the sociological locus of Jacob Riis's "other half" (often cited as an influence on *Musketeers*), but a Lower East Side at once real and symbolic, actual and image-made.

Let me consider the cinematic construction of that contact zone. In the film's opening scene, in which "The Poor Musician Goes Away to Improve His Fortune," we witness a tearful farewell between husband and wife in a tenement room crowded with shabby furniture. The young couple's expression of domestic feeling exceeds this space, spilling out into the hallway outside their door, where roving gang members are free to observe the couple's fraught farewell (figure 2.7). The return of the little

FIGURE 2.7. Screenshot, D. W. Griffith, *Musketeers of Pig Alley*, 1912.

lady—the only name she is given—to the relative safety of the tenement emphasizes how inadequate a shelter it is. Weeping, head in hands, she is made to rhyme visually with the elderly mother, whose death we will shortly witness (figure 2.8). The little lady leaves the tenement flat armed with a heavy bundle, of the size and shape typical for the piecework of the needle trades. Dire need self-evidently motivates her venture out into the ghetto world. But that movement is overdetermined, generated in part by the insufficiency of a domestic space at once oppressively full and empty of meaningful possibilities for her labor or self-expression.

In any case, the little lady is hardly unprepared for the rough-and-tumble of the street. She has barely stepped over the threshold before the Snapper Kid, leader of the Musketeers, begins a full court press, seeking to charm her into a kiss. The little lady responds by dropping her bundle, pushing him away, and slapping him hard enough to knock him into the arms of his sidekick, before going indignantly on her way. At this point, as the little lady moves out of the frame to enter into the social and economic landscape of the streets, the film cuts to its most storied location shot,

one that has been referenced in virtually every account of *Musketeers* and in innumerable encyclopedias, anthologies, and historical accounts of the birth of modern cinema. A sequence of about thirteen seconds, it features the dense, dynamic streetscape of the Lower East Side, and the little lady's movement through it. Brief as it is, this shot has arguably become a metonym for early cinema itself, which makes its mobilization of the iconography of the ghetto all the more remarkable.

Structuring the shot is Griffith's camera's placement, which reflects his deep interest in the Lower East Side as a contact zone (figure 2.9). The camera occupies a crowded sidewalk in close proximity to figures populating the street. Notably, however, the emphasis falls less on the iconic masses of the immigrant poor—as in Riis's work, or other early cinematic treatments—than on the fluidity, vitality, and subtly coded nature of contact on the East Side streetscape. Throughout the shot, the inevitable pushcart vendor and hagglers, whose presence indexes the Lower East Side, fill the left edge and background of the frame. On the right, we see an elderly man whose full lengthy beard, dark garb, and hat suggest Orthodox Jewry.

FIGURE 2.8. Screenshot, D. W. Griffith, *Musketeers of Pig Alley*, 1912.

FIGURE 2.9. Screenshot, D. W. Griffith, *Musketeers of Pig Alley*, 1912.

He reads a large tome from right to left, perhaps a religious volume in He-
brew, yet he occupies a sidewalk table in front of the very saloon in which
the gang standoff will soon ensue. Just behind him, propped insouciantly
against the window displaying the saloon's alcoholic wares, stands a young
girl with a lifeless expression, her arms crossed, her wary eyes trained,
unblinking, on the street. On location on "the Other Side," placed as and
where she is, the girl clearly animates the most fraught iconography of
tenement vice and contamination; she is another "girl of the streets," a
child prostitute.

Such an implication would hardly be lost on filmgoers immigrant or
native in the summer of 1912, at which point "the incidence of crime and
vice down there"—that is, on the actual Lower East Side—had become
"so scandalous that newspapers were reporting them daily."[37] A decade
earlier, progressive reformers and journalists had already identified as the
Lower East Side's "greatest evil" its vigorous organized trade in sex.[38] Spe-
cifically, the headworker of the reformist University Settlement Society
had noted in 1900 that the "worst sin" was that against the innocent young

girls "whose eyes are forced to behold sights which they never ought to witness," who "ceas[e] to be shocked" by the spectacle of prostitution "and come to envy the vicious women, who appear to lead an easy and comfortable existence."[39] What tender young thing, having seen and thus learned to desire, could resist? Consider, then, the girl in the picture, and what latter-day viewers have seen (or failed to see) in her. What film historians have tended to write off as the kind of effects that typify "primitive" film acting and camera work—her unblinking gaze, her stiff carriage and motionless stance—may in this case be something quite different. Not a pose but a bodily hexis, or rather the performance of one, they index a powerful apprehension of the Lower East Side as a social space.

But the girl on the street is hardly just a figure of local color, or off-color, made to serve an emergently middle-class spectatorship or the creation of distance from a threatening alterity. Her presence and conduct draw attention to striking paradoxes with respect to the sequence in question. What has long been credited within film's history as a particularly masterful use of location, predicated on the force of ghetto "actuality," could not be more overdetermined, iconographically speaking, or more self-consciously constructed for cinematic viewing. Within the purview of his street-centered camera, Griffith riffs on virtually every available icon of Lower East Side ghetto and tenement life: pushcarts and street commerce, upward mobility and love for sale, Orthodoxy and godlessness, figures of the shtetl and cosmopolites—all cohabit the space of the shot, all are coeval, *mise en place*, embedded within the cinematic frame.

And that space has been constructed with remarkable self-consciousness for the early cinema viewer. Griffith's camera angle is not frontal; rather, it cuts across the sidewalk, at a range close enough to emphasize exchanges in the foreground of the image, nearest the viewer, even as it affords a significant depth of field. All of this endows the mise-en-scène with a depth that is temporal as well as spatial—a decidedly palimpsestic quality.[40] It emphasizes the shifting, heterogeneous temporality of the (actual) Lower East Side. The figures who occupy the space and move through it, unified within the frame, embody old worlds being superseded and a radically new one being born. On the Lower East Side, Griffith understands, actuality is in a critical sense inseparable from a powerful temporal magic. Like the early trick films of Méliès, which offered early filmgoers the astonishing spectacle of one man playing seven different instruments simultaneously, or a horse-drawn omnibus transformed in the blink of an eye into a hearse,

this key location sequence in *Musketeers* images the past and the present in one, offering us a view from which history-as-image is being remade before our very eyes. What other site, we might ask, could offer such a perfect synergy with the distinctive powers of cinema?

All the more instructive, then, to discover—as film historian Russell Merritt did in 2002—that this storied Lower East Side location shot was filmed not in the storied, historical haunts of slumming and vice, but in Fort Lee, New Jersey, a favored spot for young film companies.[41] Merritt's patient, shot-by-shot research has raised a puzzling question: why would Griffith have schlepped film equipment, actors, and a full production crew across the Hudson (not yet spanned by the George Washington Bridge) to film ghetto street sequences when he could have made the short journey downtown and encountered the real thing?[42] By what logic does material, actual location become cinematic and illusory? To answer that question, I want to compare Griffith's location work in *Musketeers* with earlier shots from his 1908 Biograph film *Romance of a Jewess*, a conventional ghetto melodrama (figure 2.10). *Romance* consists of some fifteen minutes of studio tableau shots into which erupts the effect of actuality—footage, as Biograph put it, "actually taken in the thickly settled Hebrew quarters of New York City."[43] In this instance, the street is offered up as an essentially static backdrop of ethnographic interest, the suitable object of an emerging mass consumption. Shot from an elevated standpoint—a convention reminiscent of popular stereoscopic images of the ghetto, which offered viewers a sense of mastery over the density and strangeness of the alien streetscape—*Romance*'s location frames are characterized by a planar perspective that creates a familiar vanishing point, with all it implies about the prospect of visual mastery, a unified and detached observer, and a linear temporality, unfolding predictably toward the future.

In striking contrast, the location shots in *Musketeers* place the viewer decidedly in the streetscape. Paradoxically, the most notable effect of making location illusory—that is, filming not the Lower East Side but "the Lower East Side"—is to diminish the distance between cinematic space and social space. There is no visible means of escape for the viewer, or any implied movement toward a futurity whose shape has been determined for us. Analogously, the kind of street figures who provide local color in *Romance* are in *Musketeers* far more animated, and far more self-consciously cinematic. This is not just to say that they have been placed "artificially" on site, invented through casting, costuming, and filmic articulation. More to

FIGURE 2.10. Screenshot, D. W. Griffith, *Romance of a Jewess*, 1908.

the point, the unblinking child prostitute, the laborers and denizens of the saloon, the reader of sacred text, have all been placed in the frame—*mise en cadre*—in a way that suggests the interpenetration of received image and actual social experience. Self-consciously mis- or relocating his Lower East Side via a detour through iconic images of the ghetto, Griffith all the more successfully confronts his viewer with the animating powers of that social space, in which cohabit the not-yet-assimilated past and the as-yet-undetermined future: a birthplace of the modern nation and its cinema in one.[44]

The aim of *Musketeers* is not just to fashion such a palimpsestic space, but to exploit it as the setting for its most fraught sequence, the journey of the little lady out into the world, "Alone" (as an intertitle notes), vulnerable to the ever-present threat of sexual predation and social exposure. Notably, the little lady is played by Lillian Gish, then either a sixteen-year-old or a nineteen-year-old who passed for sixteen and on the brink of becoming early cinema's first icon: "a legend in her own lifetime."[45] On first meeting her, Griffith proclaimed that she had "an exquisite ethereal beauty";

on screen, he opined, "there was around Miss Gish a strange mystic light that was not made by any electrician."[46] Cameraman Bitzer goes so far as to suggest that Gish's aura created the apparatus that captured it on film, rather than the other way around. He had a special Zeiss lens built just for filming her, which he called "my *LG* lens, because I never used it except for special photography of Lillian Gish" but "carried it with me, carefully nested in my vest pocket, as I considered it a most precious possession."[47] Throughout the teens and twenties, film critics would adore Gish as "a being" with a "frail, spiritual quality that set her apart from the others."[48]

What industry players describe is Gish's uncanny fitness for the embodiment of vulnerable purity, in distinctly American form. Between 1912 and 1925, she was "saved just in the nick of time from the brutal attacks" of so many "ruffians," "German soldiers," and "conscienceless men about town" that one reviewer sardonically wished for a Gish film in which "the American hero breaks a leg and fails to get there before [the villain] smashes in the door."[49] Another critic, with equal asperity, suggested the founding of a Society for the Prevention of Cruelty to Lillian Gish.[50] But the condition of threat in *Musketeers* has a special logic. Transposed to the tenement and ghetto street, that threat is made to implicate the future of a modern, urbanizing, ever more heterogeneous America. This is not a nostalgic return to the chronotope of the plantation or some other temporally distanced space (as in so much of Griffith's oeuvre, e.g., *Birth of a Nation* or much of *Intolerance*), or a displacement of social anxieties onto a world apart (as in *Broken Blossoms*). In *Musketeers*, questions—curiosity—about the fate of the little lady, on whom America's future will depend, are pinned to a real social space, one in which actuality and cinematic effect are mutually mediating.

This crossing of actuality and iconography, of historicity and fantasy, is actualized in *Musketeers*—made visible within the cinematic frame—in one of the most iconic images in cinema history: an image that has come to stand for Griffith's early, pre-*Birth* oeuvre, and even, we might argue, for the early life of US cinema itself (figure 2.11).[51] Drawn from the location shot in question, this still image features the little lady, moving on the street toward the camera as she passes the only other unaccompanied woman in the shot. Shooting the latter from behind, as she saunters from the foreground of the frame into its center, Griffith's camera emphasizes her conspicuous hair accessory, her easy and comfortable gait, her apparent familiarity with hangers-on, and her unself-conscious consumption of

FIGURE 2.11. Screenshot, D. W. Griffith, *Musketeers of Pig Alley*, 1912.

food as she strolls. Collectively, they suggest that the street is her habitus—
that she, like the motionless girl in the doorway of the saloon, is some
kind of streetwalker. What kind of diegetics or mise-en-scène might war-
rant such an assumption? What exactly is made visible to us here?

Surprisingly, the particulars of the exchange between the little lady and
the streetwalker have gone unremarked in the long history of response to
Griffith's film. I have in mind a distinctive dynamics of doubling: the dou-
ble motion of the two young women, toward and away from the camera;
their double take—a pause just long enough for each of them to hold a
complex look, and in the little lady's case, a redoubled look back; and later,
the redoubled effects of the Lower East Side street as location, as the film
traces the passage of the Musketeers through the space the little lady has
navigated. What makes the critical silence on this moment all the more
remarkable is that its doubling is offered up to the viewer as a mirroring.
For if the little lady is played by Lillian Gish—she of the cupid mouth and
soulful eyes—the unnamed street-saunterer is Gish's actual sister Dorothy
(uncredited, as was Biograph's practice). The screen personae of the Gishes

FIGURE 2.12. Screenshot, D. W. Griffith, *An Unseen Enemy*, 1912.

would go on to develop in the directions foreshadowed here, with Dorothy as the "comedienne," the "saucy" girl, the "little disturber," to Lillian's threatened, tragic figure. But initially, and at key moments, Griffith chose to exploit their resemblance (figure 2.12).[52] Before casting them in their first film, he asked if the sisters were twins, tendentiously noting, "I can't tell you apart"; both had, in his view, "expressive bodies" suited to his project, and the spectacle of sisters at the risk of harm made his signature logic—the restoration of bourgeois familial order—all the more powerful.[53]

In *Musketeers*, however, the actresses' embodiment has other effects. Their encounter is a mirroring that marks the intersection—and even, given the presence and visual agency of the young girl, the triangulation—of purity and danger, of actuality and illusion. I stress the figure of crossing so as to recall Sergei Eisenstein's famous judgment of Griffith's work. In Griffith's films, Eisenstein charges, social reality is "perceived *only as a contrast between the haves and have-nots*," registered, through editing, in "the image of an intricate race between two parallel lines."[54] Here, however,

at a critical moment in Griffith's experiments with visualizing American social experience, those lines—story lines, lines of force—can be said to intersect, at least with respect to the play of gazes: the streetwalker hails the little lady with her gaze, the little lady gazes back with some recognition of her troubling double, the motionless young girl trains a steady gaze on the little lady. The streetscape of the Lower East Side, finally, allows Griffith to stage a fraught kind of visual intersection. Finally, in the logic of the film, the little lady's resonance as a figure of mobility, urban pioneering, and implied reproduction is attuned to her experience—especially her visual experience—of the ghetto as contact zone. With the backward glance at her own dark twin, she is learning to make a place for herself in the social space that is modern America in the making—just as Griffith prepares himself to become a master of modernity's emblematic form, cinema, by identifying with the visual dynamism, heterogeneity, and temporal instability of the Lower East Side.

As this reading suggests, the Lower East Side street in Griffith's mise-en-scène becomes notably feminized; the preponderance of women as observers of, and as figures implicated in, the little lady's mobility is striking, given conventions for ghetto location work of the era. Yet the animation of the street and the articulation of space in *Musketeers* implicate more than the fate of women alone. The embeddedness of the little lady in the tenement landscape is mirrored in a series of location shots that unfold the war between the Snapper Kid, his Musketeers, and members of the rival gang, set on the street and in the film's eponymous alley (whose actual location, we might note, has never been identified). The contest between men—here criminal and violent—for ownership of public spaces is hardly surprising, but its conduct in the film has an unexpected outcome. Even as the gang sequences animate the criminality, the raw otherness, of the Lower East Side, what Griffith calls the "feudal war" played out cinematically redoubles the effect of connection between figures on screen and the social actors who observe them. On the Lower East Side—or, more accurately, in the iconic and constructed space that signifies the Lower East Side—*Musketeers* works out a distinctive cinematic logic. Simultaneously, it suggests to cinema's changing publics how they might envision their places in a rapidly changing social landscape.

In expression of the Victorian sensibility Griffith is often said to extend, the street war between men breaks out as a contest over a woman—specifically, the little lady, whom the Snapper Kid, alert after having been

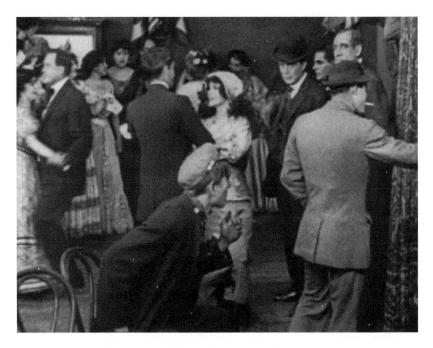

FIGURE 2.13. Screenshot, D. W. Griffith, *Musketeers of Pig Alley*, 1912.

rebuffed by her outside the threshold of her flat, keeps in his sights at the Gangster's Ball in the Grand Dance of the Jolly Three, a typical Lower East Side site for cheap amusement.[55] The little lady, brought to the dance hall by a worldly woman friend aiming to "cheer" her after her husband's departure, is introduced to a genteelly attired man. The Snapper Kid is visibly concerned as that figure escorts the little lady from the dance floor—where she politely refuses to dance, presumably on the grounds that it would be inappropriate—into a small refreshment area through a curtained doorway. As they enter, two genteel women accompanied by a well-dressed man depart from an adjacent table and a jacketed waiter with a towel over his arm appears; this is, the mise-en-scène suggests, an appropriate public space for the little lady to occupy. But the Snapper Kid can see beneath the façade of propriety. Abandoning his observation post in the dance hall, he follows the little lady and her would-be partner, pausing at the curtained threshold between the spaces to observe the pair unseen (figure 2.13). The Snapper Kid enters the café only when the little lady is about to drink from the glass her escort has drugged while he distracts her. The arrival of the

gangland territory's "Big Boss" cuts short the impending violence between the newly forged rivals; the little lady makes an outraged exit and the gangsters part with the intention of taking their contest, with reinforcements, to the streets.

Although this sequence takes place indoors (presumably on a set constructed in the studio), its articulation of cinematic space enhances the film's location and actuality effects. Here, as in the location shooting that follows, Griffith makes remarkable use of what film theorists since Noël Burch have named offscreen space, the simultaneously material and imagined space implied beyond the visible frame of the film. As Burch defines it, offscreen space comprises the distinct zones extending beyond each of the fixed borders of the screen (top, bottom, right and left edges) as well as those behind the camera and the set.[56] However indebted Griffith may be to the proscenium stage, with its relatively static imagination of theatrical space, his employment in *Musketeer*s of offscreen space is marked and innovative. Here, we might say, the attempt to visualize the density, impenetrability, and resistance to assimilation that characterize the iconic Lower East Side not only generates new uses for offscreen space. It allows Griffith to explore the shifting boundaries between icon, image, and material space, between screen actors and the social actors who observe them.

To the extent that film historians have remarked on space, on- or offscreen, in *Musketeers*, they've tended to focus on its wayward quality: a disjuncture between exteriors and interiors, the apparently random movement of gang members through their alley, the saloon, the streets. On location on the Lower East Side, however, these effects confront and challenge the spectator. Dense, maze-like, the streetscape of the iconic Lower East Side had long defied visual command by outsiders; what with its street activity, its "strange . . . geography," the ghetto continued to demand new visual strategies and techniques for apprehension.[57] In this respect, Griffith's figures on screen have a distinctive pedagogical function. They teach spectators how to make sense of the material and imagined space of the urban ghetto, precisely as a function of reading cinematic space (and vice versa). No figure embodies this possibility, this synergy between cinema and lived modernity, more powerfully than the explosive, charismatic Snapper Kid. His movements between interior spaces, between interior and exterior spaces, within spaces of contestation and within the film frame: all mark and are marked by an awareness of spatial effects that is both a cinematic and a social currency.

To consider the meaning of his movements, we have first to note a distinctive feature of Griffith's mise-en-scène. Characteristically, the edges of his interior sets—the walls or doorways that constitute the limits of the diegetic space—correlate with the edges of the film's frame. In the opening shot of the tenement flat, for example, the right edge of the frame is marked by the doorway through which burst unannounced not only the musician himself but at various points the Snapper Kid, a tenement friend, and a police officer. Similarly, as we have seen, the space of the dance hall is bounded at the right edge of the frame by the curtained doorway through which the little lady, the rival gangster, and ultimately the Snapper Kid will disappear from our view. Griffith's tendency to mark the frame in this way may well betray his dependence on conventional theatrical space as a model, as critics often claim. But it also enables him to experiment with the construction of the spectator's space and point of view. In each of these shots, the same right-edge opening or aperture onto an offscreen space— from the tenement, the exterior space of the streets; from the dance hall, the separate space of the café—will become the boundary for the left edge of the frame as the action shifts its location to that site. This reversal of the implied contents of offscreen space secures the illusion of continuity of location—a critical element in the evolution of what was becoming, in Griffith's practice, the space of narrative cinema, governed by the viewer's sustained apprehension of the visual field.

But even as Griffith exploits the narrative effects of offscreen space, he also employs it as a special effect: a location effect, we might say, of the Lower East Side as an experiential context. At the very instant of the rival gangster's play for the little lady—the moment when he slips a knockout drug into her drink—the Snapper Kid remains invisible to the viewer. Only the dense smoke of his cigarette, drifting from offscreen at the left edge of the frame, alerts us to his presence (figure 2.14). Canonical readings of the film credit such shrewd use of offscreen space as a device for generating suspense—or as film theorists David Bordwell and Kristin Thompson put it in their foundational film history, for "exploit[ing] the surprise latent in our awareness that figures are offscreen."[58] Here, however, "surprise" seems an insufficient way of naming the tensions the film creates, the way it exploits offscreen space in relation to the mise-en-scène and to the spectator's experience. For in this frame, we encounter something like a triptych, a cinematic space in which three equally powerful, equally consequential actions are being indexed or registered simultaneously, and thus elude

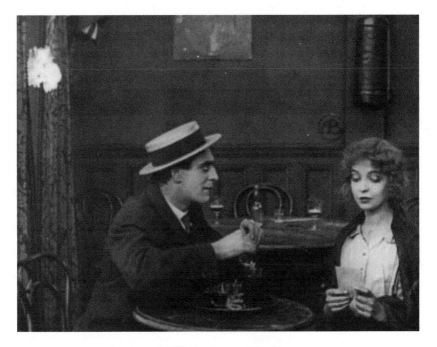

FIGURE 2.14. Screenshot, D. W. Griffith, *Musketeers of Pig Alley*, 1912.

full assimilation by the viewer's eye. Notably, each of these actions involves vision or visual apprehension in some way: the Snapper Kid's surveillance from his place of concealment; the gangster's sleight-of-hand, by which he drugs the little lady's drink as he observes her closely to ensure that she does not observe him; and the little lady's gaze, downcast and withdrawn from the impending threat as she contemplates a picture postcard the gangster has shown her as a diversion.

It's not much of a stretch to understand this moment as an allegory of *Musketeers'* stakes in the Lower East Side as a space of cinematic experience and encounter. If the little lady's absorption in the picture postcard suggests the potential dangers of mass visual culture, and the specter of the low origins and cheap amusements from which cinema was laboring to distinguish itself, the rival gangster's brutal intentions are materially linked to the earlier visual form of the still photograph, which he employs as a device of the rankest deception. Invisible, offscreen, the Snapper Kid is the figure who observes all that transpires in the instant, entering the space from beyond its borders at exactly the critical moment to wrest the

fateful glass from the little lady's hand just before it reaches her lips. Notably, the material sign of presence he produces, cigar smoke, communicates the very essence of indexicality; it is what we might call, with a nod to Charles Sanders Peirce, the quintessential actuality effect. Before our very eyes, the Snapper Kid's elusive, shape-shifting trail of smoke actualizes the distinctive character of cinematic experience, making visible the nature of light-writing or projection: its unfolding in space and time. Producer of this sign and emblem from the redoubt of his vantage point offscreen, the Snapper Kid enacts mastery not of a zone of cinematic space but of the contact zone in which cinematic and social experience collide. If the little lady can still be taken in by the illusive nature of visual experience, the Snapper Kid is the figure who himself takes everything in, the agent who embodies precisely the mastery of unified and simultaneous perspective that remains elusive for Griffith's spectator.

This command of motion and the visual field turns out to be critical to the Snapper Kid's victory in gang warfare, even as it constitutes a heightened pleasure and a test of apprehension for the film's viewer. After the altercation in the café, the bulk of the film—some five minutes—is given over to shots of the two gangs moving separately through the contested ghetto landscape (the Jolly Three dance hall, the street and the saloon, Pig Alley itself), tailing one another in anticipation of the equalizing to come. Notably, the Snapper Kid is the leader in this deadly slow-motion chase. In the contest for turf, he is the one who rounds the corner, scouts locations, and reads the scene in advance of his rival, commanding visible space from beyond its boundaries. It is his shadow—another indexical mark—that is projected onto the cinematic space as a sign of his commanding presence, just as the film itself has been projected onto the screen (figure 2.15; when his rival enters through the same doorway, the effect is quite different). The Snapper Kid's orchestrated mobilization of the space of the mise-en-scène helps create the effect of suspense. More importantly, though, it becomes the foundation for the viewer's identification, his or her absorption into the narrative logic.

This becomes particularly striking in the penultimate moments of the gangs' mutual stalking, in a shot that has become almost as ubiquitously quoted in film history as that of the little lady's look back on the street. Entering the alley from an offscreen entrance at its rear, the Snapper Kid intuits that his rival is near (a cut to a shot of the rival gang confirms this). Followed by two of his cronies, he makes his way purposively toward

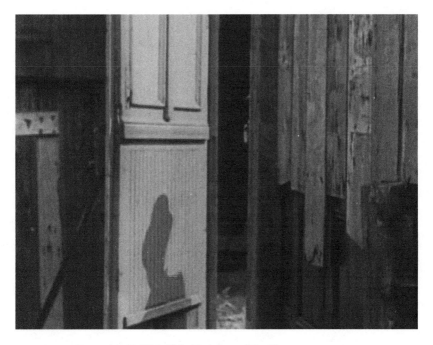

FIGURE 2.15. Screenshot, D. W. Griffith, *Musketeers of Pig Alley*, 1912.

the mouth of alley, hugging the brick wall that marks the boundary of the tightly enclosed space as well as the right edge of the frame. Slowly, inexorably, the Snapper Kid continues to move toward the camera, his unblinking eyes trained ahead on the viewer even as his body and face remain partially offscreen. He pauses in tight close-up at the right edge of the frame, entirely still but for his wary eyes, which sweep the scene before he exits offscreen at the extreme right of the frame, his musketeers in his wake (figure 2.16, figure 2.17). Two notable effects define the shot as a whole. The practiced movement of the Snapper Kid in and out of offscreen space—the shadowy entrances and exits of the alley, the shady nooks and outcroppings of tenement infrastructure—certainly heightens the effect of suspense. But it has a more pronounced effect as well: it disrupts the assignment of cinematic or narrative mastery to the spectator's point of view. At key moments in the shot, we can see the Snapper Kid even when he presumably cannot see us—a cardinal effect of narrative cinema. His gaze, however, becomes so commanding, so definitive of the mise-en-scène that it has the effect of exceeding both the screen and the spectator's gaze,

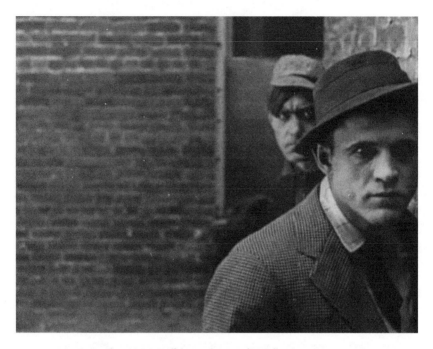

FIGURE 2.16. Screenshot, D. W. Griffith, *Musketeers of Pig Alley*, 1912.

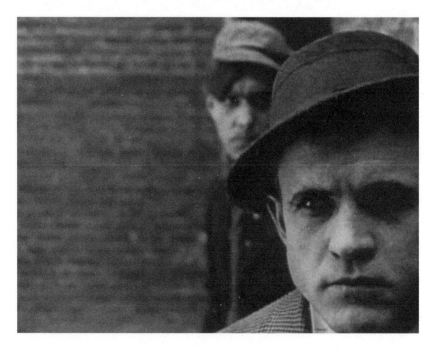

FIGURE 2.17. Screenshot, D. W. Griffith, *Musketeers of Pig Alley*, 1912.

encompassing an offscreen space, a social space, that remains inassimilable by the viewer. In this sense, the Snapper Kid's intense gaze constitutes for the spectator the same kind of challenge that the unblinking stare of the girl on the street poses for the little lady. It creates a threshold of recognition, of identification. At the same time, it clarifies the kind of acuity demanded by the animation of the street, both as a reality effect on screen and as the emergent lifeworld of lived modernity.

That Griffith intends to create some version of such a spectatorial dilemma is evident when we consider the technical innovation he developed along with his cameraman Bitzer to make this shot possible. Throughout, the Snapper Kid remains in sharp focus, from the deep space at the rear of the constricted alley to the extreme close-up in which his face fills the right half of the frame. That effect is created by the use of what has come to be called follow focus: the steady adjustment of the camera lens throughout the shot as the actor moves through the frame so that he remains, along with the background, in sharp focus. Griffith is often credited with inventing the technique; founding or no, his use of follow focus in *Musketeers* registers an urgent interest in shaping the relationship between the film's protagonist and its spectators in the film's overdetermined location. Trained on a figure of threatening alterity whose gaze looks directly back, the early film spectator is being conditioned both to identify with the wary gangster (in the emergent logic of narrative cinema, the viewer's gaze from beyond cinematic space realizes the protagonist's interiority, giving the viewer a stake in its assertion) and to feel, in the face of that larger-than-life figure, the discomfort of his or her own visibility. Just as the actual spaces of the Lower East Side generated technical innovations that allowed for their own more powerful representation—as in the case of Jacob Riis's experimental use of magnesium flash powder, *Blitzlichtpulver*, to produce the unprecedented photographs of Lower East Side alleys, roosts, and tenements that were the model for *Musketeers*—so too the project of animating that iconography. Griffith's aim of imaging the Lower East Side as a contact zone in which the exemplary modern subject's visual acuity and visual subjectivity are formed yields this double take on the Snapper Kid— and at the same time, the cinematic technique that allows for its expression.

What, by way of conclusion, might we learn from this fraught instance of location work and its special effects? First, that the uneven codes of early film allow for varied experiments with the spectator's role, with the construction of his or her relationship to cinematic space—a prospect opened,

we might say, by the distinctive properties of the Lower East Side as a visual object and even a visual field. Griffith's use of location—or rather, the illusionistic play with location that makes its reality effects all the more powerful—activates the iconography of the Lower East Side as a kind of reality testing. Like the little lady, the viewer must experience the contact zone recreated in the location work of *Musketeers* with eyes open, if she or he is to become and be an adept citizen of modernity, able to read its textured codes, able to navigate its social and semiotic challenges. In this sense, the Lower East Side is not so easily cordoned off, as a cinematic object, from social space. Griffith's location work also suggests how invisible this site has become as a locus for the generation of modalities, techniques, and practices across visual and textual media. Nearly a century of film scholars failed to identify his reconstruction of the Lower East Side as such; failed to identify his distinctive uses of the camera, of techniques of filmic seeing, to probe the effects not of purity and danger but of an iconography, a way of seeing urban modernity (now our collective history) with a social animation all its own. In this sense, Griffith's work may teach us how to look at other objects—still photographs, phototexts, other modes of engagement with America's iconic site of alterity—to learn more about the ways they continue to hold our gaze, continue to experiment with social seeing, continue to look back.

Chapter 3

What Becomes an Icon?

Photography and the Poverty of Modernism

How might Abraham Cahan's responses to a crisis of visibility help us rethink the history of visual representation? I have argued that Cahan's concern with a dynamic of arrest, whereby immigrant, Jewish, and Yiddish-language culture-makers are made invisible as active agents of American modernity, responds to a broader history of visual experience on the Lower East Side. In turn, the view from the immigrant ghetto throws unexpected light on photography as an agent of representation crucial to the evolution of modernism. Around the camera, its images and its powers, another set of aesthetic engagements with modern times and a rapidly changing nation coalesced. Surprisingly, these engagements turn out to implicate the precincts and the image repertoire of the downtown ghetto, and the modernism they generate is both embedded in the Lower East Side and predicated on making that connection disappear from view. Taking the effects of Cahan's work as a point of departure, I argue, we not only understand the birth of photographic modernism in new ways. We account more richly for the intertwined histories of photography, the tenement landscape as a site of imaginative engagement, and the evolution of Jewish America.[1]

In the summer of 1916, a rising young photographer named Paul Strand began an experiment that would have unprecedented consequences for the fate of photography as an art form in the United States. Just twenty-six years old, Strand already had a track record as a producer of fine artistic prints. Conceived in the pictorialist mode of late nineteenth-century art photography, they were moody, soft-focus, imitative of European painting,

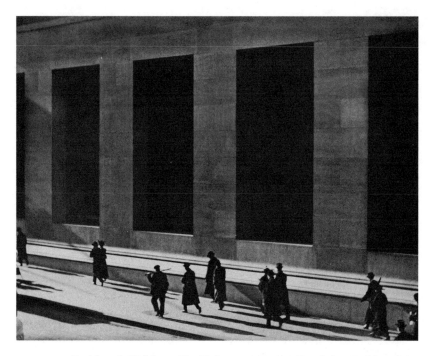

FIGURE 3.1. Paul Strand, *Wall Street, New York*, 1915. ©Aperture Foundation, Paul Strand Archive. *See also* Plate 2.

and given to titles like *Temple of Love* and *Garden of Dreams* (1911). On the strength of this work he was invited into the foremost circle of avant-garde writers and artists in the early twentieth-century United States, gathered around impresario Alfred Stieglitz and his famed 291 gallery in New York. There, Strand shaped his aesthetic in earnest at the very moment when visual modernism was being born. As it turned out, his efforts to make himself new were critical to the work of making photography modern—repurposing its practice and its objects as aesthetic experimentation and as fine art. In and around Strand's experiments, photography emerged as a privileged art form for expressing the felt experience of belonging to modern times.

Before joining the avant-garde of 291, Strand had already produced one of the images that vaulted him beyond pictorialism; it would later be judged foundational to the history of photography (figure 3.1 and plate 2). *Wall Street* (1915) was the result of Strand's attempt "to see whether one could

photograph the movement in New York, the movement in the streets, . . . the movement of people walking in the parks or wherever."[2] It has been canonized as a modernist masterpiece—"the photographic equivalent of Picasso's abstraction," "a break-through" for American visual modernism in its commitment to New York City as a subject: dynamic, driving, in a state of incessant flux.[3] Strand's real achievement with this image, however, was not the repurposing of photography for modernist aims. In his effort to capture the movement of "little people" against the "great big sinister, almost threatening shapes" of the city's corporate infrastructure, Strand sutured rigorous formalism and an abstraction borrowed from contemporary painting to the special agency of photographic seeing.[4] Inevitably taken out of the flow of lived time by the process of photographic capture, his subjects lent themselves to a modernist rage for order, an artifice beyond the reach of time. But all photographs (at least according to the conception of the era) retain some indexical charge, an animating link with the material sites and the historical present in which they were captured. *Wall Street* self-consciously explores this defining paradox, offering an object lesson in what a modernist photograph might be—and what may be lost or suppressed in reading it as such.

To put this more precisely, it wasn't just geometric possibilities or unimpeded sightlines that led Strand to train his camera on the recently completed J. P. Morgan and Company building at number 23 Wall Street. In 1916, ordinary Americans—the early twentieth-century 99 percent—saw the Morgan empire as emblematic of the monopoly-profiteering ethos driving the nation's pell-mell boom-and-bust expansion. Morgan himself figured frequently in the popular press in images emphasizing outsized power and voracious grasp (figure 3.2).[5] In the first decade of the twentieth century alone, his personal capital had resolved at least two major financial panics, and in the process fueled an ongoing national debate about the future of meaningful democracy in the face of such radical concentration of wealth and banking power.[6] Long after Morgan's death in 1913, his image as a "thick-necked financial bully, drunk with wealth and power" (to quote Wisconsin Senator Robert W. LaFollette) and the "boss croupier of Wall Street" (here, John Dos Passos) lived on.[7] So towering was his legend, so iconic his stronghold, that when the new house of Morgan was completed in 1914, it was described by New York City's *Real Estate Record and Builders Guide* as "a rival to the Parthenon," and architects and protectors of his legacy alike thought it unnecessary to mark the building with the titan's name.[8]

FIGURE 3.2. Udo J. Keppler, *Following the Piper: His Music Enchants the World*. Chromo-lithograph. *Puck*, September 17, 1902. Library of Congress, Prints and Photographs Division LC-DIG-ppmsca-25672.

With respect to Strand's image, this absence of signage has implicitly been treated as the result of Strand's photographic choices (format, camera angle, framing, scale), and it seems to have supported claims for *Wall Street* as the artifact of that newly modernist photographic sensibility: "universal" in reference, the "abstract expression of an emotional response."[9] But in context it was a distinctive feature of the material site, and for early twentieth-century inhabitants of the city would have been a clear sign or tell. The state of being physically unmarked was precisely what marked the structure as a turn-of-the-century, capitalist-modern New York City icon: a condensed, overdetermined embodiment of globalizing monopolistic Wall Street power. Within a few years the building would in fact come to be marked—but only by an anarchist bomb that, in addition to causing thirty-eight deaths and some four hundred injuries, tore deep shrapnel marks into the edifice (figure 3.3). These marks were left to speak, un-repaired, for themselves. Clearly, Morgan and Company understood the power of iconicity.[10]

So too did Strand. If we compare his epochal photograph with contemporaneous views of 23 Wall Street, we get a clear sense of his interest in what we might call the iconography effect. Descriptive images of the new

Morgan building circulated in the popular press typically register its irregular footprint and anomalous siting, its surprising modesty of scale, and the degree to which it was overshadowed by brasher corporate neighbors (figure 3.4). Strand, by contrast, deliberately suppresses all of these distinguishing features. Homing in on a single façade, he shoots from above—more precisely, across the street, from the steps of the city's Federal Hall (the site on which George Washington had taken the first presidential oath of office). Minimizing depth of field, mobilizing the effects of morning light, he exaggerates horizontality and flattens the pictorial space. Strand thereby frames 23 Wall Street as a towering scenographic backdrop across which the "little people" trudge, under what he described as the windows' "blind shapes," which are not sightless so much as opaque, impervious to any human gaze.[11] More than panoptical surveillance, however, these blind eyes are reminiscent of Strand's own camera; they resemble the photographic plates Strand himself employed in his 3¼ by 4¼ Ensign folding camera and from which he worked to make technically legendary prints.[12] In Strand's image these surfaces are blank, as yet unexposed: a screen onto which his subjects, their gazes averted, project a felt sense of the abstract power that confronts them as the grounds of their everyday social experience. *Wall*

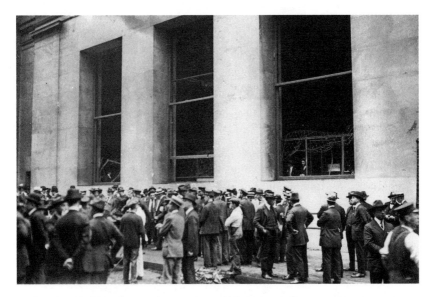

FIGURE 3.3. Bain News Service, Wall Street bomb, September 16, 1920. Library of Congress, Prints and Photographs Division LC-DIG-ggbain-31303.

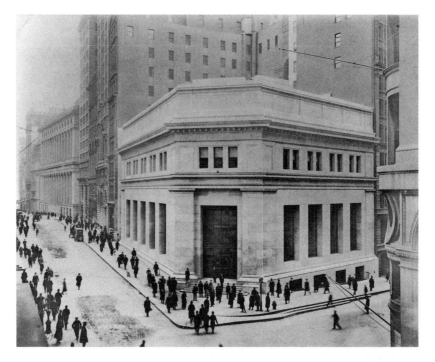

FIGURE 3.4. Irving Underhill, J. P. Morgan & Company Building, Wall and Broad Streets, ca. 1914. Library of Congress, Prints and Photographs Division LC-USZ62-124435.

Street, finally, is not just a photographic monument in its own right of modernist experimentation. It is an iconic photograph about the making of iconographies: visual repertoires for the way we live now. Exploiting with new purpose the power of photographic arrest, Strand's image opens to view the way a lived space becomes for inhabitants of shared time a sign of their social condition and history.

This interest in the iconography of modern times drives Strand's most influential work. Its pursuit led him—inevitably, I argue—to engage with a differently iconic landscape: the ever-changing space of New York's immigrant and working-class downtown. Although *Wall Street* was immediately hailed as a breakthrough for art photography, making the case for its medium-specific aesthetic powers, Strand himself thought of its achievement as preparation for an experiment he understood to be far more radical. The following summer, he returned to the city's streets to "carry out an idea which came to me at that time": the project of "photographing peo-

ple, making portraits of people anywhere without their being aware that they were being photographed."[13] To be sure, the desire to make photographs of human subjects who remained unaware of the presence of the camera long preceded Strand. But such practices had historically been driven, photo historians note, by "appetite," the thrill of secrecy and liberation from Victorian social codes—hence the steady nineteenth-century trade in "detective" cameras and other disguised photographic devices.[14] A dime novel of 1888 in Chicago-based Laird & Lee's Pinkerton Detective Series suggests the allure of such capture by stealth: "You skillfully blend into the crowd in your impeccable striped jacket and stylish top hat. Your steely gaze transfixes your unsuspecting quarry as your finger poises in anticipation over the shutter button. No-one notices, least of all the criminal, as you document the crime using your trusty Blair Hawkeye Detective Camera."[15] Cameras concealed as books and packages, as vests, hats, and other wearables, were widely marketed into the turn of the century (figure 3.5). What Strand sought in imaging by stealth, however, was something

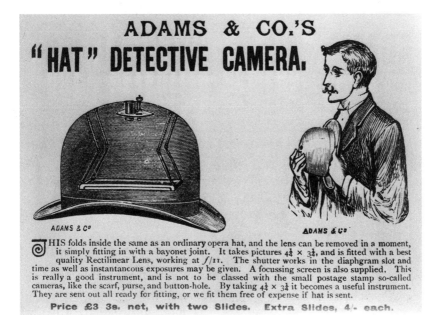

FIGURE 3.5. "Hat" Detective Camera (camera hidden inside bowler hat), Advertisement, 1900. Bettmann/Getty Images.

far more photo-centric and ambitious: a repurposing of photography's powers, predicated on the embeddedness of camera-work in lived and present spaces of modern experience.

In this project the life and afterlives of the Lower East Side turn out to play a surprising role. Let me begin to explore it by attending to a key phrase in Strand's description of his project: "making portraits of people *anywhere*" (emphasis added). Like the edifice of 23 Wall Street, and the "wherever" of Strand's interest in mobile city-dwellers, the latter term is assumed to be self-evident—to refer to the undifferentiated street as a chronotope, a paradigmatic setting for the restless activity, motion, and everyday theater that make modern life modern.[16] In fact, Strand's photographic experiment had a specific, even unique, place of origin. On the hunt for his "very first" portrait subject, Strand began by trawling a lifelong haunt, the Bowery and its contiguous spaces.[17] His favored sites outlay the concentrated grid of straitened, tenement-lined streets (Hester, Eldridge, Ludlow, Delancey, Grand) constituting the city's infamous Tenth Ward and historical Jewish ghetto. But the staging grounds Strand chose for his experimental work were continuous with that immigrant-and-tenement space, and they drew him precisely for that reason.

At this point, a note on Strand's personal context is in order. The only child of parents whose German Jewish ancestors hailed from Bohemia and who lived on the Upper West Side, he was a paradigmatic figure of assimilation.[18] A student at the secular humanist Ethnical Culture School (ECS; founded in 1878 by Felix Adler, son of the rabbi of New York's grand Temple Emmanu-el, to "develop individuals who will be competent to change their environment to greater conformity with moral ideals"), Strand identified strongly with assimilated Jewish intellectuals, Stieglitz and writer Waldo Frank among them.[19] His training under the sign of Jewish-inflected humanism clearly shaped Strand's aspirations as an artist. In fact, he first studied photography at ECS with social reform photographer Lewis Hine, who had been hired, the school's principal noted, to help give their overwhelmingly assimilated Jewish American students "the same regard for contemporary immigrants as they have for the Pilgrims who landed at Plymouth Rock."[20] But such regard in Strand's case was mediated, significantly distanced from firsthand experience of the Lower East Side and its evolving contemporary cultures. It might be argued that the closest Strand got to the latter was as a customer of the uber-grand Bowery Savings Bank, a massive, imposing classical structure on Grand and Bowery

designed—precisely because of its proximity to the Lower East Side—to "impress the beholder with its dignity and fortress-like strength" and to encourage immigrants in habits of sobriety and thrift.[21] To put this another way, when Strand withdrew his savings from its vaults in 1911 to make an epochal trip to Europe, it was never an Old Country with which he sought to connect but rather the precincts and temples of high art.[22] If what Alan Trachtenberg has called Strand's "prophetic conception of art" as a social language owes something critical to his Jewish or Jewish-inflected experience, Strand's interest in spaces of encounter with poverty and alterity was more immediately shaped by the conventions of photography itself, and by the image repertoires he sought to revise.[23]

It is in this way—that is, photographically—that consideration of Strand's Jewish context returns us to his aesthetic invocation of "anywhere." The overdetermination of his gesture becomes clear when we consider where Strand initially looked for photographic subjects: the contact zone known as Chatham Square. The north end of the square, where Division Street and East Broadway run into the Bowery, formed the junction of the historical Lower East Side and its predecessor in the urban imagination, the legendary Five Points.[24] One would be hard pressed to find another territory in New York—or any world city—as iconographically freighted as this nested space. At this intersection converged not just two historical neighborhoods but two image repertoires foundational to urban modernity in the United States and to its evolving visual forms. The first had been an infamous haunt of poverty, vice, and crime, associated in the earlier nineteenth century with immigrant, Irish American, and free African American communities, prostitution, cholera epidemics, ethno-religious violence, rioting, and brutal ward and gangland politics. Through the turn of the twentieth century, the second was the most densely populated urban area on the planet, famed for the greatest concentration of "aliens," immigrants, foreign tongues, and street commerce in the United States, and a favored object of touristic, journalistic, ethnographic, forensic, and political interest on those grounds.[25] Like many inhabitants of the early twentieth-century city, Strand was drawn to the thoroughfare that physically linked these imagined spaces across historical transformations in the built landscape: the Bowery, that imagined conduit to the Lower East Side. Still, in 1916, lined with more than a hundred lodging houses as well as labor halls, pawnshops, brothels, bars, "rescue" halls, and cheap eats joints, the Bowery remained a zone of undomesticated (read: unassimilated male)

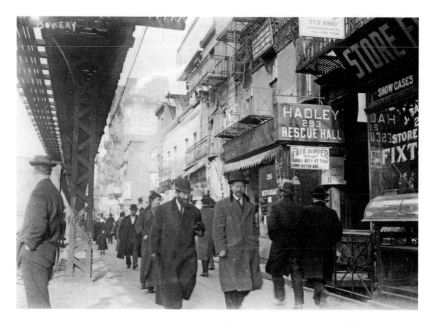

FIGURE 3.6. Bain News Service, Bowery, New York City, ca. 1910–1915. Library of Congress, Prints and Photographs Division LC-DIG-ggbain-15215.

poverty and transience (figure 3.6). Through decades of grimly dedicated missionizing and slum clearance, it continued to trail a life—and, more importantly, an iconic charge—as New York's capital of low life.[26] By 1916, when Strand began his street portraits project, the Bowery was at its apex as the very "image of decline," the conceptual home for early twentieth-century artifacts and human subjects "too shoddy, too risqué, too vile" or "too marginal" to belong elsewhere.[27]

This knotty conjunction of streets and street cultures, urban histories and image repertoires, was the precise "anywhere" to which Strand was drawn in 1916 to explore the powers of the modern camera. Shaped and signified by what we might call, after Barthes, the iconographemes of ghetto, slum, bum's roost, and street, it was a far from innocent choice—and it was fundamentally unoriginal.[28] Indeed, the contribution of Strand's street portraits to the invention of photography as a modernist art form can only be recognized as such if we understand both their site specificity and what was second-order or mimetic about their treatment of their subjects. By the mid-1910s, photographic hobbyists, journalists, and aesthetes alike had

seized on the "ghetto" and associated downtown sites as exemplary subjects for modern modes of photographic seeing, in particular the ethnographic picturesque. Writing in the popular journal *Photo Era*, published in Boston, in October 1914, photographer Allen Churchill recommended the "characters" of "the foreign settlements" of cities—"pedlers, mendicants, the children of the streets"—as "the most prolific and interesting" subject for the photographer after Jacob Riis, who "would like to know how the other half lives."[29] Naturally, New York's Lower East Side, where "one may roam about for hours . . . without hearing a word of English spoken," is the ur-site for such imaging. Churchill recommends a portable, inconspicuous 3¼ x 4¼ folding camera (precisely Strand's own choice) as the optimal equipment for "catching" subjects "unawares," thus ensuring "that unconsciousness that constitutes the charm of the picture."[30] In the same month, in the rival publication *Photographic Times*, William S. Davis likewise extols "The Pictorial Possibilities of New York" and similarly recommends the 3¼ x 4¼ folding plate camera as the most convenient tool for making "street views downtown," enabling the user to capture the picturesque aspects of that dense, heterogeneous space while remaining "sufficiently out of the crowd."[31]

As these and other accounts of the era suggest, by the time Strand set out to make his street portraits, immigrant and migrant, ethnic, working-class, not-yet-assimilated downtown was already a preferred terrain for popular photographic practice and self-instruction.[32] In fact, pictorial and "esthetic" imaging on that terrain in "the age of pictures," the Kodak, and the ten-cent photo magazine was so common that Strand found the attempt to make images by stealth there "quite nerve-racking."[33] As he later noted, rough-and-tumble denizens of downtown sites associated with poverty and vice were so accustomed to the presence of documentary, amateur, and reform-minded cameras that they were highly likely to notice "that you were up to something not quite straight."[34] This turned out to be the case in spite of the technical innovation that made Strand's street portrait project—the project of capture or arrest unaltered by the subject's awareness of that act—plausible from his perspective: the false or blind lens he fashioned and added to his camera, attached with packing tape, to allow for misdirection. (The false lens screwed to the side of the camera's barrel made it appear that Strand was shooting head-on, while the real, extended lens, concealed beneath his arm, was capturing subjects at ninety degrees to his viewfinder.) Strand recalled years after producing it that his first

FIGURE 3.7. Paul Strand, *Portrait, Five Points Square*, 1916. ©Aperture Foundation, Paul Strand Archive.

street portrait, of "an Italian" he shot near Chatham Square, was a rank failure because "two toughies watching me" accosted him for "photographing out of the side of the camera."[35] Chased or intimidated away, he relocated nearby in the square and made "the photograph of the old man with the strange eyes."[36] Thus chastened by knowing subjects of the very social and photographic history he sought to engage, what did Strand's street imaging actually accomplish or make new?

Consider in these terms the compensatory image of the old man with the "strange eyes" (figure 3.7). Perhaps what made it revelatory was the subject's air of melancholy, intensified by the force of a gaze at once starkly frontal yet unfocused on our own. Art historians have emphasized the technical choices at the back of this effect. Maria Morris Hambourg notes that

for these street portraits, Strand chose a lens stop (f/22) that produced not a razor-sharp image but "a moderately sharp one with just a hint" of "atmosphere"; lessening "the specificity of the subject," she asserts, he "made room for a remarkable, universal dimension."[37] For viewers in context, however, the "atmosphere" in question would have registered quite differently. Titled *Portrait, Five Points Square*, or alternatively *Man, Five Points Square*, the image staked Strand's claim on an all-too-familiar social territory and on the human types who had so durably populated it in the city's image repertoire. Radically unlike the subjects (or victims) of Riis's flash-blitz tenement imaging, distinct from the subjects of Lewis Hine's sympathetic concern, Strand's old man with the strange eyes can make room for a labile existential uncertainty—continuous with the viewer's own anxiety about belonging to modern times—precisely because he inhabits such socially suggestive terrain. What Strand sought in suppressing the visible markers, the sociologically specific atmosphere, of haunts downtown was precisely the effect he found in Wall Street and magnified in *Wall Street*: an absence of signs, which allowed for re-engagement with the iconography of modern times and with the process of its animation in everyday visual and social experience.

On this logic, both postpictorialist atmosphere and a predication on urban types were critical to Strand's new work. Commentary now and then, including Strand's own, has often identified his urban street subjects by ethnic type. An untitled street portrait of two men in intimate conversation needs only the luxuriant beards and *peyes* of its subjects, and perhaps their stiff Homburg hats, to mark them as Jews and thus to function as indexes of an atmosphere that need not be visualized in detail (figure 3.8). But in general, in Strand's street portraits, phenotype turns out to be remarkably resistant to view, let alone confident social knowledge. Which, for example, is "the Italian" of Strand's initial venture—the dark-eyed, heavily mustachioed man with a well-kept bowler hat and walking stick? Or the grizzled, unshaven figure of poverty whose clothes are split at their edges and shiny with prolonged wear? Here we might recall the trouble brooked by Strand's first photography teacher, photo reformer Lewis Hine, as he attempted to classify "racial" subjects of his sympathetic portraits made at Ellis Island; Hine ultimately lost a lawsuit over an image he took of a different "Italian," an Italian American youth, titled *The Toughest Kid on the Block*, whose mother complained that he was literally an altar boy.[38] Even Strand's self-evident Irish washerwoman—reddened face, coarse skin, blowsy attire

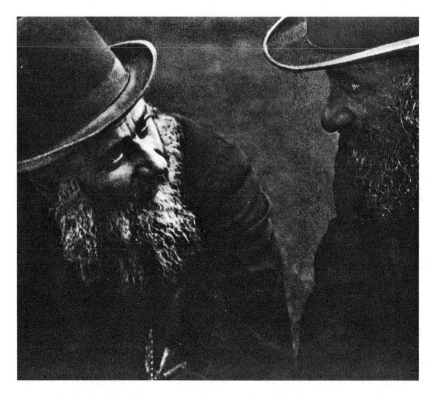

FIGURE 3.8. Paul Strand, *Conversation*, 1916. ©Aperture Foundation, Paul Strand Archive.

and all (figure 3.9)—was too unfixed to be captured in a single shot; Strand produced and exhibited an alternative portrait in which the same woman's frontal gaze and firmly pursed mouth combine with clarity of focus to create a far less settled image. Viewed in tandem, the two portraits of the woman induce a sensation of shifting contexts or assumptions. In this effect, they suggest the logic of Strand's street portraits at large. Rejecting visible markers of material location for a swirl of downtown atmosphere—ethnic "looks," illegible signage, the barely visible features of a tenement façade— his images trade on the power of the city's iconic spaces to heighten a sense of oscillation between image and transcription, type and irreducible human subject, urban documentation and aesthetic expression.

With this landmark body of street portraits, Strand shaped photographic modernism by exploiting the power of downtown settings and the associated

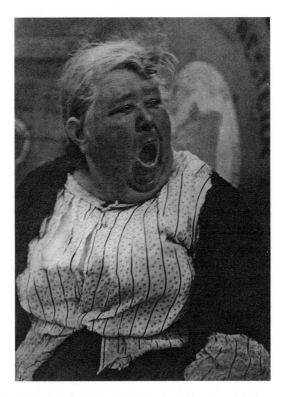

FIGURE 3.9. Paul Strand, *Portrait, New York (Yawning Woman)*, 1916. ©Aperture Foundation, Paul Strand Archive.

ethnic types so charged, still, in 1916, that they needed not be visible in order to signify iconographically. The resulting images were judged "indispensable" by observers of photographic art then and scholars of visual modernism since because they repurposed the agency of the camera, annexing for its activities the broader humanism proper to fine art (the "universal dimension" of Hambourg's accounting). They did so by occupying the ur-space of journalistic and documentary imaging: walking its beat, training a new kind of gaze on its favored subjects. That gaze was committed not to social management or charitable reform or even the mode of the picturesque but to recording the intensities of lived experience for city-dwellers whose assignment to familiar social types had rendered that experience invisible. In Strand's street portraits, the durable icons of the ghetto and downtown street—the Italian rag picker, the Irish washerwoman, the patriarchal Jew—are both invoked and

partially unsettled. This double gesture generates a new iconography of the modern city, whose subjects can be disconnected (or liberated, depending on one's disposition) by the camera from the hold of atmosphere or environment and made to signify a universal and defining isolation. Embedded in iconic spaces, Strand's camera work creates an image repertoire of modern subjects lost in space, and a set of analogues—blind windows, strange eyes, blind lenses—for the challenge of seeing them. As I will go on to suggest, Strand's work would have its most important effects belatedly. But it came just in time for self-conscious modern photography, legitimating itself as fine art, to complete its severance from the documentary and hortatory modes that preceded it—and from the downtown spaces of encounter that once, now invisibly, animated that history.

Sometime in the fall of 1928, Walker Evans—recently returned from a year-long sojourn in Paris, still in search of a medium for protest against America's naïve "right-thinking and optimism"—took a break from his day job in the Map Division of the New York Public Library to leaf through image files in the library's eclectic Picture Collection.[39] There, in a folder containing photographs that had originally appeared in Alfred Stieglitz's storied journal *Camera Work*, the twenty-five-year-old Evans found an image that struck him like a thunderbolt. Removed from a copy of the final number of *Camera Work*, it was a sumptuous, exhibition-ready photogravure of Paul Strand's 1916 street portrait of a blind woman (figure 3.10). Like the man with the strange eyes, the Irish washerwoman, the figure who may or may not have been the Italian, and other highlights of Strand's street portrait project, the blind woman had been offered up by Stieglitz in 1917 as a new kind of icon: "brutal," "devoid of any trickery" or "attempt to mystify," nothing less than "a direct expression of today."[40] What might it have meant for Evans—still under the spell of the modernism of the boulevards, still determined to become a writer in the mode of Baudelaire—to have encountered Strand's street image? This was, Evans noted retrospectively, "quite a powerful picture" for him; it sent him out of the Public Library "overstimulated," "charged . . . up" to return to the streets of New York with his own camera, impelled by the certainty that "that's the thing to do."[41] The rest is (art) history. If any single encounter can be said to mark the advent of Evans's self-conscious commitment to photography as an art form rather than a mere "left-hand hobby," Strand's blind woman would be the one.[42] This was, in other words, the image in whose image Evans

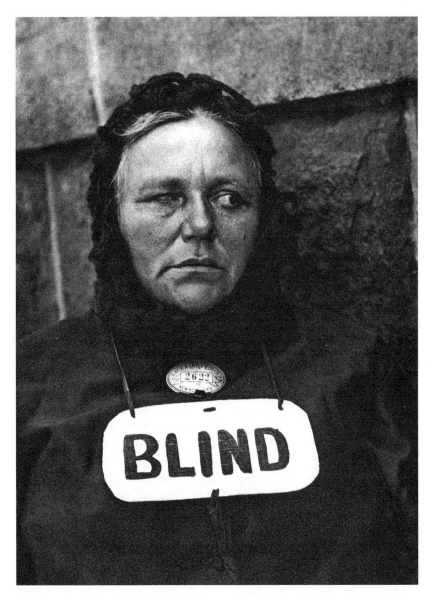

FIGURE 3.10. Paul Strand, *Blind Woman*, *New York,* 1916. ©Aperture Foundation, Paul Strand Archive. Alternate title: *Blind.*

fashioned himself as a photographer, and thereby secured the status of the photograph as the exemplary aesthetic form for modern times.

As it turns out, the "brutal" image in question was not produced on the Lower East Side or in Chatham Square, or even downtown at all. Half a century after its making, Strand told writer Calvin Tomkins that he recalled having found the blind woman near a newsstand on 34th Street.[43] Absent such information, however, viewers and photographers in the interim unselfconsciously assimilated his subject to the iconographic and social territory of the Lower East Side—a process in which they were surely aided by her disability, her status as a licensed peddler, and her vulnerability to the camera's gaze.[44] More broadly, the rhetoric of Strand's portrait encouraged such assimilation. It exemplified the logic of the documentary tradition he redirected as he explored the invisibility of social being—a project embedded, as the preceding chapters suggest, in histories of encounter on the Lower East Side.

At the same time, Strand's portrait also exemplifies a certain self-consciousness about the medium-specificity of camera work as it had historically been pursued to make hard social facts visible. But this too involves a site-specific history of imaging and its legacies. Did Strand employ his own blind eye, the prosthetic false lens that was itself in fact not invisible to his potential subjects, in order to capture this street portrait? Retrospectively, Strand noted that the woman, legitimated as an object of humanist sympathy by her legal status (license to peddle) and her crudely lettered placard, was blind in only one eye.[45] But which eye would that be? The glaucous, hooded one, narrowed against the cold and the cold facts of subsistence? Or the eye wide open and trained hard on some figure or object beyond sight of the camera? What does the blind woman see that we cannot? Whose eye, finally, is the blind one?[46] Strand was at least implicitly interested in the latter question. Although his iconic street portrait has often been published and exhibited under the title *Blind Woman* (this is, too, the title mandated by the licensing agreement under which it appears in this volume), Strand's alternate and probably original title was simply *Blind*—a level gaze at the objectivity of the documentary enterprise, ostensibly seeking some form of blind justice, and at the camera celebrated as a transcriptional device.[47] By drawing on histories of encounter embedded in the historical precincts of poverty and alterity, Strand's *Blind* can itself become a blind, a strategy for raising questions about the limits of social knowledge under the sign of photographic seeing.

This self-consciousness was presumably what inspired Evans. In any case, no photographer in the history of the medium has been accorded more of it than he. But where Strand's work sought to make photography modernist—to make it art—by changing the relationship between lived space and photographic space, between iconic sites and the act of seeing, Evans aimed to tell a new kind of time. After Strand, he fashioned himself as the artist par excellence of time out of joint, framed as the signal injury of modernity, its defining trauma. His fascination with "the temporal bent out of shape," as art historian Eric Rosenberg has put it, governs the pictorial logic of Evans's early work.[48] There, the condition of collapse and damage that had come to define American social life under the Depression becomes both a key subject and an allegory for photography's inability to document the felt experience, the actuality, of present-tense experience (figure 3.11).[49] Well before he had signed on as an information specialist for the photographic arm of the Farm Security Administration (FSA) or produced his iconic images of sharecroppers and tenant farms in the Depression-era South, Evans had already begun to plant temporal dislocation, an insuperable distance of his subjects from the *moment* of their historical being, at the heart of the photographic enterprise. In a review he published in *Hound & Horn* in 1931, Evans laid down the terms for his work to come, celebrating a photographic ethos that rejected "the quaint evocation of the past"—the mood of nostalgia associated with the same soft-focus, sepia-toned, pictorialist predecessors Strand came to resist—in favor of "an open window looking straight down a stack of decades."[50] If, as he argued, the singular logic of photography is "the element of time entering into" it, he was determined in his own work to use the agency of the camera not to document truths of the moment but to communicate—perhaps to produce—a felt sense of distance from it. Writing retrospectively, and in the third person, about his early work, he insisted that "Evans was, and is, interested in what any present time will look like as the past." This, Evans argued, was the only appropriate historical imagination for modern times. Making visible the condition of dislocation, of being lost in time, was "exactly suit[ed]" to the troubled interwar state, the depredations of capitalism on a global scale, and the American "state of mind."[51]

Thus repurposing photography's effects, Evans has been said to transcend the limits of documentary practice, and even the ontology of the photographic image itself. But the assignment of such transcendence

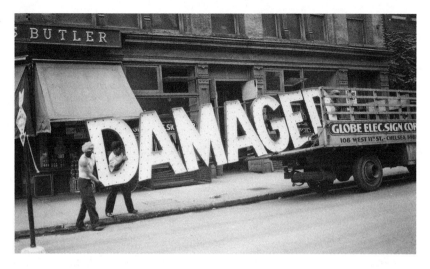

FIGURE 3.11. Walker Evans, *Truck and Sign* [workers loading neon "Damaged" sign into truck, West Eleventh Street, New York City], 1928–1930. Walker Evans Archive, 1994 (1994.241.283). Image copyright © The Metropolitan Museum of Art. Source: Art Resource, NY.

comes at a cost: that of recognizing the *place* of foundational sites of photographic contact and encounter in the evolving history of the medium, and reflecting on their afterlives. Just as Strand's epochal street portraiture depended critically on practices and iconographies embedded in the city's historical downtown, so too did Evans's development of a radically new logic for photography and what he called a "documentary style." To consider how Evans's conceptual brief for an art of temporal displacement suppresses key resources, we might well focus on the widely reproduced image *License Photo Studio* of 1934 (figure 3.12).

This photograph has a special place in Evans's oeuvre and in the career of the art photograph as such. Evans chose it as the inaugural image of his landmark 1938 monograph *American Photographs*—a project that was itself Evans's bid, Allan Sekula has argued, to "reclaim" his photographs as art (timeless, unbound by the present) from the documentary agency of the Farm Security Administration that had commanded them, often in direct conflict with Evans's aesthetic aims.[52] In an online commentary on *License Photo Studio* for general viewers, the Metropolitan Museum of Art's photo curators note that the image "displays Walker Evans's increasingly assured ability to construct meaning out of the juxtaposition" of apparently unrelated "pictorial elements." The "rebus-like quality" such images

achieve, they suggest, is in some way contingent on Evans's interest in "the decaying quarters of New York [City] during the Depression," in particular the waterfront and the Bowery, but the "battered nobility" he finds there (Evans's phrase) is nonetheless the product of his own distinctive vision.[53] Likewise, Peter Galassi, then chief photographic curator at the Metropolitan Museum of Art, reads *License Photo Studio* as emblematic

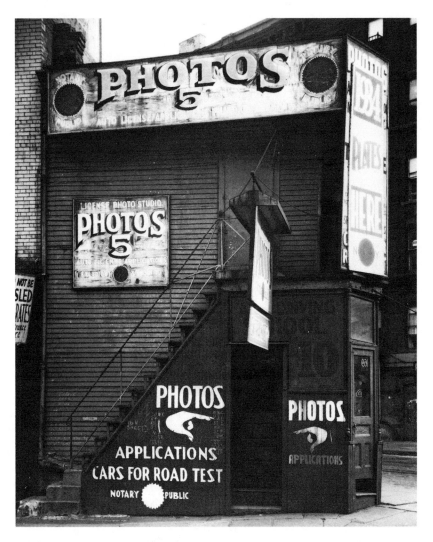

FIGURE 3.12. Walker Evans, *License Photo Studio*, New York, 1934. Image copyright © The Metropolitan Museum of Art. Source: Art Resource, NY.

of Evans's interest in photography "as a form of collecting" objects "that strike his eye as signs of the times." Conjoining vernacular authenticity with the emerging power of professional advertising, such signage confronts us with the entanglement of sharply divergent practices and temporal modes. It becomes a favored subject for Evans precisely because it enables him to announce his "equanimity" in the face of relentless commerce and the depredations of progress and historical change—"his disinclination," as Galassi puts it, "either to applaud" them or "to pretend [that they do] not exist."[54]

These strong readings echo the tenor of received commentary since the initial publication of *American Photographs*. More to the point, they follow Evans's lead in suppressing both the importance to this representative image of the site he documents and the power of that site itself to function as a time machine, a very window looking down a stack of decades—in other words, to register conditions of experience itself, of historical being, loss, and change. *License Photo Studio* was shot in Baxter Street, a space, like Strand's Chatham Square, squarely at the intersection of familiar iconic territories in the city's ghetto-and-tenement, migrant-and-transient downtown. Four blocks west of Evans's favored haunt, the Bowery, Baxter Street was not only one of the oldest thoroughfares in Manhattan (it was laid out soon after 1664, when New Amsterdam became New York); it was the historical epicenter of the slum and tenement problem. Its densely concentrated courtyards and rookeries, with such colorful names as Bandit's Roost, Bottle Alley, and Murderer's Alley, were filled with ramshackle hovels and "Alpine ranges" of trash heaps.[55] Jacob Riis, who successfully campaigned in the 1870s and 1880s to raze the site, called it "the foul core of New York's slums" and made its horrors central to the argument and iconography of *How the Other Half Lives*, as in the dramatically named image *Dens of Death* (figure 3.13).

Riis's, however, was only one in a long line of outraged screeds.[56] By the mid-nineteenth century, Baxter Street was infamous as the home of the first known opium den in New York as well as the stirrings of a nascent Jewish garment district. Thirty years before that, outraged citizens were already calling it "the most dangerous place in our city."[57] By 1934, Baxter Street and its environs—teeming hovels, noxious courtyards, basement dens of black-and-tan prostitution and drink—had been reformed, rehabilitated, and repurposed within an inch of their collective life. Like other representative spaces of poverty and failed modernity in downtown New York, however, the site bore the impress of its past and ongoing social history.

FIGURE 3.13. Jacob Riis, *Dens of Death*, 1872. Jacob A. (Jacob August) Riis (1849–1914) / Museum of the City of New York. 90.13.4.35.

How does that history figure, or fail to figure, in Evans's work? I argue that it not only haunts but enables Evans's registration of trauma and his implicit argument about the limits of photography as trauma's representational technology. In *License Photo Studio*, a profound immobility of experience is annexed from the iconic Lower East Side and rendered as the effect of self-conscious documentation—more specifically, of an artistic practice that insists on the difference between nostalgia and an unflinching look at the present as the past-to-come. But where does the iconography of downtown (static, outside social time, arrested in an unassimilated past) leave off and the look that marks this image as the oeuvre of Walker Evans begin?

Even the physical structure that is Evans's subject suggests a porous boundary. Taking account, we note its relatively small scale—a modest two stories—and its rickety external staircase and irregular footprint, registered by Evans's uncharacteristic deviation from frontality. These built features suggest the structure's probable earlier life as a jerry-rigged living space

or outbuilding, near kin to the insidiously "rotten structures" (Riis again), the dens of death, thought to have produced downtown subjects unfit for meaningful labor, citizenship, or assimilation to modernity.[58] The relative nearness of Evans's camera evokes that history, as well as the history of documentary photography itself. Although a brick structure abutting the studio can be seen on the left side of the image, and the hint of another taller building appears along its top edge, Evans's framing cuts the site off from its social context, rendering it visually analogous to the clapboard houses, rural churches, and small-town general stores that would soon feature so prominently in his FSA photographs (figure 3.14). Thus marooned, the photo studio becomes another exemplary subject for his camera's power to arrest the living present as past—not to register trauma or its unspeakability, but in effect to create them.

The logic of this transformation becomes clearer when we consider the most striking feature of *License Photo Studio*, the welter of messages affixed to the modest structure: "Photos 5c," "Photos," "Applications Cars for Road Test," "Photos," "Notary Public" (not to mention the partial message on the left side of the image, which appears to warn: "Do Not Be Misled"). These callouts are interlaced with pointing hands and notary seals and the hand-chalked graffito "Come up and see me sometime." Following Galassi and the curators of the Metropolitan Museum of Art, we might say that the subject of this image is the contest of expressive registers—vernacular versus commercial—and the mixed temporalities associated with them— organic or lived and premodern versus machine-driven and progressive. But as the work of Abraham Cahan might condition us to notice, assigning self-consciousness about the effects of such mixed messages and time frames primarily to Evans's camera, as a distinctive product of his aesthetic, is misleading. Since at least the last decade of the nineteenth century, writers emerging within the immigrant community on the Lower East Side had begun describing just this phenomenon as definitive of its social landscape. To move through the iconic streets of the ghetto and tenement district was inevitably, they asserted, to engage in just such acts of city reading across a welter of Old World and New World signs, of mother tongues and newly acquired ones, of preindustrial and decisively modern vernaculars. For citizens of the Lower East Side, making themselves at home in shifting linguistic contexts and temporal frames, apprehending the social landscape meant negotiating difference made visible as a welter of competing signs.

FIGURE 3.14. Walker Evans, *Negro Church, South Carolina*, 1936. Library of Congress, Farm Security Administration—Office of War Information Photograph Collection, Prints and Photographs Division LC-USF342-T01-008054-A.

Thus reading, translating, seeing, the protagonists of immigrant fictions resist precisely the state of traumatic arrest that Evans's camera anticipates from iconographies of the city's historical downtown, finds in its "battered" precincts, and assigns to American modernity at large. In this sense, they are endowed with a temporal energy that Evans's modernism

works to suppress. Arrested between temporal registers, hemmed in by signs of impending change, Evans's subjects—damaged if transfixed—can only be powerless to respond meaningfully to it. Already Evans has achieved the program he will later perfect in his most storied images, employing the temporality of arrest to register the defining trauma of modernity: the loss of experience as such. This impoverishment is made visible by a photographic practice that revisits the haunts of iconic poverty only to drain them of their historicity. It can in turn make visible the logic of other responses to and from the ghetto that are haunted not just by poverty, but by the relative poverty of techniques for representing it.

Chapter 4

Looking Back

Henry Roth, Ben Shahn, and the Interwar Ghetto

Even without reference to the aims of photographic modernism, Walker Evans's images of the derelict precincts of downtown New York communicate a profound sense of emptiness, psychic and material. Human subjects rarely appear. Signage resonates with the force of the relic, the trace of some vanished habitation. Drawn to these sites to develop his understanding of photography as a means of indexing the absence and loss he associated with the implacable forces of capitalism, Evans made failed excess, the leftover and left behind, a hallmark of his aesthetics. To what extent was the emptiness of his images found, or willed into view?

Along these lines, let me consider two contemporaneous images. The first is a photograph of the block of old law East Side tenements along Avenue C north of 13th Street, taken during the mid-1930s by Percy Loomis Sperr (figure 4.1). Honorifically called "the official photographer of New York" by the local press, Speer made some 30,000 images cataloguing the infrastructure of the interwar city.[1] Here, just as in Evans's work, a distinctive emptiness resonates. The windows of the tenement on the left edge of the frame appear to be boarded up from within. The storefront windows of the building at center reveal not the workings of a sweatshop or wares for sale but a disused commercial space. In the vacant lot to the north, exposed girders and a visible gap in infrastructure suggest the recent demolition of the adjacent tenement. Even the fire escapes—colorful sites, in the familiar iconography, for tenement families' laundry, socializing, and movement above crowded streets—show no sign of habitation. Sperr practiced a form of architectural photography, trained on careful transcription of the infrastructure of the built city absent its human users. Even so, his image of the tenements registers not temporary absence but profound abandonment: an infrastructure of density emptied of its life.

FIGURE 4.1. Percy Loomis Sperr, *Avenue C at 13th Street, East side to the Southeast*, 1931–1942. New York Public Library, Irma and Paul Milstein Division of United States history, Local History and Genealogy.

It wasn't only outsiders to the tenement landscape who trained their attention on this striking desolation. Raphael Soyer, the son of an immigrant Jewish family from southern Russia who studied art at the East Side's Cooper Union, made his artistic home in and around Fourteenth Street and remained committed to social realism and the representation of everyday working life, had his first one-man show in 1929; it included a painting titled *East Side Street* (figure 4.2 and plate 3a). Soyer's streetscape adopts the elevated and distant perspective typical of nineteenth-century stereographic views, typically used to emphasize the intense crowding of these sites. All the more notable here, then, are the bare foreground, reminiscent of the iconography of the ghetto as crossroads, and the relative emptiness of the streets. Small groups cluster on the sidewalks, but the mood is one of quietude. Notices along the east–west block offer rooms and lofts to let. A sign above the corner shop advertises "כאָרנער פלאָר" (the transcription into Yiddish of "corner flower," presumably a florist). In the street a series of vehicles is visible, from a vendor wheeling his pushcart in the foreground to a horse-drawn wagon, a trolley car, and automobiles in the distance. Modernity enters recessively into the picture, but it appears disconnected

from the iconic figure of the ghetto street, and indexes not plenitude but a certain absence and diminishment.

Like Evans, Soyer and Sperr and countless other twentieth-century observers and image-makers respond not only—perhaps not mainly—to material transformations in the ghetto and tenement landscape, but to their radical departure from received iconography. The definitive feature of the Lower East Side for nineteenth-century observers, and for the camera work evolving there, had been the density of human inhabitants to what Jacob Riis called "the point of suffocation."[2] (Hence the impact of photographic images of the ghetto, whose dynamite of a tenth of a second made it possible for viewers to confront masses of persons and information that had previously escaped apprehension.) The unprecedented condition of density—overwhelming, threatening, inassimilable—was critical to the emerging image repertoire and the shared understanding of the city and its modernity.

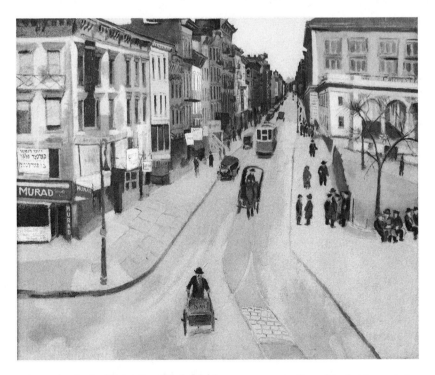

FIGURE 4.2. Raphael Soyer, *East Side Street*, oil on canvas, c. 1929. Reproduced with permission of the estate of Raphael Soyer. Photo credit: Cydney Scott. *See also* Plate 3a.

By the 1930s, however, the teeming ghetto was an afterimage rather than an observable fact, and not just as an effect of the Depression. At the turn of the twentieth century, a full one in eight of all New York City residents still lived in tenement housing below Fourteenth Street. Three decades later, that number had decreased by more than half.[3] Passage of the Johnson-Reed Act in 1924, a triumph for proponents of eugenics and a racially restricted America, effectively shut off entry from Eastern Europe and Southern Europe and banned it outright from Asia. Over the ensuing decade more Jews, Italians, Lithuanians, Poles, Japanese, and Chinese departed from the United States than arrived on its shores.[4] Their exodus intensified an ongoing local one. The building of an infrastructure of flight—the Williamsburg Bridge in 1901, the Manhattan Bridge in 1910–1911—not only encouraged economically empowered immigrants to abandon the Lower East Side for the gilded ghettos of Brooklyn and beyond. It actively necessitated their departure as it leveled their existing dwellings. By the mid-1930s, under the auspices of New Deal public works programs and an unprecedented urban planning regime focused on razing the historical ghetto, the rate of tenement clearance was so accelerated that the entire Lower East Side looked, as one distraught resident put it, "as though a cyclone had struck."[5]

This was the context with which image-makers of the 1930s engaged. Returning to a historical ghetto and tenement landscape that no longer comported with its image repertoire, they exploited the paradox of absence and emptiness in sites still imagined and associated with overwhelming density. What has been described as the virtual "evacuation" of downtown Manhattan, begun by the economic failures of the Depression and intensified by the city's growth under master builder Robert Moses, provided a stage setting for Evans's unflinching documentary style, predicated on stasis and immobility.[6] It also generated intense interest in the historical ghetto as a resource for staking claims on America's soaring urban modernity. Grandiose plans for the rebuilding of the tenements popped up in venues ranging from settlement house publications to the *Architectural Record*, which published Frank Lloyd Wright's design for a tenement project (figure 4.3), and the Museum of Modern Art, which exhibited plans for a futuristic renovation of the Chrystie–Forsyth corridor (figure 4.4). If Evans's work extracted obsolescence and temporal stasis from downtown, the agents of urban modernism seized on its emptiness as a resource for visualizing a soaring future, liberated from the drag of poverty and inassimilability and

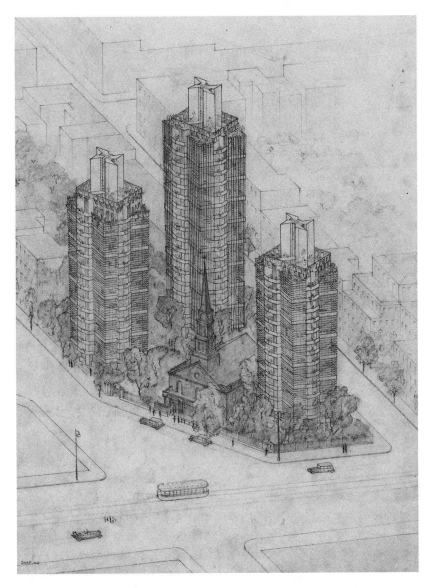

FIGURE 4.3. Frank Lloyd Wright, St. Mark's-in-the-Bouwerie Towers project, New York City, aerial perspective, ca. 1927–1931. © 2018 Frank Lloyd Wright Foundation. All rights reserved. Licensed by Artists Rights Society.

FIGURE 4.4. The proposed Chrystie-Forsyth Parkway, from *The Regional Plan of New York and Its Environs*, 1930. Courtesy of The Skyscraper Museum of New York.

vice. Once again, in a new social context, the Lower East Side enabled multiple ways of looking back and ahead, of telling modern time.

For inhabitants and legatees of the tenement landscape, the Lower East Side of the 1930s occasioned a distinctive kind of meditation on historical being and time. For well before the decimation of European Jews and their culture had transformed the Lower East Side into what Hasia Diner has called a "sacred space" for Jewish Americans, it became a critical site for experiments with looking back, meditating on the conditions of social transformation and on the work of memory.[7] For its citizens, the interwar tenement landscape lent itself to speculation on the defining paradoxes of their own assimilation to the American modernity they were shaping: plenitude and emptiness, newness and obsolescence, stasis and mobility. In this sense, the Lower East Side as a site and photographic practice as a mode of sight became analogues and mutually mediating. Each conduced to exploration of what Evans called the "actual experiments in time, actual experiments in space" that "exactly suit a post war"—and post-assimilation—"state of mind."[8]

In what follows, I want to consider the effects of these mutual mediations with respect to the work of two figures central to accounts of twentieth-century Jewish American culture. The first, Henry Roth, wrote the 1934 immigrant coming-of-age story that Alfred Kazin called "the most profound novel of Jewish life that I have ever read by an American."[9] Published in 1934, *Call It Sleep* revisits the historical tenements at the moment of their most intense crowding and transformative energy, precisely so as to explore tensions between absence and presence, mobility and arrest, as the condition of latter-day self-invention and of the modernist aesthetics appropriate to it. Although critics have emphasized the aural and oral dimensions of the novel, this exploration turns on Roth's engagement with modes of visual experience inflected by the visual technology closely associated, by the mid-1930s, with apprehension of the ghetto: photography. A photographic temporality mediates Roth's return to the Lower East Side and his fictive account of it, just as the space of the historical tenements mediates the temporal registers his narrative creates. Within that dynamic, Roth registers the experience of modern subjects negotiating transformation and loss as the condition of belonging to contemporary America.

Notably, the temporal displacement of *Call It Sleep*, looking back from the 1930s to the heyday of the ghetto, was reenacted by its reception. Roth's publisher folded soon after the novel came out, and it went out of

print until a revival in the 1960s. But the original publication resonated profoundly with another first-generation Yiddish-speaking son of tenement culture, the artist Ben Shahn, who called it "a resumé of my own life and the impressions made on me here."[10] A studio mate of Walker Evans known for his commitment to social realism (he would later be targeted on that account by the House Un-American Activities Committee), Shahn engaged with the imagery of the historical ghetto to rethink photography's agency as a mode of looking back, accounting for the promises and failures of the New World, the New Deal, and modernism's own commitment to making it new. Probing synergies between the state of photographic arrest and the stasis associated with the emptying ghetto, Shahn pictured the latter-day tenement-dwellers with whom he shared a social history as exemplary subjects of modernity and its uneven, fractured times. In so doing, Shahn repurposed the documentary thrust of photography—quite differently from Evans—at a critical moment in the cultural life of that medium. Understanding his work alongside Roth's, and both as shared responses to the afterimage of the ghetto's density and the experience of its emptying, we can better understand the mutual mediation in interwar America of camera work, Jewish American memory, and the site of their most generative encounters.

At the opening of Book II of *Call It Sleep*, set in 1907, six-year-old David Schearl and his family have made a reverse migration, moving from their first American home in the relative wilderness of Brownsville to a tenement on the East Side, at 9th Street and Avenue D. This change of address occasions a signal transformation in the young protagonist, who intuits that this new kind of urban space, "as different from Brownsville as turmoil from quiet," has created a new human sensorium; in this landscape, "it wasn't the sun that swamped one as one left the doorway, it was sound—an avalanche of sound."[11] From the outset, the Lower East Side confronts David as a soundscape, an unmelodious thrash of voices and noises that express the distinctive historical realities, vernaculars, and mixed temporality of that space, where Old World practices and New World energies jostle, chorus, and contend.

Yet for all of the novel's bravura insistence on sound, both as a feature of its protagonist's everyday life and as an agency for Roth's multilingual aesthetic, *Call It Sleep* is also and equally marked by an insistence on visual experience and the power of the visual. Book II, with which our view of the

Schearls' life on the Lower East Side in 1911 opens, is titled "The Picture," and it begins by emphasizing the profound differences, from David's perspective, between his previous environment and this (new) New World. In Brownsville, David's earliest imaginative life is dominated by the terrifying specter of his tenement's cellar. That dark space below ground encompasses a "terrible revelation" of mortality that haunts him, as well as the brutality of his own Oedipal family life, charged with intergenerational friction in the "Land where our fodders died" (69, 62). Hiding in the cellar, in a spasm of self-punishment, David invests that space with oppressive symbolic force:

> Darkness all about him now, entire and fathomless night. No single ray threaded it, no flake of light drifted through. From the impenetrable depths below, the dull marshy stench of surreptitious decay uncurled against his nostrils . . . It was horrible, the dark. The rats lived there, the hordes of nightmare, the wobbly faces, the crawling and misshapen things. (92)

In stark contrast to this underworld, the apartment the Schearls occupy in "The Picture" is on the top floor of their Lower East Side tenement, and it features "a frosted skylight over the roofstair housing that diffused a cloudy yellow glow at morning and a soft grey haze at afternoon" (144). The space there created, in vivid contrast to "the tumult" of the street and "the lower, shadowier stairs" by the hallway toilets in which tenement-dwellers hum and groan, partakes for David of the sacred (144). Even the unused stairs that lead further upward to the roof, unlike the "common" ones below that have been "blackened beyond washing" by "ground-in dirt," have "a pearliness mingled with their grey"—"They were inviolable those stairs, guarding the light and the silence" (144). The elevated space he finds, or imaginatively creates, thus counters David's terrifying encounter with the unfathomable effects of his own being in time: "The dark. In the dark earth. Eternal years" (69). David's imaging of this space—luminous, still, auratic—suggests his obsession with the achievement of enlightenment, that which makes possible clarity of apprehension, the ability to make imaginative use of his experience at the moment of naming it. His tenement haven is in effect a *camera* (from the Latin for chamber): a space removed from the world that enables the production both of knowledge, in the form of images, and of insight into the world's temporal flux, loss, and change.

Roth's framing of David's space at the top of the stairs anticipates the influential framing of photography and its phenomenology in another

bravura representation of modernist subjectivity, which is also, like David's, a quest to return to maternal plenitude: Roland Barthes's *Camera Lucida* (in the original French, *La Chambre Claire*, "the light room"). Through the agency of the chamber of light that is the camera, Barthes argues, the most urgent paradoxes of temporality, stasis, and change animate the viewer and are themselves animated. In the photographic image, this animation takes the form of a distinctive shock—a desire, a wounding, a "lacerating emphasis"—through which subjects fully and uniquely experience their own being in time.[12] For Barthes, the camera functions most profoundly as a special kind of time machine, enabling "a kind of second sight which seems to bear me forward to a utopian time, or to carry me back to somewhere in myself."[13] Inhabiting the *camera lucida*, the *chambre claire*, subjects of photography's powers—in other words, subjects of modernity and its temporal effects—find themselves as they take the measure of their real and impending losses to the movements of time and history.

In the retrospective world of *Call It Sleep*, to inhabit the tenement world self-consciously, in the person of the artist as a young boy, is to be precisely such a subject, one who seeks out the experience of wounding that auratic remnants of the past—like the indexical trace of the photograph—inflict. Indeed, David has a camera, a tiny chamber, of his own in which he carefully preserves selected "odds and ends he found in the street" (35), artifacts that enable his encounter with the realities of loss and transformation:

> His mother called them his gems and often asked him why he liked things that were worn and old. It would have been hard to tell her. But there was something about the way in which the link of a chain was worn or the thread on a bolt or a castor-wheel that gave him a vague feeling of pain when he ran his fingers over them. They were like worn shoe-soles or very thin dimes. You never saw them wear, you only knew they were worn, obscurely aching. (35–36)

In his haptic pursuit of this obscure ache, David intuitively aims to work through the key challenge that defines his entry into multiple languages, hybrid cultural identity, and the immigrant American lifeworld: accounting for the effects of impermanence, loss, and transformation. Nestled at the very bottom of his box of treasures, like Pandora's hope, is a sheaf of "Yesterday's days," leaves carefully torn from old calendars (37). When the boarder Luter asks him, "What do you want with them? To scribble on?" David replies, "No. Just save" (37). Collecting images, indexical fragments,

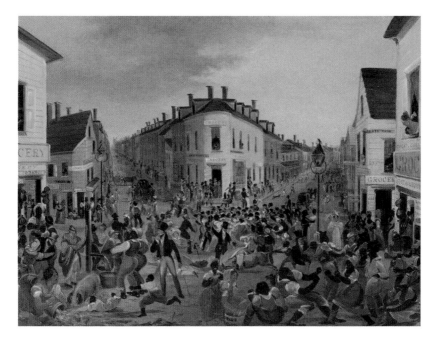

PLATE 1. Unknown Artist [formerly attributed to George Catlin], *The Five Points*, c. 1827. The Metropolitan Museum of Art. Oil on wood panel. Bequest of Mrs. Screven Lorillard (Alice Whitney), from the collection of Mrs. J. Insley Blair, 2016.

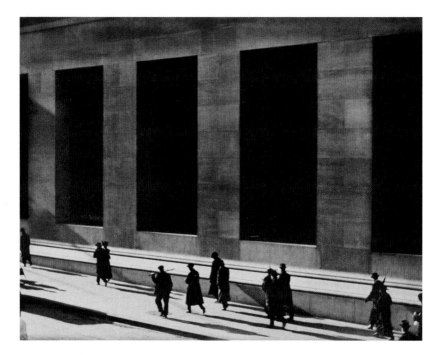

PLATE 2. Paul Strand, *Wall Street, New York*, 1915. © Aperture Foundation, Paul Strand Archive.

A

PLATE 3A.
Raphael Soyer, *East Side
Street*, oil on canvas,
c. 1929. Reproduced with
permission of the estate
of Raphael Soyer. Photo
credit: Cydney Scott.

PLATE 3B.
Henry Roderick Newman,
Fringed Gentian, 1861–1897.
Chromolithograph, Louis
Prang & Co. Collection.
Boston Public Library,
Print Department. Courtesy
of the Trustees of the
Boston Public Library.

B

PLATE 4. Ben Shahn, *Untitled* (Lower East Side, New York City), April 1936. Gelatin silver print: sheet; actual: 20.2 × 25.6 cm. (7 ¹⁵/₁₆ × 10 ¹/₁₆ in.). Image: 18.6 × 24.8 cm. (7 ⁵/₁₆ × 9 ¾ in.). Harvard Art Museums/Fogg Museum. Gift of Bernarda Bryson Shahn, P1970.2831 ©President and Fellows of Harvard College. Photo: Imaging Department © President and Fellows of Harvard College.

Collier's

15¢

August 5, 1950

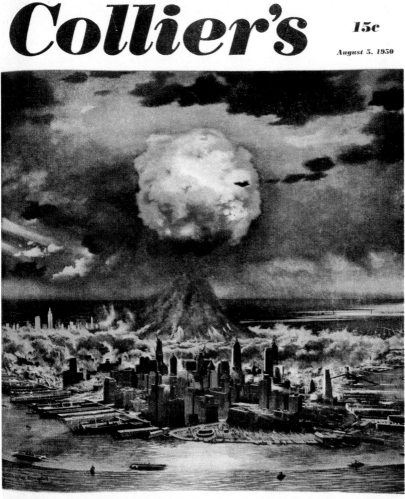

HIROSHIMA, U.S.A.

Can Anything Be Done About It?

PLATE 5. Cover, *Collier's*, August 5, 1950. University of Michigan Library. Photo credit: Austin Thomason.

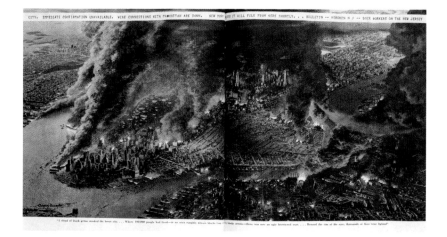

PLATE 6. *Collier's,* August 5, 1950, pages 12–13. University of Michigan Library. Photo credit: Austin Thomason.

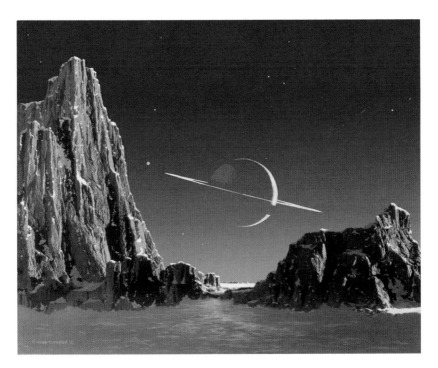

PLATE 7. Chesley Bonestell, *Saturn as Seen from Its Moon Triton*, 1944. © Chesley Bonestell. Reproduced courtesy of Bonestell LLC.

PLATE 8. Screenshot, Jeff Orlowski, *Chasing Ice*. DVD. Submarine Distribution, New York, 2012.

of the passage of time, David means to redeem himself from the terrify-
ing state of being "losted" in a world in which "Everything shifted. Ev-
erything changed" (97, 102)—not least language itself, unmoored from
stable reference to shared or sustained experience. In the heightened pres-
ent of David's stream of consciousness, the problem of time is always at
hand, and it is always "Time to look back" (94).

So far, I have argued two things. David's subjectivity is not just artis-
tic or Joycean or modernist, as readings of *Call It Sleep* have long rightly
claimed, but essentially photographic: in other words, founded in the need
to make sense of losses wrought by the experience of arrested or fractured
temporality and in heightened responsiveness to its material traces. And
the space of the real-time Lower East Side, transformed by depopulation,
offers itself as a distinctive backdrop for Roth's account of David's emerg-
ing consciousness, with its keynotes of loss, disconnection, and irrecov-
erable time. Indeed, the tenement landscape writ large—which is to say,
the imaged space of the once-teeming ghetto, inflected by its latter-day
abandonment—functions as a kind of *camera lucida* for Roth and his pro-
tagonist alike. It enables each to seek out and respond, "shock by shock,"
as Irving Howe put it, to the felt condition of inassimilability and arrest
that defines both first-generation social being and the conditions of aes-
thetic engagement.[14]

To read *Call It Sleep* in this way brings into the foreground aspects of
its matter and manner that have long been obscured. Most broadly, it helps
explain why Roth would decide to set the novel, whose perceived auto-
biographical fidelity has been critical to its reception, on the Lower East
Side at all.[15] As Roth himself noted, the lived experience that enters into
his novel decisively belonged not to the historical tenement district but to
the second settlement of Harlem, and the predominantly Irish American
enclave of East 109th Street, to which Roth's family moved in 1914. From
a nostalgic distance, Roth seized on his family's flight from the Lower East
Side as determinative of an ongoing, ever-present "sense of loss": "Con-
tinuity was destroyed when his family moved from snug, orthodox Ninth
Street . . . ; normal continuity was destroyed."[16]

At large, the question of Roth's autobiographical misdirection has been
resolved with reference to evidence of incestuous relationships with his
sister and a cousin.[17] But Roth's profession of discomfort with this act
of narrative displacement, grafting onto an organic and nurturing space
the violence and alienation that defined his life in "Mick Harlem," has

implications beyond the psychosexual. More specifically, his language suggests how useful the Lower East Side of the mid-1930s was for evoking profound temporal rupture and loss.[18] Relocating his narrative in the ghetto, Roth intensifies for his contemporary readers the shock of dissolution and discontinuity that his own earlier departure from it is said to occasion. And he reframes the traumatic experience of lost plenitude that attends the dissolution of the ghetto—which Roth later described as the "saga" of "a whole people melt[ing] away. Language and all"—as the defining aspect of his protagonist's perspective and apprehensions.[19] Finally, *Call It Sleep* is not just a portrait of the artist as a young boy, but an experiment with the Lower East Side as a *camera*: a site and agency for an arresting look back, for critical reflection on what has been lost to a modernity in the making.

I'll return shortly to the presence of the camera and the photograph as such in David's world. First, I want to note that their invocation makes visible an aspect of the novel that has been surprisingly absent for critical readers: its sustained emphasis on looking and the visual as the condition of David's entry into language and temporal being.[20] Throughout the novel, his visual experience is relentlessly shadowed by fear—as when he "shudder[s] at the image" of his father in a murderous rage, hammer in hand (27); or becomes terrified by his own observation of his mother, "the shadow between her breasts, how deep! How far it—No! No! . . . Mustn't! Mustn't!" (64); or freezes as Annie, the upstairs neighbor girl, "play[s] bad," "watching her rigidly, half hypnotized by her fierce, frightened eyes" (54). Again and again, the cost of looking upon the impurity and danger of tenement life, all that he "shouldn't have seen . . . shouldn't have known" (71), is a kind of mythic blindness: "whirling vision" (20), "furtiv[e] sight" (75), the hard-won injunction that "Wherever you look, never believe" (102). The tenement world itself, it seems, is always already a terrifyingly powerful image: the very graven image on which looking is forbidden. Indeed, David's key refrain is the commandment to himself to "Look away," and his most telling gesture is the act of "shut[ting] his eyes" so as to withdraw from the consequences of sight (56).

Such language is itself readily assimilated to the familiar proscription of the graven image. Notably, however, in spite of its Judaically inflected guilt and shame, it becomes increasingly apparent that Roth mobilizes looking so as to explore the dynamics of looking back: the exercise both of memory and of a temporal agency that stakes claims on what (and who) belongs to modernity. Among David's first experiences of his new life is an uptown

FIGURE 4.5. The Metropolitan Museum of Art, Wing A, 1st Floor Room 38. Group of children in the Hall of Casts in 1910. Image copyright © The Metropolitan Museum of Art. Source: Art Resource, NY.

excursion, via the great equalizer, the El, to the Metropolitan Museum of Art with his recently arrived Aunt Bertha, a paradigmatic greenhorn with "the dirt of Austria . . . still under [her] toe-nails" (150). That cultivated destination, where "her loud voice and Yiddish speech" are distinctly out of place (147), seems comically amiss for such a lusty, "raw jade" as she (151). But Bertha enters into the power of visual objects with suggestive intensity. Although she insists that they follow a "knowing" couple through the labyrinthine corridors of the museum—"We must look at things with only one eye," she cautions David (148)—she is repeatedly "struck" by objects in spite of herself, unable to resist a mode of looking whose intensity characterizes her posture as "gawking" (148, 149). Bertha's crudeness and arrest alike appear to comport with the museum's explicit historical project of "cultural diffusion" to the city's lower orders, seeking to promote "shared national values"—while all the while enforcing "an etiquette of appreciation" to "guard against offend[ing]" its genteel patrons.[21] Part of the museum's project, in fact, was to document in a photographic record the proper attentiveness of just such patrons in need of the training in citizenship and social order it provided (figure 4.5). (No wonder Bertha will later opine: "That place wasn't made for leaving" [150)].)

In Roth's narrative tableau, however, the museum's project has unexpected results. Unlike the visibly disciplined figures in its archival record, Bertha chooses her own objects for exuberant homage—specifically, "spectacle[s]" relevant to David's developing apprehension of time and the novel's interest in competing temporalities (149). Even as she vows that she and her nephew "must cleave" to their unknowing guides "like mire on a pig," she is unable to tear herself away from the sight of "an enormous marble figure seated on an equally huge horse, in whose presence her very eyes "bulg[e]": "This is how they looked in the old days," she notes with awe; "gigantic they were, Moses and Abraham and Jacob, and the others in the earth's youth" (149). Halakhically, as the invocation of *treyf* suggests, Bertha's reverence is nothing short of idolatrous. Yet the act of looking at monumental representations of the warriors who have founded the Western culture enshrined here in its temple intensifies her engagement with Judaic identity. In Bertha's untutored gaze, the celebration of Anglo-European cultural legacy writ as national history becomes handmaiden to a contemporary immigrant Jewish self-imagination, animated by religious tradition in a vernacular key. Productively undisciplined, Bertha assimilates the project of American cultural memory to her own needs, rather than the reverse.

This resistant looking has its limits, as is evidenced by the physical toll it takes on Bertha's libidinous sensorium. "A plague on you," she mutters of their unwitting guides; "Haven't you crammed your eyes full yet!" (149). Still, the narrative of her visual adventures is highly suggestive. When Bertha "gawk[s] at the spectacle of a stone wolf suckling two infants"—"a dog with babies! No! It could not have been!" (149)—she embodies the challenge for Roth of looking back on Jewish America as a way of making it new. Roth's "knowing" readers would recognize (as Bertha and David do not) that his aunt has been arrested by a copy of the storied Etruscan bronze sculpture of the mythic founders of Rome, Romulus and Remus, sons of the god of war—and that their lives mirror key episodes of the Hebrew Bible, not least the redemption from infanticide (down to the specter of drowning) of the prophet Moses (figure 4.6).

Such knowing readers might even be aware that the original art object was actually housed in the Capitoline Museum in Rome rather than in the Metropolitan Museum. Appropriating the object to David's experience and territory, Roth not only mobilizes key aspects of the Roman origin story—Oedipal contest; terror of the power of the father; expressive identification

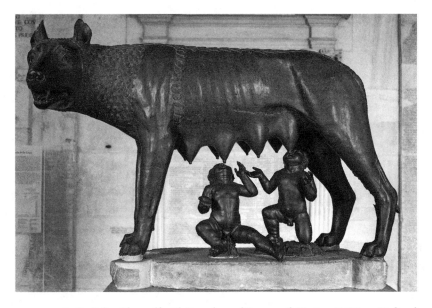

FIGURE 4.6. Capitoline She-wolf with Romulus and Remus, 5th Century B.C.E. or Medieval Age bronze. Capitoline Museum, Rome. Source: Shutterstock.

with a world-historically new kind of metropolis—to tell that of his own protagonist. He also underscores the temporal resistance that leaves Bertha, that "untidy," "rebellious" newcomer, untethered to the customs of the country or the temporal regime of assimilation (146). As the Old World newcomer to America gazes upon a copy of a European visual object made for an American museum aiming to train New World citizens in rituals of cultural power, her exercise of vision embodies paradoxes of origin and imitation, exaltation and impurity, in which Judaic, Jewish, and Anglo-European traditions become coeval, equally implicated and contested. Bertha's wayward, resistant looking is an analogue in the comic mode for Roth's own project: creating a new account of the place in modern times of Jewish America, looking back on the American lifeworld it has altered in its formation.[22]

Back on the Lower East Side, Bertha's irrepressible presence in David's everyday life becomes a vehicle for Roth's closer exploration of that site as a *camera*, a resource for the project of looking back. Bertha's agency as an interlocutor for David's mother Genya, in both the *mame-loshen* of Yiddish and the alien (for David) tongue of Polish, allows for the dramatic unfolding of a partially available conversation that yields the novel's structural

epiphany: knowledge of "the thing he was searching for," the mysterious truth of his mother's hidden past (187). Quite literally, David's search for that knowledge is prompted by his mother's purchase from a pushcart vendor of a cheaply reproduced picture, of just the kind that would have comported, in the turn-of-the-century tenement context, with the cultural offices of the chromolithograph. The reproductive mode that gave its name to *Nation* editor E. L. Godkin's 1874 diatribe against the rise of a pseudo-culture or "chromo-civilization," chromolithography enabled cheap mass reproduction, in color, of original works of art (typically oil paintings). The result of advances in lithographic processes during the 1840s and 1850s, chromos, as they were known, had their heyday at the close of the nine-teenth century, when they were being produced in the millions in the form of genre scenes, landscapes, and still lifes (not to mention fuzzy animals, winsome children, and other staples of mass appeal).[23] An exemplary ob-ject for advocates of genteel and sentimental culture and their diffusion among the masses, chromos made it possible for "just about anyone . . . to live with art," however the latter was conceived; as the National Litho-graphic Association boasted in 1893, "There is no place, high or low, where [chromos] are not now seen, for the campaign of popular education in art has been carried to the very utmost boundaries of ignorance."[24]

Those boundaries certainly encompassed the ghetto and the Lower East Side, where social workers and reformers saw a ripe field for the didactic use of imagery—in particular, images of nature, maternal devotion, and domestic order—in "leading people . . . on to better things."[25] Made avail-able through furniture dealers, religious and fraternal organizations, pro-motional giveaways, public lectures, and street peddling (even the famed Currier and Ives, whose post–Civil War outfit was located downtown on Nassau Street, "printed their goods, loaded them on wagons, and gave their spiel"), affordable chromos "hung everywhere" in the ghetto.[26] As historian Jenna Weissman Joselit notes, their ubiquity was "as much a function of necessity as of taste," as residents of the tenement sought to conceal in-frastructure fails: cracking plaster, crumbling walls, mildew, and worse.[27] But even in less dilapidated tenements, chromos featured prominently as part of an ethos of consumption, keyed to aspirations to assimilate and so robust, Joselit argues, that it typically produced visual overload and even "domestic disarray."[28]

All the more striking, then, is the resonance of the picture Genya chooses. It appears to be the only ornament in the Schearls' living space,

whose emptiness constitutes the latter's power for David as a *camera* and sanctuary. The very innocuousness of the image—"It was a picture of a small patch of ground full of tall green stalks, at the foot of which, tiny blue flowers grew" (172)—makes it strangely unequal to his mother's affect about it, "so animated, so gay" (172). Notably, Genya's picture recalls one of the three chromolithographs specifically targeted by domestic ideologues Catherine Beecher and Harriet Beecher Stowe in their popular guide to domestic order, *The American Woman's Home* (1869), which remained influential through the latter decades of the nineteenth century. Noting that "the great value of pictures for the home would be, after all, in their sentiment," they named the widely reproduced "Blue Fringed Gentians"—described by its production house as a "careful and faithful representatio[n] of vegetable life"—as an exemplary object for "train[ing]" children and other less developed subjects "to correctness of taste and refinement of thought" (figure 4.7 and plate 3b). Genya's cornflowers seem to derive from other representational traditions—landscape painting, in particular—and they are of course botanically unrelated to the gentians that figure in the Beechers' exemplar, being native to Europe rather than the New World. But the real contrast lies in Genya's relationship to her chosen image, which, like Bertha's to the objects on display in the museum, confounds the historical practices of visual expression and display that it evokes. If Genya's picture serves any kind of training, it conduces not to the nostalgia that domestic and reform discipline favored in Americans in the making, but to a far more robust kind of memory and temporal agency.[29]

That effect is most dramatic in David's response to his mother's picture. Again and again, his eyes are drawn to the image, at which he can "only stare" as he tries to fathom "why it had followed him all afternoon, why it had tugged at the mind from the ambush of the mind" (188). By the conclusion of "The Picture," the training in apprehension it provides has profoundly altered his ability to "remember" and to "know" (173). Paradoxically, its effects are most pronounced in the novel's paradigmatic scene of linguistic mastery: the moment in which Genya "seemed to beckon her sister to join her in the realm of another speech"—Polish, "that alien, aggravating tongue that David could never fathom"—so as to confess her secret past (195). Phrase by phrase, fragment by fragment, the story unfolds of Genya's relationship with a gentile organist, of his betrayal in marriage to a wealthy gentile, of her parents' fury and her enforced enactment of shame. Throughout, Genya and Bertha lapse from Polish into Yiddish as

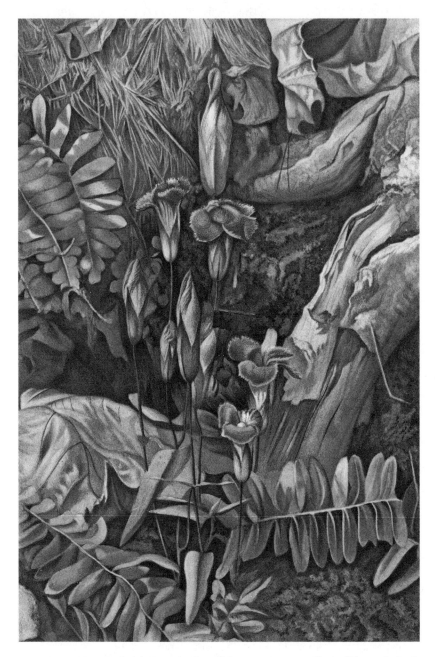

FIGURE 4.7. Henry Roderick Newman, *Fringed Gentian*, 1861–1897. Chromolithograph, Louis Prang & Co. Collection. Boston Public Library, Print Department. Courtesy of the Trustees of the Boston Public Library. *See also* Plate 3b.

David makes himself "forgotten" in the next room (199). Roth's critical readers have emphasized a decisive aural transformation within David, who initially "strive[s] with all his power to split the stubborn scales of speech" (195–96); who "waited impatiently" for intelligibility as "the unknown speech flowed on riftless, opaque" (197); who "writhed inwardly at his own impotence . . . almost paralyzed with the strain" (197)—and who ultimately becomes privy to the narrative he longs to hear ("Easy, he thought in hazy satisfaction"; 207). But these readings have failed to note the crucial role played by visual agency, both in Genya's secret history and in David's encounter with the past it brings into view.

Notably, at the heart of Genya's narrative lies an image behind the image, a picture behind the picture:

> The horror that came into her face was such that it seemed to David not something thought or remembered, but something she beheld this moment, something present in this very room. A shudder ran through him, watching her. "The light before my eyes grew black! Dear God! There on the very top of the pile of coats lay the portrait. Gazing up at me, there on top!"
> "They knew," Aunt Bertha exclaimed.
> "They knew," his mother repeated. (198)

This second, secret picture—not a bland mass reproduction but a cherished photograph, a portrait of the forbidden lover on whom Genya's disgrace turns—is the key to her history, and a metonym for the anodyne image hanging in the Schearls' kitchen. Its invocation in Genya's narrative makes fully "present" to David the depth of her loss and displacement; the "shudder" that overtakes him, an expression of sympathetic wounding, suggests the temporal effects of the *camera*. Accordingly, David's exposure to Genya's history serves only to deepen the mystery of her feeling. "Blue corn flowers?" he queries himself. "Likes them! . . . Gee! Look at it [the picture] later!" (203–4). What remains unresolved, and wounding, is the question of what Genya's display of the reproduced picture memorializes: betrayal by her lover; a lost future; the futility of all romantic desire; the solace of nature or its representation. In any case, David has been schooled in the power of images to animate an understanding wrought by the experience of lost time and of riven temporalities.

With this training in images comes the understanding that his newfound relation to his mother's past is vulnerable, in need of protection

and concealment: "They would see him," he thinks. "They would know he knew. They mustn't" (205). To ward off that possibility in the aftermath of Genya's confession, David seeks another visual object he can produce for her benefit in order to account for his continuing presence in the tenement. Trying various possibilities—the pictorialist front-room view of the East River and smoke stacks, against which "the cold, white smoke of an unseen tugboat frayed out and drifted" (205); the vivid streetscape of the avenue, with its passersby and horse carts, their breath visible in the frosty air—his eye lights on the serendipity of two boys burning a celluloid doll near the car tracks that will soon beckon David himself much nearer. "Squint[ing] to see better," he seizes on this view as "his excuse, the fascinating thing that had kept him there all this time" (206). He thus boldly calls his mother to the window, promising, "I'll show you a trick" (206). Just as Genya's story reveals something of the mystery of her being, the burning of the dolls reveals the "mejick" of their mysterious movement: a hidden piece of iron within that "makes [the doll] stand up when you push it over" (206, 207). The real trick—which is what Genya as a speaker of Yiddish hears David to be promising: a "*drick*," or kick—is the deception that allows him to remain invisible, and thus present to his mother's hidden past.

His engagement with that history, and with the photograph behind the picture, marks a distinctive change in David himself. All metamorphosis and transfiguration are now intimately bound up for him with image-making and the management of temporal registers. As the narrative of "The Picture" ends, he promises himself: "Look at it later, when nobody's here . . . Green and blue it's—Sh!" (207). The sibilant injunction to silence, even in the privacy of his unspoken thought, suggests the unspeakable power David accords both the image animated by auratic traces of the past and the apprehension it enables. Thus "The Picture" concludes, with a redirection of the traditional Judaic prohibition against the image into a nascent poetics of ekphrasis: a gesture toward the limits of language in the face of a visual object resonant with the movements of time and transformation.

This mode of image-making defines even the novel's climactic episode, in which David returns to the electrified rail of the trolley—"Where there's light in the crack" (410)—to test its power as the multilingual voices of the immigrant city swirl around him. In this moment, the violence and impoverishment of the world he seeks to redeem assault the reader just as they have terrified and tormented David. The visual character of Roth's multilayered narrative of the rail plays a leading role in that assault. On

these pages of the novel, the unsparing voices of the immigrant city in all its registers—each marked by dashes, unconventional spacing, and onomatopoeia—contend with italicized inset passages of lyric prose that convey David's interior thought.[30] The visible distinction between inner and outer, demotic and poetic, however, only underscores how engulfing is the perspective of the urban immigrant underworld, of the moral and psychic darkness of the cellar. In David's imagination, the *"crack"* in the tracks—both noun and verb, promising cleansing power—must overtake the "gash" that the broad-shouldered, dominating saloon patron O'Toole "don't have to buy" (412). So, too, the *"barbaric power"* that will be, for David, the agency and correlative of his purification is shadowed by the "knock[s]" and "smacks" narrated by world-weary working girls, latter-day sisters of Crane's Maggie who note that "Everybody gets knocked up sometimes" (415). (Likewise, the casual misogyny of saloon dwellers, woofing about "a pretty cunt come walkin' up de street . . . wit' a mean shaft an' a sweet pair o' knockers," overtakes the iconography of Liberty invoked by "the kindly faced American woman: 'And do you know, you can go all the way up inside her for twenty-five cents. For only twenty-five cents, mind you! Every American man, woman and child ought to go up inside her'" [415].)

What David seeks in the face of this pervasive, ghetto-inflected entropy—what we might call its decomposition—is not the "thrilling experience" promised by full assimilation to American ideals, but the experience of a certain kind of photography: literally, "light-writing" (415). Subjecting himself to an electrifying wounding, he aims to transform his own body as a site of arrest, and thus a liberation from the inexorable progression of language and time. In the look of the pages recounting this quest, Roth literalizes the cruel promise of the tenement bullies who earlier coaxed David to insert a sheet of zinc into the electrified car track at Tenth Street: a release of ravishing images—not just "light, unleashed, terrific light," but "all de movies in de woil! An' vawderville too!" (253, 252). (That Roth's self-image as an adolescent was closely bound up with his job preparing reels for screening at a popular vaudeville house, the Fox Theater on 14th Street, is of interest in this connection.)[31] Here at last, on the tracks, David himself becomes the very medium of light-writing. Overwhelmed by *"a siren of light/within him,"* by *"pinions of intolerable light"* (419), he *"de-/scend[s]"* into a space out of time, where every aspect of his history is present simultaneously in the form of images—reflections from *"infinite*

mirrors"—and *"all eternity's caress"* is *"fused and/granted in one instant"* (427, 430). Submitting to the shock of this *"fatal glory"* (419; all italics original), David enacts both the time-honored literary trope of the poet's descent into the underworld and the distinctive power of the photograph as Barthes describes it: to compel us, like Orpheus, "to turn back to look" on what we must lose and "to confront in it the wakening of intractable reality."[32]

For *Call It Sleep* and Roth, in the latter-day context of the emptying tenements, that act is linked with the challenges of assimilative American modernity and its relentless forward motion. When David closes his eyes at the novel's conclusion, that act is no longer motivated by the fear of visual engagement but by "strangest triumph, strangest acquiescence"—his felt sense that "every wink of the eyelids could strike a spark into the cloudy tinder of the dark, kindle out of shadowy corners of the bedroom" a host of sustaining "images" (441). Finally, the stillness implied by the novel's conclusion—"He might as well call it sleep. He shut his eyes" (441)—suggests not only an approximation of death but the auratic arrest of the rooftop stair as David first imagines it, with its "luminous silence, static and embalmed" (144). By the end of *Call It Sleep*, then, the imagined space of the Lower East Side has proven to be a *camera* writ large for Roth and his imagined latter-day readers: a site for the uncanny, generative effects of looking back at the lived realities of assimilation. In the figurative vision—the insight, the "look" (430)—accorded David in the aftermath of his shock, his past is reactivated as a living reality, and the phenomenology of immigrant experience has been reanimated by Roth as the source of consequential images of and for a modernity, both Jewish and American, coming into being. Finally, *Call It Sleep* offers itself as a meditation on the conditions of possibility for a form of insight adequate to the representation of modern experience. The latter, we come to see, requires not a mastery of language alone but a command of the look back, shaped by an emptied field of vision, uneven, disjunctive temporalities, and modes of apprehension that bring them into view.

Near the opening of the final book of *Call It Sleep*, "The Rail," in anticipation of the light-writing in which the novel will climax, David takes the considerable risk of disobeying his father's injunctions to stay on the stoop, far enough to venture to "the new photography shop in the middle of the

block" (269). As he peers into its window, he ponders the mysteries of being and time it creates:

> It was full of pictures, big and small, bridal pictures, the bride and groom standing stiffly apart despite their apparent closeness, their faces frozen in an impending smile; pictures of prize-fighters crouching in sash and tights; pictures of infants . . . And horrible, enlarged pictures of old men and women, colored and acid-clear, the magnified expanse of their brown and sunken cheeks wrinkled the way the wind wrinkles sand. Pictures. Pictures. How did they stretch the big ones out of the little ones? And that bar of glass, that extended across the top of the bow window, where did it get that strange green light that changed the color of everyone's face when one passed it? (270)

That the general effect of this encounter is disturbing—bodies stiffened, faces frozen, the erosion of individual being in the mechanical repetition of conventional poses—hardly undercuts the power of the photograph to arouse in David fundamental questions of being and becoming. What relation do these pictures have to the mental pictures he constantly forms and revises, and which are most faithful to experience? What effects are produced by changes in the scale of the image, and what relationship do serial reproductions have to one another? How do multiple images fill space, and what life do they have over time? And how does light itself— the same light whose action produced these very images, now uncanny in the form of a "strange green" emanation—make and unmake memory and historical knowledge?

By 1912, the moment in which this episode is set, there is nothing "new" about photographic portraiture as a feature of the urban lifeworld, or the uses of photography as a means for Jews, immigrants, aspiring Americans, and other modern subjects to attest to their social status and aspirations. But David's response to the photographer's window suggests something that is distinctly new: the advent, in the 1930s, of an interest in photography and the Lower East Side as linked spaces for critical apprehension of a broadly assimilative modernity. Newly emptied yet haunted by its own histories of density, a launching site for new Americans and the modern lifeworld they were shaping yet still and again an emblem of arrested time, the Lower East Side had a powerful kinship with the camera as a symbolic interwar object and with photography as an interwar cultural practice. It

became a generative territory for certain key photographers of the era who made the Lower East Side a point of departure, a space of meditation, and a proving ground for photographic practice. Exploiting its contemporary untimeliness, they meditated on the possibilities of their emergent medium and on their own identities as Jewish (and modern) Americans. As they did so, they installed the iconic power of that space at the heart of the photographic enterprise in America.

No one explored this synergy more purposively than the visual artist Ben Shahn, for whom the experience of modernity and its riven, uneven temporality was a signature concern. For his development, the Lower East Side served as his "surrogate classroom"; "No sector of Manhattan," he later wrote, "captivated me more."[33] When his family emigrated from Lithuania in 1906 they made the second Jewish settlement of Brownsville home, but Shahn's coming of age as an American and an artist began six years later (the very moment, within *Call It Sleep*, of David's window-gazing). At fourteen, Shahn left school to apprentice at a lithography shop on Beekman Street, at the lower reaches of the historically Jewish Lower East Side. There he acquired a master knowledge of printmaking—his first medium—and developed an abiding sense of himself as a politically progressive artisan-worker. A regular reader of the *Jewish Daily Forward*, identified with emerging cultures of Jewish progressivism (his father was a woodcarver and lifelong socialist), Shahn became an art student at the Lower East Side's Educational Alliance Settlement House, and began his practice as a photographer at May Day parades and demonstrations for emergency relief programs by downtown workers and activists. By 1935, when he signed on as a graphic artist for the Special Skills Division of the FSA's Resettlement Administration, he noted, his "knowledge of the United States" still came "mostly through Union Square": radical culture inflected by immigrant experience shaped both his political commitments and his photographic practice.[34] Wielding the epochal instrument for new modes of seeing, the hand-held Leica, Shahn trained it on a lifeworld being remade by loss of work, livelihoods, population, and folkways. In so doing, he embraced, and in effect reinvented, the Lower East Side as a distinctive site of photographic engagement.

Although he originally took up the camera as a mode of note-taking for his printmaking and graphic work, Shahn's interest in temporality, timeliness, and belonging is evident even in his earliest photographs. Shahn had only one lesson in photographic practice, from his then-studio-mate Walker

FIGURE 4.8. Ben Shahn, *Untitled* (Seward Park, New York City), 1932–1935. Gelatin silver print; image 16.9 × 23.9 cm (6 ⅝ × 9 ⁷⁄₁₆ in.). Harvard Art Museums/Fogg Museum, Gift of Bernarda Bryson Shahn, P1970.2858. © President and Fellows of Harvard College. Photo: Imaging Department © President and Fellows of Harvard College.

Evans. In December 1931, as Evans was departing the city for a photographic voyage to Tahiti, Shahn pressed him for a promised lesson, and Evans gave it in brief: "f9 on the sunny side of the street, f4.5 on the shady side of the street. For a twentieth of a second hold your camera steady." "That was all," Shan noted, and "it was the only lesson I ever had."[35] Paradoxically, it helped Shahn develop a mode of photographic seeing fundamentally opposed to Evans's, one that emphasized not the essential unavailability of the present as fully lived experience, but the critical problem for assimilating Americans of negotiating alternative temporalities and time frames.

For photographic experimentation with this defining challenge, the contemporary Lower East Side, visibly emptied yet imaginatively dense, offered itself as a kind of laboratory, and Shahn took advantage. Consider for example an early image he shot in Seward Park, a site he had frequented as a young laborer, art student, and everyday citizen of New York's downtown (figure 4.8). The first permanent municipally built playground in the United States, Seward Park opened in 1903 on a condemned piece

of property between Essex and Hester Streets that had housed first the Ludlow Street jail and subsequently some of the area's most crowded tenement structures.[36] Shahn's image recalls this social history—in particular, the long-standing iconography of ghetto vice and crime—but does so to focus on contemporary segmentations of social and photographic space.

Shahn's use of the horizontal—a characteristic of his work at large, in decided contrast to photo-modernism's embrace of the vertiginous upward thrust of the skyscraper and other monuments to techno-modernity—emphasizes his choice to shoot through the wrought-iron bars of the park's fence, whose effect of containment is heightened by the chain-link fence of the farther perimeter. In the background, the tenements and street sweeper, the row of trash bins, comport with historical imagery of the ghetto. Here, however, they are notional, calling attention to the essential emptiness of the space. That emptiness is all the more striking in context: Seward Park served as a gathering place for unemployed workers (at the height of the Depression, a full one-third of New York City's labor force, a million in total) seeking day and casual employment.[37] A certain dramaturgical quality; the nearness of Shahn to his foregrounded subjects; the play of their unmet gazes: all emphasize an experiential discontinuity, a temporal gulf that belies the men's physical intimacy, their rhyming headgear and similarly shabby clothing. On site, Shahn mobilizes the emptied landscape of the tenements as a kind of negative space, a blank space around the object of representation that defines it as such for viewers. Absent its iconic density, the landscape of the Lower East Side becomes a context for registering temporal effects at the level of lived experience. Despite their proximity and their shared occupation of the site, the subjects of Shahn's camera appear to embody distinctive, if not disjunctive, experiences of belonging to this moment, to this place in time.

Seward Park becomes, then, a resource for experimenting with the durable afterimage of the ghetto's density, a space for meditation on the experience, in assimilative modernity, of temporal displacement and everyday being-in-time. The invocation of density recurs throughout Shahn's downtown body of work. Consider along these lines the photograph *Untitled* (Sig. Klein Fat Men's Shop, 52 Third Avenue, New York City) (figure 4.9). Opened in 1895 on this site, on the east side of Third Avenue between 10th and 11th streets facing the iconic elevated railway, the eponymous clothier's had long been a cultural landmark by the 1930s (both Berenice Abbott and Weegee shot it and Shahn himself made a number of images there; it had featured

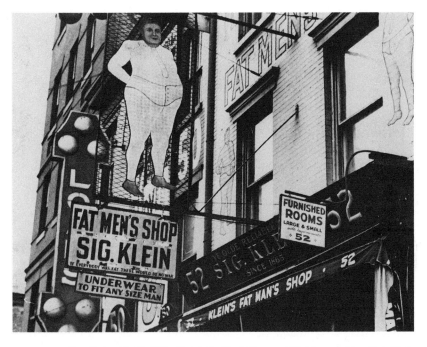

FIGURE 4.9. Ben Shahn, *Untitled* (Sig. Klein's Fat Men's Shop, 52 Third Avenue, New York City), 1935–1936. Gelatin silver print; mount (original mount); 19.6 × 25.2 cm (7 ¹¹⁄₁₆ × 9 ¹⁵⁄₁₆ in.) image: 19 × 24.5 cm (7 ½ × 9 ⅝ in.). Harvard Art Museums/Fogg Museum, Gift of Bernarda Bryson Shahn, P1970.2926. © President and Fellows of Harvard College. Photo: Imaging Department © President and Fellows of Harvard College.

in a *New Yorker* "Talk of the Town" piece in May 1931 that noted, "You can't miss it").[38] Like many of his fellow image-makers, including Evans, and with his early experience as a sign painter on Coney Island, Shahn was keenly interested in the informational density that characterized emerging forms of commercial signage and advertising.[39] Here, that density is heightened by Shahn's deviation from the frontal perspective, and linked associatively to the bodily density of the East Side's new "fat men," the alrightniks and second-generation Jews whose departure has emptied the ghetto, who return to the old neighborhood as a practice of nostalgia, or to clothe their well-fed bodies with the products of a garment industry that was historically the occasion of their rise.[40] (Hence the special force of the insider's joke; "klein" in Yiddish and German means "little," "small," or "slight.")

Shot outside the space of the tenements, Shahn's image nonetheless recalls it, in the historical link between sweatshops and alrightniks,

between the threadbare laborers in Seward Park and Sig. Klein's fat man. (He once described his aesthetic as a painter in a way that tightens that link: "There's a difference in the way a twelve-dollar coat wrinkles from the way a seventy-five dollar coat wrinkles, and that has to be right.")[41] More to the point, these links or threads create an analogy between the camera as an agency for seeing and the newly emptied Lower East Side as a kind of *camera.* The reiterated text we encounter—"Fat Men's Shop," "Fat Men's," "Klein's Fat Man's Shop"—and the ambiguous status of the prominent icon of the fat man—at once a signifier, index, symbol, and sign—suggest that Shahn shares Evans's penchant for meditation on the peculiar ontology of the photograph and its elusive grounds of being. For Shahn, however, the pure products of America are never the outmoded, vestigial artifacts of a vanishing past, seen through a relentlessly objective camera "looking straight down a stack of decades."[42] Rather, it's those who are subject to assimilation who take the real-time measure of this rapidly changing life-world. So, too, the photograph in all its ontological uncertainty shows forth the complex historical being of these inhabitants of a space that no longer comports with its own image repertoire.

Among its commercial promises and entreaties, Sig. Klein dubs itself "Ye olde reliable . . . Since 1865." That fraught date in US history—chosen, it seems, for rhetorical effect—suggests a key aspect of the storefront's appeal for Shahn, the stake of its address to East Side passersby in founding narratives of American modernity and the ongoing dream, failed yet still definitive, of a more perfect union. The past on which America will grow, Klein's signage suggests, is not that of the Anglocentric inheritance gently mocked by its commercial diction, but the alternative past of immigrant and ethnic striving, which produces subjects and citizens fully capable of meeting the challenges of assimilative modernity ("Underwear to fit any size man"; "Furnished rooms large and small"). In the register of commercial fantasy and excess, this is a foundation for a shared future in which historical trauma and rupture have been left decisively behind: "If everybody was fat, there would be no war." Nor does Shahn's framing comport easily with what Hasia Diner describes as the era's animating rhetoric of Jewish American nostalgia, keyed to the foundational biblical narrative in which God comes to "despise" the people of Israel who "grew fat and kicked . . . became fat, grew thick, gorged and sleek" and "forsook God who made" them.[43] Here, rhetorical and pictorial density serve a view of the temporal

density of the Lower East Side, offering itself for competing narratives of the collective past and the American future.

In Shahn's most pointed work, a condition of temporal density displaces the literal density of the iconic ghetto, and it allows him to claim the Lower East Side as a site uniquely conducive to meditation on the riven, uneven experience of the modern. Within his downtown portfolio, a striking number of images are shot so as to create the effect of serial, rather than conventionally multiple, human subjects. This visual logic clearly draws on Shahn's experience in nonphotographic media. By 1931, he had already begun the project that would become the acclaimed series of twenty-three gouache paintings titled *The Passion of Sacco and Vanzetti,* tracing its subjects' trial, sentencing, and execution in visually arresting tableaux. In 1933, he assisted famed Mexican muralist Diego Rivera on *Man at the Crossroads,* the mural designed for Rockefeller Center (and destroyed before its completion because of its celebration of the Soviet state and its pointed representations of capitalist venality and greed).[44] A number of critics have also suggested that Shahn's work owes something of its serial logic to cinema, particularly newsreels, with which Shahn closely engaged as part of his study of urgent social issues.[45] But Shahn's photographic work mobilizes the effects of seriality in a distinctive way, not fully assimilable to the conventions of social realism, documentary, or the mural tradition. It does so by self-consciously mobilizing the effects of the Lower East Side as a camera, palimpsest, and time machine.

For a closer view of those effects, we might consider an image of three dark-clad men standing in what appears to be an otherwise vacant space, in front of an advertisement for women's undergarments (figure 4.10). As if bringing together the effects of his shots of Seward Park and Sig. Klein's, Shahn here makes environmental emptiness—the evidence of lost or vanishing community activity—and textual density coincide. The two men on the right of the image touch; their bodies become virtually indistinguishable. But their gazes and stances, their modes of self-presentation, underscore a felt disjuncture between them. In particular, the men's hats, rhyming objects across the visual field, imply very different temporalities. The man on the right, his heavily lidded eyes almost closed, wears a full beard and a traditional black wool fedora of a kind associated with transplanted Orthodox culture; he might well be a figure of prayer in a sacred Jewish context. The subject in the middle wears a light gray hat,

FIGURE 4.10. Ben Shahn, *Untitled* (Lower East Side, New York City), November 1935–1936. Gelatin silver print; sheet; actual: 20.2 × 25.5 cm. (7 15/16 × 10 1/16 in.); image: 18.1 × 24.7 cm (7 3/8 × 9 3/4 in.). Harvard Art Museums/Fogg Museum, Gift of Bernarda Bryson Shahn, P1907.2904. © President and Fellows of Harvard College. Photo: Imaging Department © President and Fellows of Harvard College.

perhaps also felt or wool but sporting a wide black ribbon. His shaded gaze and closely trimmed beard place him in a different temporal regime, that of an ambiguous secularity and assimilation. The figure at the left of the image, separated from his fellow Lower East Siders by a small gap as well as a posture that breaks the visual rhythm, moves further still along the implied temporal continuum. His jaunty, fashionable, strikingly white panama hat; his clean-shaven chin; the glossy sheen of his neatly knotted tie; the starched precision of his dress collar: all bespeak full assimilation to the order of secular urban modernity. Against the inward gaze of the black hat and the wary gaze of the middleman, his gaze alone asserts a power to examine their shared lifeworld, to judge or consume the novelties it puts on offer, its old and its new articles of faith.

As composed by Shahn, these figures defy the presumption of the arrested development long associated with the iconic ghetto. They also resist

a stance of nostalgia or an arrested gaze back, suggesting instead a multiple, shifting temporality within this space emptied of its past, but made dense with signs in which competing frames of historical reference are simultaneously in play. That Shahn seeks to produce such simultaneity is confirmed by the uncertainty here of the viewer's visual orientation, and what it implies about how to understand the movements of Jewish American and collective history. A native speaker and lifelong reader of Yiddish, Shahn not only made reverse prints of his negatives; he played with such reversals in his transcriptions of his photographs as lithographs and paintings. Within and across media, Shahn experimented with the shifting effects of a left-to-right orientation (as in English-language reading) versus a right-to-left scheme (as in Yiddish and Hebrew texts). Intrinsic to the composition and rhetoric of seriality in this photograph, and elsewhere in his East Side work, is an ambiguity about which of these orientations applies and with what effects. The dominant narrative within postghetto interwar Jewish America, of unimpeded assimilation and access to cultural citizenship, would dictate a triumphalist view, framing the men as examplars in a willed progression from traditional Judaic subjectivity to the figure of the fat man or alrightnik, self-possessed in the secular metropolis.

Notably, however, this framing depends on the viewer's adoption of a "Yiddish" (or Jewish) orientation, a reading across the image from right to left. Furthermore, the visual dynamics resist such easy historicism. They send the viewer's eye back to the most traditional figure, whose inwardness resonates as a meaningful response to the unstable temporality of a modernity fraught with uneven developments. Again ironically, the reader experiences this revisionary relationship to "Old World" Judaism via an English-language (or "American") orientation, moving from left to right. What kind of temporal regime, after all, is being visualized? In what ways does the image move us in time? Finally, the most resonant effect of Shahn's image is its insistence on the Lower East Side as a distinctive site of competing temporalities, a kind of *camera* that invites the uses of the camera as a means for meditating on them.

Shahn's experimentation with photography as an agency belongs both to photo history and to understandings of the Lower East Side as a critical site of engagement with imaging and image repertoires. With respect to photographic practice in the United States, he anticipates the transformation of the subjects of socially conscious image-making as figures of introspection, fugitive historical being, and reverie that would come to define

FIGURE 4.11. Ben Shahn, *Untitled* (Lower East Side, New York City), April 1936. Gelatin silver print: sheet; actual: 20.2 × 25.6 cm. (7 ¹⁵⁄₁₆ × 10 ¹⁄₁₆ in.); image: 18.6 × 24.8 cm. (7 ⁵⁄₁₆ × 9 ¾ in.). Harvard Art Museums/Fogg Museum. Gift of Bernarda Bryson Shahn, P1970.2831. ©President and Fellows of Harvard College. Photo: Imaging Department © President and Fellows of Harvard College. *See also* Plate 4.

postwar street photography and subjective documentary. That the Lower East Side helps make such photographic and social futures imaginable is powerfully evident in an image we might read as exemplary of Shahn's uses of seriality and the play of density and emptiness (figure 4.11 and plate 4). Once again, *Untitled* (Lower East Side, New York City), April 1936, offers viewers a meditation on the paradoxes of a social life experienced in tension with its own received iconography. Here, Shahn shoots outside the storefront of one of the once-ubiquitous kosher butchers whose continuing presence indicated the survival of traditional Judaism (and whose wares figured, for generations of immigrants, both the Yiddish vernacular "fat" and the American chicken-in-every-pot to which they aspired). Shahn's low angle and odd cropping, along with the apparent absence of actual wares, suggests a mood of attenuation in which the logics of Depression and local depopulation coincide.

The total effect, however, is far from nostalgic. Shahn's three subjects (likely caught with his angle viewfinder) pose alternative ways of inhabiting American modernity, and competing photographic aesthetics aligned with them. The figure on the right is partially cut off by Shahn's framing. With his eyes shadowed beneath the bill of his workman's cap, he recalls the mute stolidity of the ghetto subjects of Jacob Riis, arrested by the lightning flash of the social reformer's intrusive, commanding camera and denied the power of a look back. The figure at the left foreground, reduced to his jaunty hat, becomes a mere compositional element; he embodies an instrumental modernity embraced by photographic modernism and Sig. Klein's fat men alike. Mediating their effects is the slightly unfocused figure of the young woman: dreamy, evocative, intensely private. Neither ethnographic certitude nor the ordering powers of aesthetic formalism alone can do justice to the way she inhabits this moment, to her complex look back at the viewer and into the future the camera signifies. With that look, she generates the felt requirement for an alternative way of seeing and of being in time.

That this perspective must be temporally hybrid is confirmed by the sign of the times—legible only from within the lifeworld of the emptying ghetto—that embellishes the darkened storefront. Transliterated into Yiddish orthography, it reads: "*kosher tshicken ma[rket]*." Whose history is reflecting, or reflecting on, whom? Who looks or looks back? To what degree does the experience of the interwar Lower East Side refract American modernity in ways that remain invisible to "native" Americans? Already the young woman looks forward to a photographic future, soon to be exemplified by the likes of Robert Frank, Garry Winogrand, and Diane Arbus, in which psychic distance and temporal multiplicity become key to representing current states of experience, mind, and being. Still moving, in place, with a historicity that exceeds the fixed forms of history, Shahn's arresting figure mirrors the viewer's own, perhaps as yet unacknowledged, condition of unstable belonging to modern times. On the Lower East Side, an emptying landscape dense with the imagination of the past, the photograph can pursue its destiny: to become a distinctive space of encounter, a trial of densities of experience and longing, loss and possibility—in other words, of the modernity it aims to see anew.

Chapter 5

Writers' Blocks

Allen Ginsberg, LeRoi Jones, and the Territory of the Image

In 1957, Allen Ginsberg—by then the acclaimed author of the Beat anthem *Howl* and a veteran of psychiatric treatment, mind-altering drugs, the criminal justice system, and the streets—began to compose a poetic response to the death of his mother, Naomi Ginsberg. That work would eventually become the landmark poem "Kaddish," but its commencement was serially belated. In San Francisco the previous summer, Ginsberg had learned of Naomi's passing back East. From the prow of the Arctic-bound vessel on which he then shipped as a merchant marine, he threw a tributary haiku into the Bering Sea off the coast of Naomi's birthland, Russia. In Paris, at the café Le Select—a heterotopia and shrine of bygone modernist culture "once haunted," he noted, "by Gide and Picasso," Hemingway and Henry Miller—Ginsberg drafted fragmentary lines that would anchor the penultimate section of "Kaddish."[1] But even the context of Beat Paris, with all the storied activity in his writers' lair in Rue Gît-le-Coeur, was insufficient to Ginsberg's undertaking. Only after he returned to New York in November of 1958 did he generate the poem in full. More precisely, only when Ginsberg turned to the Lower East Side as a resource—a space of lived and collective experience, competing temporalities, and distinctive mythic resonance—did he resolve long-standing technical and conceptual challenges to the memorial act.[2] Locating himself in this site of memory and nested histories, Ginsberg produced that elusive poetic object, "a great formal elegy" for his mother and for the American century.[3] And he did more: he transformed the Beats' apocalyptic howl of protest—the ragged longline form of *Howl*, with its unevenly controlled release of hallucinatory and dystopic energies—into a mode of postwar redemption. With this work, Ginsberg also redeemed the Beat enterprise—spent, exhausted by its romance with exhaustion—from itself.

The story, or perhaps the myth, of Ginsberg's composition of "Kaddish" is among the most often cited in the annals of literary history. One winter night, it goes, Ginsberg had been visiting a friend in the West Village, talking and chanting lines from Shelley to the accompaniment of Ray Charles licks. In the small hours they shot up morphine and speed (the latter a first for Ginsberg), and he began talking about his mother, her tragic history of mental illness, and the failure of his family after her death to constitute a minyan, the required community of ten Jewish adults (read: men) to chant the ritual prayer for the dead.[4] Ginsberg's friend, who hailed from the immigrant Bronx and was a veteran of Israel's war for independence, pulled from a shelf a volume on Jewish rituals dating from his own bar mitzvah, from which he read the traditional Kaddish to Ginsberg.[5] Under the influence of poetry, chant, speed, nostalgia, guilt, and ambition, Ginsberg walked at dawn from the West Village to his own apartment on the Lower East Side, "the rhythms of the Kaddish still playing in his head."[6] Arriving home, he sat at his desk, "snatched up" a pen, and began writing. With "visionary urge" but "no idea what Prophecy was at hand," he would write continuously for forty hours, discarding pens as they ran out of ink and pausing only to urinate, eat boiled eggs cooked by his partner, Peter Orlovsky, or pop Dexedrine tabs.[7] Thus was Ginsberg's "most celebrated poem" born.[8]

I revisit this origin story so as to consider received accounts of "Kaddish" as the exemplary product of a Beat poetics and temporality: spontaneous, liberated from the Moloch of conventional form, alive to the immanence of a heightened, intensified present. Ginsberg emphasized the urgency of "Kaddish" as a spontaneous event that "happened," and the poem's often-quoted opening line—"Strange now to think of you, gone without corsets & eyes, while I walk on the sunny pavement of Greenwich Village"—insists on its present-tense "happening, in time," for the poet and in the moment of the reader's encounter.[9] This sense of "Kaddish" as, in the emerging parlance of the downtown avant-garde, a *happening*, a work predicated on the ideal of "a moment overflowing with . . . spontaneous action," has been critical to its status as a cultural landmark.[10] The form of the speaker's chant, ingathering and continuous, is thought to be Ginsberg's key contribution to the historical project of an American poetics—what he once described, with a nod to his mentor William Carlos Williams, as "the Yankee practice of poetry after William James, where the poet is standing there, feeling the weight of his body in his shoes, aware of the air passing in and out of his

nose."[11] Alternatively, the poem's sustained mode of encounter has been read as an index to Ginsberg's emerging poetics of Buddhist mindfulness, the exploration of consciousness in its immediate apprehension of its own activity; and it has been hailed as party to an emergent postmodernist claim on a "more primal realm of spontaneous experience" resisting the time-discipline of the postwar suburb and the organization man.[12] What all these readings of Ginsberg's Beat way of doing time obscure, however, is the freightedness of the *moment* of "Kaddish"—its temporal disposition—with a particular image history and its implications. Ginsberg's achievement in "Kaddish" of a signature use of the continuous present as a formal structure; his resolution of contending time signatures and registers of consciousness; his representation of the mobility of consciousness itself: all depend on his reanimation of the Lower East Side, imaged as a site of origin and a gateway to multiple times.

That project underlies the opening of "Kaddish," in the speaker's account of his "Dreaming back thru life, Your time—and mine accelerating toward Apocalypse,/the final moment" (7). The very act or practice of "Dreaming back" turns out to be inseparable from that of "looking back on the mind itself that saw an American city/a flash away" (7). This extension of the poet's perception conflates the hallucinatory visions of the mentally ill Naomi (imaged as a sublime, even atomic "flash") with her primal experience as a ten-year-old child in flight from pogroms in Russia, steaming into New York Harbor and gazing on the New World for the first time.[13] Implicitly, the temporal trajectory of Americanization—that of Naomi, renamed at Ellis Island, and that of untold strivers and world-makers arriving on America's shores—underwrites the speaker's account of his own state of mourning. "No more to say, and nothing to weep for but the Beings in the Dream, trapped in its disappearance,/sighing, screaming with it, buying and selling pieces of phantom" (7): the illusory world of the phenomenal and the ravening American dream interpenetrate in his apprehension. The poet who seeks to embrace death as "that remedy all singers dream of, sing, remember, prophesy" (7) must reckon with the lived truths of the generations that precede him, tracking them "Back to" a state of being "before the world" (9)—precisely through the place of their "suffering" and "Vision" (7, 8).

That "Vision" becomes available to the poet as he undertakes a journey of his own, moving physically and imaginatively into a singular space of shared origin. "Look[ing] back" at the towering office buildings of Seventh

Avenue, the eastern boundary of Greenwich Village, the poet moves "down the Avenue to the South, to—as I walk toward the Lower East Side—where you walked 50 years ago, little girl—from Russia, eating the first poisonous tomatoes of America—frightened on the dock—/then struggling in the crowds of Orchard Street—" (8). The behavior of directional language and prepositions in these lines ("to—," "toward," "where," "from") is distinctly unruly. This fact highlights the power with which the poet's mobility recalls—and, critically, inverts—a series of familiar trajectories. "Walk[ing] the street," the poet moves from Sheridan Square, hard by the Stonewall Inn (future site of the storied Stonewall riots and the birth of the Gay Pride movement), through Washington Square, epicenter of the bygone revolutions of modernism (including the spirited 1917 declaration by Arch Conspirators Marcel Duchamp, John Sloan, and Gertrude Drick of "The Free and Independent Republic of Greenwich Village"). During the early 1920s, the same site had been home to Ginsberg's mother and father Louis, a poet whose lyric verse was later anthologized in Louis Untermeyer's volume *Modern American and British Poetry*. Movement through that space leads the poet across Second Avenue, the onetime Jewish Rialto, birthplace of the Public Theater, the Orpheum, and the fabled Yiddish Art Theatre (figure 5.1), whose legacy of an avant-garde people's art survived in the Phoenix Theater's 1956 New York premiere of Beckett's *Waiting for Godot*.[14] Walking past the sole surviving Yiddish theater on First Avenue, the poet comes to rest just north of Orchard Street in the tenement Ginsberg himself called home—an old law structure, at 170 East Second Street, built in the 1860s before the advent of Progressive Era tenement reform a la Jacob Riis. Here, both Ginsberg and the poet of "Kaddish" transform lived experience into epic, a new kind of tale of the tribe.[15] To write his Kaddish, we might say, Ginsberg had to navigate an iconic landscape: to come full circle, back to the place—"the place of poverty/you knew, and I know" (8)—where his mother's American life and the modern nation's myth of assimilation began.

To map the opening journey of "Kaddish" onto this image-dense territory is to observe how continuous these trajectories are. American modernism, the career of twentieth-century poetry, histories of radicalism and cultural dissent—all are literally familiar, mutually informing, and inseparable for the poet from the "beautiful Garbo of my Karma" (30), Naomi. His journey home to the Lower East Side, which generates the poet's vision and enables him to achieve "this Psalm . . . burst from my hand in a day"

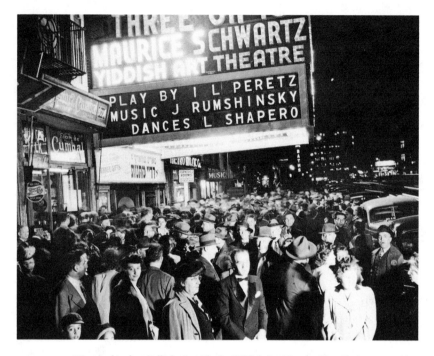

FIGURE 5.1. Weegee (Arthur Fellig), *Outside the Yiddish Art Theatre*, New York, 1945. 6 ¾ × 8 ½ in. (17.1 × 21.6 cm). © International Center of Photography. Bequest of Wilma Wilcox, 1993. Getty Images.

(12), is a movement backward in time. Or rather, his journey reanimates multiple pasts simultaneously in a heightened experience of consciousness that is also a heightened consciousness of collective experience. Such a journey has distinct contemporary resonances in the Cold War moment. That state of emergency was defined for Jewish Americans by a freighted opposition between assimilation and dissent, figured, we might say, in the standoff between Roy Cohn and Ethel Rosenberg.

Structurally, however, the "Kaddish" poet's mobility links his project with the founding works of epic in the Western tradition. Recalling the journeys of Odysseus, Aeneas, and Orpheus—not to mention the poet of Ezra Pound's *Cantos* and Jesus—his movement "down the Avenue" to the Lower East Side is a late twentieth-century katabasis, a descent into the Hades and dystopia of the motherland.[16] The latter turns out to be its own special hell, a place of alienated human being and "Babylonian" exile over which reigns a grim reaper with "a dog for his eyes—cock of a sweatshop— heart of electric irons" (26, 11). Thus the poet frames his congress with the

dead—more accurately, with his nuclear-age family, mutually implicated in the unspeakable experience of Naomi's breakdowns and ravings, her violence, and the violations of a body whose attacks could leave her "on all fours in front of the toilet—urine running between her legs— . . . the floor smeared with her black feces" (22). Only in this symbolic landscape of descent can the poet achieve direct and unmediated address to his lost mad mother, "cut through—to talk to you—as I didn't when you had a mouth" (11). Going down to (or on) the Lower East Side, the poet enters into a charged space of communion with the dead, with the history "I still haven't written" (13), with his chosen poetic ancestors, and with "Death" itself, "the mother of the universe" (30).

Singular as Ginsberg's cultural profile had become by the time "Kaddish" was published in 1961, he was hardly alone in experiencing the Lower East Side as a site of memorial and return. I have had occasion above to reference Hasia Diner's foundational argument that, in the immediate postwar period, Jewish Americans purposively reinvented the Lower East Side as a "sacred" place of rescue, futurity, and collective memory, in response to both the catastrophic destruction of European Jewry and the surge of second- and third-generation Jews from the place of first settlement to a rapidly expanding American suburbia.[17] Confronted with the devastation of ancestral sites in the old world, negotiating ambivalent feelings about the trajectory of assimilation in the new, Jewish Americans were collectively reimagining the Lower East Side as a collective place of origin, in myth and iconography if not in fact.[18]

Diner is particularly interested in this phenomenon among Jews in New York City, the children of alrightniks long distanced from the ghetto. During the postwar era, she notes, Jewish schoolchildren from affluent families on the Upper West Side were brought downtown to Orchard and Hester and Rivington Streets to tour matzo factories, watch observant Jews at prayer in old-fashioned *shtibels* (storefront synagogues), and visit that staunch bastion of Yiddish-language culture, the *Jewish Daily Forward*.[19] In their wake, suburbanites and tourists—even those who had never before set foot below Fourteenth Street—"returned" to the storied neighborhood to consume images of the struggle, privation, and loss that had enabled their collective assimilation to American progress.[20]

Strikingly, however, this postwar memory enterprise centered on the iconic ghetto was not restricted to Jews or Jewish American identity formation. By the early 1960s the Lower East Side had come to signify a broadly

authentic, foundational past for the contemporary city at large, writ as a crucible of American modernity. For New Yorkers of all stripes and origins, postwar urban renewal on a massive scale was creating its own kind of traumatic change—not only in the built environment, but in the conception of urban life and its pace and scale.[21] In this context, the streetscape and iconography of the historical ghetto became a resource for broader management of its effects. In particular, the ghetto's pushcarts, longtime icons of immigrant striving, human-scale sociality, and the will to assimilate and move forward, emerged as a cultural landmark and cause célèbre. When Gordon Parks, the first African American photographer hired by the Farm Security Administration's storied photographic division—and soon to become the first black staff photographer at *Life*—sought uplifting images of the city for an early photo assignment, he framed a pushcart vendor against icons of New York's skyscraper modernism, conjoining heroic labor and industrial might as the antithesis of fascism (figure 5.2).[22] Likewise, postwar practitioners experimenting with street photography—including Detroit-born Todd Webb, who began his career in New York in 1946—homed in on the pushcart as a subject, emphasizing the dynamic microcultures and street-level interactions it promoted (figure 5.3). By the late 1950s an intensifying press to rid the streets of pushcarts—particularly those on the Lower East Side—to make way for "modern" commercial and transportation interests had aroused public outcry. To regulate Lower East Side pushcarts and abolish the distinctive modes of commerce and sociality they enabled, wrote one journalist in 1962, would be to destroy the very image of the city itself; it would be the equivalent of removing "the Montmartre from Paris" or exploding "the Palatine Hill in Rome."[23] A veritable gateway to "old New York," the belated postwar landscape of the ghetto—iconic pushcarts, tenements, and all—had become, in the words of a popular columnist, "the most irresistible of all New York's places of wonder."[24] New Yorkers were unified, in other words, in having become citizens of a new state of creative destruction, and the Lower East Side was their *lieu de memoire*, their link to an iconic past, and their defense against increasingly corporatized, abstract, machine-scaled social relations in one.

To put the memory work of "Kaddish" in this broader context is not to diminish the poem's aspirations, but to underscore them. A dweller in the city, its poet makes his way home through history and time, and through their presence in material forms and image-dense spaces, to a singularly

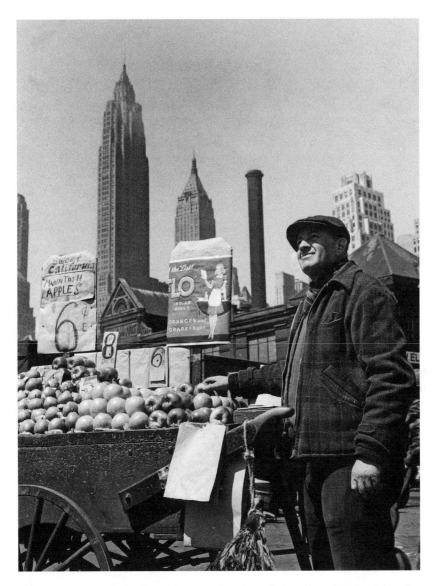

FIGURE 5.2. Gordon Parks, *New York, New York, push cart fruit vendor at the Fulton fish market*, May 1943. Library of Congress, Farm Security Administration—Office of War Information Photograph Collection, Prints and Photographs Division LC-USW3-028760-D.

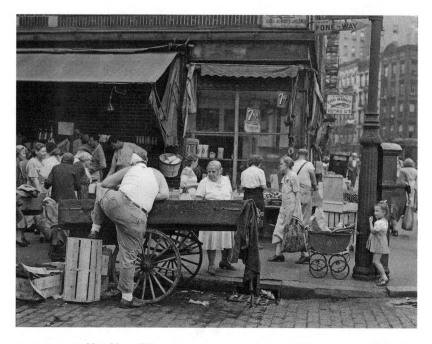

FIGURE 5.3. Todd Webb, *Suffolk and Hester Street*, New York, 1946. Photograph. ©Todd Webb Archive, Portland, Maine, USA.

generative place. Ginsberg's actual place of residence—a birthplace of early Beat culture in New York City—was two and a half short blocks north of Naomi's first American home: a tenement apartment above her family's candy shop on Orchard near Rivington, in the epicenter of the turn-of-the-century Jewish ghetto. (Another old law tenement just one block farther south, at 97 Orchard, later became the site of the Tenement Museum, opened in 1996 so as, in the words of the museum's promotional materials, to "forg[e] emotional connections between visitors and immigrants past and present.")[25] Clearly the literal and psychic journey of "Kaddish" rhymes with a broader postwar memory project. But what makes the space of origins sacred within the poem—what makes it beatific in the distinctly Beat sense—is the passage of the poet through Blakean gates of perception that mark off the Lower East Side as his own temporally complex territory of apprehension and desire, "here again,/with the cries of Spaniards now in the doorstops doors and dark boys on the street, fire escapes old as you" (8).

It is this passage that enables a certain bracing spiritual wonder, on the poet's part, in the face of "change's fierce hunger" (9). His movement

is mapped from the "here" that is "left with me" (8) to the unfathomable space of death, of a life unapprehended, whose naming becomes a benediction: "There, rest. No more suffering for you" (9). And this going down that is also a going back and a reunion anticipates and makes possible the poet's descent in part II of "Kaddish" into the most fraught depths of his own experience, the traumatic reality of a family life lived in the dark shadow of breakdown, hallucinations, the "refrain—of the Hospitals" and "remembrance of electrical shocks" (13). At the moment of "Kaddish," the Lower East Side was clearly being sacralized for a Cold War nation as a unique point of entry into a usable American past. That vision of the ghetto would culminate in a landmark 1966 exhibition at the Jewish Museum, "The Lower East Side: Portal to American Life," an event that reinvented exhibition practice and galvanized city-dwellers as consumers of the neighborhood's history.[26] In advance of that impact, the imagery of the historical ghetto as a portal or gateway to the vanished pasts offered itself as a distinctive resource for Ginsberg's poetics of prophecy and dissent.

That broader imagery is an important context for the most infamous moment of "Kaddish," midway through the poem. Here Naomi speaks in her own voice of her vision of God ("a lonely old man with a white beard") and of the "nice supper" she cooks him—"miltz," or dairy—as she offers her son "cold undercooked fish," food "more and more disconsolate" (23, 24). It is, perhaps, the "smells" of these fishy offerings that the poet associates with Naomi's body, leading him to enter into his most charged and primal memory:

> One time I thought she was trying to make me come lay her—flirting
> to herself at sink—lay back on huge bed that filled most of the room,
> dress up around her hips, big slash of hair, scars of operations,
> pancreas, belly wounds, abortions, appendix, stitching of incisions
> pulling down in the fat like hideous thick zippers—ragged long lips
> between her legs—What, even smell of asshole? I was cold—later
> revolted a little, not much—seemed perhaps a good idea to try—
> know the Monster of the Beginning Womb—Perhaps—that way. (24)

Critical readers of the poem have treated this remembrance of contemplated incest as a moment of extraordinary candor, a characteristically radical exposure by Ginsberg of his own extremities of desire.[27] But its expression is nonetheless strategic, a poetic device. Notably, the original draft of the poem represents the incest as a fait accompli—"fucked her

here," the line goes, with emphasis on the freighted space of encounter and return.[28] By contrast, the power of the final version depends on a kind of ekphrastic charge: the memory of an ambivalent desire for primal knowledge is both arrested and brought to life in the form of a poetic image, as the poet crosses a threshold of self-expression and apprehension.

It is only there and then, in a space of memory at once hallowed and perverse, sacred and grotesque, that he is at last enabled to chant the traditional Kaddish—"Yisborach, v'yistabach, v'yispoar, v'yisromam, v'yisnaseh,/v'yishador, v'yishalleh, v'yishallol, sh'meh d'kudsho, b'rich hu" (24)—and to make it his own. The lived space of contact with Naomi's lived past, in another words, is a portal for the poet's imaginative entry into the forbidden, unknowable place of his own origin in consciousness and time. And that entry underwrites and secures his vision of Naomi's place of death—"I've seen your grave! O strange Naomi! My own—cracked grave!"—in which the poet experiences yet another birth or animation: "Shema Y'Israel—I am Svul Avrum—" (27). Like the cultural fantasy of return to the Lower East Side, the poetic expression of return to the womb makes possible a state of transformative self-knowledge. The latter involves an act of radical self-constitution that responds to as it transcends traditions both sacred (Judaic) and secular (literary).

Of this moment in the poem, and its embeddedness in the iconic space of reclaimed memory, Ginsberg would later write that it urged him to a "release of particulars," allowing him to "[go] back chronologically, sketching in broken paragraphs all the first recollections that rose in my heart," thus recovering "images that were central" to his poetic imagination.[29] By 1961, Ginsberg had been a committed photo-documentarian of his own states of experience and of the relationships and daily living of his Beat coconspirators, lovers, and fellow writers for nearly a decade. Taking up photography in 1953 during his first sojourn on the Lower East Side, using a high-quality German-made Kodak Retina he bought on the cheap in a Second Avenue pawnshop, Ginsberg began producing what eventually became an archive of thousands of photographic images, some of which he inscribed retrospectively, long after the fact, with self-consciously bardic captions. This image-making came into being as an organic aspect of the latter-day lifeworld—self-consciously marginal, in the opening lines of "Howl," "poverty and tatters and hollow-eyed and high"—of the Lower East Side. It was embedded in the rough-edged, collective, off-the-grid downtown junky writing life, as an early portrait made by William Burroughs with

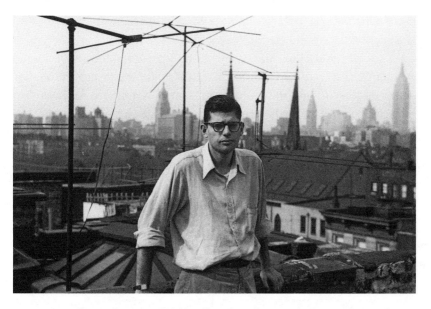

FIGURE 5.4. Allen Ginsberg, *Untitled (Myself seen by William Burroughs, Lower East Side, New York)*, 1953. Gelatin silver print, 11 ¼ × 17 ¼ in. (28.6 × 43.8 cm). © 2018 The Allen Ginsberg LLC. All rights reserved. Courtesy the Howard Greenberg Gallery, New York.

Ginsberg's camera on the roof of their shared tenement apartment suggests (figure 5.4).[30] Like this portrait, clearly identified as an artifact of life at 206 East Seventh Street, virtually all of Ginsberg's images are pegged to precise locations, as if to underline the synergy between the social territory of the tenements, the project of memory, and the act of image-making.

Ginsberg's captioned portraits of the Beat life have recently enjoyed serious critical attention, including a major exhibition at the National Gallery of Art.[31] But it would be misleading to claim for them the radical experimentalism of his poetics. (He himself would remark, ostensibly of William Burroughs's late-life painting but perhaps with his own imaging in mind, "If you establish yourself in one field, it's possible that people then take you seriously in another. Maybe too seriously.")[32] And their professed relation to his practice of image-making as a poet may be misleading. If anything, Ginsberg's image-texts reflect a willfully sentimental—or beatific—investment in the photograph as a certificate of presence, an open portal to an otherwise irrecoverable past. They thereby heighten the temporal complexity in "Kaddish" of the poet's return to the motherland of

the tenements and to the mother's body as primal sites for the release of the images that sustain his vocation.

For as the poet's imaginative encounter with "the Monster of the Beginning Womb" releases a flood of suppressed images, it suggests that the poet's place of origin—the Lower East Side of his mother's American beginning, conflated with the maternal womb of his own—has become, like David Schearl's tenement Holy of Holies, a kind of camera obscura, but this time invoked self-consciously as an agency for producing images. Historically, this prephotographic optical device allowed artists to sketch landscapes with detailed fidelity, for contemplation and use in formal studio work. In the act of sounding that is the poem, the space of return that Ginsberg and the speaker of "Kaddish" inhabit is some kind of dark chamber in which evanescent truths of the past are projected, partially captured, and made to live across time. All that has been for a lifetime unspeakable—his father's despair and extramarital sexual activity, his brother's masochism, Naomi's tragic attempts to make art, her ravings and her violent attacks on her family, a whole "gamut of Hallucinations" (27)—is released from the dark and secret place of origin by the poet's return. In this way, he is newly empowered to magnify and sanctify the reality of his loss, along with new modalities of its expression (the "Hymmnn," the invocation, and the fugue, in the ensuing parts of "Kaddish" respectively).

Notably, the images released from the site of origin—camera obscura, agency of time travel, and womb of time—beget a redemption of the lost Naomi herself as a seer. Her "Strange Prophecies" at the conclusion of part II take the form of a quasi-photographic passage through an aperture opening onto a world beyond the prison house of the self: "The key is in/the window, the key is in the sunlight at the window—I have/the key . . . the key is in/the bars, in the sunlight in the window" (31). In subsequent sections of the poem, Naomi is brought to life through the convention of the blazon. The poet recalls her "mouth of bad short stories," "fingers of rotten mandolines," "belly of strikes and smokestacks" (34). However embattled, she thus becomes present as a figure seeing and seen. Ultimately Naomi is resurrected from the depths of her own oblivion by the trope of the camera eye, whose agency to recover hidden pasts she perhaps now shares with the poet:

> with your eyes being led away by a policeman in an ambulance
> with your eyes strapped down on the operating table. . . .
> with your eyes of ovaries removed

with your eyes of shock
with your eyes of lobotomy
with your eyes of divorce
with your eyes of stroke
with your eyes alone
with your eyes
with your eyes. (IV, 34–35)

In part IV, as the poet's recuperative litany transforms Naomi's loss as a "Death full of Flowers" (35), his use of the trope of photographic seeing—which brings back from the depths of time and memory forgotten, unspeakable truths—conjoins Blakean poetics with a long history of documenting the lifeworld of the tenements and their socially marginal inhabitants, making lived experience visible and available. But visual images alone cannot suffice for the poet's aims. At the climax of his Kaddish, the poet makes clear that such transformation can be realized only through the agency of word and breath, what Ginsberg would call "pure emotive sound."[33] If the camera obscura of his origin releases a generative image archive, it will take an embodied chant to connect these recovered memories with other "instant[s] in the universe" and its "strange cry of Beings" (36). In the resonant final section of the poem (V), the "Lord Lord great Eye that stares on All and moves in a black cloud" is countered and made imaginable by the "caw caw caw" of crows shrieking over Naomi's grave (36). The persistence of their cry underscores the fugal and syncretic power of the poet's soundings. Joining his own "voice in a boundless field in Sheol" to their "call of Time" and "the roar of memory," he achieves a momentary unification of past and present, of eye and ear, of the world and the grave, the instant and eternity, the place of origin and that of final rest, image and sign: "Lord Lord Lord caw caw caw Lord Lord Lord caw caw caw/ Lord" (36). This is where the poet's katabasis leads: to a place—which is also a moment—of earned resolution for his long howl of protest, and for the fantasy of reunion with the dead that ends his earlier epic "Howl." If the final benediction of "Kaddish" sounds with a view to the traditional Judaic east—here, not Jerusalem but decisively New World "grave stones in Long Island"—that vision is the culmination of the poet's journey back and down, to a Lower East Side made new as a resource for remembering what cannot be assimilated to the ideal of progress, what has been betrayed in the name of belonging.

■

On the morning of October 26, 1961, three federal agents with an arrest warrant burst into an apartment over a "Gypsy storefront" on "the grimy East Side," the home of writer LeRoi Jones (not yet Amiri Baraka).[34] Jones was charged with sending obscene materials through the US mail, and exhibit A was the ninth issue of a little—very little—magazine coedited by Jones and fellow poet Diane DiPrima, a mimeographed compilation of new work by downtown writers titled *The Floating Bear*. The offending material included an excerpt from William Burroughs's *Naked Lunch* as well as Jones's *The Eighth Ditch*, a provocative drama that featured same-sex rape in a racially charged idiom. During the subsequent federal grand jury hearing, to which his lawyer was denied entry, Jones conducted his own defense by reading "all the good parts of Joyce's *Ulysses* and Catullus aloud to the jury" along with "Judge Woolsey's decision on *Ulysses*, which described obscene literature as being arousing 'to the normal person'" (AB 170). As Baraka later recounted it, he wound up his three-and-a-half-hour legal performance by turning the tables on the jury: "But I know none of you . . . were aroused by any of these things" (AB 170).[35] To his satisfaction, the charge was dismissed.

These grand jury dramatics and the drama they celebrated—an experiment self-consciously designed to make Baraka's writing less mimetic of Anglo-European models and "more essential, more rooted in my deepest experience" (AB 166)—exemplify the defining paradox of his place in the downtown avant-garde in the early years of the frictional 1960s, a subject of ongoing interest both to Baraka and to his critics. Lured to the Village bohemian scene and its project of "open and implied rebellion—of form and content"—against all things middle-class and middlebrow, Baraka himself was a complex work in progress (AB 156). Desperate to extirpate his own petty bourgeois black roots, struggling to "become an intellectual" with "no real qualifications save desire," he spent the early sixties transforming himself through readings of Sartre, Cocteau, Camus, Rimbaud, Williams, Joyce, and motley other modernists into a writer capable of drawing power from "the extension cord of blackness in me" (AB 120, 127, 47). If his everyday experiences in the clubs, bars, and beds of Village bohemia ultimately led him to reject the project of dissent in "the downtown Villagey sense" as debased and inauthentic, his tightening embrace of a racialized truth to self and of more-strident black nationalist commitments was nonetheless forged in downtown networks of production and encounter (AB 129). In his self-described struggle "to be

born" anew, the Lower East Side—or rather, the no-man's-land that would become the East Village, still annexed iconographically to the historical tenement landscape—played a powerful supporting role (AB 194). James Smethurst's wide-ranging study of the emergence of the Black Arts movement accounts in close detail for the emergence of an "increasingly politicized black bohemia of the Lower East Side," of which Baraka forms a part, in the context of the distinctive avant-garde, radical, Old and New Left networks criss-crossing that site.[36] In Baraka's case, however, the image repertoire as well as the institutions of the historical ghetto came to have distinctive power. Overlaid on, at times overlapping with, the site of Ginsberg's resistance through memory work to middle-class conformity, the Lower East Side of Baraka's "time . . . of transition" became a stage setting and a resource for his ongoing self-invention as a late modernist and figure of Black Arts (AB 128).

Even by the dawn of the sixties, the strident dualisms that animated Baraka's later takes on culture and aesthetics were already in evidence. His first book of poems, *Preface to a Twenty-Volume Suicide Note*, published the same year as the *Floating Bear* bust by the Totem Press Baraka founded, voices his early investment in a collective or diasporic identity—and the difficulty, for the heroic speaker, of inhabiting it:

> My silver bullets all gone
> My black mask trampled in the dust
> & Tonto way off in the hills
> moaning like Bessie Smith.[37]

But the book, whose poems Baraka deliberately arranged in order of their composition, ends with "Notes for a Speech"—one that remains, it would seem, undeliverable. (Thus his next book of poems, published in 1964, would be titled *The Dead Lecturer*.) These notes, unlike the street-inflected phrasings of Baraka's later work, sound the futility of the poet's identification with an African place of origin or collective past:

> African blues
> does not know me. . . .
> My color
> is not theirs. . . .
> . . . Africa is a foreign place. You are
> as any other sad man here
> american.[38]

In Baraka's initial book, the failure of identitarian gestures is literally the last word.

Throughout *Preface* the divide between black consciousness and the lyric subject—which Baraka would soon link with the bourgeois individual, product of the introjection of white norms, "the artificial, . . . the middle class" (AB 43)—seems irreparable. The only thing they share, it would seem, is the need for a usable past, in whose image the subject can transform himself and the conditions of consciousness. On the one hand, the poet of *Preface* appears capable, at least for the duration of his own image, of inventing an origin that promises to empower him. Each morning, he notes, he goes down "to Gansevoort St." to stand on the docks:

> I stare out
> at the horizon
> until it gets up
> and comes to embrace
> me. I
> make believe
> it is my father.
> This is known
> as genealogy.[39]

Looking west toward Baraka's birthplace, Newark, from his vantage point at the edge of Greenwich Village, the speaker establishes an African persona in the guise of son of an ancestral sun.[40] In this space of self-reckoning, sun and horizon "get up" in the West, which paradoxically opens the view back to Africa; the poet's "make believe" inverts cosmology and claims another birthright than what remains visible beneath "the huge & loveless/white-anglo sun/of benevolent step/mother America."[41] But the stepmother, far from benevolent, looms unvanquished at the poem's end, and the poet can only be yet one more of the false or impure named by way of Rimbaud in the poem's epigraph: "*Vous êtes de faux Négres.*" Throughout *Preface*, the poet's gestures of self-invention feel more sustained and sustaining when they involve not reclamation but a kind of scourging—a plaintive "note" to self to distrust or abandon all he has been taught to emulate and desire (including, above all, the means of his own poetic expression). Finally, the most convincing embodiment in *Preface* of an animating past appears in the form of "The Shadow," that disembodied mass and spectral figure of symbolic blackness

and retribution, who "knows what evil lurks in the hearts of men": "O, yes he does/O, yes he does./An evil word it is,/This Love."[42]

If the moment of *Preface* and the *Floating Bear* incident belonged to an intense and frictional time of transition, it also transpired in a distinctly transitional space. By 1961, Baraka's initial infatuation with the bohemian Village as the place "where Art was being created" (AB 126) had given way to disenchantment. The Village scene increasingly struck him as a "make-believe fairyland" inimical to authentically transformative art-making—not to mention the make-believe of self-invention in the light of black history (AB 132).[43] In this view, Baraka was hardly alone. Media hype, the overexposure of Ginsberg and other Beat figures, and the insufficiency of "hipness" to the urgencies of atomic anxiety and the civil rights struggle meant that, as Werner Sollors has put it, "the era of 'pure' Bohemianism was coming to an end."[44] Like abstract expressionism some years before, Village bohemia had come to look corrupt and self-parodic, inflated as a commodity and debased as a politics. Eager suburbanites, responding to ad-bait in the *Village Voice*, hired "genuine beatniks" to add spice to cocktail parties (figure 5.5). (Jazz poet and painter Ted Joans and photographer Fred McDarrah—the latter originated the gambit—made a matched black and white set.) Mainstays like the Café Figaro in the West Village had become "stare headquarters" for teens from the boroughs "trying to figure out where we could go to fuck."[45] For Baraka, struggling to stake his own claims on avant-garde histories and resources, the tension was acute. As he later put it, "I didn't come over to the Village for no regular middle-class shit, yet here I was in it" (AB 148).

Baraka would continue the quest to remain "*outside,*" unassimilated to the middle-class shit contaminating Beat culture and his own origins, which were problematically mixed—in his schema, "B-B-Y-W," or "Black-BrownYellowWhite" (AB 63, 49). His quest was both prolonged and figured in the move he made in the early days of 1962 with his wife, Hettie (formerly Cohen) Jones, and their infant daughters to an abandoned building on Cooper Square, just east of the Bowery above Fifth Street. Baraka had previously lived on the Lower East Side and outside what he called the "Village proper" (AB 124), but Cooper Square was a new experience. Still, then, beyond the pale of urban development, it remained a kind of foreign country to bohemians and middle-class city-dwellers alike. Hettie Jones described the space as "shockingly nondescript"—"less a place to stop than

FIGURE 5.5. Fred W. McDarrah, *"Rent-a-Beatnik" Party in Brooklyn.* Guests at a "Rent-a-Beatnik" party ($40 for the first beatnik, plus extra for each additional one), Brooklyn, New York, April 9, 1960. Getty Images.

somewhere you'd pass going anywhere else"; when they moved in, the only other visible inhabitants were "rag-wrapped, grizzled winos straggling up from the Bowery" (HJ 163). Vacant after years of disuse, their building, number 27, was literally uninhabitable. Its walls were bare concrete; there were no pipes, plumbing, or doors, and it was filled with building rubble and trash. Officially, as far as the city knew, 27 Cooper Square remained empty even after the Joneses and then their compatriots (jazzmen Archie Shepp and Marzette Watts, actor Ezra Lazley) took up residence there and illegally renovated the structure. Like many landlords of derelict buildings on the Lower East Side, theirs collected rent under the table—everyone knew "your money was good until the Fire Department caught you in your pajamas" (HJ 179). Under this dispensation, Cooper Square became headquarters for a new and increasingly African American avant-garde.

The Joneses' experience exemplifies the way in which the off-the-books space of the foundering Lower East Side—not yet the East Village of a housing market "smart trend" and the hippie invasions of the mid-1960s—was available as a territory for the ongoing reinvention of avant-garde practice, Africanist

and otherwise, because it was both empty and full.[46] Just as the featureless-
ness and social neutrality of Tenth Street had provided a material context
for development in the early fifties of the abstract expressionist aesthetic of
"no environment," the resistance to gentrification of Cooper Square and en-
virons—their persistence as officially designated "slum areas"—made them a
powerful resource for Baraka and like-minded figures of the post-Beat avant-
garde.[47] This was not just a matter of the cheap rents that drew artists and
outsiders. In play was also the sense of what sculptor Amir Bey called the
"magical, free, exciting" sense of "new horizons and endless possibilities":
a landscape emptied, materially and imaginatively, of cultural infrastructure
and attendant conventions.[48] During the late fifties and early sixties, the space—
and its historical iconography—lent itself with distinctive power to evolving
figurations of the "wild," the unassimilated, and the untamed (AB 172).

The artist and arts critic John Gruen, a habitué of the Village/bohemian
scene, noted that a self-conscious frontiersmanship animated Lower East
Side avant-garde life; cowboy style and frontier tropes became "an inte-
gral part" of the evolving movement.[49] (Poet Paul Blackburn, a protégé of
Charles Olson and a colleague of Baraka, was instantly recognizable on the
streets by his trademark black cowboy hat; fellow poet Joel Oppenheimer
countered by donning a white one.)[50] The Café Deux Mégots, newly opened
in a below-street storefront on East Seventh Street in June 1961 and co-
owned by an African American resident of the neighborhood, beckoned
participants for its landmark poetry reading series by advertising "Come
East Young Man" (HJ 172). Sonny Rollins, who lived below Houston on Clin-
ton Street and turned the Williamsburg Bridge into a territory for creating
his vanguard compositions (it was there he developed the solo technique
known as strolling), had already become a cowboy on his 1957 album *Way
Out West*, which featured astonishing improvisatory versions of "Wagon
Wheels" and "I'm an Old Cowhand" (figure 5.6).[51] Ted Joans adopted a
similar persona to suggest the resistance to civilizing of his multimedia art
(figure 5.7). As the Beat phenomenon came to seem played out, a growing
number of artists seeking an uncorrupted space of identification and art-
making lit out for the East Side territories. Here, all the discomforts of the
artist's home—cold-water flats, absent or unreliable plumbing, dysfunc-
tional infrastructure, street crime, and flophouse ambience—provided an
objective correlative for intentioned resistance to industrial capitalism, or-
ganization men, and bourgeois norms. And the long-standing iconography

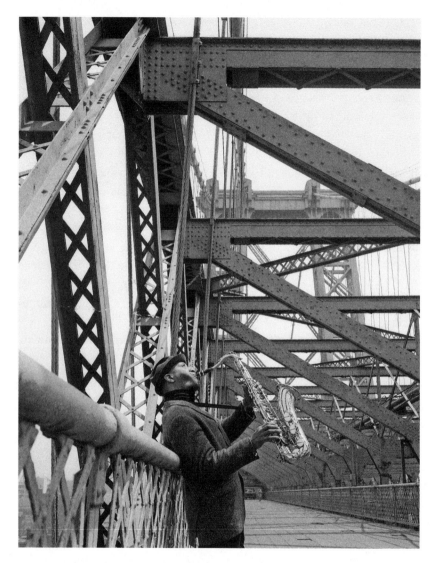

FIGURE 5.6. Sonny Rollins plays his saxophone on the Williamsburg Bridge, June 19, 1966. *New York Daily News* Archive, Getty Images.

of poverty, criminality, and vice associated with the Lower East Side— so, for example, poet James Schuyler wrote to a fellow poet, "I admire my friends who [have] the courage to live on the lower East Side; I certainly haven't"—linked the rugged individualism of the frontier trope with the sacred-violence, outlaw modernism of Rimbaud, Artaud, and Genet.[52]

Baraka's early work never indulged in the fantasy of the Lower East Side as frontier. He affected tweeds rather than ten-gallon hats or denims, and his own "Way Out West," a poem included in *Preface to a Twenty-Volume Suicide Note*, was an imagistic homage to the plain-speech, Zen-inflected verse of West Coast Beat poet Gary Snyder. But Cooper Square nonetheless meant for Baraka a clean sweep: inhabitation of a "wild place" whose very "sense of place" was predicated on its psychic distance from both the Village and the mores of the black bourgeoisie (AB 172, 173). He would later write that Cooper Square was "kind of the borderline; when you crossed it, you were really on the Lower East Side, no shit" (AB 175). No shit, no middle-class bullshit: for Baraka, the transitional, residual Lower East Side figured freedom from an oppressive personal and aesthetic past in a culturally uncontaminated space. There, "it was my own deepening sense of self"—rather than Beat mantras or the mores of the "top Negro"—that was at large (AB 93). In those precincts, real and imagined, Baraka was free to explore changing aesthetic and political commitments and their structural frictions, to "becom[e] someone else" (AB 173).

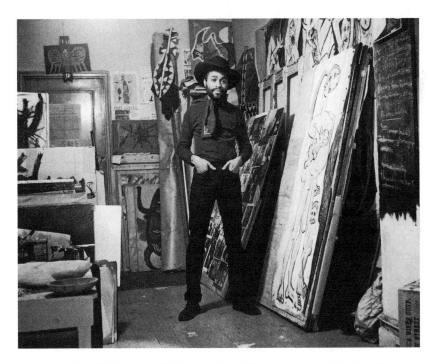

FIGURE 5.7. Fred W. McDarrah, *Ted Joans in His Loft*, November 4, 1959. Getty Images.

Like the Beat invocation of the frontier, however, that project was predicated on suppression of the social practices and histories that enabled it. This effect (or strategy) of image-making and self-fashioning becomes evident when we consider Baraka's accounts of the post-Beat avant-garde alongside other versions, beginning with that of his wife Hettie, who hailed from a working-class Jewish family in "polyglot Brooklyn" (HJ 8). For her, the Lower East Side meant both experimental poetry and alternative bookshops and "every . . . East Side landmark" of the iconic Jewish ghetto (HJ 81). She described the space of everyday life there not as blank or emptied but as socially dense, peopled with "Poles and Ukrainians, Italians and Puerto Ricans, quite a few Jews still" (HJ 175). A key aim of her 1990 autobiography, *How I Became Hettie Jones*, is to explore the competing, distinctly gendered histories and temporalities that animated post-Beat arts in this space where the "ghosts of the Yiddish theater," the making of avant-garde jazz, and the life of the bodegas—an emerging Louisaida—intersected (HJ 175).

Like Ginsberg's, Jones's take on the historical ghetto is conditioned by its resonances for postwar Jewish America, in a context of intensifying assimilation, memory-work, and nostalgia. But she is hardly alone in identifying the social histories and infrastructure of the Lower East Side as a resource for an emerging African American avant-garde. After the fact, poet and playwright Rashidah Ismaili Abubakr identified the "rich ethnic mixture of the Lower East Side"—a space "historically more progressive and diverse"—as a resource for exploration by African Americans of "the stories of their people."[53] Sarah Wright, a leading member of the Harlem Writers Guild who lived and wrote her first novel on the Lower East Side, noted that the texture of her neighborhood—part "Jewish ghetto," emerging Puerto Rican community—enabled "a kind of Harlem Renaissance downtown."[54] Poet Calvin Hernton, a founding member of the Black Arts–centered collective Umbra, describes the experience of living on the Lower East Side as generative for the project of gathering black artists together to "do something about the isolation and anonymity we felt"; in a territory "occupied" by new and vestigial working-class ethnic communities and "Jews from the Soviet Union and the East European Diaspora," Hernton noted, black writers testing the boundaries between aesthetic and political commitments, between activism and art, could simultaneously fashion themselves in contest with the Old Left and create an alternative public in the onetime home of "the 'old folks' of European descent" (pun noted).[55] Nowhere else in the city—nowhere else in America—were

entangled histories of ethnic and racial alterity, radical politics, and an infrastructure of "blight" so readily available to support avant-garde and countercultural self-fashioning. (So dense has been the entanglement here of histories of ethnic and racial alterity, radical politics, and labor organizing with discourses of the inassimilable ghetto that it ultimately gave birth to the oxymoronic notion of the "naturally occurring cultural district": an otherwise "undesirable neighborhood" whose histories and material resources allow arts communities and practice to flourish.)[56]

For Baraka, both the will to avant-garde expression and his evolving commitment to Black Arts made rejection of these histories increasingly urgent. This may have been the only way in which his conflicted aims clearly coincided. Critically at issue for Baraka was the ethos of the inassimilable: successful resistance, aesthetic and social, to bourgeois norms, assaulting the artist from without and within. As innumerable critics and Baraka himself have noted, nowhere was the possibility of such resistance more alive for him at this transitional moment—for civil rights activism, the politics of the avant-garde, and Black Arts alike—than in the sounds and reverberations of jazz. Its agency as an expression of the black avant-garde, and Baraka's engagements with it, were closely shaped by the career of postbebop jazz on the Lower East Side—in particular, in the incubator where jazz experimentation and culture-making liberated from hipness in the Village "came together": at the Five Spot, a ramshackle club on the same outlaw territory of Cooper Square.[57] A onetime Bowery bar catering to a panhandle clientele that had been "neutralized," as Baraka strikingly put it, by the abstract expressionists in the mid-fifties, the Five Spot marked a spot outside and an era beyond the "old Village scene."[58] As registered by jazz photographer Herb Snitzer, the Five Spot radiates a kind of outlaw intensity—literally, a beacon in a wasteland of vacant lots and cheap furnished rooms (figure 5.8). There, in the rising civil rights era, hard bop and free jazz improvisation conducted their furious assault on comprehension by aspirants to bohemianism, and operated for the most part beyond the reach of the law. The same police who harassed club managers and in particular black performers in high-priced Village clubs left the Five Spot and environs alone—a significant benefit of the iconic status of the Lower East Side as a ghetto wasteland, beyond economic value, cultural redemption, and policing alike. More to the point, the Five Spot's owners ignored repressive cabaret licensing laws that kept artists with drug priors (of which there were legion) from performing in the Village or uptown.[59]

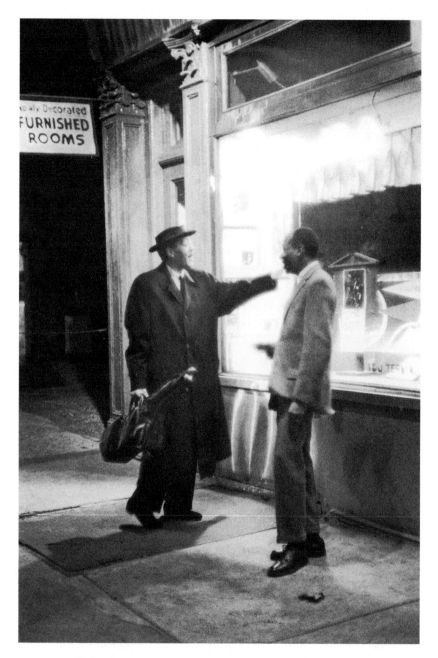

FIGURE 5.8. Herb Snitzer, jazz musician Lester Young outside the Five Spot Club, New York, 1958. The LIFE Images Collection/Getty Images.

By 1961, then, the Five Spot had become indispensable to a jazz avant-garde closely tied to civil rights and protest culture, making the music in which, Baraka wrote, "we heard our own search and our travails, our own reaching for a new definition" (AB 176). Microgenerations of the avant-garde, from Monk and Coltrane to Rollins and Ornette Coleman, showed up at the Five Spot to test themselves and the limits of their music as a form of expression and dissent. Night after night, session after session, they took listeners and one another to church, aiming to keep the music pure against the inevitable influx of hangers-on. Mingus infamously railed to a Five Spot audience against the "poppaloppers" among them (a polite term substituted in print, presumably for "motherfuckers") who failed to attend properly to its strenuous "artistic truth."[60] Coleman, who blew into the Five Spot with a plastic yellow saxophone because he'd been forced to pawn his usual instrument, staggered his listeners with atomic-age bebop, "ugly, savage sounds" that recalled for them the shock effect of Stravinsky's *Rite of Spring*.[61] This was the revolution that would not be commercialized—as Baraka put it, "Not on the radio or the television, in those streets the yeh went up of something new."[62] With that whoop and holler, a modernist commitment to purposeful unintelligibility coincided with an emergently nationalist will to authenticity—the sound of a sustained resistance to assimilation by bourgeois (and, increasingly, by Anglo-European) institutions and norms.

Through it all, Baraka had a front-row seat and ground-level view—was a key participant-observer, a close colleague and passionate critic of avant-garde jazz making itself free. He attended virtually every night of Thelonius Monk's epic six-month stint there with John Coltrane; indeed, Baraka's voice can actually be heard on certain tracks of some of the landmark live recordings made at the Five Spot, which included *Thelonius Monk Quartet with John Coltrane* (1958) and *Eric Dolphy at the Five Spot* (1961). In due time, the Jones's home in 27 Cooper Square, literally a stone's throw away from the Five Spot, became a center for the pop-up, afterhours network defining the "loft and coffeehouse" jazz scene of the early sixties.[63] In Hettie Jones's recounting, it also became—literally—material to the making of this revolutionary music. When Archie Shepp's various bands played in his studio there, they "let the sound ricochet off the factories and repeat a millisecond later on the tenement wall on Fifth Street," repurposing the very infrastructure as a vehicle for their resounding (HJ 172).

Increasingly, the condition and ethos of inassimilability that Baraka associated with the spatial logic of the Lower East Side became key to his critical engagements with jazz and black music. In his landmark work of cultural history and of self-invention, *Blues People: Negro Music in White America* (which Baraka began when he moved into Cooper Square in 1961 and published in 1963), "assimilation" becomes his critical term of art for accounting for the aesthetics and social meaning of African American musical traditions. At its core, *Blues People* proposes a continuity between the blues and jazz, or rather between black vernaculars and avant-garde expression, based not on the formal properties of black musics but on their shared reflection of a structural, ongoing, and deeply social contest. In every era, Baraka argues, "assimilationist aspirations"—the mindset of a black middle class determined to sacrifice vernacular and "unrefined" expressions "on the altar of assimilation and progress"—are countered by self-conscious resistance to them, in the form of a durable "blues impulse" that makes the full abandonment of African-descended sound, feeling, and expression "an unrealizable possibility."[64] In his history of expression of this impulse, Baraka gave pride of place to hard bebop—the Black Arts of Charlie Parker, Sonny Rollins, and John Coltrane. Their provocative honking and furious rhythmic assaults not only made jazz sound "as unmusical, or as non-Western, as possible" (BP 172), but, like the low-down culture of the black folk, rendered the form impervious "both socially and culturally"—even perhaps bodily—to "any [kind] of assimilation by black or white" (BP 143).[65]

Baraka's brief against assimilation reconciled, however tenuously, his commitments to Black Arts and his investments in art as a social good, an enterprise that conditions productive estrangement, as literary and cultural historian Scott Saul has put it, "from who we thought we were" and rejection of "the false trappings of a culture that we had unthinkingly internalized."[66] For this argument, the context of the Lower East Side provided two ready and competing resources. On the one hand, the "neutralized," emptied, liberated precincts of the former ghetto—its infrastructure and its image repertoire—gave cover to a meaningfully anti-assimilative cultural practice. With respect to jazz, the East Side made possible conditions of exploration untethered from the regulatory and profit regime of Village clubs, and enabled sustained dialogue about the relationship of revolutions of form to social protest and the usability of competing African, American, and European pasts. On the other hand, the historical inhabitants of

that same ghetto landscape—particularly the Jews who had left a defining impress on the material culture and iconography of the Lower East Side—figured with new force during the civil rights era as exemplary strivers after middle-class status and entry into the promised land of postwar suburbia: assimilation with a vengeance.

This double logic helps to account—or at least give context—for Baraka's own studied neutralization of the Lower East Side, and its iconic inhabitants, in his ongoing self-invention.[67] Old Left histories and coalitions were irrelevant to Baraka's version of the project (long familiar from modernist mythologies) of liberation of the artist's consciousness. Along with the European-descended aesthetic models in which Baraka had schooled himself, those histories would increasingly become a target for assault as he struggled to neutralize the effects of his personal past and to reinvest his debts to literary predecessors.

This dynamic underlies what is still one of the most often-cited poems of Baraka's career, "Black Dada Nihilismus," published in *The Dead Lecturer* (1964) and simultaneously released as a recorded track, Baraka reciting, on the premiere album of the newly formed free jazz ensemble the New York Art Quartet.[68] The published collection, "Black Dada" in particular, has been treated as a thrown gauntlet—warning and notice of a newfound commitment on Baraka's part to a "rhetoric of rage" and a politics of "intransigent confrontation"; "so urgent is their purpose," famously remarked poet Richard Howard in his review of *Dead Lecturer* in the *Nation*, that "not one of [his poems] can trouble to be perfect."[69] But if this transitional poetic work was, as Baraka later noted, an attempt to negotiate with the force of Ginsberg as "artistic model . . . whom I thought most about in terms of the road I was moving along" (AB 192), then "Black Dada" achieves a certain perfection in its refiguration of the terrain of Baraka's poetic activity.

Critics (in every sense of the term) have focused determinedly on the poem's central invocation of its key figure of descent, straining against the very traditions of thought that condition its vision of sacred violence:

> Come up, black dada
> nihilismus. Rape the white girls. Rape
> their fathers. Cut the mothers' throats.
> Black dada nihilismus, choke my friends
> in their bedrooms with their drinks spilling
> and restless for tilting hips . . .[70]

Baraka clearly thrived on the outrage this provocation generated. A reviewer writing in the New Left journal *Ramparts* noted that he was being "laved with cocktail party love and lionized with literary laurels" in a "culture scene . . . titillated by his maledictions."[71] But Baraka's recording of the poem—highly stylized, self-conscious, performing his own take on the bardic breath championed by the Beats—makes it clear that his real battle in "Black Dada" is psychic and internal. The same critics who focus on "the murder we intend" as a speech act and threat have failed to note the specific, fully accomplished act of ritual slaying—Bloomian, Oedipal, countercultural, what-have-you—at the core of the work. Ginsberg's "Kaddish," to which "Black Dada Nihilismus" needs to be read as in part a poetic rejoinder, wrested the act of Jewish American return to the Lower East Side from the grip of the alrightnik's nostalgia and middle-class sentimentality. Insisting on the corrosive power of the assimilation project, Ginsberg reanimates the collective site of origin, imbuing it with the urgency of lived history in a prophetic register. "Black Dada" stakes its claims on Black Arts by emptying the field of poetic or spiritual awakening of any such previous achievement—in particular, of Ginsberg's own.

More specifically, the Jew becomes Baraka's exemplary poetic figure for assimilation as the latter has been theorized in *Blues People*: a cancerous introjection of Anglo-European and bourgeois norms, sapping the capacity for collective experience and the will to resistance from within. If "The protestant loves . . . /the/ugly silent deaths of jews/under the surgeon's knife. (To awake on/69th street with money/and a hip/nose"—note here the open parenthesis that marks the failure of psychic boundaries—it is pointedly against the latter's willed surrender to the knife that the speaker of the poem seeks his own "cleansed purpose," shapes his dedication to "the secret men, Hermes, the blacker art," and creates a space of invocation for "a lost god damballah," who may "rest or save us/against the murders we intend/ against his lost white children."[72] Baraka commits the ultimate act of poetic appropriation, transforming the Jew into a willing collaborator in his own destruction: genocide by acquiescence. He thus makes the Jewish-inflected Lower East Side past and the Jew in the postwar landscape equally unavailable as figures of meaningful social resistance. Countered and aimed against the "silen[ce]" of the Jews's "ugly . . . deaths," the poet's "Black scream/ and chant/scream,/and dull, un/earthly hollering" comes into being and gathers its primal force. On this contested territory, the founding voice—the revolutionary "yeh," the primal sound—of Black Arts is raised.[73]

The imperative to neutralize, in the form of "hurling denunciations at the place of my intellectual birth" and disfiguring key predecessors there (AB 227), defined Baraka's growing commitment to Black Arts and their pursuit well beyond his transitional era. Controversy has long swirled around these disfigurations, which define key moments of Baraka's career: his storied abandonment of the Lower East Side (and "my white wife" and their daughters) for Harlem in 1965; the poetic license he took with a rhetoric of "extermination" of the figure of the "jewboy" in his 1967 throw-down for a black nationalist Black Arts, *Black Magic*; his coded invocation, in a 1980 *Village Voice* essay titled "Confessions of a Former Anti-Semite," of Jewish and Lower East Side predecessors as figures for violent sacrifice: "I think of myself as a product of an old world, one that needs to be destroyed. Jews are part of that world."[74] Debates about anti-Semitism in his work, intensified by Baraka's post-9/11 poem "Somebody Blew Up America," have continued apace after his death. More relevant to a view of the afterlives of the Lower East Side as a contested terrain, a resource for postwar projects of dystopia and dissent, is Baraka's account of the moment of his severance "from white people and a 'shadowy' life as Kin[g] of the Lower East Side": "My head," he later wrote, "was a swirl of images" (AB 219, 227). Baraka thus maps the territory on which his own self-invention and the birth of Black Arts were unfolding: a real and imagined space, shaped by histories of assimilation and its failures and contests over the production of a durable image repertoire, an imagery of social and not just poetic consequence.

That Baraka was himself a target of this activity—and inextricably bound up in it with the histories he sought to neutralize—is strikingly clear in a comic published in May 1965, just weeks after Baraka's departure for Harlem, in the seminal underground journal *The Realist*.[75] Born in 1958, the journal was the brainchild of Paul Krassner, one of Ken Kesey's Merry Pranksters and soon to become a founding member of the Youth International Party (Yippies); *The Realist* was one part each *Mad* magazine, political theater, and dissent from the society of the spectacle. In a thinly disguised parody of Baraka, "The Adventures of Superiorman!" tracks the double life of one Leroy Baldlose, a.k.a. Superiorman, who flies across the city sporting a gaudy cape, fez, and jackboots, aiming "to win back his soul brother from those most evil of evildoers . . . white liberal race mixers," by unleashing his "secret weapon: the tirade!"[76] Having accomplished his mission, Superiorman flies home, leading with a third-finger salute, to "his wife and children in their 19-room, humble abode." Here, Baraka's

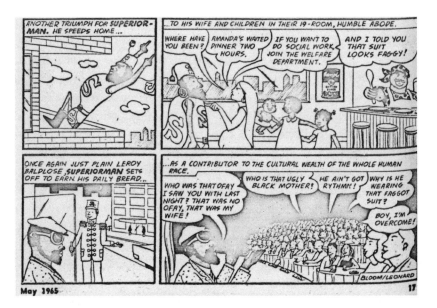

FIGURE 5.9. Detail, Leonard Bloom, "The Adventures of Superiorman!," *The Realist* 59 (May 1965), 17. University of Michigan Library, Special Collections.

self-fashioned habitus of Cooper Square has been transfigured—or more accurately disfigured—as its inverse (figure 5.9).

Black Arts experimentation is swapped out for high bourgeois domesticity and the iconography of Aunt Jemima. Baraka's intensifying critique of white-owned institutions of art production, and his considerable success generating alternative venues for publication, are displaced by the image of Andy Warhol's soup can. (Warhol had premiered the series in 1962, and it quickly became a metonym for the complicity of pop art's own cultural life with the consumerism that animated it.) Perhaps most strikingly, *The Realist*'s comic disfigures Hettie Jones née Cohen as a kind of WASP fury: blonde, all-powerful, fertile, judgmental—another version, perhaps, of Baraka's Lula in *Dutchman* (1964), whose calculated seduction and vilification of the black subway passenger Clay ends in her coolly stabbing him through the heart. Finally, the whitewashing of the figures who stand in for Baraka and his soon-to-be-ex-wife, the gentrification of the transitional and generative space they inhabited, has the intended effect of returning Baraka to the contradictions of an ideology of black "sincerity." ("It was very messy," he himself later noted [AB 221].) But it also lambastes Baraka's

status as the creature of an ethnically inflected Jewish sensibility, one the creators and many of the producers of *The Realist* embodied and shared. Thus Baraka stands in the place of exhortation, confronting his knowing white audience in the person of a Borscht-belt comedian with aggressively self-referential shtick: "Who was that ofay I saw you with last night? That was no ofay, that was my wife!" Finally, *The Realist*'s erasure of the logic of Cooper Square mirrors Baraka's, and both suggest the utility of that erasure to a repurposing of the image repertoire of oppositional cultural politics. Baraka, like Ginsberg before him, occupies a territory of images: the revolution may not be televised, but it will be powered by images. Akin to the imagined destruction of the space of the Lower East Side in other genres and media, his acts of disfiguration seek to reclaim its generative powers for an as-yet-undetermined space of Black Arts and black self-determination. Like all utopias, Baraka's may be located "nowhere" (AB 202). Its conjuration is nonetheless the revolutionary poet's howl and elegy for Black Arts and black lives in one, and a key resource for the project of being and becoming radically inassimilable.

Chapter 6

Remediating the Lower East Side

Dystopia and the Ends of Representation

On August 5, 1950, the popular weekly magazine *Collier's* featured a chilling story titled "Hiroshima, U.S.A.: Can Anything Be Done About It?" Styled as a documentary yet entirely fictive, the lavishly illustrated article offered a painstaking account of a terrifying fate: the aftermath of a successful Soviet strike on New York City, following hard on US presidential acknowledgment that the Russians had succeeded in producing an atomic bomb. On the *Collier's* cover, a full-color aerial image features a telltale mushroom cloud forming over a devastated lower Manhattan island, with the remains of the Battery and financial district in the foreground and the Empire State Building in the distance, its distinctive limestone panels aglow with reflections of the blast (figure 6.1 and plate 5). Inside the journal readers were treated to a panoramic view of the devastation splashed across a full-color, double-page spread and overprinted with telegraphic confirmation of the strike (figure 6.2 and plate 6). In this rendering, fires rage throughout lower Manhattan from the East River to the Hudson and beyond. Both the Brooklyn Bridge and the Manhattan Bridge have collapsed and sunk to the bottom of the East River. Black carbon, produced from the instantaneous incineration of tons of infrastructure, has already entered the atmosphere and darkened the sky; the pall of its livid smoke engulfs the city as far as the eye can see.[1]

I'll return shortly to the visual registers of these "documentary"—and decidedly predigital—images. First a view of the accompanying feature article by the *Collier's* associate editor, journalist John Lear. His text supplements the dramatic visual perspectives from above with ground-level observation that brings the shock and horror of the impact and its aftermath

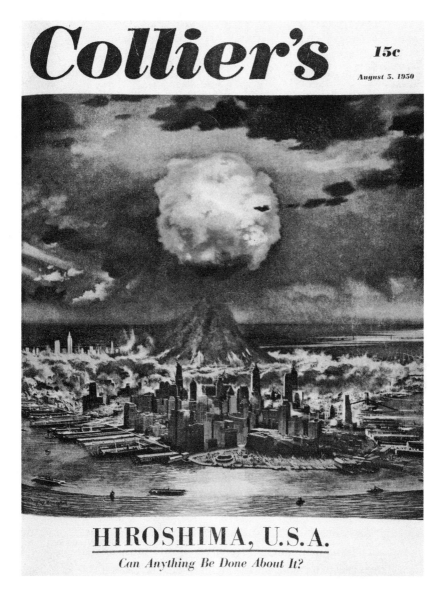

FIGURE 6.1. Cover, *Collier's*, August 5, 1950. University of Michigan Library. Photo credit: Austin Thomason. *See also* Plate 5.

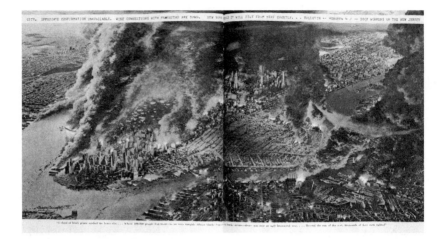

FIGURE 6.2. *Collier's*, August 5, 1950, pages 12–13. University of Michigan Library. Photo credit: Austin Thomason. *See also* Plate 6.

home, onto familiar representational territory. Lear's atmospheric opening reads this way:

> The hands of the clock on the south wall of Cooper Union stood out sharp and black against the worn red stone. Thirteen minutes after five. The time was visible for blocks down the Bowery, where . . . broad hot shafts of midsummer sun were driving through the lower windows of the west, making the sidewalks shimmer and stink beneath their burden of the misadventures of Monday night's derelicts.[2]

The *Collier's* animation of the documentary register is evident in the echo of John Hersey's bombshell account of the bombing of Hiroshima, published four years earlier, which begins by telling the time of catastrophe.[3] Beyond that, what better way to press the documentary character of the *Collier's* enterprise than to train a documenting gaze on those familiar figures of Lower East Side lore, Bowery bums—"unhappy creatures" who "drifted" along the pavement, "listlessly exchanging powerful gusts of rum and gin, each too deeply involved in the mechanics of his personal navigation to concern himself with any of the others" (11)? As preceding chapters have made clear, denizens of the Bowery had been staple objects of realist narrative and urban reportage for more than a century. They remained, in the postwar era, a default point of departure, a resource for coding the documentary enterprise as such. Ultimately, however, pressing the effects of nuclear

devastation in America requires that the reporter focus on a more estimable figure. Sustaining a ground-level view, Lear's narrative abandons the derelicts to trail "a tall distinguished graybeard" exiting a quick-lunch counter on Houston Street, close to the epicenter of the strike. Here, we presume, is a human loss that can count and be counted. Weeks later, "when they reached the spot" and "cleared away the wreckage of the El's steel frame and the rubble" of the immigrant, working-class city—"the Uncle Sam House, the barber school, the headquarters of the National Chinese Seamen Union, and the shop which advertised BLACK EYES MADE NATURAL—*15c*"—the only index to the devastation is a "shadow burned into the cracked and chipped concrete," the "radiant heat etching" of the graybeard "in the act of wiping his brow" (11).

Lear goes on to detail the aftershocks, fireballs, ash clouds, and panics that spread across the city, seaboard, region, and nation—all the implications of the horrific "fact" that *"An A-bomb fell on the lower East Side of Manhattan Island at 5:13 P.M. (edt) today"* (13; emphasis original). The journalistic and media point of Lear's hypothetical documentary accounting— down to convincing statistics and vivid descriptions of death, trauma, and damage to civic infrastructure—is to awaken a post-Hiroshima American public to the fact that, in a climate of intense anxiety about Soviet military power, "we are pathetically unprepared to face . . . any A-bomb threat" (62). An editorial titled "The Story of the Story" details a *Collier's* investigative method for producing this awakening. Lear's preparation included extensive research and interviews with the staffs of the Atomic Energy Commission, War Department, and Defense Department and other nuclear physicists and engineers. He and his research team calculated likely death and injury by correlating census figures on population in New York City with AEC data on the bombings of Hiroshima and Nagasaki (invoked without irony or comment). Their modeling, the editor confidently assures us, is meticulous, and "Every place and name used is real" (11).[4]

The one structural fact of the enterprise that goes unremarked—that appears, in other words, to need no explanation—is the siting of the fictive strike. To be sure, New York remained, in 1950, the most populous and densest city in the United States, with 7,891,957 total inhabitants in its five boroughs and 25,046 residents per square mile. And it was, Lear noted, "our greatest port, our most vital assembly and dispersal point for troops" in the context of the recent world war (64). For all these reasons, Manhattan would have been readily imaginable as the default target at the

outset of the Cold War for a preemptive bid for world dominance.[5] But why, we might ask, the particular spatial logic of the strike and of Lear's ground-level account? Why choose as a point of narrative origin Cooper Union, that iconic site of radical political discourse, of African American, immigrant, and labor activism, whose Great Hall was the venue for Abraham Lincoln's decisive 1860 "right makes might" address opposing the extension of slavery, of Frederick Douglass's postemancipation rallying cry to African American troops, of important addresses against Indian removal during the 1870s by Native American leaders like Red Cloud and Little Raven, of key speeches for women's suffrage by Susan B. Anthony and Elizabeth Cady Stanton, of the Yiddish-language address by shirtwaist-maker Clara Lemlich that kicked off an epochal garment workers' strike in 1909, the same year in which the first public meeting of the National Association for the Advancement of Colored People was held on that site?[6] Why too the Bowery, the union hall, the tattoo parlor, the Third Avenue El, the downtown lunch counter, the view from across the East River? Why the Lower East Side as the go-to "trouble zone"—a self-evident site for imagining and envisioning the "eventuality" of world-historical, epoch-defining disaster (13)?[7]

Tactical thinking alone would not make this siting self-evident. If, as Lear notes, "a half million people live below 28th Street," making lower Manhattan a diabolically attractive target, other parts of the city in 1950 had equal and even higher density rates.[8] Ultimately, the choice of the Lower East Side seems predicated on the midcentury image repertoire of the ghetto and tenement district as a Möbius-like space: on the one hand, a historical zone of threat, danger, and everything potentially inassimilable to the American way of life (including Communists, radicals, Jews, and foreigners—figures of once and future menace); on the other, a crucible for metropolitan Americans—model minorities and alrightniks, imagined by Lear as urban citizens who "loved New York" and have thrived under the sway of "its magic spell" (61).[9] It is precisely these twinned social and temporal effects that make the Lower East Side the default choice as ground zero in this *Collier's* scenario, available both to conjure and to mediate Cold War angst. Janus-faced, the Lower East Side looks backwards and ahead. It materializes a blighted past and a promissory note on American futurity; it signifies both inhuman impoverishment and affirmative community, available to be harnessed to the postwar project of liberal democracy. Other spaces in the postwar city boast denser infrastructure, vastly greater capitalization,

far more prominent institutions for commerce, culture, military activity, and art. But none is so available to mediate—to make experientially real, for readers—the challenges that face Cold War America, a democracy that is "not a good risk until it prepare[s] itself to survive" (62).

The value of the Lower East Side as a resource for the *Collier's* thought experiment in mediation becomes clearer when we consider Lear's "documentary" text in more detail. The initial apprehension of the attack, registered by an observer at a safe distance uptown, is "a babel of confusion" beneath "Great waves of purple and pinkish brown billo[wing] across the city," "the powdered ruins of thousands of brownstone tenements" (13). In the near aftermath of the attack, aerial reconnaissance offers little more clarity. A "cloud of black grime . . . masked the lower city," whose streets "could not be seen plainly":

> Many were blotted out entirely. In an area roughly 15 blocks long and 20 blocks across—from Canal Street north to Tenth and from Avenue B to Sullivan Street—where 100,000 people had lived—there was now an ugly brown-red scar. A monstrous scab defiling the earth. Somewhere in it, New York police headquarters, Wanamaker's store, the pushcart market of Orchard Street, historic St. Mark's-in-the-Bouwerie and the famous arch of Washington Square were flattened beyond recognition. (15)

All that remains of Manhattan between 38th Street and Battery Park is a vast tract of rubble, debris, and ash—"an agonized welter of suffering" and ruin, topped by the ominous fireball and mushroom cloud that are turning the sky over the Lower East Side "into a vast upsucking chimney" (15, 6). Long after the moment of impact, devastation radiates outward from the epicenter and intensifies. Tens of thousands of homeless men, women, and children are left adrift, "roam[ing] the streets above Times Square" (62). Vermin and rodents, "attracted by the stench of decomposition within the bomb blast scar," create epidemic conditions across southern Manhattan, which only worsen when inhabitants who had at first fled their ruined homes begin to return (62).

In the context of histories of documentary observation, such accounting seems neither futuristic nor prescient but distinctly familiar. It is, in fact, the return of a history that has never been repressed. Ruins and rodents, scars on the urban landscape, unimaginable suffering and uncountable hordes, illegibility and defilement: these have been the terms of art—the

iconographemes—for representing downtown New York's immigrant, working-class tenement district and its inhabitants since the earlier nineteenth century. "Here," a firsthand observer writes of the area in 1850, "where these streets diverge in dark and endless paths . . . —here is the very type and physical semblance, in fact, of hell"; here, in the 1880s, "it is almost beyond the power of words to describe the fearfully congested condition" of the streets and dwellings, which are "a scene the full horror of which can only be appreciated by one who has gazed on it."[10] Here, in the closing decade of the nineteenth century, unspeakable tenement interiors disclose "shuddering showers of crawling bugs" that scatter only to reveal "the blacker filth beneath," and the desperate immigrant who undercuts others' wages with his underpaid labor "lives like the 'rat' he is."[11] In these real and iconic precincts comes to rest the detritus "rifled from the dumps and ash barrels of the city"; here, in places of cheap entertainment and on the streets are displayed persons and objects writer Luc Sante has described as "too shoddy, too risqué, too vile, too sad, too marginal, too disgusting, too pointless" to find a home elsewhere.[12]

Given the evidence of preceding chapters, it comes as no surprise that Lear's account would reanimate a historical image repertoire of the primitive, atavistic, wasted Lower East Side as a terrifying, postatomic, dystopian future. In the *Collier's* "reportage," the midcentury project of urban renewal for which the historical tenement district was a key target reappears as a fantasy of demolition gone amok. The once teeming ghetto is now atomically uncontainable, its iconic tenements pulverized to contaminated waste in the form of "ashes" and "cloud" that blanket the entire city. Likewise, the historical "babel" of the immigrant streets recurs as a condition of unfitness to which the city's traumatized residents regress. The entire population of lower Manhattan is reduced to the state of dazed and homeless paupers, the kind of "helpless human wrecks," in Jacob Riis's words, who figured so prominently in nineteenth-century exposes, sensational journalism, reform tracts, and naturalist fiction of the ghetto.[13] The ravaged Lower East Side of the other half has rematerialized as an "upsucking chimney," threatening, in Lear's imaged future and in the *Collier's* "documentary" imaging, to draw the entire city and all its landmarks of cultural achievement, economic might, and power into its vortex.

Familiar as they may be, the nature and effects of this reanimation are of special interest with respect to postwar modes of mediation and our ways of accounting for them. All at once, the *Collier's* project implicates the mediation

of contemporary social experience by durable image repertoires; the mediation of documentary practices by the invocation of their limits; and above all, the status of print culture itself as a defining institution of postwar American life. The *Collier's* uses of the dystopian resonances of the ghetto not only enable a convincingly realistic rendering of the looming doomsday scenario. They also allow the journal to stage an attempted resuscitation, a remedial intervention into its own mission and agency as an organ of mass print. To that project, its own history is highly germane.

Founded in 1888 as a magazine of "fiction, fact, [and] sensation," *Collier's* took its place in a burgeoning print media ecology as one of a handful of new, lower-priced national weeklies for a growing readership; its competitors included *Cosmopolitan*, *McClure's*, and *Everybody's*, each with a distinctive profile.[14] *Collier's* achieved considerable success early on—its circulation by 1892 had reached a quarter-million a week—but it broke decisively from the pack and skyrocketed to cultural prominence on the eve of the Spanish-American War, whose prosecution by the United States *Collier's* aggressively promoted. In particular, the journal distinguished itself by demonstrating "quick appreciation of the possibilities" of covering the unprecedented events in Cuba (guerilla resistance to Spanish colonial power in a region of increasing relevance to US interests) "with words and pictures."[15] By way of covering the Cuban insurgency, it became a leading exponent of the use of halftone technology—quickly associated, as we have noted, with the ghetto and the specter of inassimilability as key subjects of representation.[16]

To exploit the rich possibilities of photo-based image reproduction, *Collier's* recruited the pioneering photojournalist James H. Hare, who "wrote the handbook" on photojournalism in his evolving work on Cuba and later sites of colonial and global conflict. (As one *Collier's* editor put the case, "the Maine blew up and Jimmy Hare blew in.")[17] Hare's service in and around Havana not only included collaboration with Stephen Crane, then serving as a war correspondent for the New York dailies, but a key spot of espionage on behalf of the United States, proffering military assistance to the anti-Spanish Cuban resistance.[18] Hare's unprecedentedly intimate, real-time images of the Spanish-American War, beginning with provocative shots of the wreckage of the *USS Maine* in Havana Harbor, created an immediate sensation (figure 6.3). (The *Collier's* editors boasted that Hare's "pictures . . . sell better than those of noted beauties and other celebrities"—a clear win for its new media strategy.)[19] Largely on the strength of such photo-centric

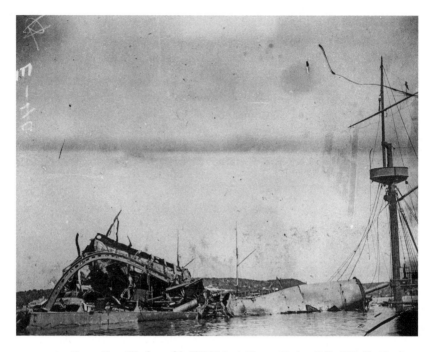

FIGURE 6.3. Jimmy Hare, *Wreckage of the USS Maine in Havana Harbor, Collier's Weekly,* March 12, 1898. James Hare Collection, Harry Ransom Center, the University of Texas at Austin.

coverage, the journal took its place as "The National Weekly" for an end-of-century America on the brink of its own imperial mission.[20] More broadly, the *Collier's* war coverage generated a new approach to journalistic illustration, training the American reader to become, photo historian Thierry Gervais argues, "a spectator of the news."[21] To the extent that readers were receptive to real-time shock effects, they were well primed to respond to the muckraking ethos with which *Collier's* became associated in its aggressive, influential campaigns for slum clearance, reform of child labor laws, and women's suffrage. Forging into the twentieth century, *Collier's* led the way in using photographic images to reposition print journalism as the definitive form for shared experience of America's modern moment.

By 1950, *Collier's* had every reason to turn to this illustrious past for inspiration. Post–World War II, the register of outrage, inflected by progressive, global military, and New Deal contexts, had become old news. Although the journal had achieved a certain "chromatic glory" after 1948,

with the use of color photographs for covers and four-color images on internal pages, that innovation was in itself insufficient to address the changing tastes of urban readers, who were rapidly losing their prewar appetite for general-interest mass weeklies.[22] In a bid to compete with a rising range of special-interest magazines focused on specialized lifestyle and leisure pursuits, *Collier's* doubled down on its historical investment in sensation, seeking ways to show itself "a little sexier, a little more violent."[23] What could be more sensational, in the attempt to revive a dying print organ in the context of the waning relevance of a long-defining sector of print media, than splashy full-color imaging of an A-bombed lower Manhattan? Paradoxically, however, in order to make immediate and real this vision of once and future devastation, *Collier's* was forced to enlist visual technologies that predated its early groundbreaking uses of mass photographic reproduction. Absent the possibility of photographs, well before the possibility of digital imaging, how to create convincing "documentation" of a nuclear strike that has not (yet) occurred?

The *Collier's* response to this challenge can be understood as an experiment in Jay David Bolter and Richard Grusin's version of remediation: the project of replacing one medium with another through representation of the precursor's logic or effects.[24] Whether keyed to production of an experience of transparency—"to get past the limits of representation and achieve the real"—or of its inverse, hypermediacy—to make us aware of representation as such, heightening the experience of encounter by multiplying the effects of mediation—the goal of remediation, Bolter and Grusin argue, is always to "reform" or "rehabilitate" media themselves.[25] So the word's broader uses suggest:

> The word remediation is used by educators today as a euphemism for the task of bringing lagging students up to an expected level of performance and by environmental engineers for "restoring" a damaged ecosystem. The word derives ultimately from the Latin *remediri*— "to heal, to restore to health." We have adopted the word to express the way in which one medium is seen by our culture as reforming or improving upon another.[26]

Although they focus on digital new media and its logics of authentication, Bolter and Grusin gesture toward a longer history of remediation (map objects in paintings, the mode of print in the telegraph, cinema in

television), and note that its practice "operates in both directions," temporally speaking—that older media can seek to appropriate new modes or technologies of reproduction.[27]

This conceptual framework helps clarify the logic of "Hiroshima, U.S.A."—and, ultimately, the role of the historical ghetto as a resource for the project of resuscitating image repertoires and media forms. The challenge for *Collier's* in 1950—to provide visual "documentation" of the Lower East Side as ground zero—was considerable. To meet it, the journal's editor commissioned a master of as-if imaging to produce the article's cover art and accompanying images: artist Chesley Bonestell. A onetime architectural designer, Bonestell had helped design the art deco façade of the Chrysler Building, the Plymouth Rock Memorial, and the US Supreme Court Building, as well as renderings of the Golden Gate Bridge. (Clearly he knew something about icons.) Based on this work, Bonestell had moved on to a significant career in Hollywood as a matte artist for special scenic effects. This meant, in the pre-CGI visual effects era, painting landscapes and locations, typically on glass, to synch with lighting and set-design elements. Done mainly for Warner Brothers and RKO Pictures and mostly uncredited, Bonestell's screen work included much-admired renderings of Notre Dame Cathedral for *The Hunchback of Notre Dame* (1939) and the Xanadu of Orson Welles's *Citizen Kane* (1941; figure 6.4), exemplary feats of conjuring apparently real spaces from thin air.[28]

From early in his career, however, Bonestell sought to create even more dramatic reality effects. Exploiting his specialized knowledge of scenography, camera angles, and photographic effects along with his expertise in modeling, he developed a special technique: making sculptural models, photographing them, and overpainting the prints to produce uncannily realistic images of astronomical events and bodies in deep space. Among these hybrid media images was a series focused on Saturn as seen from its moons that was published in *Life* in 1944 (figure 6.5 and plate 7). Nothing like these images had ever been seen before. They looked to *Life*'s viewers as though a *National Geographic* photographer had been sent into space, and were said—in a phrase resonant with the *Collier's* context—to have "hit the world of astronomy . . . like an atomic bomb."[29] The noted fantasy writer Arthur C. Clarke, a sometime collaborator of Bonestell's, noted wryly that the latter's "remarkable technique produces an effect of realism so striking that his paintings [sic] have often been mistaken for actual colour photographs by those slightly unacquainted with the present status of

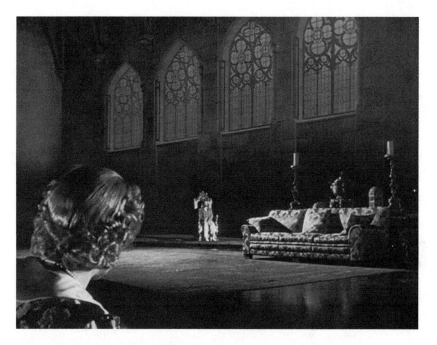

FIGURE 6.4. Screenshot, Orson Welles, *Citizen Kane*, 1941.

interplanetary flight."[30] Part sculptural, part photographic, part painterly, painstakingly keyed to available astronomical evidence yet supplemented by speculation, Bonestell's hybrid images appeared to midcentury viewers to be wholly indexical. So convincing were they as apparent trace evidence of deep space that they have been credited with jump-starting the US space program; they made it possible for a broader American public to envision, and thus support, space travel as a project.[31] What better collaborator to realize images of a terrifying counterfactual event?

Notably, however, the visual objects Bonestell produced for the two contexts—interplanetary space and the Lower East Side—differ significantly in their effects. To realize an A-bomb strike on lower Manhattan, Bonestell used a version of his signature hybrid production techniques, working as a painter with photographic sources and aiming to code, or remediate, the resulting artisanal images as in some way photographic.[32] Yet in spite of their basis in aerial photographs (an early specialty of the *Collier's* founding photographer, James Hare), Bonestell's A-bomb images lack the tonal subtlety and richness of detail of his renderings of deep space.

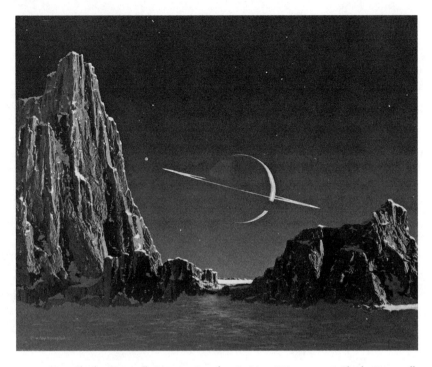

FIGURE 6.5. Chesley Bonestell, *Saturn as Seen from Its Moon Triton*, 1944. © Chesley Bonestell. Reproduced courtesy of Bonestell LLC. *See also* Plate 7.

For twenty-first-century viewers conditioned to complex photo-realistic effects, the disaster images in *Collier's* appear much more closely aligned with the visual register of midcentury commercial illustration than that of photographic documentation. (No digital native would read them as photo-realistic.) Nor do they efface the traces of their own mediation, as images aiming for transparency and the felt effect of immersion in the real tend, pace Bolter and Grusin, to do: note the artist's signature on both pictures and the telegraphic banner overprinted in lurid yellow on the double-page spread.[33] However midcentury readers registered such cues, they would have been very familiar with the codes of photo-documentation as such. How then to account for the presumption of a reality effect, one that would be convincing—or at least suggestive enough—in context?

Here, which is to say in the pages of *Collier's* sutured to the Lower East Side, content trumps form. The durable power of that site and its once-and-future ghetto as a resource for the imagination of disaster—dystopia, threats to the health of America—not only intensifies the perceived photo-realism of

"Hiroshima, U.S.A." It is their condition of possibility. Just as the invocation of a documentary stance or way of seeing, however hypermediated or obviously constructed, speaks to the historical and ongoing need for remedial work on the Lower East Side, the invocation of the Lower East Side, as a social space and a figure for the making of America, suggests the opportunity to restore or transform apprehension and its forms—media themselves. It creates the possibility of restoring their agency for making real to American citizens the legacy of America's underworld, which is also its historical point of entry into modernity. In other words, remediating the threat of disaster long signified by the Lower East Side supports the project of remediating images in print, and mass print culture itself. Animated by temporal instability, social promise and threat, the Lower East Side offers itself at midcentury as a powerful resource for this project. In the pages of *Collier's*, the space that lends itself to dystopia and a waning print ecology become mutually mediating, and thus gesture toward a doubly remedial effect.

In the short term, *Collier's* found the fictive documentary approach so rewarding that it doubled down, devoting its entire October 27, 1951 issue to a Cold War mirror image, an "Imaginary Account of Russia's Defeat and Occupation, 1952–60," reported by a team of journalistic heavyweights, including Edward R. Murrow and Walter Winchell.[34] In this *Collier's* scenario, however, the effects of nuclear warfare stateside are less than apocalyptic because of extensive US civil defense preparations. (This is, after all, an exercise in fantasy.) In contrast to "Hiroshima, U.S.A.," the prevailing visual mode here is that of graphic illustration, featuring the Pulitzer Prize–winning World War II editorial cartoonist Bill Mauldin, widely known for ground- and grunt-level depictions of the rigors and privations of warfare. The issue does include two hybrid photo-based images made by Bonestell, reprising moments of nuclear strike: one in Washington, DC, the second a decisive UN retaliatory strike on Moscow. These are more clearly coded for readers, however, as speculative, absent the registers of contending media (photographic, transcriptional, documentary, artisanal).[35] Perhaps the *Collier's* editors surmise that readers are onto their strategy; perhaps the resonances of global atomic warfare have become too fraught to conduct this thought experiment in any kind of photo-realistic register. Or perhaps it's self-evident that visualizing the as-if mode is a distinctive project on the Lower East Side, still and again offering itself as a site of social threat, temporal instability, and key challenges to futurity, and of experiments in representing and mediating them.

Alas for *Collier's*, the experiment with hypothetical documentary had short-lived success. Structural changes in the organization of print media, in the context of the rapid rise of television during the 1950s, meant the journal's days were numbered. Its final issue appeared on January 4, 1957; even lurid four-color images of atomic disaster and civil dystopia weren't remedial enough. But the case of *Collier's* evidences the availability of the Lower East Side as a site for the postwar project of remediation. It also raises productive questions about how far the notion of remediation can carry us in any account of the historical contexts and experience of postwar media. To what extent does the attempt to reanimate or remediate mass print journalism intersect with the reinvention of a genre or field of practice we recognize as documentary? How, more broadly, should we account for the relationship between genre and media form, or the incremental changes we recognize as native to the ongoing life of genres and the aspirational, transformative energies said to define remediation as a disposition, a shared enterprise, a gestalt? At what point can we draw confident distinctions between visual and narrative effects within print culture, or with respect to a socially formative image repertoire?

The editors at *Collier's* reflexively imagined the Lower East Side as ground zero, a black hole into which the futures of print culture and America alike might vanish—and, potentially, the site on which both might be reanimated and made whole. In the evolving postwar context, the same site figured in other very different projects as another kind of flash point: a point of entry into durable histories of failed assimilation and temporal uncertainty, in response to which alternatives to a hardening cultural consensus (suggested in part by *Collier's*) and the nightmare of postatomic conformity might be given shape. Let me turn now to one of these in order to explore further the force of such questions.

"Hiroshima, U.S.A." was just one of many postwar projects undertaken under the sign of documentary conventions that invoked the Bowery. The same site drew a wide range of postwar image-makers to engage in very different kinds of remediation. Case in point: in 1974, having completed an MFA in the maverick visual art program at the University of California San Diego, the Brooklyn-born artist Martha Rosler returned to New York and began making photographs on the Bowery, a site intimately familiar to her from her own sometime residence on the Lower East Side. It wasn't nostalgia that drew Rosler, however, but the force of that site as what she

called "an archetypal skid row."[36] To put this another way, she was inter-
ested in the same social and representational histories that had made the
Bowery a default point of departure for the *Collier's* narrative of atomic
dystopia. In particular, she focused on its longtime association with that
scourge of Protestant sobriety, inebriation. This Bowery was a specific
version of the one that had drawn Stephen Crane and Paul Strand: the
only major thoroughfare in New York City never to have had a church
built on it; the space described, from the mid-nineteenth century well into
the twentieth, as a scar or wound on the map of the city, slicing through
historically marginal neighborhoods and historical eras alike.[37]

As early as the 1820s, Bowery dives catering to alcoholics introduced the
three-cent, no-glass fill-up, served from behind-the-counter barrels via tubes
to customers who imbibed until they were forced to draw breath. During the
1890s, the Bowery was home to more than half of the saloons south of Four-
teenth Street, including such infamous spots as Suicide McGuirk's, Chick
Tricker's Flea Bag, and Owney Geoghegan's Hurdy-Gurdy—targets of police
raids, reform campaigns, and sensational press.[38] Vaudeville artists of the
1910s sang about the Bowery's perpetually drunken clientele; Prohibition-
era drinkers headed there to buy hardware-store shellac to mix with Coca-
Cola, stepping over unconscious bodies piled, as one denizen put it, "high'n
a sinkful of dishes."[39] During the 1930s and 1940s, the Bowery offered itself
up as the very emblem of the American Depression: dead end on the swift
slide from gainful labor, citizenship, and social visibility into a state of penury
beyond remediation.[40] From the 1950s through the mid-1970s (and a new
climate of post-Vietnam recession and stagflation), the Bowery was still and
again an iconic site of alcoholism, poverty, and petty lawlessness—and still
and again a staple object of documentary imaging.

Revisiting these intertwined histories of social marginality and documen-
tary practice, Rosler sought to face down that practice, and by extension its
power to define photography and its social uses. Moving down the Bowery
in imitation of the systematic block-by-block surveys of earlier social work
and reform photography traditions, she produced a body of images of a type
so familiar as to risk banality. Black-and-white, predominantly frontal, they
feature weathered façades, storefronts in varying states of economic dis-
tress, and the debris of the hard-knock life—most notably, liquor bottles
left behind in recessed doorways or drained and left empty on the street
(figures 6.6, 6.7). In stance and formal effect, Rosler's Bowery photographs
mimic the studied objectivity that was critical to the rhetorical power of

FIGURE 6.6. Martha Rosler, detail of *The Bowery in two inadequate descriptive systems*, 1974–1975. Suite of 45 gelatin silver prints, each framed board 10 × 22 in. 25.4 × 55.9 cm. © Martha Rosler. Courtesy of the artist and Mitchell-Innes & Nash, NY.

soaked	drenched
sodden	flying the ensign
steeped	over the bay
soused	half-seas-over
slŏshed	decks awash
saturated	down with the fish

FIGURE 6.7. Martha Rosler, detail of *The Bowery in two inadequate descriptive systems*, 1974–1975. Suite of 45 gelatin silver prints, each framed board 10 × 22 in. 25.4 × 55.9 cm. © Martha Rosler. Courtesy of the artist and Mitchell-Innes & Nash, NY.

state documentary during the New Deal era, and became differently critical (through the canonization of Walker Evans's work) to the postwar reclamation of documentary for the sphere of art. But Rosler's photographs, in distinction to the vast archive of Bowery images made in the name of exposure or reform, are strikingly empty; as she put it, they miss "the basics of traditional documentary—narrative and people."[41] Absent from them are the usual suspects: the disheveled, down-at-heels, perpetually inebriated subjects of nearly a century of documentary exposure, Bowery bums.

The *Collier's* use of the Bowery bum as a point of dystopian departure suggests how ubiquitous that figure had long been in the image-archive of the city. In the foundational work of Jacob Riis, Bowery inebriates appear as the clientele of the most pernicious establishments catering to the structurally unemployed. In one of his most widely reproduced images, the men supine in their rows of cots in a last-ditch Bowery lodging are nearly indistinguishable from the filthy clothes in which they sleep, and from one another (figure 6.8). By contrast, social reform photographer Lewis Hine's

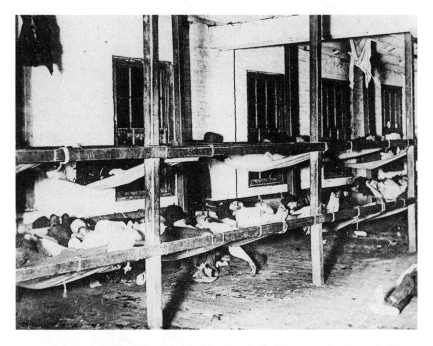

FIGURE 6.8. Jacob A. Riis, *A Seven-Cent Lodging House in the Bowery*, ca. 1895. Henry G. (Henry Granger) Piffard (1842–1910) and Richard Hoe Lawrence for Jacob A. (Jacob August) Riis (1849–1914). Museum of the City of New York. 90.13.1.327.

FIGURE 6.9. Lewis W. Hine, *Midnight at the Bowery Mission Breadline*, 1906–1907. Gelatin silver print, 11.5 × 14.9 cm (4 ½ × 5 ⅞ in.). Gift of John C. Waddell, 1998 (1998.91) Image copyright © The Metropolitan Museum of Art. Image source: Art Resource, NY.

image of a midnight bread line at the landmark Bowery Mission—itself an icon, serving homeless and alcoholic men since 1879—insists on the individuality of his tightly framed subjects (figure 6.9). Their varied headgear and expressions suggest distinctive relationships to the social order that has failed them. But their individuation only confirms the inadequacy of the charitable sympathy it means to elicit. Insofar as they embody the pathos of the drunk and destitute, Hine's subjects are living kin to Theodore Dreiser's Hurstwood, who ends his desperate search for bread, work, and recognition in a dingy Bowery rooming house, breathing in gas from an unlit jet and asking, "What's the use?"

By the late 1910s, as the progressive-charitable dispensation waned, Bowery men featured in stock commercial and news agency photos as admonitory or essentially pictorial figures of stupor and unconsciousness. Thus arrested, the derelict becomes pitiable or irritating rather than threatening, and unavailable for recruitment as a member of a class or social collective. He (always he) also features as the product of his own moral

shortcomings rather than an exemplar of the unfulfilled promises of modernity or the democratic state.[42] In the wake of such images, midcentury documentarians experimented with the formal and aesthetic possibilities of skid row in the registers of irony and detachment, suitable to a cooler ethos. Photojournalists like Weegee (so-called because his police-band radio allowed him to arrive with uncanny speed at scenes of mayhem and murder as if he were clairvoyant, like a human Ouija board) made Bowery bums and their world the stock-in-trade of a more mordant, more subjective documentary (figure 6.10). Later documentary image-makers returned to the familiar figure of the Bowery dropout to figure a constitutive, generalized condition of alienation in modern times (figure 6.11).[43] In these and other registers, the Bowery bum functioned to give currency to the gritty authenticity of the documentary mode and to the alert sensibility of the photographer who employed it. It was, Rosler would note, an easy slide from Bowery denizens as a natural subject for documentary imaging

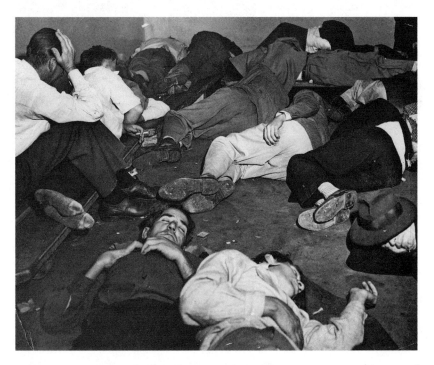

FIGURE 6.10. Weegee (Arthur Fellig), *Drunks, The Bowery*, 1950. © International Center of Photography. Getty Images.

FIGURE 6.11. Harvey Wang, *The Andrews Hotel*, 1998. © Harvey Wang. Courtesy of Traveling, Light, Inc./the artist.

to their function as guarantors of an unimpeachable and heroic realism, privileging documentary as a social practice.[44]

At the heart of Rosler's project, then, was the decision to leave the passed out, passed-over stalwarts of the doorway and gutter out of the frame, to resist making what she called "victim photography," with "stolen images" that could only confirm long-held presumptions as social knowledge—or worse, truth.[45] Mimicking or quoting photographic predecessors, Rosler raises the question of whether it might be possible to re-form documentary by confronting its history of use as a medium of reform. On the Bowery, in *The Bowery*, she works to displace the still-dominant humanist conception of photography as remediation: social management of the socially marginal. In order to achieve that end, Rosler conscripted a critical feature of

FSA practice, the self-conscious production of photographic images for use in print contexts, in textual and narrative modes. Rather than generate narrative captions or a shooting script conducive to photo-narrative arcs, however, she made lists of words describing drunkenness and alcoholism, collected from friends and acquaintances, sociological and reform agents, and Bowery denizens alike. Arranging them in associative clusters (for example, food-related phrases and military imagery), Rosler typed or printed the resulting word hoards onto stock paper, photographed them, and paired each grouping with an image with which it has uncertain relations. Sequencing these photo-text pairs to mimic the effect of movement downward—down the Bowery, and into more-troubled coherence—Rosler offers her title in the last of twenty-four image-text frames: *The Bowery in two inadequate descriptive systems*. Text and image, metaphor and index, description and transcription: however we identify the systems at work, they insist on their irreducibility to a coherent sign, their inadequacy to meaningful knowledge of a lifeworld overtaken by its uses as an icon for all that must be remedied in the name of American progress and futurity.

Since its inception, viewers have had the opportunity to encounter Rosler's Bowery work almost continuously. It would be hard to overestimate its impact and influence. Widely exhibited in both fine-art and community-based institutions, *The Bowery* has been claimed as a landmark in the annals of conceptual art, surrealism, post-pop, and a broader postwar avant-garde.[46] In large part, this reception has been conditioned by Rosler's critical "afterthoughts" on her own venture, published in the form of an essay in 1981. As art historian and theorist Abigail Solomon-Godeau puts it, it remains "the definitive analysis and demystification" of documentary as a social project, and continues to "haunt all documentary photographers to this day" (so much so, notes photographer and photo theorist Geoffrey Batchen, that it "has been difficult to get beyond").[47] In at least one important way, however, the effects of Rosler's experiment in remediation have been overlooked. In critical readings of documentary, her deadpan return to the Bowery features as an analytic strategy for making the entangled effects of documentary and American liberalism visible, and therefore available for redress in the realms of theory and practice. But the conditioning of that strategy by Rosler's own history has gone largely unremarked. The logic of her site work—which is to say, her broader project of remediation—depends on a distinctive, highly mediated relationship to the space she sets out to explore.

Let me pursue this claim in explicitly visual terms. Critics have noted that with careful observation, a viewer of *The Bowery in two inadequate descriptive systems* can discern the shadow of a human figure in several of its images (figures 6.12, 6.13). Shadows are the exemplary indexical phenomenon, in the sense that no shadow can come into being without a material body or object to cast it. (Hence the ubiquity of the shadow, at once material and insubstantial, as an early trope for the unprecedented effects of the photograph.)[48] With respect to *The Bowery*, the presence of shadows has been read as evidence of a critical double gesture on Rosler's part: a refusal to "see" her Bowery subjects photographically—to render them up as victims for an uninterested, sympathetic, or prurient viewer's experience—even as she harnesses the trace of their presence to insist on their irreducible being, their unavailability for a false social knowledge. It turns out, however, that this account of Rosler's shadows is a certain kind of remedial fantasy, a way of "fixing" documentary practice itself—and too good to be true. Just as the documentary tradition Rosler critiques found in the Bowery what it always already knew it would (as she puts it, "what could you learn" from images of that site "that you didn't already know?"), theorists of camera work have seen the evidence that confirms their accounts of her practice.[49] In fact, the shadows in question belong not to men of the Bowery at all but rather to Rosler's young son, who accompanied her on her photographic forays.[50] (Whatever role such early forays played in his education, he would go on to become an acclaimed maker of documentary and nonfiction graphic narrative.)[51] In *The Bowery*, then, the indexical sign par excellence points not to the bodies of invisible or unframed Bowery subjects but in effect to Rosler's own; not to the subject victimized by the remedial aims of documentary but to the mutual mediation of camera work and site work—including the negotiation of social contexts that, habitually left out of the frame, condition all documentary production.

That such evidence of Rosler's "positio[n] in the life-world" should remain so long obscured is striking, given the larger body of work for which she has been canonized.[52] Her early video *Vital Statistics of a Citizen, Simply Obtained* (1973; 1977) features Rosler, disrobing and then nude, being examined by white-coated figures who record her every possible physical metric, activating her own body as a site of ideological struggle and social control. Her best-known early work, *Semiotics of the Kitchen* (1975)—made, she recalls, "within a week or two" of *The Bowery* and soon established as a milestone of postwar feminist art—features Rosler, deadpan and aproned

FIGURE 6.12. Martha Rosler, detail of *The Bowery in two inadequate descriptive systems*, 1974–1975. Suite of 45 gelatin silver prints, each framed board 10 × 22 in. 25.4 × 55.9 cm. © Martha Rosler. Courtesy of the artist and Mitchell-Innes & Nash, NY.

FIGURE 6.13. Martha Rosler, detail of *The Bowery in two inadequate descriptive systems*, 1974–1975. Suite of 45 gelatin silver prints, each framed board 10 × 22 in. 25.4 × 55.9 cm. © Martha Rosler. Courtesy of the artist and Mitchell-Innes & Nash, NY.

FIGURE 6.14. Martha Rosler, *Semiotics of the Kitchen*, 1975. Video duration: 6:00 min. © Martha Rosler. Courtesy of the artist and Mitchell-Innes & Nash, NY.

before a fixed video camera, robotically demonstrating the uses of kitchen implements from "A" to "Z," transforming the alphabet into a semiotics of domestic "rage and frustration" (figure 6.14).[53] In conjunction with these works, the trace of second-order embodiment in *The Bowery* brings the question of mediation home, reminding us that the problem of inadequate, incommensurable systems of representation was native to Rosler; it was both her legacy and the condition of her coming into being as an artist.

Born during World War II to observant immigrant Jews originally from Central Europe, Rosler grew up in a largely Jewish neighborhood in Brooklyn in the second-generation context of fraught assimilation. As Cold War–era redbaiting intensified, she has noted, her parents were terrified of being identified with communism—more viscerally "terrified that the Gestapo would come in the middle of the night and take us away."[54] About the project of their own Americanization they displayed what Rosler called "total ambivalence." "So," she notes, "my mother was two people": "president of

the Sisterhood of the Crown Heights yeshiva" and "a member of the Girl Scouts."[55] Rosler describes herself as having come to feminist consciousness in response to Judaism's troubled legacy with respect to the status of women. An obsession with questions of justice was "a folk issue . . . among the girls in my [yeshiva]," at a cultural "moment of yelling *ze lo besede[r]* [this isn't fair]."[56] By her own account, an urgent need to address as such irreconcilable modes of valuation and representational histories came to define Rosler's artistic practice. Reflecting on her earlier work, she has noted that it was shaped by "two tendencies," both inflected by Jewishness. One was "to be completely abstract," "very Jewish" in the pursuit of "a kind of transcendent image"; the other, to be "very polemical and very engaged and indignant."[57] Sustaining both commitments, moving between them, Rosler sought a way to mobilize, if not repair, the condition of divided subjectivity—one that Lisa Bloom has described as the defining challenge for the "not fully assimilated Jewish female subject" of the postwar and second generation, she who is "unable to identify easily with either her American citizenship or her own immigrant group" (Bloom, 93–94).[58] In other early projects, Rosler's body enacts that condition, making it visible in her failed or parodic subjugation to regimes of assimilation and belonging. In *The Bowery*, the condition of division is reanimated by way of the social site, identified with documentary subjects marked by their hard-core inassimilability to time-discipline and sobriety. Further, this state of division is remediated as a face-off between textual and visual signs, each documenting failed incorporation into the progress narrative of postwar modernity.[59]

If at this point the question of what counts as a medium or an agency of mediation—generic forms, modes of production, aesthetic ecologies, the body itself—is unclear, so too the question, on this site and with respect to this sight work, who (or what) mediates whom. Photography, a medium that, Rosler notes, appeared at that moment in the life of postwar art practice to have "no critical history," was available to remediate the forms and practices of the art world—to function as "a system of representation that you bring to bear on other systems."[60] In its documentary mode, photography has been highly mediated in practice and ethos by Jewish American history and experience. (Hence Rosler's identification of documentary practice in New York of the era as, for many of its practitioners, "a Jewish self-help tradition.")[61] Jewish American experience of the postwar era is in turn mediated by representational practices and iconographies shaped in response to that key site of social formation and encounter, the Lower East Side. However we

conceive of this tangle of iconographies, embodiment, and spaces, Rosler remains interested not in unknotting it but in foregrounding what remains inassimilable to the social order and to documentary representation alike: the social being of her "*experiencing subjects*" as such.[62] More to the point, what is inassimilable on the Bowery and in *The Bowery* also resists remediation. As Solomon-Godeau has further observed, the "aristocratic perception of exemplary form to be found in, say sharecropper's shanties [in the work of Walker Evans], does not cross over the streets of the Bowery."[63] Rosler's Bowery subjects, like the real and iconic landscape of her encounter with the documentary tradition, cannot be similarly uplifted, revaluated, or made new. Quite the contrary: they serve to stage and make visible the failures of remediation (in every sense) that have defined the ongoing encounter with otherness on this site and in American modernity more broadly.

Returning to the trace evidence of Rosler's production of *The Bowery*, we might say that her work on this project puts into play the shadow histories of documentary. It makes visible the experiences of embodiment and embeddedness in sites of production that the legitimation narrative of documentary leaves at "the edge of sight."[64] More broadly, it insists on the mediation of documentary history and practice by its chosen sites of encounter. But the question of whether documentary can be remediated—given new social purpose and energy, new warrant for what Rosler calls "redescribing American life," in a way that conduces to better equity or justice, by way of new platforms or forms—remains open at best.[65] Rosler revisits the Bowery in order to stage the ends of documentary: the logic of its aims, the impasses it creates for any image-maker committed to "the engagement of art with real-world issues" and their remediation.[66] Retrospectively, she has noted that the possibilities opened by digital representational technologies—multiple and competing screens, varied types and levels of written text—"quite possibly" allow for documentarians "to renovate and reinvent" the form.[67] In this moment, however, the Bowery and *The Bowery* afford only a dystopian view, opened from a defining site of media and remedial experimentation.

■

The American novel is safe in Gary Shteyngart's gifted hands.
—DAVID MITCHELL[68]

From the dystopian realities of documentary to a remediated future practice: let me fast-forward to the digital, multiplatform, multimodal environment

toward which Rosler gestures—that is, our own. In an interview on NPR's *Morning Edition* on September 12, 2013, economist Tyler Cowen, author of *Average Is Over: Powering America beyond the Great Stagnation,* offered his confident predictions for economic and social life in US cities of the near-term future. Further rises in inequality, he opined, are inevitable. (No surprise there.) City-dwellers, who figure chiefly in their role as workers in a global information economy, will be ruthlessly quantified and graded, every part of their lives monitored, tracked, and recorded: "Everything will have a Yelp review. Workers will have 'credit' scores: how reliable are you? How many jobs have you had? How many lawsuits filed against you? How many traffic tickets?"[69] On the up side, such endless monitoring will reward discipline and creativity, generating wider opportunities for neoliberal winners: "Because we measure better and more over time, people who are truly talented will become millionaires more easily." Most citizens, not just this talented tenth (give or take), will be "liberated" from traditional forms of labor, although the vast majority can forget the American dream; they can expect, Cowen matter-of-factly notes, only "the income of lower-middle class." To help us picture this way of life, he invites us to "imagine a very large bohemian class of the sort that lives in parts of Brooklyn."[70]

Rarely does life imitate art or parody itself with such delicious irony. Cowen's predictive narrative could almost be a blurb for Gary Shteyngart's best-selling 2010 novel, *Super Sad True Love Story: A Novel,* a cyber-dystopian satire set in a New York City of the near future, or a slightly alternative present. In *Love Story,* New York has become the default capital of a globally corporatized, militia-ridden United States, at war with Venezuela (yes, we started it, in an attempted resource grab) and now a client state of China, which is threatening to pull the plug on a supersized national debt. This America's truly talented citizens, unlike the massive industrial reserve army of last-century workers, labor in three elite sectors defining the city's economic life: Media, Images, and Credit. They have their collective being in the militarized zones of the city's onetime public spaces—libraries have been shuttered; universities fully corporatized; the publishing industry has folded; consumer spaces have been reorganized as regulated "Retail Corridors" in protected enclaves. There, elite HNWIs (High Net Worth Individuals) seek up-to-the-minute luxury goods and use devices called äppäräti—a cross between smartphones, sonar, and the ill-fated Google Glass—to monitor incessant, constantly updated, visible data-clouds of the net worth, bodily metrics, and cultural capital of their fellow city-dwellers, and their own.

Superb as Shteyngart's satire is in offering us a futurity we already inhabit, in a key sense the city he imagines is also unrecognizable. His New York—or what's left of it—is mapped by characters as a series of sites promoted by popular consumer brands like TotalSurrender, AssDoctor, and Onionskin (transparent jeans designed to be worn without undergarments) that promise exciting lifestyle experiences and opportunities for spectacular visibility to fellow äppärät users, all for a hefty price tag, pegged to the yuan. What's missing from this geography of experience, it becomes clear, is the street: the raw space of contact, friction, exchange, spectatorship, mass action, observation, and wayward motion that has anchored social theory of the city and representation of urban life (particularly New York) for at least two centuries. In Shteyngart's vision, to borrow from Walter Benjamin, the urban street as a living spatial form has become an orchid in the land of digital technology. Jane Jacobs's eyes on the street have given way to data-transmission and data-collection apparatuses—"Credit Poles" designed to recall wooden telegraph poles, whose communicative function has been made risibly obsolete—trained on every inch of sidewalk and every passerby (54). Likewise, Jacobs's natural proprietors of the street have been expunged by corporate entities whose messaging penetrates urban infrastructure, infusing the very air. Screens, everyday objects, the environment itself is "alive with . . . information, numbers and letters and Images," flowing as the waters of the Hudson and East River once did to connect the citizens of Manhattan to larger worlds (86). In this "Post-Human," radically remediated city, there is no place, no usable past or human-scaled future. Social life, such as it is, is conducted across a series of data-use zones in which temporal experience has contracted to the radically presentist act of "updating"—all the better to stave off the all-too-human mortality that costly services like "Life Extension," a hyper-futurist mode of cryogenics hawked to desperate HNWIs, promise to overcome.

But this is a love story, offered up in the form of "A Novel" (Shteyngart's subtitle), so there is of course a critical exception to this mapping of futurity without historicity: his avatar-protagonist, the word-loving, romanticizing, second-generation, last-reader American, Lenny Abramov. The middle-aged son of Jewish immigrants from the Soviet Union (his father works as a janitor in a government lab, his mother as a clerk-typist at a credit union), Lenny has just returned from a loftier version of the Old World, Rome, to a New York and a United States teetering on the brink of financial collapse, to renew his work as Life Lovers Outreach Coordinator (Grade G) of the

Post-Human Services division of the Staatling-Wapachung Corporation. He has also fallen in love with one Eunice Park, recent college graduate and Korean-American daughter of immigrants who will soon make her own way back to New York from Europe to be closer to her economically failing, dysfunctional family. The nature of Lenny and Eunice's coupling and decoupling, against the backdrop of a new global regime in which China and Europe "decouple" from the United States, plays out in Lenny's diary entries written out old school, by hand, and transcripts of Eunice's messaging on the ubiquitous "GlobalTeens" platform. The matter of Shteyngart's novel itself is the relationship between these modes: the critical problem of the remediation of bodies, life narratives, citizenship, America as a nation form, no less than the form of the novel, as each is revalued for use and reproduction in a globalized, digital, posthistorical new world.

There is, however, one actual *place* left in the city, one space from which the on-the-ground, real-time effects of this radical revaluation of human being and sociality are fully present—Lenny describes it, in an echo of a waning rhetoric of economic mobility, as "the last middle-class stronghold in the city" (51). That site is—wait for it—none other than the historical immigrant-and-tenement district of the Lower East Side. Here, our super sad protagonist makes his home, as will Eunice with him, in a 740-square-foot apartment "high atop a red-brick ziggurat that a Jewish garment workers' union had erected on the banks of the East River when Jews sewed clothes for a living" (51). More precisely, Lenny lives (as did Shteyngart himself while he wrote *Love Story*) in a postwar housing cooperative, East River Coop, sited just west of the East River and just south of the Williamsburg Bridge—a project that exemplifies immigration history and housing and tenement reform movements stretching back to Riis, with a distinctively radical, ethnoracial flavor. (Its four structures are named, respectively, for a cofounder of the Socialist Party of America, a leader of the Polish Bund, and two presidents of the International Ladies' Garment Workers Union, one the sometime managing editor of the *Jewish Daily Forward*.)

From the balcony of his tiny perch, the scion of parents "born in what used to be the Soviet Union" and of a grandmother who "survived the last years of Stalin, although barely" (41); this specimen bewildered by the use of äppäräti to FAC (Form A Community—"it's, like, a way to judge people. And let them judge you"); this underachiever on the metric of Male Hotness who "radiate[s] the stench of a short-story collection" (91, 88, 40), has an unimpeded view of the nation's "hollow 'Freedom' Tower' "

(110)—still rising IRL (in real life) in 2010, coming to be known as 1 World Trade Center, and designed to mark and rebrand the site of the September 11, 2001 attacks. This is indeed ground zero, in Shteyngart's imagining, for a dire challenge. The only ballast, it seems, against a totalitarian "Bipartisan" government, which promotes headlong consumerism in service of postnational corporate profit as it eliminates political dissidents under the sign of American Restoration, is this threatened lifeworld, this "ugly old" place, teeming with street life and "full of authentic people who have real stories to tell" (51).

Within this redoubt, Lenny builds his own post-post–Cold War political wall—a Wall of Books on a "modernist bookshelf" whose tomes of Chekhov, Tolstoy, and Kundera are anathema to his youthful coworkers because they stink of age and decay. ("Dude," complains his seatmate of Lenny's book on a United-ContinentalDeltamerican flight, "that thing smells like wet socks" [37].) Nonetheless, Lenny shyly vows to keep his books "with me forever" and one day "to make [them] important again" (52). It is to this space that Lenny brings his super sad love object Eunice to shield her from an abusive father and the frightening instability of the American empire. One index of their super sad romantic fate is, in fact, Eunice's response to Lenny's books—as she texts a former college friend in astonishment, "I saw Len reading . . . And I don't mean scanning a text like we did in Euro Classics with that Chatterhouse of Parma I mean seriously READING" (144). It is, in other words, precisely because he is a person of the Book—a member of a "tired, broken race" bound by "that ancient Jewish affliction for words" (126, 220)—that Lenny remains a person at all, or as Eunice puts it, "what Prof Margaux in Assertiveness Class used to call 'a real human being'" (75).

Linking "non-streaming Media artifacts" with death and cultural extinction by way of Jewish experience—"the pogrom within and the pogrom without" (164)—foregrounds certain familiar aspects of the historical ghetto as a site for dystopian thinking. Once again, and not quite as farce, it enables a view of what has gone catastrophically wrong with America, and how that wrong might be redressed or remediated (90). Tellingly, *Love Story*'s New York asserts itself not for but over and against a late twentieth-century wave of immigrants fleeing an imploding Iron Curtain empire, brutal state reprisals against democratic movements in Asia, and every other traumatic economic failure, civil war, and massacre wrought by late twentieth-century realignments of state, corporate, and military power.

The ethnic enclave of Fort Lee, New Jersey (IRL, as I have noted above, a birthplace of cinema as an American industry), is already a militarized zone. Long Island offers a "rich, smelly tapestry" of "Salvadorans and Irish and South Asians and Jews" (129); brown and black Americans-in-training are being forcibly removed from their homes along the Van Wyck Express-way (JFK to the Bronx, Queens to Northern Boulevard). But the Lower East Side still and again indexes with special power the object of the Resto-ration progress narrative ("Latinos Save/Chinese Spend/ . . . 'Together We'll Surprise the World!'" [54]), and the threat of resistance to it.

Here again is consigned everything without value or *credit*. Still an icon of waste and decay, the neighborhood has become a NORC (Naturally Oc-curring Retirement Community), full of "withered," nonantiseptic per-sons beyond the bounds of Indefinite Life Extension and otherwise beyond the pale: uneducated, Media-illiterate, of color. But here, too, impoverished and marginalized, live the vestiges of community or species-being, in a space whose residents spill out, eat, make love, fight, agitate, shit, and die on their unremediated streets lined with meager, one-off businesses, lit-tered with refuse, marked by failed developments and the wayward passage of the inebriate and unemployed. And here, not just Lenny's books, but human speech—what Eunice and her friends call "verballing": fractured, heteroglossic, code-switching, dialectical—remains very much alive, a blooming, buzzing "call-and-response of [the] neighborhood." "Overblown verbs, explosive nouns, beautifully bungled prepositions": in this space not fully colonized by Media or Credit, "Language" still resists the hegemony of data, as its speakers still, again, resist assimilation, now to a totalitarian, digitally made world order. This perhaps explains the presence, at the epi-center of Shteyngart's future anachronism—the intersection of Essex and Delancey Streets—of a New York Army National Guard personnel carrier with a rotating roof-mounted .50-caliber Browning automatic, trained "like a retarded metronome" on the lively but peaceable streetscape (56). Like the *Collier's* opening image of the Cooper Union clock, this militarized control of space figures as a mode of timekeeping, itself temporally out of joint, arrested or retarded. Whither futurity itself, in a city evacuated of the civic logic that historically sustained its sociality? And how does the novel as a form navigate the prospect of temporal collapse in a social world emptied of meaningful futurity?

Shteyngart's Manhattan project clearly recalls that of *Collier's*. Here, however, the end of the city, the end of history, the curtain on America

are coimplicated with the death of the book (versus magazine) and its reading subject, as the print in Benedict Anderson's print capitalism has been remediated by virtual capitalism, relentlessly re-forming the imagined community as a postnational network via image dissemination, stream, and screen: "GLOBALTEENS SUPER HINT: *Switch to Images today. Less words = more fun!!!*" (27). On Lenny's Lower East Side, the human cost of this project is writ large. Part of the Williamsburg Bridge, that sentry of the historical ghetto, collapses, only to be left unrepaired; weaponized "Harm Reduction"—the eviction and displacement of Low Net Worth Individuals—has begun to make way for new developments like "Habitats East," an "EXCLUSIVE TRIPLEX COMMUNITY FOR NON-U.S. NATIONALS," with units zoned for exemption from cavity, data, and property searches going for a mere twenty million euros (152). And here, too, a "burst of bottom-up energy" of resistance begins in gatherings of the evicted, uncompensated veterans, the unemployed: "The real action is in Tompkins Square," texts Lenny's friend, "which Media isn't covering at all" (100). Shteyngart has done his homework; clearly he invokes the long prominence of Tompkins Square Park in any people's history, from the 1874 riot led there by Samuel Gompers to its use in 2010–2011 as the de facto meeting site for planners of the epochal September 2011 Occupy Wall Street event—at least one of whom was heard to ask: "Where is Zucchini Park?"[71] Through all its verbal exploits and high-wire narrative arcs, *Love Story* takes the historical Lower East Side as a key resource for testing the power of the novel to retell—to remediate—the once-defining national narrative of assimilation, uplift, and progress.

Unsurprisingly, then, the epochal event known as the Rupture (these are truly end times) makes itself visible on this familiar territory. As the Bipartisan government falls to the Venezuelans and the Chinese, in a managed handover of US assets to creditors—the new "sovereign wealth funds. Norway, China, Saudi Arabia" (233)—troops wage a brutal reprisal against democratic uprisings that begin with "an old-school protest march down Delancey Street" (257). By chance, Lenny and Eunice have a firsthand, eyewitness perspective on this decisively historical event. As the collapse of the United States of America plays out, they scramble to make their way by ferry from a gathering in now-hip, Media-flush Staten Island back to lower Manhattan. Eunice is desperate to get to Tompkins Square Park, where unbeknownst to Lenny she has befriended the leader of the people's movement, an ex-National Guardsman, and worked alongside her father

to provide food, water, and healthcare to the LNWIs living and protesting there. Heaving Eunice, by sheer force of "innate Russianness, ugliness, Jewishness," onto the *Guy V. Molinari* ferry, Lenny watches from its deck, along with his fellow evacuees, as an incoming aircraft targets the ferry preceding them and destroys it with missile fire (245). It later becomes clear that Lenny's boss has colluded in ensuring that key Media figures speaking out against the new order, particularly Lenny's close friend Noah Weinberg— "fellow alumn[us] of what used to be called New York University" (83), who published "one of the last [novels] you could actually go out and buy in a Media store" before the publishing industry folded (85)—were targeted for "controlled demise" in the attack (256). Reenacting the iconic journey of golden-age immigrants through the harbor, in full view of Ellis Island and the Statue of Liberty, Lenny, Eunice, and the rest of this huddled mass discover there is no America to which they can belong. They find themselves "lost in the pain of suddenly understanding their own extinction" (248).

Jewish American origin narratives, the model minority trope, the American Century, the nation-form of democracy, the citizen-reader: if all of these come to an end in *Love Story*, what then can be remediated? The tenements are decimated; Eunice ("It from the Greek," Lenny's father reminds him, "*you-nee-kay*. Meaning 'victorious'") leaves Lenny; Lenny himself—child of expert investors in futurity—has no place in "America 2.0," and after a period of transition in "Stability-Canada" crosses the ocean in a reverse migration to settle in a small farmhouse in the Tuscan Free State to contemplate the deep truth of national, ethnoracial, and individual erasure ("I never had children") (328, 329). But the super sad true love story has legs, or least an afterlife. In the new global world order established after the Rupture, surveillance is so endemic that Lenny has no idea "some unknown individual or group of individuals" would "pillage our GlobalTeens accounts and put together the text you see on your screen" (327). Brought under the sign of a totalitarian "Sino-American" culture, yoked with Eunice's IMs, Lenny's writing can now comport with the new People's Capitalist Party mantra, "To write text is glorious!" (327)

Ostensibly Lenny addresses a reader who is reading on screen, in a world in which his "own slavish emulation of the final generation of American 'literary' writers," his "tribute to literature as it once *was* [emphasis mine]," is so retro or obsolete as to seem compelling. Within the post-American world of the novel, this story has already been remediated as "the Lenny ♥ *Euny Super Sad True Love* series," produced by Hengdian World Studios in

Zhejiang, and Cinecittà is producing a new "video spray" of Lenny's diaries (330). But IRL, where average is over and the so-called American Dream is history, Shteyngart robustly makes the case that the novel—heteroglossic, many-registered, variously animating—is still or anew the representational form that most powerfully explores what it means to be subject to the temporality of digital life, its free-floating, incorporeal, corporatized power. The story of failed American futurity, he insists, is intertwined with that of the book, and both achieve their robust, heteroglossic expression only within that narrative form whose voracious appetite, hybridity, and transformational power encompass even itself. At large, Shteyngart imagines the failed future of an American state of being and exception by remediating the novel in reverse. Returning to its epistolary history (Benn, Rousseau, Goethe, Choderlos de Laclos, Dostoyevsky), he puts its modes of thought in dystopian dialogue with the power of the instantaneous image, the instant message, the real-time download, the tweet, intensifying the dissonance between Lenny and Eunice, old media and new, as a standoff between ethnoracial models for belonging to America. For this anatomizing, the Lower East Side—IRL gentrified, developed, remediated beyond recognition—is still and again a key resource for imagining America and, perhaps, a less imperfect union.

Finally, the Lower East Side of *Super Sad True Love Story* offers itself as a way to mark both the canonicity of Shteyngart's text and the current social life of the novel form, which takes its place in the array of technologies and projects for imaging America that I have considered. As Lenny and Eunice's epiphanic moment on board the ferry suggests, with its view from the nether place, the shadow, the below of global modernity, the image repertoire of the Lower East Side, that real and imagined space, continues to animate American views and representations across platforms, media histories, and modes of apprehension and experience. Oh say, can we see? For saying, for seeing; for apprehending modernity's failures and their remediation: no place has made it more richly possible to say or see the pasts America has left behind or the futures we once imagined.

Coda

How We Look Now

This book began with a speculative map, and I will end it with another.

In 2005, environmental photographer James Balog went on assignment in the Arctic for *National Geographic* to make photographs that would capture on film, somehow, the realities of climate change. A former climate skeptic, Balog not only produced remarkable images. He had an epiphany. Based on his observation of some of the most remote places on earth, he conceived a documentary project called the Extreme Ice Survey (EIS): a massively ambitious coordination of cameras across the Arctic, and eventually well beyond, to create a multiyear record of the world's rapidly changing glaciers—or more pointedly, "time-lapse proof of extreme ice loss."[1]

Beginning in 2007, Balog and a band of some thirty young scientists and engineers devised and managed an imaging system equal to that task. Through trial and error, they purpose-built digital camera mechanisms—ultimately forty-three of them—which they installed in fixed locations ranging from Iceland, Greenland, and Alaska to the Rocky Mountains, the Alps, Brazil, and Antarctica, to capture images at hourly intervals during daylight. Over an initial three-year span, the team made more than thirty expeditions to revisit EIS photo posts and retrieve data from them. They used the stored images to create time-lapse video sequences of local glacier activity, compressing years' worth of environmental activity into minutes or even seconds. The resulting footage gives evidence of an epochal—and terrifying—transformation at the geologic scale: the rapid retreat of glacier systems, as massive ice structures respond to rising temperatures, melt, and flow in soaring volume into the world's seas.

Among the many uses of the images produced by Balog and the EIS crew (including wide international distribution in print and broadcast organs, display at major United Nations climate conferences, and screening at the Obama White House and the US Congress) was the 2012 Emmy Award–winning documentary *Chasing Ice*. Focusing on the heroic ventures of Balog and EIS, the film climaxes in a breathtaking sequence: footage

from the real-time record of a massive calving (the term for the rupture of chunks of ice from the edge of a glacier) of Jakobshavn Glacier, at the eastern end of the Ilulissat Icefjord in Greenland.[2] In duration, this was the longest such event ever captured on film, and its scale—1.8 cubic miles of ice crashing off, with 400-foot-tall ice forms shooting up to 600 feet above water level—was truly epic. (That Jakobshavn is said to be the source of the iceberg that sank the *Titanic* only magnifies the shock effect.) On camera in *Chasing Ice*, EIS team members emphasize the serendipity of their photographic capture, which goes to the heart of Balog's mission: to offer up to a broader public an irrefutable "piece of visual evidence, something that grabs them in the gut." (Note the echoes of Jacob Riis on his tenement images as viewed by nineteenth-century guardians of order: "from them there was no appeal.")[3] At stake are both the agency of documentation to make visible our era's most "miraculous, horrible" ecological phenomenon, and the possibility of any remediation of the urgent challenge it poses to planetary survival.[4]

It's not a surprise that *Chasing Ice* puts its most arresting, dynamic footage in narrative pride of place. Just before the film's concluding sequence, it serves as the pivot for an invitation to both diegetic observers (attendees of Balog's presentations) and viewers of the documentary itself to become actors in the campaign to reduce carbon emissions, thus literally to change the world. But even the extraordinary visual transcript—the intensely moving images—of rapid glacier retreat require overdetermination to convey the magnitude of this ecological threat and its nearness to everyday experience (at least the experience of subjects in global, world industrial cities). Accordingly, Balog's presentation of the calving event, in a lecture captured on screen for viewers of *Chasing Ice,* includes a striking visual aid. Noting that he'll "resort to some illustrations to give you a sense of scale," Balog screens a video sequence in which the vast terrain of the Ilulissat is overprinted with a digital color 3D map (figure C.1 and plate 8). Its outline should be familiar to readers of this volume: an aerial view of downtown New York City as seen from the east, centered in frame on the area between the Manhattan and Brooklyn Bridges.[5] Digitized to fade, in effect to implode, in synch with the recorded time-lapse retreat of the glacier, the map graphic allows viewers to apprehend the event more nearly—to see it, as Balog puts it, "as if the entire lower tip of Manhattan" had broken off, in an immediate, catastrophic alteration of the land mass and the image of the city.[6]

FIGURE C.1. Screenshot, Jeff Orlowski, *Chasing Ice*. DVD. Submarine Distribution, New York, 2012. *See also* Plate 8.

Why this image, here and now? The lived memory of the actual catastrophic strike on Lower Manhattan only a decade earlier clearly figures in the effect Balog seeks. (This is, as Art Spiegelman put it in his graphic narrative of 2004, a place in the shadow of no towers.)[7] But the long history I have been exploring, of the precincts real and imagined of an inassimilable other half, has its own remarkable power. Like the imagination of nuclear disaster, the specter of devastating climate change can apparently be made real to Americans through an animation (in both senses) of the site's historical image repertoire, in which threats of disaster and the imagination of American perfectibility are inseparable—form, indeed, an uncannily perfect union. That *Chasing Ice* invokes the image of a world industrial city whose voracious capital activity has encouraged the predatory extraction, development, and carbon consumption practices that produced the devastating change in question may be an irony lost on Balog and his team members. In any case, the iconography of the city's other half and below lends itself all at once to cinematic shock and awe, the critical task of making change visible, and—just maybe—the possibility of remediating this defining, terrifying "fact of our century."[8] From the apprehension of the tenement to the fate of the planet: this too is a chapter in the evolving history of the Lower East Side and its image, continuing to shape the way we look backward and ahead.

Acknowledgments

I might as well say that this project began four decades ago, when I was in junior high school. In some kind of recognition of my Jewish and American coming of age, my maternal grandmother, Clara Carnam Sebell, started to send me clippings from the *Jewish Daily Forward*: grainy images of the doings of the neighborhood and the tribe; monitory accounts of their devolution. Neither she—nor any of my maternal or paternal relatives, for that matter—ever made their home on New York City's Lower East Side. But she understood the point of a *lieu de memoire*, and offered it up as a kind of prophylactic, a source of experiences that would keep me from forgetting how complicated was this business of being an American daughter of the children of ancestors of the shtetl. In retrospect, however, that growing archive of scissored, irregularly shaped newsprint already suggested how a material place and its evolving history—nostalgia, mythmaking, revisionism, and all—might be indebted to images and narratives—composed of them, even, and their mutual mediation. It's fitting that I begin by appreciating her gifts here, as I'm sure I never properly did then.

In terms of more recent history, I owe much to the place in which this work took shape, my home of Ann Arbor and the University of Michigan. At the outset, I had the very good luck (mazel indeed!) to be a member in 2007–2008 of the inaugural class of Frankel Fellows at the Frankel Institute for Advanced Judaic Studies, for a theme year focused on Jews and the City. To my fellow fellows—particularly the UM seminar leaders Deborah Dash Moore and Anita Norich and UM colleagues Julian Levinson and Shachar Pinsker, as well as Lila Corwin Berman, Gil Klein, Scott Lerner, Barbara Mann, and Alona Nitzan-Shiftan—a special thanks for their robust, lively engagement, which helped me considerably in shaping this project. I'm also grateful to Deborah for her pioneering work and interest in the matter of Jews and photography, and for the opportunity to curate a 2010 exhibition, *The View from Below: Photography, Innovation, & the Lower East Side*,

with welcome support from Michigan's Frankel Center for Judaic Studies and Institute for the Humanities.

Across our expansive campus, other colleagues and friends have provided many kinds of aid and comfort (more than they know), including Michael Awkward, Jay Cook, Anna Fisher, Laurence Goldstein, Daniel Hack, Kristin Hass, June Howard, Hui-Hui Hu, Marjorie Levinson, Lisa Nakamura, Sidonie Smith, Antoine Traisnel, Alan Wald, and Rebecca Zurier. Toward the end stages, Kelly Cunningham, Jeff Frumkin, Christine Gerdes, and Lori Pierce made it possible for me to continue doing this work even when circumstances conspired against it. Until her untimely death in 2014, the late Patricia Yaeger was an unfailingly generous, incisive, joyous interlocutor for this project as in all things; it is an honor to remember her here and to have been appointed to a chaired professorship at Michigan that bears her name.

Thanks to wonderful hosts and bracing interlocutors elsewhere, I also had the opportunity to enrich this work farther afield. I'm especially grateful to Mark Goble, Elisa Tamarkin, and the Berkeley American Studies seminar; David Alworth and the Harvard American Literature Colloquium; Allison Shachter and Jennifer Faye, the Department of Jewish Studies, the Film Theory and Visual Culture Seminar, and the Robert Penn Warren Center at Vanderbilt; Jeffrey Shoulson and the Judaic Studies and English Departments at the University of Connecticut; and Michael Rothberg, Gordon Hutner, Dale Bauer, and the Vivian Marcus Lecture program at the University of Illinois Champaign-Urbana. Late in the process but no less invigorating for it, the 2017 Critical Visualities symposium of the Visual Culture Workshop at the University of Michigan gave me the opportunity to think with remarkable companions, including Jennifer DeVere Brody, Iyko Day, Leigh Raiford, Shawn Michelle Smith, and Ruby Tapia. Thoughtful copanelists and conversation partners at various ASA, MSA, ASAP, and Toronto Photography Seminar conferences—among them Shawn again, Jane Garrity, Grace Hale, Karen Jacobs, Joseph Jeon, and Laura Wexler—gave generous responses and suggestions that have made this work better and more pleasurable to pursue.

Parts of this volume have lived earlier lives in print (official acknowledgments below). For editorial acuity and exceptional generosity in rare combination, I'm deeply grateful to Anthony Lee and Margaret Olin. The opportunity to contribute to scholarly projects they each lead, and which I've long admired, was especially gratifying. Sally Stein and Laura Katzman

provided feedback and conversation of real moment; Tyler Anbinder and Bill Truettner responded generously to local queries. I've also been lucky in collaborations that have intersected with my pursuit of this work, giving me the invaluable chance to write and converse with Eric Rosenberg on the timeliness of photography, and with Joseph Entin and Franny Nudelman on past and current documentary cultures and why they matter, always to the enrichment of my own ideas. I have also benefitted from broader conversations about photography and cultural history in New York with Paul Roth and Thomas Sugrue, about aesthetics with Ross Posnock, and about all manner of things visual and literary with fellow members of the beloved Bread Loaf School of English community—not least Jonathan Freedman, Shalom Goldman, Marina Rustow, and Jeffrey Shoulson, copanelists for a summer 2016 extravaganza titled "What Is Jewish American Literature?" that will not soon be forgotten.

The work that became *How the Other Half Looks* also grew around seminar tables and in exchanges with current and former students. For their supportive responses and lively conversation, I'm grateful to Angela Berkley, Nan Z. Da, Paul Farber, Kyle Frisina, Joseph Ho, Khaliah Mangrum, and Hayley O'Malley (with special thanks to Joseph for his rich photographic gifts and to Hayley for her ready end-stage help with the manuscript). I take special pleasure in seeing their remarkable work coming into the world. I'm also grateful to the graduate students of my fall 2016 seminar, Narrative and Visual Forms, for the very special intellectual community they sustained—an invaluable resource in trying times.

Likewise, I'm grateful to the far-flung, occasionally antic, always responsive community of fellow readers and citizens gathered online and sometimes IRL, whose members have offered support, scholarly resources, early- and late-hours conversation, and indispensable suggestions for titles (a special shout-out to friend and neighbor David Scobey FTW). These and other friends and friendly helpers, including Jay D'Lugin and Jim Sabin, brought me and mine through an urgent and challenging time, for which I will always be grateful.

Valuable as these virtual connections have been, this book is after all an argument about the power of site work. As my most acute reader, Jonathan Freedman, often points out, I've been persistent (or just lucky) enough to make New York City—its archives and museums, its communities of image-makers and image readers—a continuing subject and resource for my work. A number of image professionals have helped make that possible.

For access they have graciously offered to materials, for their expertise in the history of images and their cultural life, and for their fellowship, I'm most grateful to Howard Greenberg and Nancy Leiberman of the Howard Greenberg Gallery; Norma Stevens; James Martin, Director of the Richard Avedon Foundation; Keren Sachs, latterly of Shutterstock; Maya Benton, Adjunct Curator, International Center of Photography; and Sharon Cott, Vice President, Secretary, and General Counsel of the Metropolitan Museum of Art, who made some special permissions efforts on my behalf. Miriam Stewart, Curator of the Collection, Harvard Art Museums, graciously enabled access to key materials; Nancy Barr, Curator of Photography, Detroit Institute of Arts, did the same. Special thanks also to Nancy for the opportunity to collaborate on her dynamic work at the DIA, and to contribute something of my engagements with New York–based photo practice to the 2017 DIA exhibition *Detroit After Dark*.

In meeting the challenges of work with image archives, I have also benefited from the expert help of staff in the University of Michigan Library Special Collections; the Prints and Photographs Division at the New York Public Library; the Library of Congress Prints and Photographs collections; the Chicago Historical Society; and the Boston Public Library Print Department. Peter Hale, Joseph S. Lieber, Herb Snitzer, Sam Walker, and Harvey Wang were gracious respondents to my requests for permission to reproduce images; I am very grateful for their support. Martha Rosler, whose images and critical thinking have long been a mainstay for my work, generously provided permission to reproduce her own (dayanu) as well as attentive feedback. Along the way, photographers Cydney Scott and Austin Thomason did just-in-time shooting that has helped me make the visual case within these pages.

On the matter of images, no project of this kind could come into being without significant material support for its pursuit and publication. Over the course of its unfolding, my work was supported by a 2011 American Council of Learned Societies Fellowship, and by generous funding at the University of Michigan from the Department of English, the College of Literature, Science, and the Arts, and the Office of the Provost. I am especially grateful for the publication subvention provided by LSA and the University of Michigan Office of Research, and for the always welcome help of staff colleagues Jane Johnson and Halley Widlak with funds management.

I'm grateful, too, for the attentive care of Princeton's able editor, Anne Savarese, and production team, to copyeditor Anne Sanow, and to the

anonymous press readers, to whose remarkably generous, rigorous responses I hope I have done justice.

By way of publication acknowledgments:

Part of chapter 1 appeared in an earlier version, "Whose Modernism Is It? Abraham Cahan, Fictions of Yiddish, and the Contest of Modernity," in *MFS Modern Fiction Studies* 51, no. 2 (Summer 2005), 259–84. Copyright © for the Purdue Research Foundation by Johns Hopkins University Press.

Parts of chapter 3 and of chapter 4 appeared in earlier versions in "Against Trauma: Documentary and Modern Times on the Lower East Side," in Sara Blair and Eric Rosenberg, *Trauma and Documentary Photography of the FSA* (Berkeley: University of California Press, 2012), 10–51.

Part of chapter 3 also appeared in an earlier version in "About Time: Photographs and the Reading of History," *PMLA* 125, no. 1 (January 2010), 161–71. © 2010 by The Modern Language Association of America.

Likewise, parts of chapter 4 appeared in an earlier version in "Visions of the Tenement: Jews, Photography, and Modernity on the Lower East Side," *Images: A Journal of Jewish Art and Visual Culture*, volume 4, issue 1 (2010), 57–81. © Copyright 2011 by Koninklijke Brill NV, Leiden, The Netherlands.

Some material from a section of chapter 6 will appear in "After the Fact: Postwar Dissent and the Art of Documentary," in Sara Blair, Joseph P. Entin, and Franny Nudelman, eds., *Remaking Reality: U.S. Documentary Culture after 1945*, forthcoming from University of North Carolina Press, 2018.

Individual image acknowledgments are recorded in the list of illustrations. I am grateful to all the institutions, rights holders, and agencies that have made image reproductions possible.

I end with my deepest debts, closest to home. The Blair and Freedman mishpuchot have, each and all, been an unfailing source of support, hospitality, and so much more; I am grateful to each and all of you. Over the years of this work, Benjamin Blair Freedman and Miriam Blair Freedman have themselves come of age, facing riven times with equal measures of skepticism and hope. I am indebted to them for both, and for the deep joy of their company. Right here beside me through it all has been Jonathan Freedman. His shrewd optimism, unflagging humor, and remarkable resilience are the gifts of a lifetime, now and always. This, my indispensables, is for you.

Notes

How the Other Half Looks: A Preview

1. Michael Schudson, *Discovering the News: A Social History of American Newspapers* (New York: Basic Books, 1978), 96–98, connects the rapid rise in daily newspaper circulation and especially in illustrated news with the explosive growth of immigrant readerships; William Huntzicker, *The Popular Press, 1833–1865* (Westport, CT: Greenwood Press, 1999), 19–33, sketches the emergence in the 1830s of the "ideal metropolitan daily newspaper" (24) as a project attuned to ever-larger and increasingly diverse readerships, which would become exponentially more so over the course of the century.

2. Throughout, I engage the ongoing project of Americanist visual culture study that Larry J. Reynolds, "American Cultural Iconography," in Reynolds and Gordon Hutner, eds., *National Imaginaries, American Identities: The Cultural Work of American Iconography* (Princeton, NJ: Princeton University Press, 2000), 3–28, has called "American cultural iconography." More broadly, Reynolds, 6–9, offers a cogent account of the rise of iconography as a critical approach within American studies, marked by Sacvan Bercovitch and Myra Jehlen's landmark edited volume, *Ideology and Classic American Literature* (New York: Cambridge University Press, 1987). Scholars whose work on iconographies, visual cultures, and the methodological challenges of addressing both has influenced my framing include David Holloway and John Beck, eds., *American Visual Cultures* (New York: Continuum, 2005); Shirley Samuels, *Facing America: Iconography and the Civil War* (New York: Oxford University Press, 2004); David Morgan and Sally Pomey, eds., *The Visual Culture of American Religions* (Berkeley: University of California Press, 2001); Patricia Johnson, ed., *Seeing High and Low: Representing Social Conflict in American Visual Culture* (Berkeley: University of California Press, 2005); Angela Miller, *The Empire of the Eye: Landscape Representation and American Cultural Politics, 1825–1875* (Ithaca, NY: Cornell University Press, 1996); Denis Cosgrove and Stephen Daniels, *The Iconography of Landscape* (Cambridge: Cambridge University Press, 1988); and Shawn Michelle Smith, *American Archives: Gender, Race, and Class in Visual Culture* (Princeton, NJ: Princeton University Press, 1999), and more broadly, W.J.T. Mitchell, particularly in *Picture Theory: Essays on Verbal and Visual Representation* (Chicago: University of Chicago Press, 1994).

3. Ronald Sanders, *The Lower East Side: A Guide to Its Jewish Past in 99 New Photographs* (New York: Dover, 1994), 1.

4. Robert Amell, "The Story Behind the Lower East Side," *Manhattan Unlocked*, March 2, 2011, http://manhattanunlocked.blogspot.com/2011/03/story-behind-lower-east-side.html.

5. Hasia Diner, *Lower East Side Memories: A Jewish Place in America* (Princeton, NJ: Princeton University Press, 2000), 14, sums up the context in this way: "We have no history of the designation 'Lower East Side,' its coinage, usage, [or] why this name, as opposed to other, stuck. It is not even clear . . . where the boundaries of that neighborhood ought to be drawn, who lived there, how they defined themselves, and how they used space." She goes on to consider "the lack of a fixed set of historical borders marking off the Lower East Side from the urban spaces around it" (41), and the challenges it raises to understandings of a unified Jewish American past.

Other pointed readings of the shifting boundaries of the Lower East Side and the fluidity of experience of and in its spaces include Richard A. Blake, *Street Smart: The New York of Lumet, Allen, Scorsese and Lee* (Lexington: University Press of Kentucky, 2005), 156–57; Fred Good, "The Origins of Loisaida," (essay 21–36), in *Resistance: A Radical Social and Political History of the Lower East Side*, ed. Clayton Patterson (New York: Seven Stories Press, 2007), 21. More broadly, the exemplary sociologist Mitchell Duneier, *Ghetto: The Invention of a Place, The History of an Idea* (New York: Farrar, Straus and Giroux, 2016), considers the powerful reach of "ghetto" as a concept and historical artifact whose invocation over and against its actual pasts in the early modern world of Europe has been a resource for new projects of social control and ghettoization in fascist Germany and the twentieth-century United States, in which the material evidence of the ghetto's squalor "provide[s] an apparent justification for the original condition" (11).

Conceptually, we might connect this problem of site and situation with the kind of site work David Alworth, *Site Reading: Fiction, Art, Social Form* (Princeton, NJ: Princeton University Press, 2016), has proposed, after Bruno Latour, with respect to the novel as a cultural form: broadly, an attunement to the way sites figure (at least fictively or narratively) as "determinants of sociality" that exercise a distinct kind of agency (96). I also draw on conversations about space, location, and their implication with culture that have informed the new modernist studies, which are cogently overviewed by Douglas Mao and Rebecca L. Walkowitz, "The New Modernist Studies," *PMLA* 123, no. 3 (May 2008), 737–48.

6. More broadly, scholarship on Jews, Jewishness, and visual culture—and its relationship to the visual modes of a Judaism long presumed to be indifferently visual or aniconic—has flourished over the last decade; I respond (and hope to contribute) to conversations begun by the likes of Kalman P. Bland, *The Artless Jew: Medieval and Modern Affirmations and Denials of the Visual* (Princeton, NJ: Princeton University Press, 2000); Margaret Olin, *The Nation without Art: Modern Discourses on Jewish Art* (Lincoln: University of Nebraska Press, 2001); J. Hoberman and Jeffrey Shandler, eds., *Entertaining America: Jews, Movies, and Broadcasting* (Princeton, NJ: Princeton University Press, 2003); and Carol Zemel, *Looking Jewish: Visual Culture and Modern Diaspora* (Bloomington: Indiana University Press, 2015). My debts in context to others working on Jews, photographic practice, and American visual contexts will be visible below.

7. Accounts that emphasize the multilingual, multiethnic, and imperial-colonial origins of early Manhattan and their role in shaping the emergence of the modern and contemporary global city include Russell Shorto, *The Island at the Center of the World: The Epic Story of Dutch Manhattan and the Forgotten Colony that Shaped America* (New York: Vintage, 2005); Edwin G. Burrows and Mike Wallace, *Gotham: A History of New York City to 1898* (New York: Oxford University Press, 2000); and Ted Steinberg, *Gotham Unbound: The Ecological History of Greater New York* (New York: Simon & Schuster, 2014).

8. Shorto, *The Island*, 26; "Lower East Side," Wikipedia, modified February 12, 2015, http://en.wikipedia.org/wiki/Lower_East_Side. See also Eric Homberger, *The Historical Atlas of New York City: A Visual Celebration of Nearly 400 Years* (New York: Holt, 2005), 60–61.

9. Ann L. Buttenwieser, *Manhattan Water-Bound: Manhattan's Waterfront from the Seventeenth Century to the Present,* 2nd ed. (Syracuse, NY: Syracuse University Press, 1999), 41.

10. John Russell Bartlett, *Dictionary of Americanisms: A Glossary of Words and Phrases Usually Regarded as Peculiar to the United States*, 2nd ed. (Boston: Little, Brown and Company, 1859), 201. See also Matthew Hale Smith, *Sunshine and Shadow in New York* (Hartford, CT: J. B. Burr and Company, 1869), 232–33.

11. Alan M. Kraut, *Silent Travelers: Germs, Genes, and the Immigrant Menace* (Baltimore: Johns Hopkins University Press, 1994), especially 31–35; Charles Rosenberg, *The Cholera Years: The United States in 1832, 1849, and 1866* (Chicago: University of Chicago Press, 1987), 25–35. A firsthand account of the 1832 epidemic and data about treatment and fatalities in the cholera

hospital at Corlear's Hook can be found in Dudley Akins, *Reports of Hospital Physicians and Other Documents in Relation to the Cholera Epidemic* (New York: G. & C. & H. Carvill, 1832), 112–39.

12. I draw on several accounts of the history, legal status, and social implications of the tenement housing form in lower Manhattan, following the city's landmark Tenement House Act of 1867: John F. Bauman, "Introduction: The Eternal War on the Slums," *From Tenements to the Taylor Homes: In Search of an Urban Housing Policy in Twentieth-Century America*, ed. John F. Bauman, Roger Biles, and Kristin M. Szylvian (University Park: Pennsylvania State University, 2000), 1–17; Robert B. Fairbanks, "From Better Dwellings to Better Neighborhoods: The Rise and Fall of the First National Housing Movement," in Bauman, Biles, and Szylvian, 21–42 (citation 22); Richard Plunz, "On the Uses and Abuses of Air: Perfecting the New York Tenement, 1850–1901," *Berlin/New York: Like and Unlike: Essays on Architecture and Art from 1870 to the Present*, ed. Josef Paul Kleihues and Christina Rathgeber (New York: Rizzoli, 1993), 159–79, and Plunz's foundational *A History of Housing in New York City: Dwelling Type and Social Change in the American Metropolis* (New York: Columbia University Press, 1992), particularly 4–6.

13. Henry Street Studies, *A Dutchman's Farm: 301 Years at 284 Corlears Hook* (New York: Henry Street Studies, 1939), 5. The scale of pre–Civil War and midcentury immigration to New York City, in particular the Lower East Side, is typically obscured by an insistent focus on post-1880 trends. The city established the Castle Garden Immigration Station in 1855; from that time until its closing in 1890, more than eight million people entered the United States. Although the overall population of the city grew more than threefold during that period its foreign-born population remained nearly constant, at close to one in two of all New Yorkers (45.7% in 1850; 42.2% in 1890). See "Population by Nativity, 1790–2000," New York City Department of City Planning Population Division, n.d., accessed October 7, 2017, www1.nyc.gov/assets/planning /download/pdf/data-maps/nyc-population/historical-population/1790-2000_nyc_foreign_birth _graph.pdf.

14. Roland Barthes, *Empire of Signs*, transl. Richard Howard (New York: Hill and Wang, 1983), 16. Laura Mulvey, "The Index and the Uncanny," in *Time and the Image*, ed. Carolyn Bailey Gill (Manchester: Manchester University Press, 2000), 139–48, addresses Barthes's interest in the affinity between photography and the deictic, or the instance that "gives a grammatical form [and thus visibility] to actual physical relations of time, space or person" (142).

15. Roland Barthes, *Camera Lucida: Reflections on Photography* (New York: Hill and Wang, 1981), 5.

16. In its broader understandings of the photograph and its contexts, my work has been closely informed by revisionary accounts of modern photographic practice offered by a new generation of visual historians, who are concerned not just with the readiness-to-hand of the photographic image for social and ideological conscription but with the complex life and afterlives of photographs as social encounters and performances, material artifacts, and protonarrative or -textual objects. These include Anthony Lee, *A Shoemaker's Story: Being Chiefly about French Canadian Immigrants, Enterprising Photographers, Rascal Yankees, and Chinese Cobblers in a Nineteenth-Century Factory Town* (Princeton, NJ: Princeton University Press, 2008); Margaret Olin, *Touching Photographs* (Chicago: University of Chicago Press, 2012); Elizabeth Edwards, "Photographic Uncertainties: Between Evidence and Reassurance," *History and Anthropology* 24, no. 2 (2014), 171–88; Elizabeth Edwards and Janice Hart, "Introduction: Photographs as Objects," in *Photographs Objects Histories: On the Materiality of Images*, ed. Edwards and Hart (London: Routledge, 2004), 1–16; and Elizabeth Abel, *Signs of the Times: The Visual Politics of Jim Crow* (Berkeley: University of California Press, 2010).

17. Diner, *Lower East Side Memories*, 31.

18. For foundational accounts of that hybridity, see Bryan Cheyette, *Between "Race" and Culture: Representations of "the Jew" in English and American Literature* (Redwood City, CA: Stanford

University Press, 1996); Jonathan Freedman, *Klezmer America: Jewishness, Ethnicity, Modernity* (New York: Columbia University Press, 2008).

19. William Truettner, senior curator of painting and sculpture at the Smithsonian American Art Museum, has attested to the unlikeliness of the attribution of *Five Points* to Catlin. He notes that "the image, with its caricatures of blacks and its emphasis on class differences, seems to me far away from Catlin's interests at that point in his career. Furthermore, from what I could tell thru a magnifying class, the artist who did the Five Points illustration was a good deal more skillful than Catlin, who never did learn how to draw figures in motion." Truettner, email to author, November 5, 2011. Such assessments clearly influenced the decision of the Metropolitan Museum of Art in 2017, in the final stages of production of this project, to shift the long-time attribution of the painting from Catlin to "Unknown Artist."

20. George Catlin, cited in Harold McCracken, *George Catlin and the Old Frontier* (New York: Dial Press, 1959), 24.

21. Cornelius, Letter to the Editor, *New York Evening Post*, 1826; cited in Tyler Anbinder, *Five Points: The 19th-Century New York City Neighborhood That Invented Tap Dance, Stole Elections, and Became the World's Most Notorious Slum* (New York: Free Press, 2001), 20.

22. Anbinder, *Five Points* 26.

23. On African American participation in the sexual and underground economies of the Five Points, see Timothy J. Gilfoyle, *City of Eros: New York, Prostitution, and the Commercialization of Sex* (New York: Norton, 1994), 41–42.

24. H. Barbara Weinberg and Carrie Rebora Barratt, "American Scenes of Everyday Life, 1840–1910." In *Heilbrunn Timeline of Art History* (New York: The Metropolitan Museum of Art, 2000–), September 2009, www.metmuseum.org/toah/hd/scen/hd_scen.htm. Elizabeth Johns, *American Genre Painting: The Politics of Everyday Life* (New Haven, CT: Yale University Press, 1993), offers a revisionary account of genre painting, focusing on the ideological construction of everyday life and its expression of ideologies of race, class, gender, and regional identity; the work attributed to Catlin is no less anomalous from this perspective.

25. "The Population of New York City, Slave and Free 1698–1855," from Rosenwaike's *Population History of New York City* (Syracuse, NY: Syracuse University Press, 1972), Tables 1, 2, 3, and 6, pages 8, 16, 18, and 36 respectively.

26. Anbinder, *Five Points* 25; his account addresses the original image.

27. Meredith McGill, *American Literature and the Culture of Reprinting, 1843–1853* (Philadelphia: University of Pennsylvania Press, 2007), 28. On the yoking of illustration with originality, McGill, 29, notes that hand-colored, finely made plates and other innovations in visual illustration helped insure sustained and rising demand both for periodical and gift book publications.

28. William A. Rogers, *A World Worth While: A Record of "Auld" Acquaintance* (New York: Harper & Brothers, 1922), 39.

29. "The Slaves of the Sweaters," *Harper's Weekly*, April 26, 1890, 335.

30. Carol Lasser and Joanna Steinberg, "Making Gendered Poverty Visible: W. A. Rogers's 'Slaves of the Sweaters' and Attitudes toward Women and Child Wage Earners," September 2005, http://womhist.alexanderstreet.com/visuals/slaves.htm, note that "the expansive road in the foreground would be more likely found in an uptown location . . . for all their concern to make visible urban poverty, the *Harper's Weekly* staff remained geographically and psychologically distant from the locale they sought to portray."

31. "Slaves of the Sweaters," 335.

32. William Dean Howells, "An East-Side Ramble," in *Impressions and Experiences* (New York: Harpers & Brothers, 1896), 127–49; Henry Collins Brown, *Old New York Yesterday and Today* (New York: Valentine's Manual, 1922), 66.

33. Johannes Fabian, *Time and the Other: How Anthropology Makes Its Object* (New York: Columbia University Press, 2002), argues for the historical centrality to anthropology as a discipline

of the arrest of its ethnographic subjects in a temporality cordoned off from that of Western knowledge production, via the opposition between the modern "moving" time of the observer and the static, archaic time of the observed. Christopher Pinney, Introduction to *Photography's Other Histories,* ed. Christopher Pinney and Nicolas Peterson (Durham, NC: Duke University Press, 2003), 5, emphasizes modes of "latency," "recursive" framing, and futurity in the photographic practices of colonial subjects that resist the presumption of arrest. John Tagg, *The Disciplinary Frame: Photographic Truths and the Capture of Meaning* (Minneapolis: University of Minnesota Press, Press, 2009), 3, cogently describes the camera as "the machinery of capture."

34. Influential accounts of the labile or traumatic temporality associated with Judaism and Jews includes Zygmunt Bauman, *Modernity and the Holocaust* (Ithaca, NY: Cornell University Press, 2001); Jonathan Boyarin, *Storm from Paradise: The Politics of Jewish Memory* (Minneapolis: University of Minnesota Press, 1992); and Cathy Caruth, *Unclaimed Experience: Trauma, Narrative, and History* (Baltimore: Johns Hopkins University Press, 1996), particularly 66–71.

35. Allon Schoener, *Portal to America: The Lower East Side, 1870–1925* (New York: Holt, Rinehart, and Winston, 1967).

Object Lesson: Halftone and the Other Half

1. Joshua Brown, *Beyond the Lines: Pictorial Reporting, Everyday Life, and the Crisis of Gilded Age America* (Berkeley: University of California Press, 2002), 36, 38–39.

2. Robert Taft, *Photography and the American Scene: A Social History, 1839–1889* (New York: Macmillan, 1964), 434.

3. "Note Books of Stephen H. Horgan," in *The Beginnings of Halftone,* ed. Lida Rose McCabe (Chicago: The Inland Printer, 1924), n.p. (2).

4. E. L. Godkin, "Chromo-Civilization," *Nation,* September 24, 1874, 201–2. See also "The Perils of Photography," *Nation* 85 (July 11, 1905), 28–29; Stephen Henry Horgan, "The World's First Illustrated Newspaper," *Penrose Annual* 35 (1933): 23–24; Frank Luther Mott, *American Journalism: A History of Newspapers in the US through 250 Years, 1690–1940* (New York: Macmillan, 1941), 502; W. A. Rogers, *A World Worth While* (New York: Harper and Brothers, 1922), 6–10.

5. *Harper's,* cited in McCabe, n.p. [5].

6. Neil Harris, "Iconography and Intellectual History: The Half-Tone Effect," in John Higham and Paul K. Conkin, eds., *New Directions in American Intellectual History* (Baltimore: Johns Hopkins University Press, 1977), 196–211, citation 200.

7. See, for example, Brown, *Beyond the Lines,* 267, fn 16.

8. Nathaniel Hawthorne, *Passages from the American Note-Books,* vol. II (Boston: Houghton, Mifflin and Company, 1868; reprint Riverside Press), 146.

9. Daniel Cassidy, *How the Irish Invented Slang* (Chico, CA: CounterPunch Press/AK, 2007), 5, 250, 252.

10. Jacob Riis, *How the Other Half Lives: Studies in the Tenements of New York* (New York: Scribner's, 1889), 164; Mike McCormack, "Shanty Town, New York," February 21, 2009, 2014, www.nyaoh.com/2009/02/21/91/.

11. See Valentine, *Manual of the Corporation of New York City,* 1864; Lisa Goff, *Shantytown, USA: Forgotten Landscapes of the Working Poor* (Cambridge, MA: Harvard University Press, 2016), 55–84, especially 80–83.

12. Paul Martin Lester, *Visual Communication: Images with Messages* (Belmont, CA: Cengage Learning, 2013), 160.

13. Lester, *Visual Communication,* 160; Brown, *Beyond the Lines,* 62, 266, fn 8. See the 1870 map of lower Manhattan, http://freepages.genealogy.rootsweb.ancestry.com/~marshallfamily/1870%20Map%20of%20Lower%20Manhattan.html; and the Ward Map for 1890–1910, www

.demographia.com/db-nyc-ward1800.htm, marking wards 7, 10, 11, and 13 as belonging to "the Lower East Side."

14. All citations are from *Daily Graphic*.

15. As the well rehearsed story goes, the so-called golden age of immigration, from 1880 to 1924, brought more than twenty million immigrants to the United States, primarily from Eastern and Southern Europe; during that period, the population of Jews in the United States rose from 250,000 to some 4.5 million. During the decade beginning in 1881—at the moment of a wave of pogroms within the Pale of Settlement following on the assassination of Tsar Nicholas II—immigration of Jews from Russia alone increased fivefold, to an annual average of over 20,000. See "Jewish Immigration," http://constitutioncenter.org/timeline/html/cw08_12150 .html (February 21, 2011).

16. I am indebted here and throughout to Harris and to Estelle Jussim, *Visual Communication and the Graphic Arts: Photographic Technologies in the Nineteenth Century* (New York: R. R. Bowker Company, 1974), for her broader sense of the transformation of the photographic image by way of halftone to "an optical illusion with surrogate power" (288).

17. Jussim, *Visual Communication*, 288.

18. Jussim, *Visual Communication*, 288.

19. Philip Gilbert Hamerton, *Portfolio Papers* (Boston: Roberts, 1889), 334–35, cited in Jussim, *Visual Communication*, 235.

20. Jussim, *Visual Communication*, 188.

21. Hamerton, *Portfolio Papers*, 334–35, cited in Jussim, *Visual Communication*, 235.

22. Alexander Alland, Sr., *Jacob A. Riis: Photographer & Citizen* (New York: Aperture, 1993), 194, 26–27. See also Julia Van Haaften, *Original Sun Pictures: A Checklist of the New York Public Library's Holding of Early Works Illustrated with Photographs, 1844–1900* (New York: New York Public Library).

23. Jacob Riis, *How the Other Half Lives*, 16.

24. Riis, *The Making of an American* (New York: Macmillan Co., 1901), 11.

25. Riis, *The Making of an American*, 273.

26. Yochelson, "Photography Changes Our Awareness of Poverty" *click!* (Smithsonian Photography Initiative), n.d., http://click.si.edu/Story.aspx?story=436 (accessed July 14, 2014); Riis, *The Making of an American*, 268–69.

27. Yochelson, "Photography Changes Our Awareness of Poverty."

28. Riis, *The Making of an American*, 266.

29. We should also consider the plethora of maps, charts, blueprints, and data tables enhancing Riis's narrative throughout; they suggest not only a will to rationalize the study of poverty and the unassimilated, but the need to mobilize multiple and varied modes for visualizing the ghetto—and for training readers to see the photographs representing it as indexical, a meaningful resource for remediation.

30. See Peter Hales, *Silver Cities: Photographing American Urbanization, 1839–1939* (Albuquerque: University of New Mexico Press, 2006 [1984]), especially 282–85, and Keith Gandal, *The Virtues of the Vicious: Jacob Riis, Stephen Crane and the Spectacle of the Slum* (New York: Oxford University Press, 1997).

31. Lightning-flash powder produces intense, incandescent illumination by directing an oxyhydrogen flame (sometimes nicknamed "bang gas") at quicklime. Ivan Tomachev, "A Brief History of Photographic Flash," January 19, 2011, http://photography.tutsplus.com/articles/a -brief-history-of-photographic-flash—photo-4249, notes that "simply grinding the components [for flash powder] was dangerous enough, and a number of photographers died while either preparing the flash powder or setting it off."

32. "The American Magic Lantern Theater," www.magiclanternshows.com/filmhistory.htm, March 26, 2008.

33. Tom Gunning, "Animated Pictures: Tales of Cinema's Forgotten Future," *Michigan Quarterly Review* 34, no.4 (Fall 1995): 465–85.

34. Riis, *How the Other Half Lives*, 271.

Chapter 1. On Whose Watch?

1. Jacob A. Riis, *The Making of an American*, 184.

2. Daniel Czitrom, "Jacob Riis's New York," in Bonnie Yochelson and Daniel Czitrom, *Rediscovering Jacob Riis: Exposure Journalism and Photography in Turn-of-the-Century New York* (New York: New Press, 2008), 1–120, citation 82; see 86–97 on Riis's lectures as entertainment.

3. Czitrom, 86; Title: Library of Congress Copyright Office title page, March 19, 1888, in General Correspondence, container 4, Riis Papers; cited Czitrom, 87.

4. "Jacob Riis: Photographs and Lantern-Slide Lectures," accessed Feb. 22, 2017, http://xroads .virginia.edu/~ma01/davis/photography/riis/lanternslides.html.

5. Review of lecture, *New York Herald*, January 26, 1888, clipping in "How the Other Half Lives," Lecture Reviews, Serials, container 12, Riis Papers, Library of Congress.

6. Howard Markel, *Quarantine!: East European Jewish Immigrants and the New York City Epidemics of 1892* (Baltimore: Johns Hopkins University Press, 1999), 39, 74; on "quarantine by ethnicity," 74; on the targeting of Russian Jews, 75.

7. As one member of the clergy in attendance noted approvingly, Riis ended with an image of "the Saviour," exuding benevolence not for the inhabitants of the ghetto so much as the right-minded spectators enlightening themselves about its evils. Lecture Reviews, Serials, container 12, Riis Papers.

8. On the careers of Crane's parents, see Thomas A. Gullason, "Stephen Crane and His Family: A Modern Portrait," in Gullason, ed., *Stephen Crane's Literary Family: A Garland of Writings* (Syracuse, NY: Syracuse University Press, 2002), 1–20.

9. Christopher Benfey, *The Double Life of Stephen Crane* (New York: Knopf, 1992), 56–63; Linda H. Davis, *Badge of Courage: The Life of Stephen Crane* (New York: Houghton Mifflin, 1998), 40–53.

10. Davis, *Badge of Courage*, 53.

11. "A Police Reporter's Camera. He Catches Queer Pictures of City Life with It," *New York News*, January 27, 1888, Jacob A. Riis Papers, Library of Congress, Container 11. See also Benfey, *The Double Life of Stephen Crane*, 59.

12. On the "power of attraction," see David Morgan, *Protestants & Pictures: Religion, Visual Culture, and the Age of American Mass Production* (New York: Oxford University Press, 1999), 252, and, more broadly on visual pedagogy, 199–232; Robert F. Y. Pierce, *Pictured Truth: A Hand-Book of Blackboard and Object Lessons* (New York: Fleming H. Revell Company, 1895), 150–57; Ella N. Wood, *Chalk; or, We Can Do It* (Chicago: F. H. Revell, 1903), 117–31; T. J. Jackson Lears, *Fables of Abundance: A Cultural History of Advertising in America* (New York: Basic Books, 1995), 240–43.

13. Gullason, "Mother and Son: A Dual Portrait," in Gullason, *Stephen Crane's Literary Family*, 142–43.

14. Davis, *Badge of Courage*, 53.

15. Anonymous, "Flashes from the slums: Pictures taken in dark places by the lighting process: Some of the results of a journey through the city with a camera—The poor, the idle and the vicious," *New York Sun*, February 12, 1888. Jacob A. Riis Papers, Container 11, Reel 8. Reprinted in Alexander Alland Sr., *Jacob A. Riis: Photographer and Citizen* (Millerton, NY: Aperture, 1993), 26–27.

16. "A Police Reporter's Camera," n.p., Jacob A. Riis Papers, Container 11, Reel 8.

17. "Flashes from the slums," Jacob A. Riis Papers, Container 11, Reel 8. Reprinted in Alland, *Jacob A. Riis*, 26–27.

18. Riis, *Making of an American*, 268, 269.

19. On the attempt to fix, see Alma Davenport, *The History of Photography: An Overview* (Santa Fe: Focal Press/University of New Mexico Press, 1999), 6–9; Hernut Gernsheim, *A Concise History of Photography*, 3rd rev. ed. (New York: Dover/Thames and Hudson, 1986), 2–3; Beaumont Newhall, *The History of Photography from 1839 to the Present Day* (New York: Museum of Modern Art/Simon and Schuster, 1949), 11.

20. Allan Sekula, "The Body and the Archive," *October* 39 (Winter, 1986), 3–64. Available online at http://chnm.gmu.edu/courses/magic/sekula.pdf (November 11, 2004).

21. Maren Stange, "Jacob Riis and Urban Visual Culture," *Journal of Urban History* 15, no. 3 (May 1989): 274–303; citation 291.

22. Lucy R. Lippard, "Doubletake: The Diary of a Relationship with an Image," in Liz Wells, ed., *The Photography Reader* (London: Routledge, 2003), 343–52, has aptly characterized this problem as foundational to both photographic and postcolonial modes of encounter.

23. Anonymous, Review of *Maggie, New York Tribune*, May 31, 1896, 26; cited in Gullason, *Norton*, 149.

24. Anonymous, Review, *New York Times*, 26.

25. On literary naturalism and the matter of time scales, evolutionary time, and temporality, see Christophe Den Tandt, *The Urban Sublime in American Literary Naturalism* (Champaign: University of Illinois Press, 1998), and Jennifer Fleissner, *Women, Compulsion, Modernity: The Moment of American Naturalism* (Chicago: University of Chicago Press, 2004).

26. Fleissner, *Women, Compulsion, Modernity*, 9. See also June Howard, *Form and History in American Literature Naturalism* (Chapel Hill: University of North Carolina Press, 1985), 105–25.

27. Suggestive accounts of the regime of standard time and the institution of clock time after Georg Simmel and Henri Lefebvre include Mark M. Smith's *Mastered by the Clock: Time, Slavery, and Freedom in the American South* (Chapel Hill: University of North Carolina Press, 1997); Ian Bartky, *Selling the True Time: Nineteenth-Century Timekeeping in America* (Redwood City, CA: Stanford University Press, 2000), 104–14; Michael O'Malley, *Keeping Watch: A History of American Time* (Washington, DC: Smithsonian, 1996); Carlene E. Stephens, *On Time: How America Has Learned to Live by the Clock* (Boston: Little, Brown and Company/Smithsonian Institution National Museum of American History, 2002); and Stephen Kern, *The Culture of Time and Space, 1880–1918*, 2nd ed. (Cambridge, MA: Harvard University Press, 2003). Alan Trachtenberg argues in *The Incorporation of America: Culture and Society in the Gilded Age* (New York: Hill & Wang, 2007), 59, that the American railroad creates "new regions of comprehension and economic value" as it "incorporate[s] a prehistorical geological terrain into historical time."

28. See Davis, *Badge of Courage*, 53.

29. Philip S. Foner and David R. Roediger, *Our Own Time: A History of American Labor and the Working Day* (London: Verso, 1989), 20. David Grider, "James Gregory and the Dreamland Bell," http://davidgrider.com/blog/blog.htm (October 11, 2009), details the status of the timepiece—literally a bell—as a workers' "triumph," rung to mark the ten-hour day shipyard workers had won through collective action. In *Seventy Years of Life and Labor* (New York: E. P. Dutton, 1925), 288, Samuel Gompers—founder of the American Federation of Labor and its president beginning in 1886—described the sound of the striking Mechanics' Bell as his "earliest impression of the meaning of the eight-hour day," and a critical benchmark and meme for the ongoing eight-hour campaign. Karl Marx's Preface to *Capital: A Critique of Political Economy*, Volume I, transl. Samuel Moore and Edward Aveling (Moscow: Progress Publishers; orig. 1887), 7, famously deploys the figure of the worker's bell, or tocsin, as an agency of historical marking or timekeeping and revolutionary action: "As in the 18th century, the American war of independence sounded the tocsin for the European middle class, so that in the 19th century, the American Civil War sounded it for the European working class."

30. Bernard Bailyn et al., *The Great Republic: A History of the American People* (Lexington, MA: D. C. Heath and Company, 1985), 563.

31. Amanda Matthews Chase, *Primer for Foreign Speaking Women* (1918), 12–13. See also Sara Redempta O'Brien, *English for Foreigners* (Boston: Houghton Mifflin, 1909), 88.

32. Elizabeth Ewen, *Immigrant Women in the Land of Dollars: Life and Culture on the Lower East Side, 1890–1925* (New York: Monthly Review Press, 1985), 63, 65.

33. Jacob Riis, *How the Other Half Lives*, 174.

34. Howard, *Form and History*, 105, aptly observes that "There is a fundamental difference between treating an other . . . as a producer of signs or as a sign" and that "the construction of two polarized categories of characters—one of sign-producers, one of signs—is one of the most distinctive elements of naturalism." That distinction, I'm suggesting, becomes all the more consequential when it is materialized transformed at the level of visual signification.

35. Gullason, *Stephen Crane's Literary Family*, 143.

36. For Riis's account of their collaboration, see Jacob A. Riis, *Theodore Roosevelt, the Citizen* (Norwood, CT: The Outlook Company, 1904), 127–54.

37. Moses Rischin, *Grandma Never Lived in America* (Bloomington: Indiana University Press, 1985), xxi. Due at least in part to "Cahan and the Ghetto," Steffens wrote, 308, "the commercial city room had ideals and flaunted them openly."

38. Jacob Riis, *How the Other Half Lives*, 108, 107.

39. Rischin, "Abraham Cahan," 14.

40. Riis, *How the Other Half Lives*, 112.

41. Abraham Tabachnik, quoted in Dan Wakefield, "New York's Lower East Side Today: Notes and Impressions," *Commentary* (June 1959): 461–71; citation 461.

42. See Christopher Mele, *Selling the Lower East Side: Culture, Real Estate and Resistance* (Minneapolis: University of Minnesota Press, 2000); Christine Stansell, *American Moderns: Bohemian America and the Creation of a New Century* (New York: Macmillan, 2000; David Hollinger, "Ethnic Diversity, Cosmopolitanism, and the Emergence of the American Liberal Intelligentsia," *American Quarterly* 27 (1975): 133–51.

43. Howells, Review of *The Imported Bridegroom and Other Stories of the New York Ghetto, Literature*, December 31, 1898, cited in Bernard G. Richards, Introduction to Cahan, *Yekl and the Imported Bridegroom* (New York: Dover, 1970), vii.

44. See Cahan, *Education*, 196–219.

45. Howells, Review of *Imported Bridegroom*.

46. Quoted in Hutchins Hapgood, *The Spirit of the Ghetto: Studies of the Jewish Quarter in New York* (New York: Funk & Wagnalls, 1902), 234.

47. Cahan's celebrity status, with its dependence on his embeddedness in "low life" New York, is occasioned by William Dean Howells's puff piece "New York Low Life in Fiction" in the *New York World* of July 26, 1896; in keeping with the new mass market tactics of its founder, Joseph Pulitzer, the paper's staff plastered posters and handbills featuring Cahan's likeness all over the city.

48. See Hana Wirth-Nesher, *Call It English: The Languages of Jewish American Literature* (Princeton, NJ: Princeton University Press, 2006), 39, on the analogy with Jacob.

49. Abraham Cahan, *Yekl, A Tale of the New York Ghetto* (New York: D. Appleton and Company, 1896), 1. All subsequent references, unless otherwise indicated, are to this edition and are given parenthetically in the text.

50. Wirth-Nesher, *Call It English*, 43–44, compares the self-presentation and tone of the narrator in Cahan's Yiddish version of *Yekl* (written after the English version), and notes the effect of the narrator's claims to first-person, firsthand knowledge of Jake. The shift in voice, I argue, highlights the nearness to Cahan's work of Riis's image-text treatments of the ghetto.

51. See Cahan, *Education,* 243.

52. I am indebted throughout to Wirth-Nesher's reading. She notes in *Call It English,* 37, that Cahan "does not record speech variation as a permanent condition of region, race, or class in American society" but as "a progressive movement toward becoming American in a dynamic linguistic environment"—a matter, we might say, of keeping an alternative kind of time.

53. Mikhail Bakhtin, *The Dialogic Imagination: Four Essays,* ed. Michael Holquist, transl. Caryl Emerson and Michael Holquist (Austin: University of Texas Press, 1981), 366; cited in Wirth-Nesher, *Call It English,* 37–38.

54. Wirth-Nesher, *Call It English,* 33.

55. On the turn against sight dialect, see Elsa Nettels, *Language, Race, and Social Class in Howells's America* (Lexington: University Press of Kentucky, 1988), 62–71, and Eric Sundquist, *To Wake the Nations: Race in the Making of American Literature* (Cambridge, MA: Harvard University Press, 1993), 312–13.

56. Phillips Barrish, *American Literary Realism, Critical Theory, and Intellectual Prestige, 1880–1995* (Cambridge: Cambridge University Press, 1995), 83. Louis Harap, *The Image of the Jew in American Literature: From Early Republic to Mass Immigration* (Rutherford, NJ: Fairleigh Dickinson University Press, 1988), 495.

57. Jerome McGann, *Black Riders: The Visible Language of Modernism* (Princeton, NJ: Princeton University Press, 1993).

58. Gregory L. Ulmer, "The Object of Post-Criticism," in *The Anti-Aesthetic: Essays on Postmodern Culture,* ed. Hal Foster (Port Townsend, WA: Bay Press, 1983), 83–110.

59. Marjorie Perloff, "Collage and Poetry," *Encyclopedia of Aesthetics,* ed. Michael Kelly, vol. 1 (New York: Oxford University Press, 1998), 384–87.

60. David Antin, "Some Questions about Modernism," *Occident* 8 (Spring 1974): 7–38; cited in Perloff, 306.

61. David M. Henkin, *City Reading: Written Words and Public Spaces in Antebellum New York* (New York: Columbia University Press, 1998); see especially 15–17, 200–201.

62. Notably, the 1896 Appleton edition, as well as later editions, includes without comment photographs made by Riis or modeled on his tenement images that become by default evidentiary of the historical condition of arrested development that attaches to ghetto dwellers.

Chapter 2. On Location

1. Gerry Turvey, "Panoramas, Parades and the Picturesque: The Aesthetics of British Actuality Films, 1895–1901," *Film History* 16, no 1 (2004), 9, likewise notes that "All early actuality films were, in a sense, about location."

2. See Thomas Gunning, "An Aesthetic of Astonishment; Early Film and the (In)Credulous Spectator," in Linda Williams, ed., *Viewing Positions: Ways of Seeing Film* (New Brunswick, NJ: Rutgers University Press, 1995), 114–33, citation 114–15; Stephen Bottomore, "The Panicking Audience?: Early Cinema and the 'Train Effect,'" *Historical Journal of Film, Radio and Television* 19, no. 2 (1999), 177–216.

3. Gunning, "Aesthetic of Astonishment," 118.

4. Gunning, "Aesthetic of Astonishment," 118.

5. Benjamin, "On Some Motifs in Baudelaire," 175.

6. Gunning, *D. W. Griffith and the Origins of American Narrative Film: The Early Years at Biograph* (Champaign-Urbana: University of Illinois Press, 1994), 262.

7. Gunning, *Griffith and the Origins,* 88.

8. Miriam Hansen, *Babel and Babylon: Spectatorship in American Silent Film* (Cambridge, MA: Harvard University Press, 1991), 63. On the location of early screening spaces and later movie houses, see Linda Arvidson, *When the Movies Were Young* (New York: Dover, 1970).

9. Gunning, *Griffith and the Origins,* 88.

10. Adolph Zukor, cited in Will Irwin, *The House that Shadows Built* (New York: Doubleday, Doran and Company, 1958), 151; cited in Robert Sklar, *Movie-Made America*, 46; cited in Hansen, *Babel & Babylon*, 64. On Jewish Americans and the birth of the film industry, see Neal Gabler, *An Empire of Their Own* (New York: Crown, 1988), Patricia Erens, *The Jew in American Cinema* (Bloomington: Indiana University Press, 1988), and the more recent and expansive *Entertaining America: Jews, Movies, and Broadcasting*, ed. J. Hoberman and Jeffrey Shandler (Princeton, NJ: Princeton University Press, 2003).

11. Advertistment [D. W. Griffith], *New York Dramatic Mirror*, December 1913 (70: 1825), 36.

12. Gunning, *Griffith and the Origins*, 33, 23.

13. This argument differs from others that seek to explore the formal and aesthetic power of *Birth of a Nation* either as distinct or inseparable from its racialism and racism. A suggestive version of the latter is made by Richard Brody, "The Worst Thing about *Birth of a Nation* Is How Good It Is," *New Yorker* online, February 1, 2013, www.newyorker.com/culture/richard-brody/the-worst-thing-about-birth-of-a-nation-is-how-good-it-is.

14. Hansen, *Babel and Babylon*; Erens, *The Jew in American Cinema*.

15. *Moving Picture World*, June 11, 1910, 1005, cited in Erens, *The Jew in American Cinema*, 43.

16. Hansen, *Babel and Babylon*, 74.

17. Erens, *Jew in American Cinema*, 42–52, discusses variations in the matter of ghetto films, and provides a comprehensive filmography, 423–28, of productions by such rival companies as Kalem, Lubin, and Yankee.

18. Hansen, *Babel and Babylon*, 76.

19. In other words, the motives that shape his location work in the ghetto' what one film synopsis describes as that "theater within a theater," where "the stage . . . is [always] set" for dramatic incident—Marcus Eli Ravage, *An American in the Making: The Life Story of an Immigrant* (New York: Harper and Brothers, 1927), 87—are not entirely cinematic.

20. My use of "animation" is informed by film theorists and historians interested in the "moving" aspect of moving pictures as a matter not just of diegetics or ontology but of the embodied experience of cinema: Karen Beckman, ed., *Animating Film Theory* (Durham, NC: Duke University Press, 2014), particularly Beckman, Introduction 8–11; Tom Gunning, "Landscape and the Fantasy of Moving Pictures: Early Cinema's Phantom Rides," in *Cinema and Landscape*, ed. Graeme Harper and Jonathan Rayner (Chicago: Intellect Books, 2010), 31–70; Gunning, "Animated Pictures: Tales of Cinema's Forgotten Future," *Michigan Quarterly Review* 34, no. 4 (Fall 1995), 465–85.

21. Arvidson, *Young*, 5; Stern, Gilmartin, and Mellins, *New York 1930*, 246; Gish, *The Movies*, 54.

22. Herman Bernstein, Introduction to Walter E. Lagerquist, "The Old East Side Gives Way to the New," *New York Times,* Magazine Section, April 3, 1910, 1. See Mario Maffi, "A Geography of Cultures: Or, Why New York's Lower East Side Is an Important Case Study," *E-rea: Revue électronique d'études sur le monde Anglophone* 7, no. 2 (2010), http://erea.revues.org/1121#ftn1.

23. G. W. Bitzer, *Billy Bitzer His Story: The Autobiography of D. W. Griffith's Master Cameraman* (New York: Farrar, Straus and Giroux, 1973), 7.

24. Arvidson, *Young*, 49.

25. Griffith and Hart, *The Man Who Invented Hollywood: The Autobiography of D. W. Griffith* (Louisville, KY: Touchstone Publishing Company, 1972), 87, 73, 84. On the tailor, see Gish, *The Movies*, 73.

26. On the locations of early studios, see Arvidson, *Young* 32; Gary W. Harner, "The Kalem Company, Travel and On-Location Filming: The Forging of an Identity," *Film History* 10, no. 2, Film, Photography and Television (1998), 188–207.

27. Arvidson, *Young*, and Gish, *The Movies,* 125.

28. Gunning, *Griffith and the Origins*, 50, 139.

29. Griffith and Hart, *Man*, 29.

30. Griffith and Hart, *Man*, 53.

31. Griffith and Hart, *Man*, 56; see also Richard Schickel, *D. W. Griffith: An American Life* (New York: Limelight, 2004), 54–55.

32. Gunning, *Griffith and the Origins*, 176.

33. *New York Times*, "Gambler Who Defied Police Is Shot Dead," July 16, 1912, 1.

34. *New York Times*, "Eight Days Later, Wide Search for Slayers Starts," July 24, 1912, 1.

35. See, e.g., Robert Nash, "Charles Becker: The 'Crookedest' Cop in New York," Annals of Crime, www.annalsofcrime.com/04-01.htm (n.d.; accessed July 10, 2014). Paul Sorrentino, *Stephen Crane*, 200–209; Stanley Wertheim and Paul Sorrentino, *The Crane Log: A Documentary Life of Stephen Crane, 1871–1900* (Boston: G. K. Hall, 1994), 208, 210; Davis, *Badge of Courage*, 163, 167; Benfey, *The Double Life of Stephen Crane*, 179; Stanley Wertheim, *A Stephen Crane Encyclopedia* (Westport, CT: Greenwood Press, 1997), 5–6, 56.

36. F. Scott Fitzgerald, *The Great Gatsby* (New York: Scribner, 2004 [1925]), 75.

37. Albert Fried, *The Rise and Fall of the Jewish Gangster in America* (New York: Columbia University Press, 1994), 1. In spite of protestation to the contrary by community leaders, prostitution had clearly come by 1900 to be a "distinctive Jewish illegal activity" in the ghetto. One outfit based in an Essex Street saloon ran 200 "lady" managers and 85 employment offices supplying prostitutes to dance halls and brothels, and an 1897 report counted some 135 brothels and "disorderly places" in the Tenth Ward alone. Maffi, *Gateway to the Promised Land*, 131; see also Jenna Weissman Joselit, *Our Gang: Jewish Crime and the New York Jewish Community, 1900–1940* (Bloomington: Indiana University Press, 1983).

38. *Year Book of the University Settlement Society of New York*, 1899, cited in Fried, *Rise and Fall*, 13; see also Fried, *Rise and Fall*, 7, 1.

39. Headworker of the University Settlement Society, 1900, cited in Fried, *Rise and Fall*, 13.

40. See David Cook, *A History of Narrative Film*, 3rd ed. (New York: Norton, 1996), 400 (image reproduction 74).

41. Russell Merritt, "Griffith's East Side Scenes Were Probably in Fort Lee," *The Record* (*Bergen County, NJ*), September 7, 2003. See also Tracy Goessel, *First King of Hollywood: The Life of Douglas Fairbanks* (Chicago: Chicago Review Press, 2016), 83.

42. Merritt, "Griffith's East Side."

43. *Biograph Bulletin*, October 25, 1908; reprinted in Tom Gunning, "Outsider as Insiders: Jew and the History of American Silent Film," The National Center for Jewish Film, www.jewishfilm .org/pdf/Insiders%20as%20Outsiders_Gunning%20article.pdf (n.d.), accessed May 25, 2017.

44. Schickel, *Griffith: An American Life*, 180, describes *Musketeers* as "a series of Jacob Riis photographs come to life."

45. Anthony Slide, *The Griffith Actresses* (South Brunswick, NJ, and New York: A. S. Barnes and Company), 93.

46. Cited in Slide, *Griffith Actresses*, 35.

47. Bitzer, *Billy Bitzer His Story*, 87, emphasis in original.

48. Cited in Slide, *Griffith Actresses*, 94–95.

49. Quirk, *Photoplay*, 39, cited in Slide, *Griffith Actresses*, 95.

50. See Slide, *Griffith Actresses*, 37.

51. Examples include David Cook, *A History of Narrative Film*, 74; Hansen, *Babel and Babylon*; Robert M. Henderson, *D. W. Griffith: The Years at Biograph* (New York: Farrar, Straus and Giroux, 1970); James Monaco, *How to Read a Film: The Art, Technology, Language, History, and Theory of Film and Media, rev. ed.* (New York: Oxford University Press, 1981), 238. I note that I have chosen a slightly later frame than the one that has circulated so widely, in order to emphasize the complex dynamics of this visual encounter.

52. Arvidson, *Young*, 227, notes that Dorothy was "too perky" for Griffith; the actress described her own trajectory in "And So I Am a Comedienne," *Ladies Home Journal* 42, no. 2 (July 1925).

53. Cited in Eisenstein, *Film Form*, 234–35. Gish, *The Movies,* 37; Gish notes that Griffith gave them red and blue hair ribbons to wear, ostensibly to allow him to tell them apart.
54. Eisenstein (emphasis original), cited in Leyda, *Film Form*, 234–35.
55. On cheap amusements there, see Bella Lindner Israels (later Moscowitz), cited in Fried, *Rise and Fall*, 16–17.
56. Noël Burch, *Theory of Film Practice*, transl. Helen R. Lane (New York: Praeger, 1973), 17–21.
57. Maffi, *Promised Land,* 67.
58. David Bordwell and Kristin Thompson, *Film Art: An Introduction*, 8th ed. (Boston: McGraw-Hill, 2008), 188.

Chapter 3. What Becomes an Icon?

1. Notable work on the mutual mediation of Jewish American history and the history of photographic practice includes A. D. Coleman, "No Pictures: Some Thoughts on Jews and Photography" (1998), available in the Photography Criticism Cyberarchive (n.d.; 2003–2005), www.photocriticism.com/members/archivetexts/photocriticism/coleman/colemannopix .html; Sara Blair, "Jewish America through the Lens: On Fictions of Photography," in Blair and Jonathan Freedman, eds., *Jewish in America* (Ann Arbor: University of Michigan Press, 2004), 113–34; Deborah Dash Moore and MacDonald Moore, "Observant Jews and the Photographic Arena of Looks," in Vincent Brook, ed., *"You Should See Yourself!" Jewish Identity in Postmodern American Culture* (New Brunswick, NJ: Rutgers University Press, 2006), 176–204; Mason Klein and Catherine Evans, *The Radical Camera: New York's Photo League, 1936–1951* (New Haven, CT: Yale University Press, 2011); and Jane Livingston, *The New York School: Photographs, 1936–1963* (New York: Stewart Tabori & Chang, 1992). See also Michael Berkowitz, *Jews and Photography in Britain* (Austin: University of Texas Press, 2015).
2. Paul Strand, Portfolio notes, n.d., Paul Strand Papers, Archival Group 17, Box 7, Folder 1, Center for Creative Photography (CCP).
3. Maria Morris Hambourg, *Paul Strand Circa 1916* (New York: Metropolitan Museum of Art/ Harry N. Abrams, 1998), 26; Stieglitz, *Camera Work* 49/50 (June 1917); Liz Hager, "Paul Strand and the Birth of Modernism in Photography," *Venetian Red,* November 9, 2008, http:// venetianred.net/2008/11/09/paul-strand-and-the-birth-of-modernism-in-photography/1.
4. Calvin Tomkins, Interview with Paul Strand, June 30, 1973, typescript, Menschel Library, Metropolitan Museum of Art, 4.
5. See, e.g., the term that entered common usage in 1902, "Morganization," *Oxford English Dictionary*, www.oed.com/view/Entry/254471?redirectedFrom=morganization#eid, accessed May 31, 2016.
6. Jean Strouse, *Morgan: American Financier* (New York: Random House, 2014), 5–6; Steven H. Jaffe and Jessica Lautin, *Capital of Capital: Money, Banking, and Power in New York City, 1784–2012* (New York: Columbia University Press, 2014), 102–3.
7. Cited in Strouse, *Morgan*, ix–x; see also Matthew Josephson, *The Robber Barons: The Great American Capitalists 1861–1901* (New Brunswick, NJ: Transaction Publishers, 2011; originally Harcourt, Brace, and Company, 1934).
8. "A Rival to the Parthenon," *The New York Real Estate Record and Guide* (July 18, 1914), 90.
9. Hambourg, *Paul Strand,* 24, 29.
10. See Ella Morton, "The Wall Street Bombing: Low-Tech Terrorism in Prohibition-Era New York," September 16, 2014, www.slate.com/blogs/atlas_obscura/2014/09/16/the_1920_wall_st _bombing_a_terrorist_attack_on_new_york.html.
11. Calvin Tomkins, Interview with Paul Strand, June 30, 1973, Menschel Library, Metropolitan Museum of Art.

12. See Hambourg, *Paul Strand*, 157.

13. Strand, conversation with Naomi Rosenblum, March 1975, Naomi Rosenblum Papers, CCP.

14. Colin Westerbeck and Joel Meyerowitz, *Bystander: A History of Street Photography* (New York: Little Brown, 2001), 101.

15. Nathan D. Urner, *The Detective's Secret: or The Widow's Plot* (Chicago: Laird & Lee, 1888), Pinkerton Detective Series 14 (April 1888), 17.

16. Clive Scott, *Street Photography from Atget to Cartier-Bresson* (London: I. B. Tauris, 2007), 6.

17. Strand, conversation with Naomi Rosenblum, March 1975, Naomi Rosenblum Papers, CCP.

18. Alan Trachtenberg, "Introduction," 9, and Naomi Rosenblum, "The Early Years," in *Paul Strand: Essays on His Life and Work*, ed. Maren Stange (New York: Aperture, 1990), 32.

19. New York Historical Society, "From the Classroom to the World: Hine, Ulmann, Strand, Arbus and the Ethical Culture Fieldston School" (April 6–July 18, 2004), www.nyhistory.org /exhibitions/classroom-world-hine-ulmann-strand-arbus-and-ethical-culture-fieldston-school.

20. Cited in Naomi Rosenblum, *Biographical Notes in America and Lewis Hine: Photographs 1904–1940* (New York: Aperture 1977), 17.

21. Committee of The Bowery Savings Bank, guidelines to architects, 1893, cited in David Huyssen, *Progressive Inequality: Rich and Poor in New York, 1890–1920* (Cambridge, MA: Harvard University Press, 2014), 43.

22. Strand, conversation with Naomi Rosenblum; see also Michael E. Hoffman, ed., *Paul Strand: Sixty Years of Photographs* (New York: Aperture, 1934), 142.

23. Alan Trachtenberg, Introduction, Maren Stange, ed., *Paul Strand: Essays on His Life and Work* (New York: Aperture, 1990), 1–17, citation 9.

24. Naomi Rosenblum, email to author, August 22, 2011.

25. Tyler Anbinder, *Five Points* (New York: Free Press, 2001); Luc Sante, *Low Life: Lures and Snares of Old New York* (New York: Farrar, Straus and Giroux, 2003); Herbert Asbury, *The Gangs of New York: An Informal History of the Underworld* (New York: Knopf, 1928).

26. Sante, *Low Life*, 9, 13, 72.

27. Sante, *Low Life*, 12, 99.

28. I have in mind Barthes's language in *Camera Lucida*, 30: "I like certain biographical features which, in a writer's life, delight me as much as certain photographs; I have called these features 'bjographemes'; Photography has the same relation to History that the biographeme has to biography."

29. Allen Churchill, "Photography among City Byways," *Photo Era* 33, no. 4 (October 1914), 165–70; citation 165.

30. Allen Churchill, "Photography," 165, 166.

31. William S. Davis, "The Pictorial Possibilities of New York," *Photographic Times* 41 (October 1914), 395–400.

32. See, for example, Harry A. Brodine, "Street Scenes," *Photographic Times* 45 (1913), 49–53; William H. Zerbe, "Picturesque New York," *The American Annual of Photography* 31 (1917), 202–3, plates 203–205; John Bartlett, "High Art and the Snapshot," *The Camera* 18 (1914), 24–28. An intriguing point of reference for Strand's street portraits is Sidney Allan (pseudonym for Sadakichi Hartmann), "How to Make Large Heads," *Wilson's Photographic Magazine* 50 (1913), 175.

33. Strand, Transcript of interview with Milton Brown, November 1971, for the Archives of American Art, The Smithsonian Institution, 6. Paul Strand Collection, Center for Creative Photography, Archive Group 17, Box 37.

34. Strand, Interview with Milton Brown, 6.

35. Strand, Interview with Milton Brown, 6.

36. Strand, Interview with Tomkins, 6.

37. Hambourg, *Paul Strand*, 24.

38. On Hine's problematic assignments of racial identity to his subjects see Jonathan L. Doherty, ed., *Lewis Wickes Hine's Interpretive Photography: The Six Early Projects* (Chicago: University of Chicago Press, 1978), 2; Sara Blair, *Henry James and the Writing of Race and Nation*, fn 19, 171.

39. On the Picture Library and its holdings, see Anthony T. Troncale, *Worth Beyond Words: Romana Javitz and The New York Public Library's Picture Collection* (New York: New York Public Library, 1995). Walker Evans, cited in James R. Mellow, *Walker Evans* (New York: Basic Books, 2008), 76.

40. Alfred Stieglitz, *Camera Work* 49/50 (June 1917).

41. Walker Evans, cited in Mellow, *Walker Evans*, 75–76. See also Evans, "Paul Strand," in *Quality: Its Image in the Arts* (New York: Athaneum, 1969), 179, and *Heilbrunn Timeline of Art History*, Metropolitan Museum of Art, n.d., accessed February 9, 2015, www.metmuseum .org/toah/works-of-art/33.43.334,

42. Mellow, *Walker Evans*, 43–44.

43. Calvin Tomkins, "Look to the Things Around You," *New Yorker* 50 (September 16, 1974), 44–94. See also Tomkins, Interview with Paul Strand, 4.

44. Waltern Rosenblum, "A Personal Memoir," in Maren Stange, ed., *Paul Strand: Essays on His Life and Work* (New York: Aperture, 1989), 141–43, citation 142.

45. Interview with Naomi Rosenblum, Naomi Rosenblum Research Files, Series III, box 5, Center for Creative Photography.

46. On the visual rhetoric of Strand's image in the context of disability aesthetics and theory, see Nicholas Mirzoeff, "Blindness and Art," in Lennard J. Davis, ed., *The Disability Studies Reader* (New York: Routledge, 2006), 379–90, especially 386–87. Susan M. Schweik, *The Ugly Laws: Disability in Public* (New York: New York University Press, 2010), features Strand's work as its cover image, without comment; as I hope I have suggested, Strand's work itself raises questions about whether a blind person can be seen as visibly at work and about what it means to constitute the "unsightly," "glaring disability," and those bodies that are readily subject to the look of others (17).

47. For example, the catalogue of the Metropolitan Museum of Art, accession number 33.43.334, appeared on the museum's *Heilbrunn Timeline of Art History* as "Blind," through 2017. Accessed May 28, 2017, www.metmuseum.org/toah/works-of-art/33.43.334/.

48. Eric Rosenberg, "With Trauma: Walker Evans and the Failure to Document," in Sara Blair and Eric Rosenberg, *Trauma and Documentary Photography of the FSA* (Berkeley: University of California Press, 2012), 52–98; citation 64.

49. Rosenberg, "With Trauma," 63–64.

50. Walker Evans, "The Reappearance of Photography," *Hound & Horn* 5 (October–December 1931), reprinted in Rosenheim and Eklund, *Unclassified*, 80–84, citation 80.

51. Evans, unpublished introductory note for the 1961 reissue of *American Photographs*, reprinted in *Walker Evans at Work* (New York: Thames and Hudson, 1984), 151.

52. Allan Sekula, "The Body and the Archive," 59.

53. "Walker Evans: License Photo Studio," Heilbrunn Timeline of Art History, the Metropolitan Museum of Art, updated January 3, 2013, www.metmuseum.org/toah/works-of-art/1972 .742.17.

54. Peter Galassi, *Walker Evans and Company* (New York: Museum of Modern Art, 2000), 161. Galassi notes that such temporal collapse is part of what makes "Evans's work forward-looking," the reason why it "now seems closer to what has come after than to what came before."

55. Cited in Timothy J. Gilfoyle, *A Pickpocket's Tale: The Underworld of Nineteenth-Century New York* (New York: Norton, 2007), 19.

56. "Ephemeral New York: Baxter Street," December 15, 2011, accessed May 31, 2016. http:// ephemeralnewyork.wordpress.com/tag/baxter-street/. On Baxter Street alleys, see Thomas N.

Doutney, *Thomas N. Doutney: His Life-Struggle and Triumphs, Also a Vivid Pen-Picture of New York* (Battle Creek, MI: W. C. Gage & Sons, 1893), 109–10.

57. Nick Tosches, *King of the Jews* (New York: Ecco, 2005), 122, 10.

58. Riis, *How the Other Half Lives*, 79.

Chapter 4. Looking Back

1. Ralph Blumenthal, "Take 2: A Photo Archive of City Streets," *New York Times*, March 14, 2000, E8.

2. Riis, *How the Other Half Lives*, 26.

3. See Steven G. Kellman, *Redemption: The Life of Henry Roth* (New York: Norton, 2005), 27, 37.

4. On the cultural impact of the Johnson-Reed Act, see Julian Levinson, *Exiles on Main Street: Jewish American Writers and American Literary Culture* (Bloomington: Indiana University Press, 2008), 54; Steven G. Koven and Frank Götzke, *American Immigration Policy: Confronting the Nation's Challenges* (New York: Springer, 2010), 133.

5. Joel Schwartz, *The New York Approach: Robert Moses, Urban Liberals, and Redevelopment of the Inner City* (Columbus: Ohio State University Press, 1993), 13. For an account from the ground-level view of the ensuing "decentralization and . . . dispersion of the Jewish population," and the difficulties of apprehending the loss of "from one-third to one-half" of the Jewish population, see "Adjusting Our Lives," *Jewish Daily Bulletin,* August 20, 1934, www.jta .org/1938/08/20/archive/adjusting-our-lives-22.

6. Schwartz, *The New York Approach*, 38.

7. Diner, *Lower East Side Memories*, 8.

8. Evans, "The Reappearance of Photography," 80–81.

9. Alfred Kazin, Review of *Call It Sleep, New York Review of Books*, October 10, 1991.

10. Ben Shahn, unpublished "Autobiography" (1965), Introduction, 16–18, citation 18, Stephen Lee Taller Archive, Harvard University Fine Arts Library; see Laura Katzman, "Ben Shahn's New York: Scenes from the Living Theater," in Deborah Martin Kao, Laura Katzman and Janna Webster, *Ben Shahn's New York: The Photography of Modern Times* (Cambridge, MA and New Haven, CT: Fogg Art Museum, Harvard University Art Museums/Yale University Press, 2000), 34.

11. Henry Roth, *Call It Sleep* (New York: Picador, 2005), 143. All subsequent citations are given in the text.

12. Barthes, *Camera Lucida*, 96.

13. Barthes, *Camera Lucida*, 40.

14. Irving Howe, "Life Never Let Up," *New York Times Book Review*, October 25, 1964, 1, 60; citation 1.

15. See Morris Dickstein, "Memory Unbound," *Threepenny Review* 110 (Summer 2007), www .threepennyreview.com/samples/dickstein_su07.html.

16. Henry Roth, "No Longer at Home," *New York Times*, April 15, 1971, reprinted in *Shifting Landscape*, ed. Mario Materassi (Philadelphia: Jewish Publication Society, 1987), 168.

17. On the incest narrative in Roth's self-representation see Myles Weber, "Henry Roth's Secret," *Michigan Quarterly Review* 45, no. 3 (Summer 2006), 560–67.

18. Roth, "No Longer at Home," 168.

19. Roth, cited in Kellman, *Redemption*, 44.

20. On the aurality of Roth's work, see Hana Wirth-Nesher, "Between Mother Tongue and Native Language: Multilingualism in Henry Roth's *Call It Sleep*," *Prooftexts* 10, no. 2 (May 1990), 297–312, and *Call It English: The Languages of Jewish American Literature* (Princeton, NJ: Princeton University Press, 2006), 76–99.

21. On the museum and the masses see George Cotkin, *Reluctant Modernism: American Thought and Culture, 1880–1900* (Lanham, MD: Rowman & Littlefield, 1992), 106, 107; Roy Rosenzweig and Elizabeth Blackmar, *The Park and the People: A History of Central Park* (Ithaca, NY: Cornell University Press, 1992).

22. Henry Roth, letter to Byron Franzen, November 14, 1968, cited in Kellman, *Redemption*, 49.

23. Peter C. Marzio, *The Democratic Art: Pictures for a Nineteenth-Century America: Chromolithography 1840–1900* (Boston: David R. Godine, 1979), 43, notes that chromos of that era cost as little as five cents and that, by 1890, annual production of chromos was valued at twenty million dollars (over $25 billion in 2014 dollars). See also Joan M. Marter, *The Grove Encyclopedia of American Art*, vol. 1 (New York: Oxford University Press, 2011), 468.

24. National Lithographers' Association, 1983, cited in Marzio, *Democratic Art*, 5.

25. Russell Sturgis to Louis Prang, cited in Marzio, *Democratic Art*, 106.

26. Marzio, *Democratic Art*, 61; Jenna Weissman Joselit, *The Wonders of America: Reinventing Jewish Culture 1880–1950* (New York: Hill and Wang, 1996), 140. On the chromo and tenement domesticity, see Katharine Martinez, "At Home with Mona Lisa: Consumers and Commercial Visual Culture, 1880–1920," in *Seeing High and Low* 160–176, especially 162–64.

27. Joselit, *Wonders of America*, 140–41.

28. Joselit, *Wonders of America*, 141. See also Ewen, *Immigrant Women in the Land of Dollars: Life and Culture on the Lower East Side, 1890–1925* (New York: Monthly Review Press, 1985), 157–58.

29. On nostalgia, see Marzio, *Democratic Art*, 123.

30. On Roth's specific uses and redirection of eye dialect in relation to his multilingualism, see Wirth-Nesher, *Call It English*, 83–84, 90–91; Paul H. Bowdre Jr., "Eye Dialect as a Literary Device," in *A Various Language*, eds. J. V. Williamson and V. M. Burke (New York: Holt, Rinehart & Winston, 1971), 178–79; and Elizabeth Fine, "In Defense of Literary Dialect: A Response to Dennis R. Preston," *Journal of American Folklore* 96, no. 381 (1983): 323–30.

31. Kellman, *Redemption*, 56–57; Roth, "Nature's First Green," in *Shifting Landscape*, 252, describes himself as having been "the reigning comedian of 119th Street in East Harlem."

32. Barthes, *Camera Lucida*, 47, 119.

33. Laura Katzman, "Ben Shahn's New York," 14, 181. On Shahn's career in relation to Judaic and Jewish sources and contexts see Davis Pratt, Preface, *The Photographic Eye of Ben Shahn*, ed. Davis Pratt (Cambridge, MA: Harvard University Press, 1975), xi; Matthew Baigell, *American Artists, Jewish Images* (Syracuse, NY: Syracuse University Press, 2006); Frances K. Pohl, *Ben Shahn* (San Francisco: Pomegranate Artbooks, 1993), 7.

34. Deborah Martin Kao, "Ben Shahn and the Public Use of Art," in Kao, Katzman, and Webster, *Ben Shahn's New York*, 41; Richard K. Doud, Oral history interview with Ben Shahn, April 14, 1964, Smithsonian Archives of American Art, www.aaa.si.edu/collections/interviews/oral -history-interview-ben-shahn-12760.

35. Ben Shahn, in Doud, Oral history interview. See also James R. Mellow, *Walker Evans*, 118.

36. *Hammond's New Guide Map of Manhattan and the Bronx*, 1909, Lionel Pincus and Princess Firyal Map Division, New York Public Library.

37. See Katzman, "Ben Shahn's New York," 20–21.

38. "Out-Sizes," *The New Yorker*, May 2, 1931, 13–14, citation 14.

39. On Evans's engagements with commercial signs, see Walker Evans and Andrei Codrescu, *Walker Evans: Signs* (Los Angeles: Getty Trust: J. Paul Getty Museum, 1998), and Peter Galassi, *Walker Evans & Company*, 161–201.

40. See Diner, *Lower East Side Memories*, 119–20, on the "fat-laden" food associated with cultural authenticity.

41. James Soby, *Ben Shahn* (New York: Penguin Books, 1947); see also Laura Katzman, "'Mechanical Vision': Photography and Mass Media Appropriation in Ben Shahn's Sacco and Vanzetti

Series," in *Ben Shahn and the Passion of Sacco and Vanzetti*, ed. Alejandro Anreus (Jersey City, NJ: Jersey City Museum, 2001), 55.

42. Walker Evans, "The Reappearance of Photography."

43. Deuteronomy 32:15; Diner, *Lower East Side Memories*, 27.

44. See Diana L. Linden, *Ben Shahn's New Deal Murals: Jewish Identity in the American Scene* (Detroit: Wayne State University Press, 2015).

45. Jenna Webster, "Ben Shahn and the Master Medium," in Kao, Katzman, and Webster, *Ben Shahn's New York*, 75–95.

Chapter 5. Writers' Blocks

1. Ginsberg, letter to Jack Kerouac, November 13, 1957, *Letters of Allen Ginsberg,* ed. Bill Morgan (Cambridge, MA: Da Capo Press, 2008), 169.

2. Ginsberg, letter to Jack Kerouac, November 13, 1957, *Letters of Allen Ginsberg*, 168.

3. Allen Ginsberg to Jack Kerouac, cited in James Campbell, *This Is the Beat Generation: New York-San Francisco-Paris* (Berkeley: University of California Press, 1999), 237.

4. See Barry Miles, *Ginsberg: A Biography* (New York: Simon & Schuster, 1989), 10–11; Michael Schumacher, *Dharma Lion: A Critical Biography of Allen Ginsberg* (New York: St. Martin's Press, 1994), 232–33, 299–300.

5. "William Putterman; Emmy Award-Winning Producer," *L.A. Times*, June 4, 1995, Obituary section, 1, http://articles.latimes.com/1996–06–04/news/mn-11647_1_emmy-award -winning-producer.

6. Schumacher, *Dharma Lion*, 300.

7. Schumacher, *Dharma Lion*, 300; see also Miles, *Ginsberg*, 11.

8. Miles, *Ginsberg*, 11. Ginsberg gives his canonical account of the making of the poem, "How *Kaddish* Happened," in Ginsberg, *Deliberate Prose: Selected Essays, 1952–1995*, ed. Bill Morgan (New York: Harper Collins, 2000; orig. 1987), 232–36; originally published as liner notes, *Allen Ginsberg Reads Kaddish* (Atlantic Recording Corp., Atlantic Verbum Series 4001, 1966).

9. Ginsberg, "Kaddish," in *Kaddish and Other Poems, 1958–1950* (San Francisco: City Lights Books, 1961), 7, hereafter cited parenthetically in the text; Ginsberg, "How *Kaddish* Happened," 236.

10. Erik Mortenson, *Capturing the Beat Moment: Cultural Politics and the Poetics of Presence* (Carbondale: Southern Illinois University Press, 2012), 16.

11. William Carlos Williams, "Introduction," *Empty Mirror: Early Poems by Allen Ginsberg* (New York: Totem Press, 1961), 6; Ginsberg, "Meditation and Poetics," in Morgan, *Deliberate Prose*, 267–73, citation 268.

12. Tony Triglio, *Allen Ginsberg's Buddhist Poetics* (Carbondale: Southern Illinois University Press, 2007), especially 5–8. See also Mortenson, *Capturing the Beat Moment*, 11–12.

13. For an account of the arrival in America of Naomi Livergant-become-Levy, see Schumacher, *Dharma Lion*, 4–5.

14. Ronald Sanders, *The Lower East Side: A Guide to Its Jewish Past in 99 New Photographs* (New York: Dover, 1994), 14.

15. See Miles, *Ginsberg*, 9–10. For useful context see Ross Wetzsteon, *Republic of Dreams: Greenwich Village: The American Bohemia, 1910–1960* (New York: Simon and Schuster, 2002); Terry Miller, *Greenwich Village and How It Got That Way* (New York: Crown, 1990); Sanders, *The Lower East Side*, 13–17.

16. On "katabasis" as a quest (as in the opening phrase of Plato's *Republic*, "kateben," "I went down") and harrowing, see David Leeming, *The Oxford Companion to World Mythology* (New York: Oxford University Press, 2005), 98; John Freccero, *The Poetics of Conversion* (Cambridge, MA: Harvard University Press, 1988), 108.

17. Diner, *Lower East Side Memories*, 31, 35.

18. See Diner, *Lower East Side Memories*, 169.

19. See Diner, *Lower East Side Memories,* 171. On this cultural context, see also Eli Lenderhendler, *New York Jews and the Decline of Urban Ethnicity, 1950–1970* (Syracuse, NY: Syracuse University Press, 2001), especially 79–80. Almost two decades later, Moses Rischin's preface to the 1977 reprint of his classic *The Promised City: New York's Jews, 1870–1914* (Cambridge, MA: Harvard University Press, 1977), x, viii, insists on the Lower East Side as a "usable past," "sustain[ing] more than the illusion of direct continuity with a vital, earlier time."

20. See, for example, Lisa Zapol, "'Stores of Memory': An Oral History of Multigenerational Jewish Family Businesses in the Lower East Side," MA Thesis, Oral History, New York University, 2011, 12.

21. "The Planning Debate in New York (1955–75)," *New York: The Center of the World*, PBS, American Experience, accessed January 7, 2016, www.pbs.org/wgbh/americanexperience/features /general-article/newyork-planning/.

22. See Mayor's Pushcart Commission, "The New York Pushcart: Recommendations of the Mayor's Commission," *Charities and the Commons* 16 (September 22, 1906), 615–18.

23. On the historical battle over pushcarts, see Suzanne Wasserman, "Good Old Days of Poverty: Merchants and the Battle over Pushcart Peddling on the Lower East Side," *Business and Economic History* 27, no. 2 (Winter 1998), 330–39; "New York City and Open Air Markets (1929–1948)," accessed March 2, 2105, www.pages.drexel.edu/~dgp48/eport/documents /foodcartpaper.pdf ; Charles Grutzner, "Pushcart Cause Won at City Hall: 'Village' Defenders Rout Plan to Oust Curbside Venders," *New York Times*, May 11, 1962, 32; Daniel London, "Progress and Authenticity: Urban Renewal, Urban Tourism, and the Meaning(s) of New York in the Mid-Twentieth Century," *Journal of Tourism History* 5, no. 2 (2013), 3; Jean Merrill, *The Pushcart War* (New York: William R. Scott, 1964).

24. Grutzner, "Pushcart Cause"; Earl Wilson, *Earl Wilson's New York* (New York: Simon & Schuster, 1964), 171; cited in London, "Progress and Authenticity," 3.

25. "Our Mission," "About the Tenement Museum" landing page, accessed February 23, 2012, www.tenement.org/about.html.

26. Jenna Weissman Joselit, "Best-in-Show: American Jews and the Modern Museum," in *Imagining the American Jewish Community,* ed. Jack Wertheimer (Lebanon, NH: University Press of New England, 2007), 141–57, citation 147. For documentation of the show, its logic, and its impact in the mode of environmental exhibition, see Allon Schoener, *Portal to America: The Lower East Side, 1870–1925* (New York: The Jewish Museum, 1967).

27. Counterarguments are made by Ekbert Faas, "Confronting the Horrific," in *Under Discussion: On the Poetry of Allen Ginsberg,* ed. Lewis Hyde (Ann Arbor: University of Michigan Press, 1984), 434–50, especially 434–35, who connects the incest drive with poetic form; and James Breslin, "Allen Ginsberg: The Origins of 'Howl' and 'Kaddish,'" *The Iowa Review* 8, no. 2 (1977), 82–108, who reads incest in "Kaddish" as an expression of epistemophilia and thus critical to the poem's formal strategies. The long-standing presumption of the absence or failure of formal logic in Ginsberg's work is summarized by Marjorie Perloff, "A Lion in Our Living Room," Review of *Collected Poems 1974–1980* by Allen Ginsberg, *The American Poetry Review* 14, no. 2 (March/April 1985), 35–46.

28. Manuscript, "Kaddish," "Elegy for Mama," Allen Ginsberg Archive, Stanford University, Box 7.1, Folders 56, 57; Allen Ginsberg Manuscript Collection, Fales Special Collections, New York University, Box 69, Folders 1–9. On the judgment of Elise Cowen, who typed the poem, that "You still haven't finished with your mother," see Tony Triglio, "Reading Elise Cowen's Poetry," Ronna Johnson and Nancy McCampbell Grace, eds., *Girls Who Wore Black: Women Writing the Beat Generation* (New Brunswick, NJ: Rutgers University Press, 2002), 119–39, citation 120.

29. Ginsberg, "How Kaddish Happened," 233–34.

30. A narrative caption later appended by Ginsberg would identify the site as "our apartment roof Lower East Side between Avenues B & C . . . Neighborhood was heavily Polish and Ukrainian, some artists, junkies, medical students, cheap restaurants like Leshko's corner 7ᵗʰ & A, rent was only ¼ of my monthly $120 wage as newspaper copyboy." See Sarah Greenough and Allen Ginsberg, *Beat Memories: The Photographs of Allen Ginsberg* (New York: Prestel, 2010).

31. Greenough and Ginsberg, *Beat Memories;* Ginsberg, *108 Images/Hiro Yamagata Earthly Paradise* (Santa Monica, CA: Fred Hoffman Fine Art, 1995); Ginsberg, *Photographs*, a volume designed by photographer Robert Frank (San Francisco: Twin Palms, 1991); Ginsberg, *Snapshot Poetics: Allen Ginsberg's Photographic Memoir of the Beat Era*, eds. Michael Köhler (San Francisco: Chronicle Books, 1993).

32. Ginsberg, Interview with Thomas Gladysz, in Greenough, *Beat Memories.*

33. Ginsberg, "How *Kaddish* Happened," 234.

34. Amiri Baraka, *The Autobiography of LeRoi Jones* (New York: Freundlich Books, 1984), 167. Hettie Jones, *How I Became Hettie Jones* (New York: Grove Press, 1990), 142–43. All subsequent citations to *The Autobiography* and *How I Became Hettie Jones* will be given parenthetically as AB and HJ, respectively, in the text.

35. See J. R. Goddard, "Poet Jailed for Obscenity: Literary Magazine Hit. LeRoi Jones & Floating Bear," *Village Voice,* October 26, 1961, 3; "Floating Bear Floats Free," *Village Voice,* May 3, 1962, 3.

36. James Smethurst, *The Black Arts Movement: Literary Nationalism in the 1960s and 1970s* (Chapel Hill: University of North Carolina Press, 2005), 123, 139; see at large 101–147.

37. Baraka, "Look for You Yesterday, Here You Come Today," *Preface to a Twenty-Volume Suicide Note*, 18.

38. Baraka, "Notes for a Speech," *Preface to a Twenty-Volume Suicide Note*, 46.

39. Baraka, "Hymn for Lanie Poo," *Preface to a Twenty-Volume Suicide Note*, 9.

40. On the sun as a touchstone for black/paternal identity in Baraka's early poetry, see Werner Sollors, *Amiri Baraka/LeRoi Jones: The Quest for a "Populist Modernism"* (New York: Columbia University Press, 1978), 48.

41. Baraka, "Hymn to Lanie Poo," *Preface to a Twenty-Volume Suicide Note*, 12.

42. Baraka, "In Memory of Radio," *Preface to a Twenty-Volume Suicide Note*, 13.

43. Baraka, "Milneburg Joys (or, Against 'Hipness' As Such)," *Kulchur* 1, no. 30 (Summer 1961), 41–43.

44. Sollors, *Amiri Baraka/LeRoi Jones*, 63.

45. Jones, *How I Became*, 47; Ronald Sukenick, *Down and In: Life in the Underground* (New York: Beech Tree Books/William Morrow, 1987), cited 96.

46. On a heightened "discourse of decline" from 1955–65 see Daniel Kane, *All Poets Welcome: The Lower East Side Poetry Scene in the 1960s* (Berkeley: University of California Press, 2003), 7, 145.

47. On the appeal of this kind of extraterritorial site for second-generation abstract expressionists, see Harold Rosenberg, "Tenth Street: A Geography of Modern Art" (1959), reprinted with slight alterations in Harold Rosenberg, *Discovering the Present: Three Decades in Art, Culture, and Politics* (Chicago: University of Chicago Press, 1973), 146–67.

48. Amir Bey, "An Interview with Raphael McAdem: Dem Changes: A Commentary on the Lower East Side" (2007), *New Times Holler!,* September 14, 2008, http://thenewtimesholler.com /ARCHIVE/archiveDisplay.php?ID=51.

49. John Gruen, *The New Bohemia* (New York: A Cappella Books, 1990), 26.

50. Bob Holman, "History of the Poetry Project," Poetry Project Archives, St. Mark's Church, New York, 1978, cited in Kane, *All Poets Welcome*, 21.

51. For discussion of the cowboy as icon, fashion statement, and poetic resource, see Kane, *All Poets Welcome*, 17–23; Gruen, *The New Bohemia*, 8–9.

52. James Schuyler to Gerard Malanga, November 28, 1971, cited in Kane, *All Poets Welcome*, 18. Mele, *Selling the Lower East Side*, 26, notes that framing the Lower East Side as marginal and exotic "suited the image and the identity of romantic artists as 'frontier scouts' of culture, moving ahead of their contemporaries into uncharted territories where they would undergo privation and sacrifices." See also Kane, *All Poets Welcome*, 13–16.

53. Rashidah Ismaili Abubakr, "Slightly Autobiographical: The 1960s on the Lower East Side," *African American Review* 27, no. 4 (Winter 1993): 585–92, citations 585, 586.

54. Sarah Wright, "Lower East Side: A Rebirth of World Vision," *African American Review* 27, no. 4 (Winter 1993): 593–96, citation 594.

55. Calvin Hernton, "Umbra: A Personal Recounting," *African American Review* 27, no. 4 (Winter 1993): 579–83; citation 580. Like Hernton, Mele, *Selling the Lower East Side*, 152, invokes the imagery of the "quilt," conjoining distinctive ethnic and racial communities that are "stitched together largely by representations about them and their neighborhood." See also Tom Dent, "Umbra Days," *Black American Literature Forum* 14, no. 3 (1980), 243–94.

56. See "Naturally Occurring Cultural Distrincts," *Urban Omnibus: A Project of the Architectural League of New York*, November 17, 2010, http://urbanomnibus.net/2010/11/naturally-occurring-cultural-districts/.

57. Sukenick, *Down and In*, 58.

58. Baraka, "Marion Brown"; Sukenick, *Down and In*, 58.

59. On the exodus east, see Ned Polsky, *Hustlers, Beats, and Others* (Chicago: Aldine Publishing Company, 1967), 154; Sukenick, *Down and In*, 168.

60. A transcript of Mingus's response is provided by Diane Dorr-Dorynek in *The Jazz Word*, ed. Dom Cerulli et al. (New York: Da Capo, 1987), 14–18. See Scott Saul, *Freedom Is, Freedom Ain't: Jazz and the Making of the Sixties* (Cambridge, MA: Harvard University Press, 2001), 169–72 on Mingus's "consecration" of jazz performance in relation to "the solidarity of a neighborhood" (citations 169, 172).

61. Baraka, *The Autobiography*, 176; Sukenick, *Down and In*, 142.

62. Baraka, "Marion Brown."

63. Jones, *How I Became*, 172. On the Five Spot and neighborhood music scene, see Baraka, "Loft and Coffee Shop Jazz," in *Black Music* (New York: Perseus, 1968), 92–97; originally published as "Loft Jazz," *Down Beat*, May 3, 1963.

64. LeRoi Jones [Amiri Baraka], *Blues People: Negro Music in White America* (New York: William Morrow, 1963), 59, 142. Hereafter cited in the text as BP.

65. Jones [Baraka], *Blues People*, 172, 143.

66. Saul, *Freedom Is*, 233.

67. See Baraka's often-cited *Village Voice* essay, "Confessions of a Former Anti-Semite" (December 17–23, 1980), 1, 19–20, 22–23.

68. The album was released on the ESP label, whose commitment to artistic freedom from market forces was printed on every release: *"The artists alone decide what you will hear on their ESP-Disk."* See Jason Weiss, *Always in Trouble: An Oral History of ESP-Disk', the Most Outrageous Record Label in America* (Lebanon, NH: University Press of New England, 2012).

69. M. L. Rosenthal, "Some Thoughts on American Poetry Today," *Salmagundi* 22–23 (Spring–Summer 1973): 57–70; citations 61, 62. Richard Howard, "Two Against Chaos," *The Nation*, March 15, 1964, 289.

70. LeRoi Jones, *The Dead Lecturer* (New York: Grove Press, 1964), 64.

71. Stephen Schneck, "LeRoi Jones, or, Poetics & Policemen, or, Trying Heart, Bleeding Heart," *Ramparts*, July 13, 1968, 14–19; citation 14.

72. Jones, *Dead Lecturer*, 63, 65.

73. On Baraka and the scream, see William J. Harris, " 'How You Sound??': Amiri Baraka Writes Free Jazz," *Uptown Conversation: The New Jazz Studies*, eds. Robert G. O'Meally, Brent

Hayes Edwards, and Farah Jasmine Griffin (New York: Columbia University Press, 2004), 312–25, especially 313; Kimberly W. Benston, *Performing Blackness: Enactments of African-American Modernism* (New York: Routledge, 2000), 189–226 (beginning with the observation, 189, that "Nobody says *muthafaucka* like Amiri Baraka"). Smethurst, *The Black Arts Movement* 131, argues for the broader need among black radicals and avant-gardists downtown to stage discontinuity from Jewish American and Jewish-inflected Old Left models and politics.

74. Baraka, "Confessions of a Former Anti-Semite," 1.

75. Elihu Edelson, "*Both Sides Now* Remembered: Or, The Once and Future Journal," in *Insider Histories of the Vietnam Era Underground Press*, part 2, ed. Ken Wachsberger (East Lansing: Michigan State University 2012), 254.

76. Leonard Bloom, "The Adventures of Superiorman!," *The Realist* 59 (May 1965), 16.

Chapter 6. Remediating the Lower East Side

1. On the broader history of such representations, see Max Page, *The City's End: Two Centuries of Fantasies, Fears, and Premonitions of New York's Destruction* (New Haven, CT: Yale University Press, 2008).

2. John Lear, "Hiroshima, U.S.A.: Can Anything Be Done About It?" *Collier's Weekly*, August 5, 1950, Cover; 11–17; 64 ff.; hereafter cited in the text.

3. John Hersey, "Hirsoshima," *New Yorker*, August 31, 1946, 15–68; www.newyorker.com /magazine/1946/08/31/hiroshima.

4. "Hiroshima, U.S.A.," 11.

5. US Bureau of the Census, Table 18: Population of the 100 Largest Urban Places: 1950, available online, posted June 15, 1998, accessed March 4, 2016, www.census.gov/population/www /documentation/twps0027/tab18.txt.

6. Abraham Lincoln, "Cooper Union Address," New York, February 27, 1860; Frederick Douglass, "The Proclamation and the Negro Army," Cooper Institute, New York, February 6, 1863.

7. Michael Alexander, *Jazz Age Jews* (Princeton, NJ: Princeton University Press 2001), 77; Bruce Allen Murphy, *The Brandeis/Frankfurter Connection: The Secret Political Activities of Two Supreme Court Justices* (New York: Oxford University Press, 1982), 264.

8. According to the1950 US Census, Table 3. Characteristics of Dwelling Units by Census Tracts: 1950, the highest rates of density per housing unit and block are on the West Side in Chelsea, on the Upper East Side, and Central Park West.

9. The number of Jews in New York City reached a peak of two million in the 1950s, when Jews constituted one-quarter of the city's population. Paul Ritterband, "Counting the Jews of New York, 1900–1991: An Essay in Substance and Method," *Jewish Population Studies* 29 (Papers in Jewish Demography) 29 (Jerusalem: Avraham Harman Institute of Contemporary Jewry, 1997), 199–228, especially 215, details the context for assessing these demographics.

10. George C. Foster, *New York by Gaslight and Other Urban Sketches* (Berkeley: University of California Press, 1990 [1850]), 52; Allen E. Churchill, "Photography among City Byways," *Photo-Era (The American Journal of Photography)* 23, no. 4 (October 1914), 165–69, (citation 166); *Frank Leslie's Illustrated Weekly*, March 18, 1882, 55–57, (citation 57), cited in Anbinder, *Five Points*, 351.

11. Riis, *How the Other Half Lives*, 72, 137.

12. Riis, *How the Other Half Lives*, 55; Sante, *Low Life*, 99.

13. Riis, *How the Other Half Lives*, 255.

14. Laurie Collier Hillstrom, *Defining Moments: Muckrakers and the Progressive Era* (Detroit: Omnigraphics, 2009), 27, 28.

15. Frank Luther Mott, *A History of American Magazines, Volume 4: 1885–1905* (Cambridge, MA: Harvard University Press, 1957), 454. On the *Collier's* groundbreaking use of photographs, see Thierry Gervais, "The 'Greatest of War Photographers': Jimmy Hare, a Photojournalist at the Turn of the Twentieth Century," transl. James Gussen, *Études photographiques* 26 (November 2010): 1–15, https://etudesphotographiques.revues.org/3452#text, accessed February 20, 2016.

16. Mott, *History of American Magazines*, 454; 455.

17. Cited in Lewis Gould and Richard Greff, *Photojournalist: The Career of Jimmy Hare* (Austin: University of Texas Press, 1977), 11.

18. Kenneth Kobré and Betsy Brill, *Photojournalism: The Professionals' Approach*, Volume 1 (Boston: Focal Press, 1996), 340. On Crane's mediation of his encounter with Cuban insurgents for US readers by way of his tenement experience, see Michael Robertson, *Stephen Crane, Journalism, and the Making of Modern American Literature* (New York: Columbia University Press, 1997), 162.

19. "The Havana Tragedy," *Collier's Weekly*, March 12, 1898, 4–5.

20. Kenneth Kobré and Betsy Brill, *Photojournalism,* 340.

21. Gervais, "The 'Greatest of War Photographers.'"

22. Mott, *History of American Magazines*, 476; see 475–76.

23. Mott, *History of American Magazines,* 479; David Abrahamson, *History of the Book*, Volume 5: *Magazines*, "Reflecting and Shaping American Culture: Magazines Since World War II," accessed May 24, 2016, www.davidabrahamson.com/WWW/Articles/MagSinceWW2.txt.

24. Jay David Bolter and Richard Grusin, *Remediation: Understanding New Media* (Cambridge, MA: MIT Press, 2000), 44, 45.

25. Bolter and Grusin, *Remediation*, 53, 33–34.

26. Bolter and Grusin, *Remediation*, 59.

27. Bolter and Grusin, *Remediation*, 48.

28. On Bonestell's Hollywood projects see Ron Miller and Federick C. Durant III, *The Art of Chesley Bonestell* (London: Paper Tiger, 2001), 35–36.

29. Miller and Durant, *Art*, 44.

30. Arthur C. Clarke, January 26, 1950, *The Aeroplane*, cited in Miller and Durant, *Art*, 60, 62.

31. Miller and Durant, *Art,* 77, note of the *Collier's* space feature that it "hit the American pubic of fifty-odd years ago like a bombshell."

32. To be sure, media cross-referencing between painting and photography is as old as the latter medium. The earliest known surviving photograph, made in 1826–1827 by Joseph Nicéphore Niépce, replicates reigning conventions of the landscape "view." Likewise, art photography after the advent of the Kodak sought to differentiate itself from vulgar snap-shooting with the use of labor-intensive production processes that yielded markedly painterly images.

33. Indeed, his image is identified, in an attribution at some distance from it on the page, as a painting.

34. For this number *Collier's* increased its print order from 3,400,000 to 3,900,000 copies, and almost doubled its usual advertising sales.

35. "Preview of the War We Do Not Want," *Collier's Weekly*, October 27, 1951, 18.

36. Rosler, "In, Around, and Afterthoughts (On Documentary Photography)," *3 Works* (Halifax, Nova Scotia: Nova Scotia College of Art and Design Press, 2006 [1981]), 71.

37. Martha Rosler, in Benjamin Buchloh, "A Conversation with Martha Rosler," in *Martha Rosler: Positions in the Life World*, ed. Catherine de Zegher (Cambridge, MA: MIT Press, 1998), 38.

38. Sante, *Low Life*, 119–20.

39. Smokey, "Skid Row, New York," oral history of Bowery life, Roy Lisker, *Ferment*, accessed May 29, 2016, www.fermentmagazine.org/Bio/skidr.html.

40. Henry McBride, *New York Sun*, April 8, 1933, cited in *Art Digest*, April 15, 1933.

41. Rosler, in Buchloh, *Martha Rosler*, 42.

42. See Rosler, "In, Around, and Afterthoughts," on this issue.

43. On Wang's project of capturing a (yet again) vanishing New York, embracing his role as "a bard of the old New York," see Sam Dolnick, "A World of Times on the Lower East Side," *Lens: Photography, Video and Visual Journalism, New York Times*, November 29, 2011, http://lens .blogs.nytimes.com/2011/11/29/a-world-of-change-on-the-lower-east-side/?_r=0.

44. Rosler, "In, Around, and Afterthoughts."

45. Rosler, "In, Around, and Afterthoughts," 78.

46. Craig Owens, "The Discourse of Others: Feminists and Postmodernism," in Donald Preziosi, *The Art of Art History: A Critical Anthology* (New York: Oxford University Press, 2006), 335–51, especially 344; Craig Saper, "Academia's Exquisite Corpse: An Ethnography of the Application Process," in Kanta Kochhar-Lindgren et al., eds., *The Exquisite Corpse: Chance and Collaboration in Surrealism's Parlor Game* (Lincoln: University of Nebraska Press, 2009), 189–204, especially 194; Geoffrey Batchen, "Looking Askance," *Picturing Atrocity: Photography in Crisis*, eds. Geoffrey Batchen et al. (London: Reaktion, 2012), 227–40, citation 231–32.

47. Abigail Solomon-Godeau, *Photography at the Dock: Essays on Photographic History, Institutions, and Practices* (Minneapolis: University of Minnesota Press, 1994), fn 4, 300; Batchen, "Looking Askance," 233.

48. Charles Sanders Peirce, *The Collected Papers of Charles Sanders Peirce* (Cambridge, MA: Belknap Press of Harvard University Press), vol. 2, 287.

49. Rosler, "In, Around, and Afterthoughts," 79.

50. Edwards, *The Bowery*, 53.

51. See for example Josh Neufeld, *A. D.: New Orleans after the Deluge* (New York: Pantheon, 2010), and Brooke Gladstone and Josh Neufeld, *The Influencing Machine: Brooke Gladstone on the Media* (New York: Norton, 2012). Neufeld provides accounts of recent collaborations with his mother, including an online art/public service campaign, *The Art of Saving a Life,* promoting vaccination and featuring the life of Jonas Salk, as well as work on the European debt crisis, education versus prison spending, and the Iraq War and Guantanamo, on "Comix & Stories," February 9, 2015, https://joshcomix.wordpress.com/tag/martha-rosler/.

52. The quoted phrase is the title of a landmark 1999 volume of Rosler's work, interviews, and critical responses; De Zegher, ed., *Martha Rosler: Positions in the Life-World.*

53. Rosler, in Buchloh, "A Conversation," 46; Edward Helmore, "Feminine Mystique," *W,* November 1, 2007, www.wmagazine.com/culture/art-and-design/2007/11/rosler_jonas/; Rosler, Martha Rosler Video, http://home.earthlink.net/~navva/video/index.html.

54. Rosler, unpublished interview, December 1997, cited in Lisa E. Bloom, *Jewish Identities in American Feminist Art: Ghosts of Ethnicity* (New York: Routledge, 2006), 88.

55. Rosler, unpublished interview, August 1999, cited in Bloom, *Jewish Identities,* 89.

56. Rosler, unpublished interview, December 1997, cited in Bloom, *Jewish Identities,* 87, 87–88.

57. Rosler, unpublished interview, February 2000, cited in Bloom, *Jewish Identities,* 90.

58. Bloom, *Jewish Identities,* 93–94. Rosler herself, "In, Around, and Afterthoughts," 81, describes the practice of irony this way: "One speaks with two voices."

59. More broadly, Rosler's account of her turn to photography (Rosler, in Buchloh, "A Conversation," 24, 43) suggests how mediated it was by histories of Jewish experience, and Jewish engagements with photography itself. The darkroom she used to print her images was run by students of the legendary New York Photo League teacher and documentarian Walter Rosenblum, who for Rosler "*embodied* New York photography" (emphasis original); of the League itself, she notes, its projects "were of that New York milieu that I shared," shaped by "a Jewish self-help tradition."

60. Rosler, in Buchloh, "A Conversation," 24, 33.

61. Rosler, in Buchloh, "A Conversation," 43.

62. Rosler, "In, Around, and Afterthoughts," 74.

63. Solomon-Godeau, *Photography at the Dock*, 120.

64. Shawn Michelle Smith, *At the Edge of Sight: Photography and the Unseen* (Durham, NC: Duke University Press, 2013).

65. Rosler, in Buchloh, "A Conversation," 42.

66. Rosler, in Buchloh, "A Conversation," 46.

67. Rosler, in Buchloh, "A Conversation," 46.

68. Blurb, Gary Shteyngart, *Super Sad True Love Story: A Novel* (New York: Random House, 2011), back cover. All subsequent citations are given parenthetically in the text.

69. Tyler Cowen, Interview, NPR, September 12, 2013; partial transcription available online, Author Interviews, "Tired of Inequality? One Economist Says It'll Only Get Worse," www.npr.org/2013/09/12/221425582/tired-of-inequality-one-economist-says-itll-only-get-worse.

70. Cowen, Interview.

71. Mattathias Schwartz, "How Occupy Wall Street Chose Zuccotti Park," *New Yorker*, November 18, 2011, www.newyorker.com/news/news-desk/map-how-occupy-wall-street-chose-zuccotti-park; Ethan Earle, "A Brief History of Occupy Wall Street," accessed June 7, 2016, www.rosalux-nyc.org/wp-content/files_mf/earle_history_occupy.pdf. Notably, Occupy organizers posted travel options between Tompkins Square Park and Zuccotti Park featuring foot, subway, taxi, and Uber options, as here: www.rome2rio.com/s/Occupy-Wall-Street/Tompkins-Square-Park, accessed June 7, 2016. *Super Sad True Love Story* was published in July 2010, a year before the proposal for action generated by the newly formed OWS.

Coda: How We Look Now

1. James Balog, "Time-lapse proof of extreme ice loss," TEDGlobal 2009, 19:22, filmed July 2009, www.ted.com/talks/james_balog_time_lapse_proof_of_extreme_ice_loss#t-652043.

2. Ilulissat Icefjord, southeast of the town of Ilulissat, was declared a UNESCO World Heritage Site in 2004.

3. Balog, in Jeff Orlowski, *Chasing Ice*, 2012; Riis, *Making of an American*, 273.

4. Balog, in Orlowski, *Chasing Ice*.

5. Balog, in Orlowski, *Chasing Ice*.

6. Balog, in Orlowski, *Chasing Ice*.

7. Art Spiegelman, *In the Shadow of No Towers* (New York: Pantheon, 2004).

8. Balog, in Orlowski, *Chasing Ice*.

Bibliography

Archival Sources

Allen Ginsberg Papers. The Fales Manuscript Collection. Stanford University Libraries.
Jacob A. Riis Papers. Manuscript Division, Library of Congress.
Lionel Pincus and Princess Firyal Map Division. New York Public Library.
Menschel Library. Metropolitan Museum of Art. New York.
Paul Strand Papers. Center for Creative Photography (CCP). Tucson, AZ.
Raphael Soyer Papers. Archives of American Art, Smithsonian Institution.
Stephen Lee Taller Ben Shahn Archive. Harvard University Fine Arts Library. Cambridge, MA.

Published Sources

Abel, Elizabeth. *Signs of the Times: The Visual Politics of Jim Crow*. Berkeley: University of California Press, 2010.
Abrahamson, David. "*History of the Book*, Volume 5: Magazines, 'Reflecting and Shaping American Culture: Magazines Since World War II.'" Accessed May 24, 2016. www.davidabrahamson .com/WWW/Articles/MagSinceWW2.txt.
Abu-Lughod, Janet. *From Urban Village to East Village: The Battle for New York's Lower East Side*. Cambridge, MA: Wiley-Blackwell, 1995.
"Adjusting Our Lives." *Jewish Daily Bulletin*, August 20, 1934.
Akins, Dudley. *Reports of Hospital Physicians and Other Documents in Relation to the Cholera Epidemic*. New York: G. & C. & H. Carvill, 1832.
Alexander, Michael. *Jazz Age Jews*. Princeton, NJ: Princeton University Press, 2001.
Allan, Sidney [Sadakichi Hartmann]. "How to Make Large Heads: A New Phase of Photographic Portraiture." *Wilson's Photographic Magazine* 50, no. 9, 1913, 121–22.
Alland, Alexander Sr. *Jacob A. Riis: Photographer & Citizen*. New York: Aperture, 1993.
Alworth, David. *Site Reading: Fiction, Art, Social Form*. Princeton, NJ: Princeton University Press, 2016.
Amell, Robert. "The Story Behind the Lower East Side." *Manhattan Unlocked*, March 2, 2011. Accessed July 30, 2014. http://manhattanunlocked.blogspot.com/2011/03/story-behind-lower -east-side.html.
Anbinder, Tyler. *Five Points: The 19th Century New York City Neighborhood that Invented Tap Dance, Stole Elections, and Became the World's Most Notorious Slum*. New York: Free Press, 2001.
Antin, David. "Some Questions about Modernism." *Occident* 8 (Spring 1974): 7–38.
Arvidson, Linda. *When the Movies Were Young*. New York: Dover, 1970.
Asbury, Herbert. *The Gangs of New York: An Informal History of the Underworld*. New York: Knopf, 1928.
Atwood, William. "How America Feels as We Enter the Soaring Sixties." *Look* 24 (January 5, 1960): 11–15.

Baigell, Matthew. *American Artists, Jewish Images*. Syracuse, NY: Syracuse University Press, 2006.

Bailyn, Bernard, Robert Dallek, David Davis, David Donald, and John Thomas, eds. *The Great Republic: A History of the American People*. Lexington, MA: D.C. Heath and Company, 1985.

Bakhtin, Mikhail. *The Dialogic Imagination: Four Essays*. Edited by Michael Holquist. Translated by Caryl Emerson and Michael Holquist. Austin: University of Texas Press, 1981.

Baraka, Amiri [LeRoi Jones]. *The Autobiography of LeRoi Jones*. New York: Freundlich Books, 1984.

Baraka, Amiri [LeRoi Jones]. *Blues People: Negro Music in White America*. New York: William Morrow, 1963.

Baraka, Amiri [LeRoi Jones]. "Confessions of a Former Anti-Semite." *Village Voice*, December 17–23, 1980.

Baraka, Amiri [LeRoi Jones]. *The Dead Lecturer*. New York: Grove Press, 1964.

Baraka, Amiri [LeRoi Jones]. "If's It's Anger . . . Maybe That's Good." Interview by Judy Stone. *San Francisco Chronicle*, August 23 1964, 39–42.

Baraka, Amiri [LeRoi Jones]. "Loft and Coffee Shop Jazz." *Black Music*. New York: Perseus, 1968.

Baraka, Amiri [LeRoi Jones]. "Milneburg Joys (or, Against 'Hipness' as Such)." *Kulchur* 1, no. 30 (Summer 1961): 41–43.

Baraka, Amiri [LeRoi Jones]. *Preface to a Twenty-Volume Suicide Note*. New York: Totem Press, 1969.

Barrish, Phillip. *American Literary Realism, Critical Theory, and Intellectual Prestige, 1880–1995*. Cambridge: Cambridge University Press, 1995.

Barthes, Roland. *Camera Lucida: Reflections on Photography*. New York: Hill and Wang, 1981.

Barthes, Roland. *Empire of Signs*. Translated by Richard Howard. New York: Hill and Wang, 1983.

Bartky, Ian. *Selling the True Time: Nineteenth-Century Timekeeping in America*. Redwood City, CA: Stanford University Press, 2000.

Bartlett, John Russell. *Dictionary of Americanisms: A Glossary of Words and Phrases Usually Regarded as Peculiar to the United States*. 2nd ed. Boston: Little, Brown and Company, 1859.

Bartlett, John Russell. "High Art and the Snapshot." *The Camera* 18 (1914): 24–28.

Baskind, Samantha. *Raphael Soyer and the Search for Modern Jewish Art*. Chapel Hill: University of North Carolina Press, 2004.

Batchen, Geoffrey. "Looking Askance." In *Picturing Atrocity: Photography in Crisis,* edited by Geoffrey Batchen, Mick Gidley, Nancy K. Miller, and Jay Prosser, 227–40. London: Reaktion Books, 2012.

Bauman, John F., Roger Biles, and Kristin M. Szylvian, eds. *From Tenements to the Taylor Homes: In Search of an Urban Housing Policy in Twentieth-Century America*. University Park: Pennsylvania State University, 2000.

Bauman, Zygmunt. *Modernity and the Holocaust*. Ithaca, NY: Cornell University Press, 2001.

Beckerman, Jim. "Griffith's East Side Scenes Were Probably in Fort Lee." *The Record*, September 7, 2003. http://proxy.lib.umich.edu/login?url=https://search-proquest-com.proxy.lib.umich.edu/docview/425606187?accountid=14667.

Beckman, Karen, ed. *Animating Film Theory*. Durham, NC: Duke University Press, 2014.

Beecher, Catherine, and Harriet Beecher Stowe. *The American Woman's Home*. New Haven, CT: Yale University Press, 1873 [1869].

Benfey, Christopher. *The Double Life of Stephen Crane: A Biography*. New York: Knopf, 1992.

Benjamin, Walter. "On Some Motifs in Baudelaire." In *Illuminations: Essays and Reflections*, edited by Hannah Arendt, 155–200. New York: Harcourt Brace Jovanovich, 1968.

Benston, Kimberly W. *Performing Blackness: Enactments of African-American Modernism*. New York: Routledge, 2000.

Bercovitch, Sacvan, and Myra Jehlen, eds. *Ideology and Classic American Literature*. Cambridge: Cambridge University Press, 1987.

Berkowitz, Michael. *Jews and Photography in Britain*. Austin: University of Texas Press, 2015.

Bey, Amir. "An Interview with Raphael McAdem: Dem Changes: A Commentary on the Lower East Side." *New Times Holler!*, September 14, 2008. http://thenewtimesholler.com/ARCHIVE /archiveDisplay.php?ID=51.

Bitzer, G. W. *Billy Bitzer His Story: The Autobiography of D. W. Griffith's Master Cameraman*. New York: Farrar, Straus and Giroux, 1973.

Blair, Sara. *Henry James and the Writing of Race and Nation*. Cambridge: Cambridge University Press, 1996.

Blair, Sara. "Jewish America through the Lens: On Fictions of Photography." In *Jewish in America*, edited by Blair and Jonathan Freedman, 113–34. Ann Arbor: University of Michigan Press, 2004.

Blake, Angela. *How New York Became American, 1890–1924*. Baltimore: John Hopkins University Press, 2006.

Blake, Richard A. *Street Smart: The New York of Lumet, Allen, Scorsese and Lee*. Lexington: University Press of Kentucky, 2005.

Bland, Kalman P. *The Artless Jew: Medieval and Modern Affirmations and Denials of the Visual*. Princeton, NJ: Princeton University Press, 2000.

"Blind." In *Heilbrunn Timeline of Art History*. New York: The Metropolitan Museum of Art, 2000–. Accessed May 28, 2017. www.metmuseum.org/toah/works-of-art/33.43.334.

Bloom, Leonard. "The Adventures of Superiorman!" *The Realist* 59 (May 1965): 16–17.

Bloom, Lisa E. *Jewish Identities in American Feminist Art: Ghosts of Ethnicity*. New York: Routledge, 2006.

Blumenthal, Ralph. "Take 2: A Photo Archive of City Streets." *New York Times*, March 14, 2000.

Bolter, Jay David, and Richard Grusin. *Remediation: Understanding New Media*. Cambridge, MA: MIT Press, 2000.

Bordwell, David, and Kristin Thompson. *Film Art: An Introduction*. 8th ed. Boston: McGraw-Hill, 2008.

Borton, Terry. The American Magic-Lantern Theater. "Film History Began with the Magic-Lantern." March 26, 2008. www.magiclanternshows.com/filmhistory.htm.

Borton, Terry, and Deborah Borton. *Before the Movies: American Magic Lantern Entertainment and the Nation's First Great Screen Artist, Joseph Boggs Beale*. Bloomington: Indiana University Press, 2015.

Bottomore, Stephen. "The Panicking Audience?: Early Cinema and the 'Train Effect.'" *Historical Journal of Film, Radio and Television* 19, no. 2 (1999): 177–216.

Bourne, Randolph. "The Jew and Transnational America." In *War and the Intellectuals: Collected Essays, 1914–1919*, edited by Carl Resek, 124–33. New York: Harper, 1964.

Bowdre, Paul H. Jr. "Eye Dialect as a Literary Device." In *A Various Language*, edited by J. V. Williamson and V. M. Burke, 178–86. New York: Holt, Rinehart & Winston, 1971.

Bowser, Eileen. *The Transformation of Cinema*. Volume 2: 1907–1915. Berkeley: University of California Press, 1990.

Boyarin, Jonathan. *Storm from Paradise: The Politics of Jewish Memory*. Minneapolis: University of Minnesota Press, 1992.

Breslin, James. "Allen Ginsberg: The Origins of 'Howl' and 'Kaddish.'" *The Iowa Review* 8, no. 2 (1977): 82–108.

Brodine, Harry A. "Street Scenes." *Photographic Times* 45 (1913): 49–53.

Brown, Henry Collins. *Old New York Yesterday and Today*. New York: Valentine's Manual, 1922.

Brown, Joshua. *Beyond the Lines: Pictorial Reporting, Everyday Life, and the Crisis of Gilded Age America*. Berkeley: University of California Press, 2002.

Buchloh, Benjamin. "A Conversation with Martha Rosler." In *Martha Rosler: Positions in the Life World*, edited by Catherine de Zegher, 23–55. Cambridge, MA: MIT Press, 1998.

Burch, Noël. *Theory of Film Practice*. Translated by Helen R. Lane. New York: Praeger, 1973.

Burke, Seán. *The Death and Return of the Author: Criticism and Subjectivity in Barthes, Foucault and Derrida*. Edinburgh: Edinburgh University Press, 1998.

Burrows, Edwin G., and Mike Wallace. *Gotham: A History of New York City to 1898*. New York: Oxford University Press, 2000.

Buttenwieser, Ann L. *Manhattan Water-Bound: Manhattan's Waterfront from the Seventeenth Century to the Present*. 2nd ed. Syracuse, NY: Syracuse University Press, 1999.

Cahan, Abraham. *The Education of Abraham Cahan*. Translated by Leon Stein, Abraham P. Conan, and Lynn Davison. Philadelphia: Jewish Publication Society of America, 1969.

Cahan, Abraham. *Yekl, A Tale of the New York Ghetto*. New York: D. Appleton and Company, 1896.

Campbell, James. *This Is the Beat Generation: New York–San Francisco–Paris*. Berkeley: University of California Press, 1999.

Caruth, Cathy. *Unclaimed Experience: Trauma, Narrative, and History*. Baltimore: Johns Hopkins University Press, 1996.

Cassidy, Daniel. *How the Irish Invented Slang: The Secret Language of the Crossroads*. Chico, CA: CounterPunch and AK Press, 2007.

Cerulli, Dom, Burt Korall, and Mort L. Nasatir, eds. *The Jazz Word*. New York: Da Capo, 1987.

Chase, Amanda Matthews. *Primer for Foreign Speaking Women*. California: Commission of Immigration and Housing, 1918.

Cheyette, Bryan. *Between "Race" and Culture: Representations of "the Jew" in English and American Literature*. Redwood City, CA: Stanford University Press, 1996.

Churchill, Allen E. *Photo Era* 33, no. 4 (October 1914): 165–70.

Cocks, Catherine. *Doing the Town: The Rise of Urban Tourism in the U.S., 1850–1915*. Berkeley: University of California Press, 2001.

Cohen, Morris Raphael. *A Dreamer's Journey*. Boston: Beacon, 1949.

Coleman, A. D. "No Pictures: Some Thoughts On Jews and Photography" (1998). In *The Photography Criticism Cyberarchive* (n.d.; 2003–2005). Accessed May 24, 2017. www.photocriticism .com/members/archivetexts/photocriticism/coleman/colemannopix.html.

Cook, David. *A History of Narrative Film*. 3rd ed. New York: Norton, 1996.

Cooke, Charles, and Robert M. Coates. "Out-Sizes." *New Yorker*, May 2, 1931, 13–14.

Cosgrove, Denis, and Stephen Daniels. *The Iconography of Landscape*. Cambridge: Cambridge University Press, 1988.

Cotkin, George. *Reluctant Modernism: American Thought and Culture, 1880–1900*. Lanham, MD: Rowman & Littlefield, 1992.

Cowen, Tyler. Interview by *Morning Edition, NPR*. September 12, 2013. Partial transcript: "Tired of Inequality? One Economist Says It'll Only Get Worse." www.npr.org/2013/09/12/221425582 /tired-of-inequality-one-economist-says-itll-only-get-worse.

Crane, Stephen. *Maggie: A Girl of the Streets*. Edited by Thomas A. Gullason. New York: Norton, 1979.

Czitrom, Daniel. "Jacob Riis's New York." In *Rediscovering Jacob Riis: Exposure Journalism and Photography in Turn-of-the-Century New York*, edited by Bonnie Yochelson and Daniel Czitrom, 1–120. New York: New Press, 2008.

Davenport, Alma. *The History of Photography: An Overview*. Sante Fe: Focal Press/University of New Mexico Press, 1999.

Davis, Kay. "Jacob Riis: Photographs and Lantern-Slide Lectures." In *Documenting "The Other Half": The Social Reform Photography of Jacob Riis & Lewis Hine*. Accessed Feb. 22, 2017. http://xroads.virginia.edu/~ma01/davis/photography/riis/lanternslides.html.

Davis, Linda H. *Badge of Courage: The Life of Stephen Crane*. New York: Houghton Mifflin, 1998.

Davis, William S. "The Pictorial Possibilities of New York." *Photographic Times* 41 (October 1914): 395–400.

De Zegher, Catherine, ed. *Martha Rosler: Positions in the Life-World*. Cambridge, MA: MIT Press, 1999.

Dent, Tom. "Umbra Days." *Black American Literature Forum* 14 (1980): 243–94.

Dickstein, Morris. "Memory Unbound." *Threepenny Review* (Summer 2007). www.threepenny review.com/samples/dickstein_su07.html.

Diner, Hasia. *Lower East Side Memories: A Jewish Place in America*. Princeton, NJ: Princeton University Press, 2000.

Doherty, Jonathan L., ed. *Lewis Wickes Hine's Interpretive Photography: The Six Early Projects*. Chicago: University of Chicago Press, 1978.

Dolnick, Sam. "A World of Times on the Lower East Side." Lens: Photography, Video and Visual Journalism. *New York Times,* November 29, 2011. http://lens.blogs.nytimes.com/2011/11/29/a-world-of-change-on-the-lower-east-side/?_r=0.

Doud, Richard K. "Oral History Interview with Ben Shahn, 1964 Apr. 14." *Smithsonian Archives of American Art*. Accessed Nov. 17, 2015. http://www.aaa.si.edu/collections/interviews/oral-history-interview-ben-shahn-12760.

Douglass, Frederick. "The Proclamation and the Negro Army." Cooper Institute, New York, February 6, 1863, *Frederick Douglass Papers Digital Edition*. Accessed Feb. 8 2017. http://frederick douglass.infoset.io/islandora/object/islandora%3A2288#page/1/mode/1up.

Doutney, Thomas N. *Thomas N. Doutney: His Life-Struggle and Triumphs, Also a Vivid Pen-Picture of New York*. Battle Creek, MI: W. C. Gage & Sons, 1893.

Duneier, Mitchell. *Ghetto: The Invention of a Place, The History of an Idea*. New York: Farrar, Straus and Giroux, 2016.

Earle, Ethan. "A Brief History of Occupy Wall Street." Accessed June 7, 2016. www.rosalux-nyc.org/wp-content/files_mf/earle_history_occupy.pdf.

Edelson, Elihu. "*Both Sides Now* Remembered: Or, The Once and Future Journal." In *Insider Histories of the Vietnam Era Underground Press, Part 2*, edited by in Ken Wachsberger, 369–84. East Lansing: Michigan State University, 2012.

Edwards, Elizabeth, and Janice Hart. "Introduction: Photographs as Objects." In *Photographs Objects Histories: On the Materiality of Images*, edited by Elizabeth Edwards and Janice Hart, 1–16. London: Routledge, 2004.

Edwards, Elizabeth. "Photographic Uncertainties: Between Evidence and Reassurance." *History and Anthropology* 25, no. 2 (2014): 171–88.

Edwards, Steve. *Martha Rosler: The Bowery in Two Inadequate Descriptive Systems*. London: Afterall, 2012.

"Eight Days Late, Wide Search for Slayers Starts." *New York Times*, July 24, 1912.

Eisenstein, Sergei. *Film Form: Essays in Film Theory*. Edited and translated by Jay Leyda. New York: Harvest/Harcourt, Brace, Jovanovich, 1949.

"Ephemeral New York: Baxter Street." *Ephemeral New York*, December 15, 2011. http://ephemeral newyork.wordpress.com/tag/baxter-street/.

Erens, Patricia. *The Jew in American Cinema*. Bloomington: Indiana University Press, 1984.

Evans, Walker, and Andrei Codrescu. *Walker Evans: Signs*. Los Angeles: Getty Trust/J. Paul Getty Museum, 1998.

Evans, Walker. "Photography." In *Quality: Its Image in the Arts*, edited by Louis Kronenberg, 169–210. New York: Athaneum, 1969.

Evans, Walker . "The Reappearance of Photography." *Hound & Horn* 5 (October–December 1931): 124–28.

Evans, Walker. *Walker Evans at Work*. New York: Thames and Hudson, 1984.

Ewen, Elizabeth. *Immigrant Women in the Land of Dollars: Life and Culture on the Lower East Side 1890–1925*. New York: Monthly Review Press, 1985.

Faas, Ekbert. "Confronting the Horrific." In *Under Discussion: On the Poetry of Allen Ginsberg*, edited by Lewis Hyde, 434–50. Ann Arbor: University of Michigan Press, 1984.

Fabian, Johannes. *Time and the Other: How Anthropology Makes Its Object*. New York: Columbia University Press, 2002.

"Fiction: Recent Books." *Time*, February 25, 1935. http://content.time.com/time/magazine/article /0,9171,754585,00.html?internalid=atb100.

Fine, Elizabeth. "In Defense of Literary Dialect: A Response to Dennis R. Preston." *Journal of American Folklore* 96, no. 381 (1983): 323–30.

Fitzgerald, F. Scott. *The Great Gatsby*. New York: Scribner, 2004 [1925].

Fleissner, Jennifer. *Women, Compulsion, Modernity: The Moment of American Naturalism*. Chicago: University of Chicago Press, 2004.

"Floating Bear Floats Free." *Village Voice*, May 3, 1962.

Foner, Philip S., and David R. Roediger. *Our Own Time: A History of American Labor and the Working Day*. London: Verso, 1989.

Foster, George C. *New York by Gaslight and Other Urban Sketches*. 1850. Berkeley: University of California Press, 1990 [1850].

Freccero, John. *The Poetics of Conversion*. Cambridge, MA: Harvard University Press, 1988.

Freedman, Jonathan. *Klezmer America: Jewishness, Ethnicity, Modernity*. New York: Columbia University Press, 2008.

Fried, Albert. *The Rise and Fall of the Jewish Gangster in America*. New York: Columbia University Press, 1994.

Gabler, Neal. *An Empire of Their Own*. New York: Crown, 1988.

Galassi, Peter. *Walker Evans & Company*. New York: Museum of Modern Art, 2002.

Gandal, Keith. *The Virtues of the Vicious: Jacob Riis, Stephen Crane and the Spectacle of the Slum*. New York: Oxford University Press, 1997.

Garland, Hamlin. Review of *Maggie: A Girl of the Streets*, by Stephen Crane. *Arena*, June 1893, viii, xi–xii.

Garland, Hamlin. "The West in Literature." *Arena* 6 (November 1892): 669–76.

Gernsheim, Hernut. *A Concise History of Photography*. 3rd ed. New York: Dover/Thames and Hudson, 1986.

Gervais, Thierry. "The 'Greatest of War Photographers': Jimmy Hare, a Photojournalist at the Turn of the Twentieth Century." Translated by James Gussen. *Études photographiques* 26 (November 2010): 1–15. https://etudesphotographiques.revues.org/3452#text.

Gilfoyle, Timothy J. *City of Eros: New York, Prostitute, and the Commercialization of Sex*. New York: Norton, 1994.

Gilfoyle, Timothy J. *A Pickpocket's Tale: The Underworld of Nineteenth Century*. New York: Norton, 2007.

Ginsberg, Allen. *108 Images/Hiro Yamagata Earthly Paradise*. Santa Monica, CA: Fred Hoffman Fine Art, 1995.

Ginsberg, Allen. *Deliberate Prose: Selected Essays, 1952–1995*. Edited by Bill Morgan. New York: Harper Collins, 2000.

Ginsberg, Allen. *Kaddish and Other Poems, 1958–1950*. San Francisco: City Lights Books, 1961.

Ginsberg, Allen. *Letters of Allen Ginsberg*. Edited by Bill Morgan. Cambridge, MA: Da Capo Press, 2008.

Ginsberg, Allen. *Photographs*. Design by Robert Frank. San Francisco: Twin Palms, 1991.

Ginsberg, Allen. *Snapshot Poetics: Allen Ginsberg's Photographic Memoir of the Beat Era*. Edited and introduced by Michael Köhler. San Francisco: Chronicle Books, 1993.

Gish, Dorothy. "And So I Am a Comedienne." *Ladies Home Journal* 42, no. 2, July 1925.

Gish, Lillian. *The Movies, Mr. Griffith and Me*. New York: Prentice Hall, 1969.

Gitelman, Lisa. *Always Already New: Media, History, and the Data of Culture.* Cambridge, MA: MIT Press, 2006.

Gladstone, Brooke, and Josh Neufeld. *The Influencing Machine: Brooke Gladstone on the Media.* New York: Norton, 2012.

Goddard, J. R. "Poet Jailed for Obscenity: Literary Magazine Hit. LeRoi Jones & Floating Bear." *Village Voice,* October 26, 1961.

Godkin, E. L. "Chromo-Civilization." *Nation,* September 24, 1874.

Godkin, E. L. "The Perils of Photography." *Nation,* July 11, 1905.

Goessel, Tracy. *First King of Hollywood: The Life of Douglas Fairbanks.* Chicago: Chicago Review Press, 2016.

Goff, Lisa. *Shantytown, USA: Forgotten Landscapes of the Working Poor.* Cambridge, MA: Harvard University Press, 2016.

Gompers, Samuel. *Seventy Years of Life and Labor.* New York: E. P. Dutton, 1925.

Good, Fred. "The Origins of Loisaida." In *Resistance: A Radical Social and Political History of the Lower East Side,* edited by Clayton Patterson, 21–36. New York: Seven Stories Press, 2007.

Gould, Lewis, and Richard Greff. *Photojournalist: The Career of Jimmy Hare.* Austin: University of Texas Press, 1977.

Greenfeld, Howard. *Ben Shahn: An Artist's Life.* New York: Random House, 1998.

Greenough, Sarah, and Allen Ginsberg. *Beat Memories: The Photographs of Allen Ginsberg.* New York: Prestel, 2010.

Grider, David. "James Gregory and the Dreamland Bell." October 11, 2009. http://davidgrider.com /blog/blog.htm.

Griffith, D. W., and James Hart. *The Man Who Invented Hollywood: The Autobiography of D. W. Griffith.* New York: Touchstone Publishing Company, 1972.

Gruen, John. *The New Bohemia.* New York: A Cappella Books, 1990.

Grutzner, Charles. "Pushcart Cause Won at City Hall: 'Village' Defenders Rout Plan to Oust Curbside Venders." *New York Times,* May 11, 1962.

Gullason, Thomas A, ed. *Stephen Crane's Literary Family: A Garland of Writings.* Syracuse, NY: Syracuse University Press, 2002.

Gunning, Tom. "An Aesthetic of Astonishment; Early Film and the (In)Credulous Spectator." In *Viewing Positions: Ways of Seeing Film,* edited by Linda Williams, 114–33. New Brunswick, NJ: Rutgers University Press, 1995.

Gunning, Tom. *D. W. Griffith and the Origins of American Narrative Film: The Early Years at Biograph.* Champaign: University of Illinois Press, 1994.

Gunning, Tom. "Illusions Past and Future: The Phantasmagoria and Its Specters." Key Text for *Refresh! The First International Conference on the Histories of Art, Science and Technology.* Media Art Histories Archive, 2004. Accessed Jan. 14, 2017. www.mediaarthistory.org/refresh /Programmatic%20key%20texts/pdfs/Gunning.pdf.

Gunning, Tom. "Landscape and the Fantasy of Moving Pictures: Early Cinema's Phantom Rides." In *Cinema and Landscape,* edited by Graeme Harper and Jonathan Rayner, 31–70. Chicago: Intellect Books, 2010.

Gunning, Tom. "Outsiders as Insiders: Jews and the History of American Silent Film." *The National Center for Jewish Film.* Accessed Jan. 28, 2017. www.jewishfilm.org/pdf/Insiders%20 as%20Outsiders_Gunning%20article.pdf.

Haaften, Julia Van. *Original Sun Pictures: A Checklist of the New York Public Library's Holding of Early Works Illustrated with Photographs, 1844–1900.* New York: New York Public Library, 1977.

Hager, Liz. "Paul Strand and the Birth of Modernism in Photography." *Venetian Red,* November 9, 2008. https://venetianred.wordpress.com/2008/11/09/paul-strand-and-the-birth-of -modernism-in-photography/.

Hales, Peter. *Silver Cities: Photographing American Urbanization, 1839–1939*. 1984. Albuquerque: University of New Mexico Press, 2006.

Hambourg, Maria Morris. *Paul Strand Circa 1916*. New York: Metropolitan Museum of Art/ Harry N. Abrams, 1998.

Hamerton, Philip Gilbert. *Portfolio Papers*. Boston: Roberts, 1889.

Hansen, Miriam. *Babel and Babylon: Spectatorship in American Silent Film*. Cambridge, MA: Harvard University Press, 1991.

Hapgood, Hutchins. *The Spirit of the Ghetto: Studies of the Jewish Quarter in New York*. New York: Funk & Wagnalls, 1902.

Harap, Louis. *The Image of the Jew in American Literature: From Early Republic to Mass Immigration*. Rutherford, NJ: Fairleigh Dickinson University Press, 1988.

Hare, Ernest. "The Bowery Bums." Diva label, 2740-G. January 21, 1913.

Harner, Gary W. "The Kalem Company, Travel and On-Location Filming: The Forging of an Identity." *Film History* 10, no. 2 (1998) 188–209.

Harris, Neil. "Iconography and Intellectual History: The Half-Tone Effect." In *New Directions in American Intellectual History*, edited by John Higham and Paul K. Conkin, 196–211. Baltimore: Johns Hopkins University Press, 1977.

Harris, William J. "'How You Sound??': Amiri Baraka Writes Free Jazz." In *Uptown Conversation: The New Jazz Studies*, edited by Robert G. O'Meally, Brent Hayes Edwards, and Farah Jasmine Griffin, 312–25. New York: Columbia University Press, 2004.

Harshav, Benjamin. *The Meaning of Yiddish*. Redwood City, CA: Stanford University Press, 1999.

Hatfield, Rev. Edwin F. *Memoir of Elihu W. Baldwin*. New York: Jonathan Leavett, 1843.

"The Havana Tragedy." *Collier's Weekly*, March 12, 1898, 4–5.

Hawthorne, Nathaniel. *Passages from the American Note-Books*. Vol. II. Boston: Houghton, Mifflin and Company, 1868.

Heap, Chad. *Slumming: Sexual and Racial Encounters in American Nightlife, 1885–1940*. Chicago: University of Chicago Press, 2009.

Helmore, Edward. "Feminine Mystique." *W*, November 1, 2007. www.wmagazine.com/culture /art-and-design/2007/11/rosler_jonas/.

Henderson, Robert M. *D. W. Griffith: The Years at Biograph*. New York: Farrar, Straus and Giroux, 1970.

Henkin, David M. *City Reading: Written Words and Public Spaces in Antebellum New York*. New York: Columbia University Press, 1998.

Herton, Calvin. "Umbra: A Personal Recounting." *African American Review* 27, no. 4 (Winter 1993): 579–83.

Hillstrom, Laurie Collier. *Defining Moments: Muckrakers and the Progressive Era*. Detroit: Omnigraphics, 2009.

Hoberman, J., and Jeffrey Shandler, eds. *Entertaining America: Jews, Movies, and Broadcasting*. Princeton, NJ: Princeton University Press, 2003.

Hollinger, David. "Ethnic Diversity, Cosmopolitanism, and the Emergence of the American Liberal Intelligentsia." *American Quarterly* 27, no. 2 (May 1975): 133–51.

Holloway, David, and John Beck, eds. *American Visual Cultures*. New York: Continuum, 2005.

Homberger, Eric. *The Historical Atlas of New York City: A Visual Celebration of Nearly 400 Years*. New York: Holt, 2005.

Hoffman, Michael E., ed. *Paul Strand: Sixty Years of Photographs*. New York: Aperture, 1934.

Horgan, Stephen Henry. "The World's First Illustrated Newspaper." *Penrose Annual* 35 (1933): 23–24.

Howard, June. *Form and History in American Literature Naturalism*. Chapel Hill: University of North Carolina Press, 1985.

Howard, Richard. "Two Against Chaos." *Nation*, March 15, 1964.

Howe, Irving. "Life Never Let Up." *New York Times Book Review*, October 25, 1964.

Howells, William Dean. *Impressions and Experiences*. New York: Harper, 1896.

Howells, William Dean. "New York Low Life in Fiction." *New York World*, July 26, 1896.

Howells, William Dean. Review of *The Imported Bridegroom, and Other Stories of the New York Ghetto*, by Abraham Cahan. *Literature*, December 31, 1898, 629.

Huntzicker, William. *The Popular Press, 1833–1865*. Westport, CT: Greenwood Press, 1999.

Huyssen, David. *Progressive Inequality: Rich and Poor in New York, 1890–1920*. Cambridge, MA: Harvard University Press, 2014.

Irwin, Will. *The House that Shadows Built*. New York: Doubleday, Doran and Company, 1958.

Ismaili Abubakr, Rashidah. "Slightly Autobiographical: The 1960s on the Lower East Side." *African American Review* 27, no. 4 (Winter 1993): 585–92.

Jaffe, Steven H., and Jessica Lautin. *Capital of Capital: Money, Banking, and Power in New York City, 1784–2012*. New York: Columbia University Press, 2014.

James, Henry. *The American Scene*. Bloomington: Indiana University Press, 1968 [1907].

"Jewish Immigration." *Centuries of Citizenship: A Constitutional Timeline*, National Constitution Center. Accessed July 21, 2014. http://constitutioncenter.org/timeline/html/cw08_12150.html.

Johns, Elizabeth. *American Genre Painting: The Politics of Everyday Life*. New Haven, CT: Yale University Press, 1993.

Johnson, Patricia, ed. *Seeing High and Low: Representing Social Conflict in American Visual Culture*. Berkeley: University of California Press, 2005.

Jones, Hettie. *How I Became Hettie Jones*. New York: E. P. Dutton, 1990.

Joselit, Jenna Weissman. "Best-in-Show: American Jews and the Modern Museum." In *Imagining the American Jewish Community*, edited by Jack Wertheimer, 141–57. Lebanon, NH: University Press of New England, 2007.

Joselit, Jenna Weissman. *Our Gang: Jewish Crime and the New York Jewish Community, 1900–1940*. Bloomington: Indiana University Press, 1983.

Joselit, Jenna Weissman. *The Wonders of America: Reinventing Jewish Culture 1880–1950*. New York: Hill and Wang, 1996.

Josephson, Matthew. *The Robber Barons: The Great American Capitalists 1861–1901*. New Brunswick, NJ: Transaction Publishers, 2011. First published 1934 by Harcourt, Brace, and Company.

Jussim, Estelle. *Visual Communication and the Graphic Arts: Photographic Technologies in the Nineteenth Century*. New York: R. R. Bowker Company, 1974.

Kane, Daniel. *All Poets Welcome: The Lower East Side Poetry Scene in the 1960s*. Berkeley: University of California Press, 2003.

Kao, Deborah Martin, Laura Katzman, and Janna Webster, eds. *Ben Shahn's New York: The Photography of Modern Times*. Cambridge, MA and New Haven, CT: Fogg Art Museum, Harvard University Art Museums and Yale University Press, 2000.

Katzman, Laura. " 'Mechanical Vision': Photography and Mass Media Appropriation in Ben Shahn's Sacco and Vanzetti Series." In *Ben Shahn and the Passion of Sacco and Vanzetti*, edited by Alejandro Anreus, 51–88. Jersey City, NJ: Jersey City Museum, 2001.

Kazin, Alfred. Review of *Call It Sleep*. *New York Review of Books*, October 10, 1991, 15–18.

Keil, Charlie. *Early American Cinema in Transition: Story, Style, and Filmmaking, 1907–1913*. Madison: University of Wisconsin Press, 2001.

Kellman, Steven G. *Redemption: The Life of Henry Roth*. New York: Norton, 2005.

Kern, Stephen. *The Culture of Time and Space, 1880–1918*. 2nd ed. Cambridge, MA: Harvard University Press, 2003.

Kim, Daniel Wong-gu. " 'In the Tradition': Amiri Baraka, Black Liberation, and Avant-Garde Praxis in the U.S." *African American Review* 37, no. 2/3 (Summer/Autumn 2003): 345–63.

Klein, Mason, and Catherine Evans. *The Radical Camera: New York's Photo League, 1936–1951*. New Haven, CT: Yale University Press, 2011.

Kobré, Kenneth, and Betsy Brill. *Photojournalism: The Professionals' Approach.* Vol. I. Boston: Focal Press, 1996.

Koven, Steven G., and Frank Götzke. *American Immigration Policy: Confronting the Nation's Challenges.* New York: Springer, 2010.

Kraut, Alan M. *Silent Travelers: Germs, Genes, and the Immigrant Menace.* Baltimore: Johns Hopkins University Press, 1994.

Lagerquist, Walter E. "The Old East Side Gives Way to the New." *New York Times,* April 3, 1910.

Lasser, Carol, and Joanna Steinberg. "Making Gendered Poverty Visible: W. A. Rogers's 'Slaves of the Sweaters' and Attitudes toward Women and Child Wage Earners." *Women and Social Movements in the United States, 1600–2000.* September 2005. http://womhist.alexander street.com/visuals/slaves.htm.

Lear, John. "Hiroshima, U.S.A.: Can Anything Be Done About It?" *Collier's Weekly,* August 5, 1950.

Lears, T. J. Jackson. *Fables of Abundance: A Cultural History of Advertising in America.* New York: Basic Books, 1995.

Lee, Anthony. *A Shoemaker's Story: Being Chiefly about French Canadian Immigrants, Enterprising Photographers, Rascal Yankees, and Chinese Cobblers in a Nineteenth-Century Factory Town.* Princeton, NJ: Princeton University Press, 2008.

Leeming, David. *The Oxford Companion to World Mythology.* New York: Oxford University Press, 2005.

Lenderhendler, Eli. *New York Jews and the Decline of Urban Ethnicity, 1950–1970.* Syracuse, NY: Syracuse University Press, 2001.

Lester, Paul Martin. *Visual Communication: Images with Messages.* 6th ed. Belmont, CA: Wadsworth / Cengage Learning, 2013.

Levinson, Julian. *Exiles on Main Street: Jewish American Writers and American Literary Culture.* Bloomington: Indiana University Press, 2008.

Lincoln, Abraham. "Cooper Union Address." New York, February 27, 1860. *Abraham Lincoln Online.* Accessed February 8, 2017. www.abrahamlincolnonline.org/lincoln/speeches/cooper.htm.

Linden, Diana L. *Ben Shahn's New Deal Murals: Jewish Identity in the American Scene.* Detroit: Wayne State University Press, 2015.

Lippard, Lucy R. "Doubletake: The Diary of a Relationship with an Image." In *The Photography Reader,* edited by Liz Wells, 343–52. London: Routledge, 2003.

Livingston, Jane. *The New York School: Photographs, 1936–1963.* New York: Stewart Tabori & Chang, 1992.

London, Daniel. "Progress and Authenticity: Urban Renewal, Urban Tourism, and the Meaning(s) of New York in the Mid-Twentieth Century." *Journal of Tourism History* 5, no. 2 (2013): 172–84.

Mackey, Nathaniel. "The Changing Same: Black Music in the Poetry of Amiri Baraka." *boundary 2* 6, no. 2 (Winter 1978): 355–86.

Maffi, Mario. *Gateway to the Promised Land: Ethnic Cultures of New York's Lower East Side.* New York: New York University Press, 1995.

Maffi, Mario. "A Geography of Cultures: Or, Why New York's Lower East Side Is an Important Case Study." *E-rea: Revue électronique d'études sur le monde Anglophone* 7, no. 2 (2010).

Mao, Douglas, and Rebecca L. Walkowitz. "The New Modernist Studies." *PMLA* 123, no. 3 (May 2008): 737–48.

Markel, Howard. *Quarantine!: East European Jewish Immigrants and the New York City Epidemics of 1892.* Baltimore: Johns Hopkins University Press, 1999.

Marter, Joan M. *The Grove Encyclopedia of American Art.* Vol. I. New York: Oxford University Press, 2011.

Martinez, Katharine. "At Home with Mona Lisa: Consumers and Commercial Visual Culture, 1880–1920." In *Seeing High and Low: Representing Social Conflict in American Visual Culture,* edited by Patricia Johnston, 160–76. Berkeley: University of California Press, 2006.

Marx, Karl. Preface to *Capital: A Critique of Political Economy*, Volume I by Marx. Translated by Samuel Moore and Edward Aveling. Moskow: Progress Publishers, 1887.

Marzio, Peter C. *The Democratic Art: Pictures for a Nineteenth-Century America: Chromolithography 1840–1900*. Boston: David R. Godine, 1979.

Materassi, Mario, ed. *Shifting Landscape*. Philadelphia: Jewish Publication Society, 1987.

Mayor's Pushcart Commission. "The New York Pushcart: Recommendations of the Mayor's Commission." *Charities and the Commons* 16 (September 22, 1906): 615–18.

McCabe, Lida Rose, ed. *The Beginnings of Halftone: From the Note Books of Stephen H. Horgan*. Chicago: The Inland Printer, 1924.

McCormack, Mike. "Shanty Town, New York." *New York State Board Ancient Order of Hiberians*, February 21, 2009. www.nyaoh.com/2009/02/21/91/.

McCracken, Harold. *George Catlin and the Old Frontier*. New York: Dial Press, 1959.

McGann, Jerome. *Black Riders: The Visible Language of Modernism*. Princeton, NJ: Princeton University Press, 1993.

McGill, Meredith. *American Literature and the Culture of Reprinting, 1843–1853*. Philadelphia: University of Pennsylvania Press, 2007.

McNeur, Catherine. "The Shantytown: Nineteenth-Century Manhattan's 'Straggling Suburbs.'" From the Stacks: The N-YHS Library Blog. June 5, 2013. http://blog.nyhistory.org/the-shanty town-nineteenth-century-manhattans-straggling-suburbs/.

Mele, Christopher. *Selling the Lower East Side: Culture, Real Estate and Resistance*. Minneapolis: University of Minnesota Press, 2000.

Mellow, James R. *Walker Evans*. New York: Basic Books, 2008.

Merrill, Jean. *The Pushcart War*. New York: William R. Scott, 1964.

Miles, Barry. *Ginsberg: A Biography*. New York: Simon & Schuster, 1989.

Miller, Angela. *The Empire of the Eye: Landscape Representation and American Cultural Politics, 1825–1875*. Ithaca, NY: Cornell University Press, 1996.

Miller, Ron, and Federick C. Durant III. *The Art of Chesley Bonestell*. London: Paper Tiger, 2001.

Miller, Terry. *Greenwich Village and How It Got That Way*. New York: Crown, 1990.

Mirzoeff, Nicholas. "Blindness and Art." In *The Disability Studies Reader*, edited by Lennard J. Davis, 379–90. London: Routledge, 2006.

Mitchell, W.J.T. *Picture Theory: Essays on Verbal and Visual Representation*. Chicago: University of Chicago Press, 1994.

Monaco, James. *How to Read a Film: The Art, Technology, Language, History, and Theory of Film and Media*. Revised ed. New York: Oxford University Press, 1981.

Monteiro, George. *Stephen Crane's Blue Badge of Courage*. Baton Rouge: Louisiana State University Press, 2003.

Morgan, Bill. *I Celebrate Myself: The Somewhat Private Life of Allen Ginsberg*. New York: Penguin Books, 2007.

Moore, Deborah Dash, and MacDonald Moore. "Observant Jews and the Photographic Arena of Looks." In *"You Should See Yourself!" Jewish Identity in Postmodern American Culture*, edited by Vincent Brook, 176–204. New Brunswick, NJ: Rutgers University Press, 2006.

Morgan, David, and Sally Pomey, eds. *The Visual Culture of American Religions*. Berkeley: University of California Press, 2001.

Morgan, David. *Protestants & Pictures: Religion, Visual Culture, and the Age of American Mass Production*. New York: Oxford University Press, 1999.

Morgan, David. *Visual Piety: A History and Theory of Popular Religious Images*. Berkeley: University of California Press, 1999.

Mortenson, Erik. *Capturing the Beat Moment: Cultural Politics and the Poetics of Presence*. Carbondale: Southern Illinois University Press, 2012.

Morton, Ella. "The Wall Street Bombing: Low-Tech Terrorism in Prohibition-Era New York." September 16, 2014. www.slate.com/blogs/atlas_obscura/2014/09/16/the_1920_wall_st _bombing_a_terrorist_attack_on_new_york.html.

Mott, Frank Luther. *American Journalism: A History of Newspapers in the United States Through 250 Years, 1690–1940.* New York: Macmillan, 1941.

Mott, Frank Luther. *A History of American Magazines.* Volume 4: *1885–1905.* Cambridge, MA: Harvard University Press, 1957.

Mulvey, Laura. "The Index and the Uncanny." In *Time and the Image,* edited by Carolyn Bailey Gill, 139–48. Manchester: Manchester University Press, 2000.

Murphy, Bruce Allen. *The Brandeis/Frankfurter Connection: The Secret Political Activities of Two Supreme Court Justices.* New York: Oxford University Press, 1982.

Nagel, James. *Stephen Crane and Literary Impressionism.* University Park: Pennsylvania State University Press, 1981.

Nash, Robert. "Charles Becker: The 'Crookedest' Cop in New York." *Annals of Crime.* Accessed July 10, 2014. www.annalsofcrime.com/04-01.htm.

National Constitution Center. "Jewish Immigration." In *Centuries of Citizenship: A Constitutional Timeline.* February 21, 2011. http://constitutioncenter.org/timeline/html/cw08_12150.html.

"Naturally Occurring Cultural Districts." *Urban Omnibus: A Project of the Architectural League of New York,* November 17, 2010. http://urbanomnibus.net/2010/11/naturally-occurring-cultural -districts/.

Nettels, Elsa. *Language, Race, and Social Class in Howells's America.* Lexington: University Press of Kentucky, 1988.

Neufeld, Josh. *A. D.: New Orleans After the Deluge.* New York: Pantheon, 2010.

Neufeld, Josh. *Comix & Stories,* February 9, 2015. https://joshcomix.wordpress.com/tag/martha -rosler/.

New-York Historical Society. "From the Classroom to the World: Hine, Ulmann, Strand, Arbus and the Ethical Culture Fieldston School, Apr. 6-July 18, 2004." *Making History Matter.* Accessed February 9, 2014. www.nyhistory.org/exhibitions/classroom-world-hine-ulmann-strand-arbus -and-ethical-culture-fieldston-school.

New York Times, July 12, 1912.

Newhall, Beaumont. *The History of Photography from 1839 to the Present Day.* New York: Museum of Modern Art, 1949.

Norris, Frank. "Stephen Crane's Stories of Life in the Slums: *Maggie* and *George's Mother.*" *San Francisco Wave,* July 4, 1896.

Nye, Edgar Wilson. *A Guest at the Ludlow.* New York: Bobbs-Merrill, 1896.

O'Brien, Sara Redempta. *English for Foreigners.* Boston: Houghton Mifflin, 1909.

O'Malley, Michael. *Keeping Watch: A History of American Time.* Washington, DC: Smithsonian Institution Press, 1996.

Olin, Margaret. *The Nation without Art: Modern Discourses on Jewish Art.* Lincoln: University of Nebraska Press, 2001.

Olin, Margaret. *Touching Photographs.* Chicago: University of Chicago Press, 2012.

"Operation Eggnog." *Collier's Weekly* 128, no. 17 (October 27, 1951): 6–13.

Owens, Craig. "The Discourse of Others: Feminists and Postmodernism." In *The Art of Art History: A Critical Anthology,* edited by Donald Preziosi, 335–51. New York: Oxford University Press, 2006.

Page, Max. *The City's End: Two Centuries of Fantasies, Fears, and Premonitions of New York's Destruction.* New Haven, CT: Yale University Press, 2008.

Peirce, Charles Sanders. *The Collected Papers of Charles Sanders Peirce.* Cambridge, MA: Harvard University Press, 1932.

Perloff, Marjorie. "Collage and Poetry." *Encyclopedia of Aesthetics*, vol. 1, edited by Michael Kelly, 384–87. New York: Oxford University Press, 1998.

Perloff, Marjorie. "A Lion in Our Living Room." Review of *Collected Poems 1974–1980* by Allen Ginsberg. *American Poetry Review* 14, no. 2 (Mar/Apr. 1985): 35–46.

Phillips, Christopher, ed. *Photography in the Modern Era: European Documents and Critical Writings, 1913–1940.* New York: Metropolitan Museum of Art, 1989.

Pierce, Robert F. Y. *Pictured Truth: A Hand-Book of Blackboard and Object Lessons.* New York: Fleming H. Revell Company, 1895.

Pinney, Christopher, and Nicolas Peterson, ed. *Photography's Other Histories.* Durham, NC: Duke University Press, 2003.

Pizer, Donald, ed. *The Literary Criticism of Frank Norris.* Austin: University of Texas Press, 1964.

"The Planning Debate in New York (1955–75)." *New York: The Center of the World.* Accessed Jan. 7, 2016. www.pbs.org/wgbh/americanexperience/features/general-article/newyork-planning/.

Plunz, Richard. *A History of Housing in New York City: Dwelling Type and Social Change in the American Metropolis.* New York: Columbia University Press, 1992.

Plunz, Richard. "On the Uses and Abuses of Air: Perfecting the New York Tenement, 1850–1901." In *Berlin/New York: Like and Unlike: Essays on Architecture and Art from 1870 to the Present*, edited by Josef Paul Kleihues and Christina Rathgeber, 159–79. New York: Rizzoli, 1993.

Pohl, Frances K. *Ben Shahn.* San Francisco: Pomegranate Artbooks, 1993.

Polsky, Ned. *Hustlers, Beats, and Others.* Chicago: Aldine Publishing Company, 1967.

"Population by Nativity, 1790–2000." *New York City Department of City Planning Population Division.* Accessed October 7, 2017. , www1.nyc.gov/assets/planning/download/pdf/data-maps /nyc-population/historical-population/1790-2000_nyc_foreign_birth_graph.pdf.

Prang's Chromo: A Journal of Popular Art 1, no. 3 (September 1868). https://archive.org/stream/acd 2738.0001.003.umich.edu/acd2738.0001.003.umich.edu_djvu.txt.

Pratt, Davis, ed. *The Photographic Eye of Ben Shahn.* Cambridge, MA: Harvard University Press, 1975.

"Preview of the War We Do Not Want." *Collier's Weekly*, October 27, 1951.

Ravage, Marcus Eli. *An American in the Making: The Life Story of an Immigrant.* New York: Harper & Brothers, 1917.

Reynolds, Larry J. "American Cultural Iconography." In *National Imaginaries, American Identities: The Cultural Work of American Iconography*, edited by Reynolds and Gordon Hutner, 3–28. Princeton, NJ: Princeton University Press, 2000.

Richards, Bernard G. "Introduction: Abraham Cahan Cast in a New Role." *Yekl and The Imported Bridegroom and Other Stories of Yiddish New York*, by Abraham Cahan, iii–viii. New York: Dover, 1970.

Riis, Jacob A. *How the Other Half Lives: Studies Among the Tenements.* New York: Charles Scribner's Sons, 1889.

Riis, Jacob A. *The Making of an American.* New York: Macmillan Co., 1901.

Riis, Jacob A. *Theodore Roosevelt, the Citizen.* Norwood, CT: The Outlook Company, 1904.

Rischin, Moses. *Grandma Never Lived in America.* Bloomington: Indiana University Press, 1985.

Rischin, Moses. *The Promised City: New York's Jews, 1870–1914.* Cambridge, MA: Harvard University Press, 1977.

Ritterband, Paul. "Counting the Jews of New York, 1900–1991: An Essay in Substance and Method." *Jewish Population Studies (Papers in Jewish Demography)* 29 (Jerusalem: Avraham Harman Institute of Contemporary Jewry, 1997), 199–228.

"A Rival to the Parthenon." *New York Real Estate Record and Guide* 94, July 18, 1914.

Robertson, Michael. *Stephen Crane, Journalism, and the Making of Modern American Literature.* New York: Columbia University Press, 1997.

Rogers, William A. *A World Worth While: A Record of "Auld" Acquaintance.* New York: Harper & Brothers, 1922.

Rosenberg, Charles. *The Cholera Years: The United States in 1832, 1849, and 1866.* Chicago: University of Chicago Press, 1987.

Rosenberg, Eric. "With Trauma: Walker Evans and the Failure to Document." In *Trauma and Documentary Photography of the FSA,* edited by Sara Blair and Eric Rosenberg, 52–98. Berkeley: University of California Press, 2012.

Rosenberg, Harold. *Discovering the Present: Three Decades in Art, Culture, and Politics.* Chicago: University of Chicago Press, 1973.

Rosenberg, Harold. "Tenth Street: A Geography of Modern Art." *Art News Annual* 28 (1959): 120–92.

Rosenblum, Naomi. *Biographical Notes in America and Lewis Hine: Photographs 1904–1940.* New York: Aperture, 1977.

Rosenheim, Jeff L., and Douglas Eklund. *Unclassified: A Walker Evans Anthology.* New York: The Metropolitan Museum of Art, 2000.

Rosenthal, M. L. "Some Thoughts on American Poetry Today." *Salmagundi* 22–23 (Spring–Summer 1973): 57–70.

Rosenwaike, Ira. *Population History of New York City.* Syracuse, NY: Syracuse University Press, 1972.

Rosenzweig, Roy, and Elizabeth Blackmar. *The Park and the People: A History of Central Park.* Ithaca, NY: Cornell University Press, 1992.

Roskolenko, Henry. *The Time That Was Then: The Lower East Side, 1900–1914: An Intimate Chronicle.* New York: Dial Press, 1971.

Rosler, Martha. "In, Around, and Afterthoughts (on Documentary Photography)." In *3 Works,* 61–93. Halifax: Nova Scotia College of Art and Design Press, 2006.

Rosler, Martha. Martha Rosler, Semiotics of the Kitchen. 1974–1975. Video. Duration: 6:00 minutes.

Roth, Henry. *Call It Sleep.* New York: Picador, 2005 [1934].

Roth, Henry. "No Longer at Home." *New York Times,* April 15, 1971.

Samuels, Shirley. *Facing America: Iconography and the Civil War.* New York: Oxford University Press, 2004.

Sanders, Ronald. *The Lower East Side: A Guide to Its Jewish Past in 99 New Photographs.* New York: Dover, 1994.

Sante, Luc. *Low Life: Lures and Snares of Old New York.* New York: Farrar, Straus and Giroux, 2003.

Saper, Craig. "Academia's Exquisite Corpse: An Ethnography of the Application Process." In *The Exquisite Corpse: Chance and Collaboration in Surrealism's Parlor Game,* edited by Kanta Kochhar-Lindgren, Davis Schneiderman, and Tom Denlinger, 189–204. Lincoln: University of Nebraska Press, 2009.

Saul, Scott. *Freedom Is, Freedom Ain't: Jazz and the Making of the Sixties.* Cambridge, MA: Harvard University Press, 2001.

Schickel, Richard. *D. W. Griffith: An American Life.* New York: Limelight, 2004.

Schneck, Stephen. "LeRoi Jones, or, Poetics & Policemen, or, Trying Heart, Bleeding Heart." *Ramparts* (July 13, 1968): 14–19.

Schoener, Allon. *Portal to America: The Lower East Side, 1870–1925.* New York: Holt, Rinehart and Winston, 1967.

Schudson, Michael. *Discovering the News: A Social History of American Newspapers.* New York: Basic Books, 1978.

Schumacher, Michael. *Dharma Lion: A Critical Biography of Allen Ginsberg.* New York: St. Martin's Press, 1994.

Schwartz, Joel. *The New York Approach: Robert Moses, Urban Liberals, and Redevelopment of the Inner City.* Columbus: Ohio State University Press, 1993.

Schwartz, Mattathias. "How Occupy Wall Street Chose Zuccoti Park." *New Yorker*, November 18, 2011. www.newyorker.com/news/news-desk/map-how-occupy-wall-street-chose -zuccotti-park.

Schweik, Susan M. *The Ugly Laws: Disability in Public*. New York: New York University Press, 2010.

Scott, Clive. *Street Photography from Atget to Cartier-Bresson*. London: I. B. Tauris, 2007.

Sekula, Allan. "The Body and the Archive." *October* 39 (Winter 1986): 3–64.

Shorto, Russell. *The Island at the Center of the World: The Epic Story of Dutch Manhattan and the Forgotten Colony that Shaped America*. New York: Vintage, 2005.

Shteyngart, Gary. *Super Sad True Love Story: A Novel*. New York: Random House, 2011.

Shulevitz, Judith. "The Skinless Novelist." *Slate*, June 20, 2010.

Sklar, Robert. *Movie-Made America: A Cultural History of American Movies*. New York: Vintage, 1994.

"The Slaves of the Sweaters." *Harper's Weekly*, April 26, 1890, 335.

Slide, Anthony. *The Griffith Actresses*. South Brunswick, NJ and New York: A. S. Barnes and Company, 1973.

Smethurst, James. *The Black Arts Movement: Literary Nationalism in the 1960s and 1970s*. Chapel Hill: University of North Carolina Press, 2005.

Smith, Mark M. *Mastered by the Clock: Time, Slavery, and Freedom in the American South*. Chapel Hill: University of North Carolina Press, 1997.

Smith, Matthew Hale. *Sunshine and Shadow in New York*. Hartford, CT: J. B. Burr and Company, 1869.

Smith, Shawn Michelle. *American Archives: Gender, Race, and Class in Visual Culture*. Princeton, NJ: Princeton University Press, 1999.

Smith, Shawn Michelle. *At the Edge of Sight: Photography and the Unseen*. Durham, NC: Duke University Press, 2013.

Smokey. "Skid Row, New York." Oral history of Bowery life, Roy Lisker, *Ferment*. Accessed May 29, 2016. www.fermentmagazine.org/Bio/skidr.html.

Soby, James. *Ben Shahn*. New York: Penguin Books, 1947.

Sollors, Werner. *Amiri Baraka/LeRoi Jones: The Quest for a "Populist Modernism."* New York: Columbia University Press, 1978.

Solomon-Godeau, Abigail. *Photography at the Dock: Essays on Photographic History, Institutions, and Practices*. Minneapolis: University of Minnesota Press, 1994.

Sorrentino, Paul. *Stephen Crane: A Life of Fire*. Cambridge, MA: Harvard University Press, 2014.

Stange, Maren, ed. *Paul Strand: Essays on His Life and Work*. With an introduction by Alan Trachtenberg. New York: Aperture, 1989.

Stange, Maren. "Jacob Riis and Urban Visual Culture." *Journal of Urban History* 15, no. 3 (May 1989): 274–303.

Stansell, Christine. *American Moderns: Bohemian America and the Creation of a New Century*. New York: Macmillan, 2000.

Steffens, Lincoln. *The Autobiography of Lincoln Steffens*. New York: Harcourt, 1931.

Steinberg, Ted. *Gotham Unbound: The Ecological History of Greater New York*. New York: Simon & Schuster, 2014.

Stephens, Carlene E. *On Time: How America Has Learned to Live by the Clock*. Boston: Little, Brown and Company / Smithsonian Institution National Museum of American History, 2002.

Stern, Robert A. M., Gregory F. Gilmartin, and Thomas Mellins. *New York 1930: Architecture and Urbanism Between the Two World Wars*. New York: Rizoli, 1997.

Stieglitz, Alfred. *Camera Work* 49/50 (June 1917).

Strouse, Jean. *Morgan: American Financier*. New York: Random House, 2014.

Studies, Henry Street. *A Dutchman's Farm: 301 Years at 284 Corlears Hook.* New York: Henry Street Studies, 1939.

Sukenick, Ronald. *Down and In: Life in the Underground.* New York: Beech Tree Books, 1987.

Sundquist, Eric. *To Wake the Nations: Race in the Making of American Literature.* Cambridge, MA: Harvard University Press, 1993.

Taft, Robert. *Photography and the American Scene: A Social History, 1839–1889.* New York: Macmillan, 1964.

Tagg, John. *The Disciplinary Frame: Photographic Truths and the Capture of Meaning.* Minneapolis: University of Minnesota Press, 2009.

Tandt, Christophe Den. *The Urban Sublime in American Literary Naturalism.* Champaign: University of Illinois Press, 1998.

Tomachev, Ivan. "A Brief History of Photographic Flash." *EnvatoTuts+,* January 19 2011. http://photography.tutsplus.com/articles/a-brief-history-of-photographic-flash—photo-4249.

Tomkins, Calvin. "Look to the Things Around You." *New Yorker* 50, no. 30 (September 16, 1974): 44–94.

Tosches, Nick. *King of the Jews.* New York: Ecco, 2005.

Trachtenberg, Alan, ed. *Classic Essays on Photography.* New York: Leetes Island, 1980.

Trachtenberg, Alan. *The Incorporation of America: Culture and Society in the Gilded Age.* New York: Hill & Wang, 2007.

Triglio, Tony. *Allen Ginsberg's Buddhist Poetics.* Carbondale: Southern Illinois University Press, 2007.

Triglio, Tony. "Reading Elise Cowen's Poetry." In *Girls Who Wore Black: Women Writing the Beat Generation,* edited by Ronna Johnson and Nancy McCampbell Grace, 119–39. New Brunswick, NJ: Rutgers University Press, 2002.

Troncale, Anthony T. *Worth Beyond Words: Romana Javitz and the New York Public Library's Picture Collection.* New York: New York Public Library, 1995.

Turvey, Gerry. "Panoramas, Parades and the Picturesque: The Aesthetics of British Actuality Films, 1895–1901." *Film History* 16, no.1 (2004): 9–27.

Ulmer, Gregory L. "The Object of Post-Criticism." In *The Anti-Aesthetic: Essays on Postmodern Culture,* edited by Hal Foster, 83–110. Port Townsend, WA: Bay Press, 1983.

Urner, Nathan D. *The Detective's Secret: or The Widow's Plot.* Chicago: Laird & Lee, 1888.

US Bureau of the Census. "Table 18: Population of the 100 Largest Urban Places: 1950." June 15, 1998. www.census.gov/population/www/documentation/twps0027/tab18.txt.

Valentine, D. T. *Manual of the Corporation of the City of New York for the Year 1864.* New York: Edmund Jones & Co., 1864.

Wakefield, Dan. "New York's Lower East Side Today: Notes and Impressions." *Commentary* (June 1959): 461–71.

"Walker Evans: License Photo Studio." In *Heilbrunn Timeline of Art History.* New York: The Metropolitan Museum of Art, 2000–. Accessed Jan. 8, 2013. www.metmuseum.org/toah/works-of-art/1972.742.17.

Wasserman, Suzanne. "Good Old Days of Poverty: Merchants and the Battle over Pushcart Peddling on the Lower East Side." *Business and Economic History* 27, no. 2 (Winter 1998): 330–39.

Wasserman, Suzanne. "New York City and Open Air Markets (1929–1948)." Accessed March 2, 2015. www.pages.drexel.edu/~dgp48/eport/documents/foodcartpaper.pdf.

Weber, Myles. "Henry Roth's Secret." *Michigan Quarterly Review* 45, no.3 (Summer 2006): 560–67.

Weinberg, H. Barbara, and Carrie Rebora Barratt, "American Scenes of Everyday Life, 1840–1910." In *Heilbrunn Timeline of Art History.* New York: The Metropolitan Museum of Art, 2000–. September 2009. www.metmuseum.org/toah/hd/scen/hd_scen.htm.

Weiss, Jason. *Always in Trouble: An Oral History of ESP-Disk', the Most Outrageous Record Label in America.* Lebanon, NH: University Press of New England, 2012.

Wertheim, Stanley and Paul Sorrentino. *The Crane Log: A Documentary Life of Stephen Crane, 1871–1900*. Boston: G. K. Hall, 1994.

Wertheim, Stanley. *A Stephen Crane Encyclopedia*. Westport, CT: Greenwood Press, 1997.

Westerbeck, Colin, and Joel Meyerowitz. *Bystander: A History of Street Photography*. New York: Little Brown, 2001.

Wetzsteon, Ross. *Republic of Dreams: Greenwich Village: The American Bohemia, 1910–1960*. New York: Simon & Schuster, 2002.

Wikipedia. "Lower East Side." Modified February 12, 2015. http://en.wikipedia.org/wiki/Lower _East_Side.

"William Putterman; Emmy Award-Winning Producer." *L. A. Times*, June 4 1995, Obituary section, 1. http://articles.latimes.com/1996-06-04/news/mn-11647_1_emmy-award-winning-producer.

Williams, William Carlos. Introduction to *Empty Mirror: Early Poems by Allen Ginsberg*. New York: Totem Press, 1961.

Wilson, Earl. *Earl Wilson's New York*. New York: Simon & Schuster, 1964.

Wirth-Nesher, Hana. "Between Mother Tongue and Native Language: Multilingualism in Henry Roth's Call It Sleep." *Prooftexts* 10, no. 2 (May 1990): 297–312.

Wirth-Nesher, Hana. *Call It English: The Languages of Jewish American Literature*. Princeton, NJ: Princeton University Press, 2006.

Wood, Ella N. *Chalk; or, We Can Do It*. Chicago: F. H Revell, 1903.

"A World of Change on the Lower East Side." *New York Times Lens*, November 29, 2011. http:// lens.blogs.nytimes.com/2011/11/29/a-world-of-change-on-the-lower-east-side/?_r=0.

The WPA Guide to New York City: The Federal Writers Project Guide to 1930s New York. New York: New Press, 1992.

Wright, Sarah. "Lower East Side: A Rebirth of World Vision." *African American Review* 27, no. 4 (Winter 1993): 593–96.

Yochelson, Bonnie. "Photography Changes Our Awareness of Poverty." *click!,* Smithsonian Photography Initiative, Smithsonian Museum, February 10, 2009. http://click.si.edu/Story.aspx ?story=436.

Zapol, Lisa. "'Stores of Memory': An Oral History of Multigenerational Jewish Family Businesses in the Lower East Side." MA thesis, Oral History, New York University, 2011.

Zemel, Carol. *Looking Jewish: Visual Culture and Modern Diaspora*. Bloomington: Indiana University Press, 2015.

Zerbe, William H. "Picturesque New York." *American Annual of Photography* 31 (1917): 202–5.

Index

Note: Page numbers in **bold** indicate illustrations.

Abubakr, Rashidah Ismaili, 174

actuality: effect and location, 61–62, 64–67, 72–73, 85; Evans' historical imagination and, 111–12; in Griffith's use of location, 78, 85; Lumière's cinema, 60–63; and temporality, 77–78

"The Adventures of Superiorman" (cartoon, Bloom), 181–82, **182**

advertising: in Evan's photography, 114, 116; for "Hat" Detective Camera, **99**; in Shahn's photography, 145, 147; "sign function" of, 20–21; in Soyer's painting, 120; Strand and omission of, 95–96; tobacco advertisement, *Knights of Labor*, **38**

afterlife of images: as context for method or logic of photography, 100, 112; and the dystopian futures, 190–91; *Five Points* as example, 7–11, **8, 10, plate 1**; halftone reproduction and, 19; of the Lower East Side, 2–3; *Scene in Shantytown* as example, 18–19; and tensions between past and present, 121–22, 126, 144

alterity: and assimilation, 48–49; Bowery bums and, 186, 201–6; and immobility or belatedness, 46–47; and language, 131, 133–34; Lower East Side as space of, 101, 103; and modernity as "native," 47; and observation, 45–46

American Biograph Company, 66–68, 70, 72, 78

American Photographs (Evans), 112–14

The Andrews Hotel (Wang), **204**

animation: and arrest, 34, 35, 43; and Crane's narrative, 35; of Griffith by the ghetto and street, 67, 70, 71, 79, 83, 92; and the illusion of projected motion, 61–63; and indexical link between photo and subject, 95; Méliès

on, 63; motion pictures and, 63–64, 67; and narrative, 42–43; and the past, 168–69; reanimation of the past, 154–56, 162, 180; Riis's photography and, 33–34, 43; and sensory experience of cinema, 67; as shock, 128, 162; of spectator or reader, 33, 43, 47, 57; in Strand's work, 94–95; of the street, 63

anonymity, 43

Antin, David, 55

Arbitration is the True Balance of Power (Keppler), **39**

arrest, 13–14; animation linked to, 34, 35, 43; "arrested development," 136, 148–49; Cahan and, 49, 51, 57, 93; class immobility, 35–36; criminal arrest as spectacle, 33; dystemporality in Crane's *Maggie*, 35–36; and emptiness, 126; Evans and, 116–18; and failure of agency, 42–43; in Hine's photographs, 202–3; literary naturalism and class immobility, 36–37; and poetry, 162–63; Riis's photographs and arrest of the subject, 13–14, 32–34; Roth and, 125, 129, 131, 132, 139–41; social immobility in Crane's *Maggie*, 35, 41–45; Strand and, 97–98, 103; time as retarded or collapsing, 215; and the unaware subject, 98–100, 204; of the viewer's gaze, 148–49; *see also* temporality

assimilation: Baraka and Jew as figure of, 180–81; Baraka and resistance to, 177–81, 183; Ginsberg and tensions of, 154–57, 165; of Jewish Americans, 146, 147–48, 157, 174, 179–81; language and, 215; Lower East Side and inassimilablity, 57, 85, 116, 129, 198, 209–10; and modernity, 126; in Roth's *Call It Sleep*, 125, 126, 139–40, 208–9; in

assimilation (*continued*)
Shahn's photography, 146, 147–48; Strand's photography and rhetoric of, 110; and temporality, 133; and time-discipline, 37–41
authenticity, 8, 72, 114, 157–58, 169, 193–94, 214
Avenue C at 13th Street (Sperr), **120**

Bakhtin, Mikhail, 51
Balog, James, 219–21
Baraka, Amiri: arrest for obscenity, 166; "Black Dada Nihilismus," 179–80; and black diasporic identity, 166–69; *Blues People: Negro Music in White America*, 178, 180; "Confessions of a Former Anti-Semite," 181; *The Dead Lecturer*, 167, 179; *The Eighth Ditch*, 166; and jazz, 175, 177–78; and the Jew as figure of assimilation, 180–81; and Lower East Side, 166–67, 169–71, 173, 181–83; and modernism, 166; political activism of, 166–67; *Preface to a Twenty-Volume Suicide Note*, 167–69; and resistance to assimilation, 180–81, 183; and "The Shadow" as figure, 168–69; "Somebody Blew Up America," 181
Barratt, Carrie Rebora, 9
Barthes, Roland, 6, 102; *Camera Lucida*, 128, 140
Beats: Baraka and rejection of, 169–73; decline of, 171; *"Rent-a-Beatnik" Party in Brooklyn* (McDarrah), **170**; *see also* Ginsberg, Allen
Becker, Charles, 72–73
Beecher, Catherine, 135
Benjamin, Walter, 63, 212
Bey, Amir, 171
Birth of a Nation (Griffith), 66
Bitzer, G. W. "Billy," 70, 91
Black Arts movement, 167, 180–82
"Black Dada Nihilismus" (Baraka), 179–80
Blind Woman, New York (Strand), 108–10
Bloom, Leonard, 181–82; cartoon by, **182**
Bloom, Lisa, 209
Blues People: Negro Music in White America (Baraka), 178, 180
Bolter, Jay David, 193, 198
Bonestell, Chesley: as architect and matte painter, 194; photo-based images and reality effects, 194–95, 197; *Saturn as Seen from Its Moon Triton*, **196, plate** 7

the Bowery, **102**; bums and, 186, 201–6; Evans and, 113–14; Strand and street portraiture in, 100–103
The Bowery in two inadequate descriptive systems (Rosler), **200**, 205–6, **207**; Rosler's "afterthoughts" on, 206
Brace, Charles Loring, **44**
Brispot, Henri, poster by, **65**
Burch, Noël, 85
Burroughs, William, 166

Cahan, Abraham: assimilation, 54–55, 57; as belated imitator, 46–48; and linguistic hybridity, 51–54; literary realism and, 51–53; and mutual mediation of the immigrant and the native, 53–55; and reading as translation, 52–55; as Riis's apprentice, 45–46; and types, 50–51; and use of English language, 47–48; and visibility, 45–48, 52–53; *see also Yekl* (Cahan)
Call It Sleep (Roth): and assimilation into language, 128–30, 140; and link between photography and retrospection, 128–29, 133–38; and photographic subjectivity, 127–29; and prohibition of images, 130, 132, 138; resistant looking in, 132–33; and temporal displacement, 125–26, 129–30, 137–38; visual agency in, 126–30, 133–37
Camera Lucida (Barthes), 128, 140
cameras: camera's agency and gaze, 19, 64, 97, 99, 110; hidden, 99–100; Kinetograph camera, **62**; Lower East Side as camera, 130, 133–35, 140, 146; visual agency of, 127–28, 146
Capitoline She-wolf with Romulus and Remus, **133**
Catlin, George, 7–10
Chasing Ice (Orlowski, documentary film), 219–21; screenshot from, **221, plate 8**
"Cheap Clothing: The Lives of the 'Sweaters'" (Rogers), 11–13, **12**
chromolithography, 134
Churchill, Allen, 103
Cinématographe Lumière poster, **65**
Citizen Kane (Welles), **195**
Clarke, Arthur C., 194
Cohn, Roy, 156
Coleman, Ornette, 177
collage, 55–56

Collier's: and Bonestell as illustrator, 194–96, **197**; circulation of, 191, 198; and documentary register, 186–87; fictive documentary approach in, 184–90, 197–98; halftone screening used in, 191; Hare and photojurnalistic coverage of war, 191–93; "Hiroshima, U.S.A." illustrations for, **185, 186, plate 5, plate 6**; "Imaginary Account of Russia's Defeat and Occupation" in, 197; and remediation, 193; and sensationalism, 191, 193; "The Story of a Story," 187; use of Lower East Side as site of fictive atomic blast, 189–91, 196–97; war coverage and reader as spectator, 192, **192**

Coltrane, John, 177–78

"Confessions of a Former Anti-Semite" (Baraka), 181

contact zone: Griffith and cinematic construction of, 73–75, 83, 87–92; Lower East Side as, 68, 73–75, 83, 91–92, 101, 112, 212; Riis and slums as, 33

Conversation (Strand), **106**

Cooper Union, as iconic site, 186, 188, 215

Cowen, Tyler, 210–11

Crane, Mary Helen Peck, 31–32

Crane, Stephen: and Charles Becker, 73; experience of animation linked to aesthetic of arrest, 35; and Protestant social reform agenda, 31–32; Riis as influence on, 30–32, 34, 42–45, 57, 73, 191; and shock, 32 (see also *Maggie*)

crime and vice linked to Lower East Side, 1–2, 5–6, 13, 45, 68, 71–72, 76, 101–2, 144, 171–72

Czitrom, Daniel, 29

The Daily Graphic, cover image, 1880, **21**

Davis, William S., 103

The Dead Lecturer (Baraka), 167, 179

deictic language, 6

Dens of Death (Riis), 114, **115**

detective cameras, 99–100

dialect: Cahan's use of Yiddish in *Yekl*, 50–55; in Crane's *Maggie*, 34; and literary naturalism, 34; Riis and use of, 29; Shteyngart's "verballing," 215

Diner, Hasia, 6–7, 125, 146, 157

Di Prima, Diane, 166

documentary: *Collier's* illustrations and documentary register, 186–87; Evans and reinvention of, 111–12, 115–16; and Great Depression subjects, 111; and Lower East Side, 186–87; Rosler and "demystification" of, 205; Rosler and remediation of, 199, 204–6, 209–10; and self-consciousness of the photographer, 204–5; Strand and redirection of, 108, 110; viewers and response to fictive images, 195–96

doubling: Cahan's linguistic hybridity and, 51–52; and Griffith's casting of the Gish sisters, 82; of the photograph as spectacle and evidence, 29–30

Drunks, The Bowery ("Weegee" Fellig), 203

East Side Street (Soyer), 120, **121, plate 3A**

Edison, Thomas, 60

The Eighth Ditch (Baraka), 166

Eisenstein, Sergei, 82

11:30 a.m. (Hine), **41**

ethnic identity, 6–7

Evans, Walker: *American Photographs*, 112–14; and arrest, 117–18; and conflicting temporal registers, 111–12, 114, 116–18; and Farm Security Administration, 111, 112; *License Photo Studio*, 112, **113**, 114–16; *Negro Church, South Carolina*, 117; and photography as historical imagination, 111–12; and reinvention of documentary photography, 111–12, 115–16; and Shahn, 126, 142–43; Strand as influence on, 108; *Truck and Sign*, **112**

evidentiary power of photography, 1, 23–27, 29–30, 219–20

Ewen, Elizabeth, 40

Fellig, Arthur (Weegee), 144, **156**, 203, **203**

The Five Points (attrib. Catlin), 7–10, **8, plate 1**

Five Points (McSpedon & Baker, lithograph), **10**

Five Spot Club, 175–77

Five Spot Club (Snitzer), **176**

flash lighting technology and night photography, 2, 24, 32, 91, 105; and arrest, 33

Fleissner, Jennifer, 34–35

The Floating Bear (magazine), 166

Following the Piper (Keppler, chromolithograph), **96**

the foreign. *See* alterity

Fort Lee, New Jersey, 78

Fringed Gentian (Newman), 135, **136, plate 3B**

Galassi, Peter, 113–14

gaze: arrest of, 148–49; camera's agency and, 19, 64, 97, 99, 110; Griffith and cinematic, 72, 76–77, 81–83, 89–92; journalistic attention and, 18–19, 186; Roth and resistant looking, 132–33; Shahn and disjuncture of, 144, 147–48; subjects and frontal, 76–77, 104, 147–48

Gervais, Thierry, 192

ghetto: Crane's *Maggie* and depiction of the slums, 34, 43–45; "ghetto films," 66–67; Griffith and the, 66–67, 70–71, 77–79, 83, 92; Riis and ghetto as subject, 1–2, 30, 32–33, 43, 103, 114; shanty towns, **16**, 17–20; as space of encounter, 32–33; as space of poverty and otherness, 28; as target of social reform, 24, 33, 47–48, 76, 101–2, 114, 134, 151, 155, 161, 192, 201–2, 204–5

Ginsberg, Allen: and apocalypse, 154; and Beat poetics or sensibilities, 152–54, 160, 162–63; and the continuous present, 153–54, 168; *Howl*, 152, 162–63, 165; and iconic landscape of Lower East Side, 155–58; and Lower East Side as maternal, 155, 157–58, 164; and Lower East Side as site of memory, 152–55, 157, 162; and Lower East Side as space of orgin, 159–62; and the past, 154–55; as photo-documentarian, 162–63; and photographic seeing, 164–65; self-portrait (*myself seen by William Burroughs*), **163**; and tensions of assimilation, 154–57, 165; zen Buddhism and, 154; *see also* "Kaddish" (Ginsberg)

Ginsberg, Louis, 155

Ginsberg, Naomi, 152; mental illness of, 153, 154, 156–57, 161, 164; as voice in Ginsberg's "Kaddish," 161

Gish, Dorothy, 81–82

Gish, Lillian, 79–82

Godkin, E. L., 17, 134

Griffith, D. W.: *Birth of a Nation*, 66; and cinematic construction of contact zone, 73–75, 83, 87–92; and cinematic gaze, 72, 76–77, 81–83, 89–92; and follow-focus, 91; "ghetto films" and filmic realism, 66–67; and the ghetto or street as animating, 67, 70–71, 79, 83, 92; literary naturalism as influence on, 70–71; and offscreen space, 85–91; *Romance of a Jewess*, 78–79, **79**; and spectatorial dilemma, 89–91;

street-level location shots and, 78–79; and temporality, 77–78; and transformation of filmic language, 66; *An Unseen Enemy*, **81**; and use of ghetto iconography, 77–79; *see also The Musketeers of Pig Alley*

Gruen, John, 171

Gunning, Tom, 27, 61–63

halftones: *Collier's* use of, 191; *Daily Graphic's* use of, 16–20, **21**; objectivity or fidelity of, 17, 19; and photography as unmediated experience, 20, 23, 25, 27; readers and intelligibility of, 23, 25–27; *A Scene in Shantytown* and newspaper publication of, 2, **2**, 18–19; and shift in print culture, 20–23; and urban poverty as subject matter, 19–20, 24, 28

Hambourg, Maria Morris, 104–5

Hamerton, Philip Gilbert, 23

Hansen, Miriam, 64, 66, 67, 71

Hare, James H., 191

Harris, Neil, 17, 23

Hawthorne, Nathanial, 18

Henkin, David M., 56

Hernton, Calvin, 174

Hersey, John, 186

Hine, Lewis Wickes, 40, 105; *11:30 a.m.*, **41**; *Midnight at the Bowery Mission Breadline*, **202**

"*Hiroshima, U.S.A.*" (Lear), 184–87

Horgan, Steven Henry: halftone screening, 16–17; *Shantytown*, **16**

Howe, Irving, 129

Howells, William Dean, 13, 47

How I Became Hettie Jones (Jones), 174

Howl (Ginsberg), 152, 162–63, 165

How the Other Half Lives (Riis), 11, 24–28, 114; "Five Cents a Spot," 24, **25**, **26**, 32

iconographemes, 102, 189–90

iconography: and actuality in Griffith's *Musketeers*, 73, 80–82; and arrest of the subject, 24–25, 32–33, 43, 47, 51, 58; Baraka and, 166–67; Baraka and ghetto, 171–75, 178–79; bodily, 48; of ethnic "types," 105–8; Ginsberg and, 155–58, 162; halftones and ghetto, 24; of Lower East Side, 2–3, 6–9, 13, 20, 24, 64, 67–70, 110, 155–58, 186, 188, 215, 221; mass reproduction of images and ghetto, 20–21, 24; photography and, 6, 25,

32–33; Riis and modern ghetto, 32–33, 121; Shahn and, 144–46, 145–46; Strand and iconographic effect, 96–98

"Imaginary Account of Russia's Defeat and Occupation" (Murrow and Winchell), 197

interiority, 91

invisibility. *See* visibility

Irish Americans, 4–5, 18, 105–6, 108, 129

James, William, 153

Jazz, 169–70, 174–79

Jewish Americans: and cultural dislocation, 56; cultural production of, 1, 46–47, 93, 151, 155, 174 (see also *specific individuals*); diversity of, 50; as invisible, 13, 46, 48, 93; and Lower East Side as social context, 123–25; and modernity, 146–47; as stubbornly belated, 46; as "types" made visible through arrest, 13

Joans, Ted, 171, **173**

Johnson-Reed Act, 122

Jones, Hettie (neé Cohen), 169–70, 174, 177, 181, 182

Jones, LeRoi. *See* Baraka, Amiri

Joselit, Jenna Weissman, 134

Jussim, Estelle, 23

"Kaddish" (Ginsberg): incestuous encounter in, 161; and katabasis, 156–57, 165–66; Lower East Side as resource and context for composition of, 152–53; as memorial, 152, 158–61; and reanimation of the past, 154–56, 162, 180; reversals and inversions in, 154–55; temporal disposition of, 154–60; as visionary, 153, 154–55, 160–61, 164–66

Kazin, Alfred, 125

Keppler, Joseph, illustration by, **39**

Keppler, Udo J., chromolithograph by, **96**

Kinetograph camera, **61**

Kinetoscope, 60

Krassner, Paul, 181

labor: activism on Lower East Side, 13, 46–47, 68, **68**, 155, 188; "liberation" from, 211; Shahn and, 143–46; time discipline and, 37–40

language: and alterity, 131, 133–34; as barrier to assimilation, 135–38, 149; and collage effect, 50–55; and cultural invisibility,

45–47, 93; deictic language, 6; Lower East Side and heteroglossia, 116, 118, 215, 218; orthography and orientation to text, 56, 149, 151; Rosler and photo-text pairs, 205; Yiddish-language press and writers, 45–47, 55–56, 157

Lear, John, "Hiroshima U. S. A." by, 184–90

License Photo Studio (Evans), 112, **113**, 114–16

Lower East Side: as abandoned or empty, 119–22, 126, 144, 147, 151, 170–71, 201; as animating for Griffith, 70–71; Baraka and context of, 166–67, 169–71, 173, 181–83; and Black avant garde, 167–69, 174–77; as camera, 130, 133–35, 140, 146, 147; as contested space, 6, 83–84; as diverse, 50, 174; and film industry, 66–70 (*see also under* Griffith, D. W.); Five Points, 7–11, **8**, **10**, 101; Fort Lee, New Jersey as cinematic double of, 78; as frontier, 171–73; as geographical location, 3–6; as Ginsberg's site of memory and history, 152–55, 157–58; history of, 1–6; as iconic, 2–3, 6–7, 9, 13, 20, 24, 64, 67–70, 110, 158, 186, 188, 221; and Jewish American cultural production, 1, 46–47, 93, 155, 174; labor activism on, 13, 46–47, 68, 188; and modernity, 2–3, 6, 46, 66–67, 70–73, 101, 141–42, 155–56; as moral threat, 29–30 (*see also* vice and crime *under this heading*); and *A Plan of the City of New York* (1776), **4**; political activism in, 155, 188; and reality effect, 73; as scale for understanding climate change events, 221; as site of fictive atomic strike, 184–91, 196–98, 201; as site of future catastrophe, 215–18, 221; as site of loss, 130; "social map" of, **69**; as space of encounter, 14, 28, 66, 103, 126, 151, 161–62; as subject for visual media, 1–2; as target of reformers, 2, 24, 33, 47–48, 76, 101–2, 114, 134, 151, 155, 161, 201–2; as time machine, 114, 128, 147 (*see also* as Ginsberg's site of memory *under this heading*); and urban renewal, 18, 114, 122, 158, 190; vice and crime linked to, 1–2, 5–6, 13, 45, 68, 71–72, 76, 101–2, 144, 171–72

"The Lower East Side: Portal to American Life" (exhibition, Jewish Museum), 161

Lumière, Louis and August, 59–60

Maggie: A Girl of the Streets (Crane), 30–37, 41–43, 73; clock-time and time-discipline

Maggie (*continued*)
 in, 34, 36–41; dialect in, 34; and narrative
 stasis temporality, 34–35; social immobility
 in, 35, 41–45; temporality and stasis in,
 34–35
magic—lantern-slide shows, 27, 29–33, 35,
 43, 47
Man, Five Points Square (Strand), **104**, 104–5
*The Manual of the Corporation of the City of
 New York*, 9–11
The Man Who Invented Hollywood (Griffith),
 70–71
mapping, location of the Lower East Side, 3–6
maps: overlay in *Chasing Ice*, **221**; *A Plan of
 the City of New York* c.1776, **8**; "Social Map
 of the Lower East Side," **69**
Mauldin, Bill, 197
McDarrah, Fred W.: *"Rent-a-Beatnik" Party in
 Brooklyn*, **170**; *Ted Jones in His Loft*, **173**
McGann, Jerome, 53
McGill, Meredith, 11
Méliès, Georges, 63
Metropolitan Museum of Art: children
 visiting Wing A, **131**; in Roth's *Call It
 Sleep*, 130–32
Midnight at the Bowery Mission Breadline
 (Hine), **202**
Mitchell, David, 211
modernism: Evans and photographic, 119;
 Ginsberg and literary, 155; New York
 skyscrapers as icons of, 158; realism and,
 14; Roth and literary, 125–26; Shahn and
 literary, 119; Shahn and photographic,
 126, 151; Strand and photographic, 93–95;
 Yiddish language and literary, 46
modernity, 6–7; in Cahan's *Yekl*, 46–49;
 clocks and time-discipline as symbol of,
 37–40; the ghetto and urban, 120–22;
 immigrants as unassimilated to, 11; Lower
 East Side as site of urban, 2–3, 6, 46, 66–
 67, 70–73, 101, 155–56; and negotiation of
 multiple cultural frames, 56; observation
 of, 2, 14–15, 28; Riis and photographic
 documentation of urban, 24; and
 time-discipline, 37–41; and women's
 social roles, 34–35
Monk, Thelonius, 177
Morgan, J. P., 94–95
Moses, Robert, 122

Murrow, Edward R., 197
The Musketeers of Pig Alley (film, Griffith):
 casting for, 79–80, 82–83; compared to
 Romance of a Jewess, 78–79; iconography
 and actuality in, 73, 80–82; location
 filming for, 72–78, 81, 83, 85, 91–92;
 offscreen space in, 85–91; Riis as influence
 on, 73; screenshots from, **74, 75, 76, 81,
 82, 84, 87, 89, 90**

naturalism, literary: Crane's *Maggie* and,
 30–31, 34; critical interest in, 34; and
 depiction of the underclass, 36–37;
 Griffith influenced by, 70–71; and
 repetition, 34
Negro Church, South Carolina (Evans), 117
Newman, Henry Roderick, 135; *Fringed
 Gentian*, **136, plate 3B**
Newton, Henry, 18–29
New York, New York, push cart fruit vendor
 (Parks), **159**
New York Public Library: Picture Collection,
 108–9
nickelodeons, 66
nuclear holocaust, visualization of, 2, 184–90,
 185, 186, 189–91, 196–97, **plate 5, plate 6**

offscreen space, 85–91
Orlovsky, Peter, 153
Orlowski, Jeff, *Chasing Ice*, 219–20, **221**
the other. *See* alterity
Outside the Yiddish Art Theatre ("Weegee"
 Fellig), **156**

Parker, Charlie, 178
Parks, Gordon, 158; photo by, **159**
The Passion of Sacco and Vanzetti (Shahn,
 painting series, 147
Peirce, Charles Sanders, 88
photography: animation and, 33–34, 43,
 61–63, 128, 162; Barthes on, 128, 162; as
 evidentiary, 1, 24–27, 29–30, 219–20;
 flash lighting and night photography, 2,
 24, 32–33, 91, 105; halftone screening and
 publication of, 16–17, 19–20, 23, 25, 27, 28,
 191; and retrospection (memory), 128–29,
 130–31, 140; and temporal disjunction,
 33; visual effects and manipulation of
 images, 27 (*see also* remediation); *see*

also cameras; *specific photographs or photographers*

A Plan of the City of New York (1776), **4**

point of view: aerial perspective and, **123**; elevated perspectives, 120; frontal perspectives, 116; Griffith and street-level, 78–79; Lear's documentary, 184–86; Shahn and, 145

Portrait, Five Points Square (Strand), **104**, 104–5

Portrait, New York (Yawning Woman) (Strand), **107**

Preface to a Twenty-Volume Suicide Note (Baraka), 167–69

realism: and authenticity, 193–94; and Bonstell's hybrid photo-based images, 194–95, 197; Cahan's *Yekl* and linguistic hybridity, 51–54; Catlin and environmental authenticity, 8–9; and ghetto as space of encounter, 28; Griffith's "ghetto films" and filmic, 66–67; "instrumental social realism" (Sekula), 33; and Lower East Side, 186–87; Lumière's cinematic realism, 60–63; and reality effects, 194–95; Shahn's social realism, 126; and subjectivity of the artist, 27; *see also* actuality

The Realist (journal), 181–83

remediation: Bolter and Grusin on, 193–94; and Bowery as site of, 206–7; Lower East Side and, 197–98; and postwar media, 198; Rosler and, 199, 204–7, 209–10; Shteyngart and, 211–12

"Rent-a-Beatnik" Party in Brooklyn (McDarrah), **170**

Riis, Jacob: animation and arrest in work, 33–34, 105; Cahan as apprentice of, 45–46; *Dens of Death*, 114, **115**; as exploitative of his subjects, 46; *Five Cents a Spot*, 24, **25**, **26**, 32; flash lighting technology and night photography, 2, 24, 32, 91, 105; and ghetto as subject, 1–2, 30, 32–33, 43, 103, 114; *How the Other Half Lives*, 11, 24–28, 114; and iconography of the Lower East Side, 32–33, 121; as influence on Crane, 30–32, 34, 42–45, 57, 73, 191; as influence on Griffith, 73; *Lodgers in a Crowded Bayard Street Tenement—"Five Cents a Spot,"* 24, **25**, **26**, 32; and magic-lantern projections, 27, 29–30; and moral reform agenda, 29–30;

and photography as evidentiary, 1, 24–27, 29–30; and temporal disjunction, 33

Rogers, William A., 11, 12, 20, **22**, 23

Romance of a Jewess (film, Griffith): compared to *Musketeers*, 78–79; screenshot from, **79**

Roosevelt, Theodore, 45

Rosenberg, Eric, 111

Rosenberg, Ethel, 156

Rosler, Martha, 198–201; *The Bowery in two inadequate descriptive systems*, **200**, 205–6, **207**; and documentary objectivity, 199–204; and emptiness or abandonment, 201; and feminism, 206–9; and inadequacy of representational systems, 205–8; Jewish identity and, 208–9; photo-text pairs, 205; political valence of works, 206–10; and rejection of "victim photography," 204, 206; and remediation, 199, 204–7, 209–10; *Semiotics of the Kitchen* (Rosler), 206–8, **208**; *Vital Statistics of a Citizen, Simply Obtained*, 206

Roth, Henry: and autobiographic misdirection, 129–30; as influence on Shahn, 126; and literary modernism, 125–26; and Lower East Side as site of loss, 129–30; multilingual aesthetic of, 126, 128, 138; and photographic mediation of experience, 125–29; and temporal displacement, 125, 128–29; see also *Call It Sleep* (Roth)

Sanders, Ronald, 3

Saturn as Seen from Its Moon Triton (Bonestell), 194, **196**

Saul, Scott, 178

A Scene in Shantytown (Horgan, halftone), 16–20

A Scene in Shantytown (Newton, photograph), 18–19

Sekula, Allan, 33, 112–13

Semiotics of the Kitchen (Rosler), 206–8, **208**

seriality: and mechanical reproduction, 141; Shahn and serial logic of photography, 147, 149–50

A Seven-Cent Lodging House in the Bowery ("Weegee" Fellig), **201**

Shahn, Ben: and commercial advertising as subject, 145–47; and documentary photography, 126; and empty landscape

Shahn, Ben (*continued*)
as negative space, 144; and Evans, 126,
142–43; and horizontality, 144; and
iconography of Lower East Side, 144,
145–46; and image reversal, 149, 151;
and modernity or modernism, 119, 126,
142, 146–47, 151; *The Passion of Sacco and
Vanzetti*, painting series, 147; and photo-
graphic experimentation, 143; and political
activism, 126, 142; Roth as influence on, 126;
and seriality, 147, 149–50; and temporality,
142–44; training as printmaker, 142; *Untitled*
(Lower East Side, New York City), 147–50,
148, 150, plate 4; *Untitled* (Seward Park,
New York City), 143, 143–47, **145**; *Untitled*
(Sig Klein Fat Men's Shop, New York City),
144–47, 151–15
Shantytown (Horgan), **16**
shanty towns, **16**, 17–20
Shepp, Archie, 177
shock: Barthes and animation as, 128; cinema
and, 63; Crane and, 34–35; Jazz and, 177;
rhythm of shock in cinema, 63; Riis's flash
photography and, 32
Shteyngart, Gary: and collapse of time,
215–16; and Lower East Side, 213–14;
and political valence of satire, 211–12;
and remediation, 211–12; and virtual
mediation of human experience, 211–14;
see also *Super Sad True Love Story: A
Novel* (Shteyngart)
Sketch of Tenement Life (Rogers), 20, **22**
skyscrapers, **123, 124,** 144, 158
"Slaves of the Sweaters" (Rogers), 11–13, **12**
slums. *See* ghetto
Smethurst, James, 167
Snitzer, Herb, 175; photo by, **176**
Snyder, Gary, 173
social reform, 2, 24, 32–33, 47–48, 76, 101–2,
114, 134, 151, 155, 161, 201–2, 204–5
Solomon-Godeau, Abigail, 205, 210
"Somebody Blew Up America" (Baraka), 181
Sonny Rawlins, 171
La Sorite de l'Usine Lumière à Lyon (film,
Lumière), 59–60; screenshot from, **60**
Soyer, Raphael, *East Side Street* by, 120, **121,
plate 3A**
Sperr, Percy Loomis, 119–20, **120**
Stange, Maren, 33

Steiglitz, Alfred, 94, 100, 108
Stow, Harriet Beecher, 135
Strand, Paul: and abstraction, 95; and agency
of the camera, 95; and animation, 94–
95; and architectural subjects, 95; and
assimilation, 100–101; and blindness, 97,
103, 108–10; *Blind Woman, New York*,
108–10; *Conversation*, **106**; horizontality
and, 97; and iconography, 96–98, 105–8;
and Jewish identity, 100–101; and Lower
East Side as iconic landscape, 98–102;
Man, Five Points Square, **104**, 104–5;
and photographic arrest, 97–100, 103;
photographic method and equipment of,
97, 103–5; and political valence of work,
95, 100; *Portrait, New York (Yawning
Woman)*, **107**; as printmaker, 93–94; and
suppression of visible markers, 95–96,
105–6
"The Street-Girl's End" (Brace), **44**
Suffolk and Hester Street (Webb), **160**
Super Sad True Love Story: A Novel
(Shteyngart): commercialism in, 211–12;
and Lower East Side as setting, 211, 213,
215–16, 218; and reading or books, 214–16,
218; "verballing" in, 215
surveillance: Cahan's work as confrontation
of, 46; Crane's narrative mode and
"watching," 34; detective cameras and
secret, 99–100

Ted Joans in His Loft (McDarrah), **173**
temporality: and actuality in Griffith, 77–78;
Arbitration is the True Balance of Power
(Keppler), **39**; belatedness linked to
alterity, 46–47; Cahan and belatedness,
46–48, 51–52, 55; clock-time and time-
discipline in Crane's *Maggie*, 34, 36–
41; collage and temporal effects, 55–
56; Crane's *Maggie* and narrative stasis,
34–35; Evans and temporal dislocation,
111–12, 114, 116–18; Ginsberg and the
continuous present, 153–54, 168; in
Ginsberg's *Kaddish*, 154–60; literary
naturalism and, 34; modernity and time-
discipline, 37–41; Shteyngart and collapse
of time, 215–16; visibility and being "in
time," 48
time. *See* temporality

Trachtenberg, Alan, 101
Truck and Sign (Evans), **112**
typography: in Cahan's *Yekl*, 51–55; in Roth's
 Call It Sleep, 139

An Unseen Enemy (film, Griffith), screenshot
 from, **81**
Untitled (Lower East Side, New York City)
 (Shahn), 147–50, **148**, **150**, **plate 4**
Untitled (Seward Park, New York City)
 (Shahn), **143**, 143–47, **145**
Untitled (Sig Klein Fat Men's Shop, New York
 City) (Shahn), 144–47, 151–15

urban modernity: in Cahan's *Yekl*, 46–49,
 55–57; Griffith and, 67, 70–73, 83, 85,
 91–92; Riis and, 34

Valentine's Manual, 9–11
the Village, as frontier, 171–72
visibility: and being "in time," 48; Cahan
 and, 45–48, 52–53; deictic language and,
 6; and encounter, 23, 66; Jewish cultural
 production as invisible, 151; Lower East
 Side and, 1–2, 5, 13, 14, 20, 25, 33–34,
 93, 108, 151, 199; McGann and "visible
 language of modernism," 53; mise-en-
 scène and cinematic, 64, 72, 80–81, 85
 (*see also* offscreen space); photography
 and, 1–2, 5, 13, 14, 20, 25, 33–34, 95–96,
 105–10; in Roth's *Call It Sleep*, 138–39;
 Strand and social being as invisible,

108–10; Strand and suppression of visible
 markers, 95–96, 105–6
Vital Statistics of a Citizen, Simply Obtained
 (Rosler), 206

Wall Street, New York (Strand), **94**, 94–95,
 105, **plate 2**
Wang, Harvey, *The Andrews Hotel*, **204**
Webb, Todd, 158; photograph by, **160**
Weegee (Arthur Fellig), 144, 203; *Drunks,
 The Bowery*, **203**; *Outside the Yiddish Art
 Theatre*, **156**
Weinberg, H. Barbara, 9
Williams, William Carlos, 153–54
Winchell, Walter, 197
Workers Leaving the Lumière Factory (film,
 Lumière), 59–60
Wreckage of the USS Maine in Havana Harbor
 (Hare), **192**
Wright, Frank Lloyd, 122; aerial perspective
 architectural drawing by, **123**
Wright, Sarah, 174

Yekl (Cahan): collage effect in, 50–55; dialect
 in, 50–55; eye or sight dialect controversy,
 51–53; modernity in, 46–49, 55–57; and
 realism, 51–54
Young, Lester, **176**

Zola, Emile, 70
Zukor, Adolph, 66